Making the Woman Worker

DECENT WORK AND RIGHTS
FOR DOMESTIC WORKERS
Demanding an ILO Convention in 2011

Frontis. Domestic Worker Campaign Poster, 2011. By Ivy Climacosa for the Design
Action Collective and Steering Committee for Global Campaign for Decent Work and
Rights for Domestic Workers—Asian Migrant Domestic Workers' Alliance (ADWA),
International Domestic Workers Network (IDWN), Migrant Forum Asia (MFA),
RESPECT Network Europe, and National Domestic Workers Alliance (NDWA), with
permission.

Making the Woman Worker

Precarious Labor and the Fight for Global Standards, 1919–2019

EILEEN BORIS

OXFORD
UNIVERSITY PRESS

OXFORD
UNIVERSITY PRESS

Oxford University Press is a department of the University of Oxford. It furthers
the University's objective of excellence in research, scholarship, and education
by publishing worldwide. Oxford is a registered trade mark of Oxford University
Press in the UK and certain other countries.

Published in the United States of America by Oxford University Press
198 Madison Avenue, New York, NY 10016, United States of America.

CIP data is on file at the Library of Congress
ISBN 978–0–19–087462–9

1 3 5 7 9 8 6 4 2

Printed by Sheridan Books, Inc., United States of America

Contents

List of Illustrations vii

Acknowledgments ix

List of Abbreviations xiii

A Note on Nomenclature xvii

Prologue xix

Introduction: Making Women, Defining Work 1

PART I: *Difference: The Problem of the Woman Worker, 1919–1958*

1. Protection 17

2. Equality 53

PART II: *Difference's Other: Women in "Developing" Countries, 1944–1996*

3. Development 89

4. Reproduction 122

5. Outwork 155

PART III: *Difference All: Centering Care, 1990s–2010s*

6. Home 193

7. Women's Place (in the Future of Work) 229

Appendix 1: List of Key Conventions and Recommendations 243

Appendix 2: Publications of the Programme on Rural Women, 1978–1988 245

Notes 249

Index 321

Illustrations

Frontis. Domestic Worker Campaign Poster, 2011. By Ivy Climacosa
for the Design Action Collective and Steering Committee
for Global Campaign for Decent Work and Rights for
Domestic Workers—Asian Migrant Domestic Workers'
Alliance (ADWA), International Domestic Workers Network
(IDWN), Migrant Forum Asia (MFA), RESPECT Network
Europe, and National Domestic Workers Alliance
(NDWA), with permission. ii

1.1 "A Group of Delegates" at the International Congress of
Working Women, 1919. Left to Right, sitting: Mlle. Yadwiga
Lukasiuk, Poland; Mlle. Georgette Bouillet, France; Mlle.
Jeanne Bouvier, France; Mrs. Raymond (Margaret Dreier)
Robins, President of the National Women's Trade Union League
of America; Dr. Melanie Bornstein, Poland; Mlle. Konstancja
Olszewska, Poland. Standing: Mlle. Victoire Cappe, Belgium;
Mlle. Sophie Dobrzanska, Poland; Mlle. Berthe de Lalieux,
Belgium; Mme. Marie Majerová, Czechoslovakia, and Mme.
Luisa Landova-Stychova, Czechosolvakia. Library of
Congress. 18

1.2 1st International Congress of Working Women, Washington,
DC, October 28, 1919. Library of Congress. 25

1.3 First ILC Session, Washington, DC. Photo from International
Labour Organization, with permission. 25

1.4 Committee on the Night Work of Women, ILC, 1934. At the
back table: Committee Chair Kerstin Hesselgren (Sweden),
Marguerite Thibert (ILO), reporter Milena Atanatskovitch
(Yugoslavia), and Worker Vice-Chair Julia Varley (Great Britain).
Photo from International Labour Organization, with
permission. 37

2.1 ILC, 1944, Philadelphia. Eleanor Hinder (ILO), Robert
 Lafrance (ILO), Bertha Lutz (Brazil), and Marguerite Thibert
 (ILO). Photo from International Labour Organization, with
 permission. 54

2.2 Mildred Fairchild, Chief of Women's and Young Workers
 Division, 1947–1954. Photo from International Labour
 Organization, with permission. 68

2.3 Frieda Miller, Director, US Women's Bureau, 1944–1953.
 Photo from Schlesinger Library. 69

3.1 Frieda Miller with Indian women. Photo from Schlesinger
 Library, Liberty News. 100

3.2 A student at Dar Atayad, Syrian Arab Republic where the
 ILO trained carpet weavers, 1961. Photo from International
 Labour Organization, with permission. 106

4.1 Cover, *Rural Development and Women in Africa* (Geneva:
 ILO, 1984). Photo from International Labour Organization,
 with permission. 123

4.2 Elizabeth Croll, *Women and Rural Development in China*
 (Geneva: ILO, 1985). Photo from International Labour
 Organization, with permission. 140

5.1 SEWA, women marching. Photo from SEWA, with
 permission. 174

6.1 Asian Domestic Workers Network, patchwork quilt
 demonstration, June 8, 2010, Geneva. Photo by Jennifer
 N. Fish, on behalf of the International Domestic Workers
 Federation, with permission. 194

6.2 Founding of the International Domestic Workers
 Federation, Montevideo, Uruguay, October 2013. Photo
 by the author. 226

6.3 Hall with T-shirt display, Second Congress of the International
 Domestic Workers Federation, Cape Town, South Africa,
 November 2018. Photo by the author. 227

7.1 Domestic workers lobby for an ILO Convention on Violence
 and Harassment Against Men and Women in the World of
 Work, 2018. Photo by Jennifer N. Fish, on behalf of the
 International Domestic Workers Federation, reworked by
 Ye Ting Ma, with permission. 234

Acknowledgments

THIRTY YEARS AGO, when I became aware of the convention and knowledge making of the ILO, I had no idea that this PhD in the history of American civilization (Brown's highfalutin name for American studies at the time of my degree) would become a global labor historian and transnational feminist scholar. Or that I would travel across the world engaging with other researchers and archives. It's been a heady time, layering the new on the old, and I feel so fortunate to have had such wonderful and smart companions and friends along this journey.

I've accumulated many debts in the decade that I have worked on this book. First and foremost, I thank the staff of the ILO, especially Remo Becci and Jacques Rodriquez of the Archives and the Century Project under Emmanuel Reynaud and Dorothea Hoehtker. I also appreciate those from the ILO's Geneva Office who took time out of their busy schedules to provide me with information and answer questions. I'm particularly grateful to Manuela Tomei, director of the now named WORKQUALITY Department, and Claire Hobden, technical officer in the Working Conditions branch focused on domestic work. I'm obliged to those who played a part in this story for talking or e-mailing with me, including Tomei and Hobden; Renana Jhabvala of SEWA; Dan Gallin, retired leader of the IUF; Jill Shenker, formerly of the National Domestic Workers Alliance; Lourdes Benería; Guy Standing; Marty Chen of WIEGO; Elizabeth Tang, Ip Fish, Chris Bonner, and others with the International Domestic Workers Federation. Chris Edgar and the Publications branch at ILO facilitated permissions.

Jill Jensen, whose doctoral committee at UCSB I had the pleasure of joining, introduced me to the possibilities of researching the ILO. When Kitty Sklar and Tom Dublin asked me to write an essay on the ILO and women's economic justice for Women and Social Movements, International, I turned to Jill to become my co-author rather than just picking her brains as graduate advisors sometimes do. We've continued collaborating over the last decade, and I'm the richer and wiser for it. I thank other UCSB graduate research assistants, including Heather Berg, Kit Smemo, Megan Undén, and Nicole de Silva, and graduate students

Johnnie Kallas of Cornell ILR School and Jessica Auer of UNC Chapel Hill for retrieving archival files for me.

I've gained so much wisdom from Dorothea Hoehtker, now with the Research Department of the ILO, and Susan Zimmermann, the finest scholar of gender and class of the interwar period I know, both of whom coedited *Women's ILO: Transnational Networks, Global Labour Standards, and Gender Equity, 1919 to Present* with me. They have kept me from numerous mistakes. I wish I could read Susan's book in German, but have to be content with her numerous articles in English. Dorothea has gone beyond friendship to find photos and documents when the archives staff could not. I have benefited from the efforts of the contributors to our collection, whose work I had the pleasure of editing: Dorothy Sue Cobble, Françoise Thébaud, Kristen Scheiwe, Lucia Artner, Silke Neunsinger, Yevette Richards, Chris Bonner, Pat Horn, Renana Jhabvala, Marieke Louis, Paula Lucia Aguilar, Eloisa Betti, Akua O. Britwum, Sonya Michel, and Mahua Sarkar. I also have learned from other scholars who participated in the workshops connected to that volume: Jennifer N. Fish, Glaucia Fraccaro, Kristen Ghodsee, Albertina Jordao, Nora Natchkova, Céline Schoeni, and Olga Sanmiguel-Valderrama. Jennifer Fish brought me into the world of IDWF, and I thank her for providing wonderful photographs and field notes from her own research. Silke Neunsinger, Susan Zimmermann, Sonya Michel, Jill Jensen, Magaly Rodríguez García, Jackie Eisenberg, and Katherine Marino also shared documents. I further benefited from conversations with Sandrine Kott, Elisabeth Prügl, and Marcel van der Linden.

Those who read the manuscript, or portions of it, helped enormously in this attempt to span a century and capture the movement of people and ideas across the globe, though I take responsibility for the final product: Adelle Blackett, Dorothy Sue Cobble, Jennifer Fish, Mary Margaret Fonow, Dorothea Hoehtker, Claire Hobden, Jill Jensen, Lisa Levenstein, Nelson Lichtenstein, Leila Rupp, Lara Vapnek, Leandra Zarnow, and Susan Zimmermann. A number of people commented on earlier versions of my material, which took the form of conference papers, book chapters, or journal articles. I especially thank Howard Brick; Leon Fink; Joan Tonto; Tom Dublin and Kitty Sklar; Sonya Michel and Ito Peng; Jill Jensen and Nelson Lichtenstein; Raffaella Sarti, Anna Bellavitis, and Manuela Martini; Lisa Jacobson and Kenneth Lipartito; Beth English, Mary E. Frederickson, and Olga Sanmiguel-Valderrama; Dirk Hoerder, Elise van Nederveen Meerkerk, and Silke Neunsinger; Lora Wildenthal and Jean Quataert; and Barbara Molony and Jennifer Nelson.

UCSB and Oxford University Press are the two other institutions that made this book possible. Funding from the Hull Chair in Feminist Studies, which I have the privilege of holding, facilitated my research. Without Blair Hull's

generosity, none of this would have taken place. Additional funding came from the Institute for Social, Behavioral and Economic Research (ISBER), and the Academic Senate. Dave McBride has proven again to be a supportive and discerning editor. I thank his entire team, especially Holly Mitchell. Again, I thank Marta Peluso for photographing me for the book jacket and Sherri Barnes for compiling the index.

It's been four decades, Nelson, and nearly as long, Dan. We are still fighting the good fight and doing writing that matters. Work is even better when there is love.

Credits

Material in the Preface and Chapter 5 is adapted from Eileen Boris, "SEWA's Feminism," in *Women's Activism and 'Second Wave' Feminism: Transnational Histories*, ed. Barbara Molony and Jennifer Nelson (New York: Bloomsbury Academic, 2017), 79–98, with permission from Bloomsbury Publishers.

Material in chapters 2, 4, and 5 is adapted from Eileen Boris, "Regulating Home Labors: The ILO and the Feminization of Work," in *What Is Work*, ed. Raffaella Sarti, Anna Bellavitis, and Manuela Martini (New York: Berghahn Books, 2018), 269–294, with permission from Berghahn Books.

Material in chapters 2 and 3 is adapted from Eileen Boris, "Equality's Cold War: The ILO and the UN Commission on the Status of Women, 1946–1970," in *Women's ILO: Transnational Networks, Global Labour Standards, and Gender Equity, 1919 to Present*, ed. Eileen Boris, Dorothea Hoehtker, and Susan Zimmermann (Geneva: ILO; Leiden: Brill, 2018), 97–120, © 2018 by ILO. Used with permission of the ILO.

Material in chapter 3 is adapted from Eileen Boris, "Difference's Other: The ILO and 'Women in Developing Countries,'" in *The ILO from Geneva to the Pacific Rim: East Meets West*, ed. Jill M. Jensen and Nelson Lichtenstein (Geneva and London: ILO and Palgrave, 2016), 134–155. © 2016 by ILO. Used with permission of the ILO.

Material in chapters 5 and 6 is adapted from Eileen Boris, "Recognizing the Home Workplace: Making Workers through Global Labor Standards," in *Global Women's Work: Perspectives on Gender and Work in the Global Economy*, ed. Beth English, Mary E. Frederickson, and Olga Sanmiguel-Valderrama (New York: Routledge, 2018), 17–35. © 2018 and reproduced with permission of The Licensor through PLSclear.

Material in chapter 6 is adapted from Eileen Boris and Jennifer N. Fish, "Decent Work for Domestics: Feminist Organizing, Worker Empowerment, and the ILO," in *Towards a Global History of Domestic and Caregiving Workers*, ed. Dirk

Hoerder, Elise van Nederveen Meerkerk, and Silke Neunsinger (Leiden: Brill, 2015), 530–552, permission from Brill. Other material in chapter 6 is adapted from Eileen Boris and Jennifer N. Fish, "'Slaves No More': Making Global Standards for Domestic Workers," *Feminist Studies*, 40:2 (Summer 2014): 411–443. © 2014 by *Feminist Studies*. Used with permission of *Feminist Studies*.

Additional material in chapter 6 is adapted from Eileen Boris and Megan Undén, "The Intimate Knows No Boundaries: Global Circuits of Domestic Worker Organizing," in *Gender, Migration, and the Work of Care*, ed. Sonya Michel and Ito Peng (New York: Palgrave, 2017), 245–268, reproduced with permission from Palgrave/Springer.

Abbreviations

ACTRAV	Bureau for Workers' Activities (Office)
AFL	American Federation of Labor
AFL-CIO	American Federation of Labor-Congress of Industrial Organizations
ASD	Archive of Social Democracy (Bonn)
CEDAW	Convention on the Elimination of All Forms of Discrimination Against Women
CONDI/T	Conditions of Work and Welfare Facilities Branch (Office)
CSW	Commission on the Status of Women (UN)
DAWN	Development Alternatives with Women for a New Era
DWBOR	Domestic Workers' Bill of Rights (US)
ECOSOC	Economic and Social Council (UN)
EMPLOI	Employment and Development Branch (Office)
EMP/RU	Rural Employment Policies Branch (Office)
ERI	Equal Rights International
FAO	Food and Agriculture Organization (UN)
FEMMES	Office for Women Workers' Questions
FNV	Federatie Nederlandse Vakbeweging
GAD	Gender and Development
GENDER	Bureau of Gender Equality (Office)
ICWW	International Congress of Working Women
ICFTU	International Confederation of Free Trade Unions
IDWF	International Domestic Workers Federation
IDWN	International Domestic Workers Network
IFTU	International Federation of Trade Unions
IFWW	International Federation of Working Women
ILC	International Labour Conference
ILGWU	International Ladies' Garment Workers' Union
ILO	International Labour Organization
ILOA	International Labour Organization Archives (Geneva)
IPEC	International Programme on the Elimination of Child Labour

IRENE	International Restructuring Education Network Europe
ITGLWF	International Textile, Garment, and Leather Workers' Federation
ITS	International Trade Secretariats
ITUC	International Trade Union Confederation
IUF	International Union of Food, Agricultural, Hotel, Restaurant, Catering, Tobacco and Allied Workers' Associations
IWSA	International Woman Suffrage Alliance
IWY	International Women's Year (UN)
LEG/REL	Legal Relations (Office)
LoN	League of Nations
MIGRANT	Migrant Bureau (Office)
NARA	National Archives and Records Administration (US)
NDWA	National Domestic Workers Alliance (US)
NGO	non-governmental organization
NORMS/STANDARDS	International Labour Standards (Office)
NWP	National Woman's Party
OCED	Organisation for Economic Co-operation and Development
ODI	Open Door International
Office	International Labour Office
PIACT	Working Conditions and Environment (Office)
PICUM	Platform for International Cooperation on Undocumented Migrants
RELTRAV	External Relations Branch (Office)
SEWA	Self Employed Women's Organization (India)
SIDA	Swedish International Development Agency
SL	Schlesinger Library
SOW	Subordination of Women Workshop
TLA	Textile Labour Association (India)
TRAVAIL	Conditions of Work (Office)
UN	United Nations
UNESCO	United Nations Educational, Scientific and Cultural Organization
UNRISD	United Nations Research Institute for Social Development
US	United States
USSR	Union of Soviet Socialist Republics
USWB	United States Women's Bureau

WAD	Women and Development
WEP	World Employment Programme
WID	Women in Development
WIDF	Women's International Democratic Federation
WIEGO	Women in Informal Employment: Globalizing and Organizing
WWP	World Woman's Party
YWCA	Young Women's Christian Association

A Note on Nomenclature

THE ILO REFERS to its members as member States. The tripartite groups consist of Workers' group and Employers' group, also using the apostrophe when speaking of the Employers' Vice-Chairman, for example. I also refer to Government, Employer, or Worker delegates or advisors. Such capitalization refers to tripartite partners. The annual conference through 1934 was published under the umbrella of the League of Nations and the record is named *International Labour Conference*. The title becomes *Record of Proceedings* in 1932. Beginning in 1935, the ILC becomes the publisher. There is no number for the 1941 meeting. The date of publication is not necessarily the same as the year of the ILC. When the record is provisional, that is indicated. Until 1948 the title of the head of the organization is Director; afterwards, Director-General. The Office would issue first and second reports on proposed instruments, which are so noted. Dependent territories and non-metropolitan are terms used during the first half or so of the 20th century to refer to colonies.

I have used American spellings except for titles and direct quotations. The ILO uses British English.

Archival material comes from International Labour Organization Archives, Geneva, unless otherwise noted.

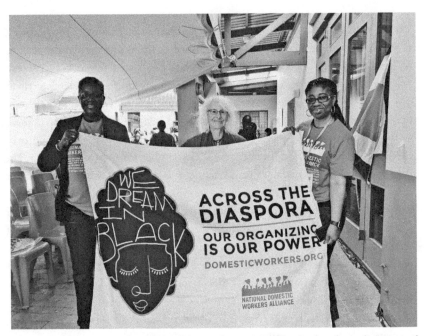

Author with June Barrett and Gilda Blanco, domestic worker leaders from the National Domestic Workers Alliance, Cape Town, South Africa, November 2018. Photo taken with author's iPhone.

Prologue

IN APRIL 1989, the Self Employed Women's Association (SEWA) and the Mahatma Gandhi Labour Institute organized an "International Workshop on Homebased Workers," funded by the Ford Foundation and the Canadian International Development Research Centre.[1] The International Labour Organization (ILO) often supported such efforts to facilitate its own gathering of information, which was used to spur the development of global conventions. As a historian of industrial home work in the United States, I was among some thirty "experts" who traveled to Ahmadabad, India, to discuss what we knew about home-based labor and to develop a research agenda. We considered definitions and types of home work, organizing strategies, occupational health, legal contexts, and macro- and microeconomic trends. During the meeting, SEWA, a union of own-account workers whose significance this book explores, actively shaped our perceptions of such labor. We visited the SEWA Reception Centre and toured the slums of Ahmadabad to observe garment sewers and incense makers in their working and living spaces. We met with grassroots leaders, including women trained as paralegals to defend other members in court against municipal regulations, police harassment, and employer non-payment.

During the final discussion on future research, each of us pledged to take further action after returning home. I announced that as a historian of the United States, I did not have to seek funding from the ILO, but I could advance awareness of the emerging campaign for an international convention on home-based workers. I would be able to organize a session at the Fourth International Conference on Women's Studies to be held at Hunter College in New York City the following year, especially for papers linked to household, kinship, or gender issues. I could also edit a collection on the subject to disseminate findings.[2]

It was uncanny to find a report on this workshop in the ILO archives nearly twenty-five years later when I returned to the issue of home-based labor and the ILO as a historian rather than as a practitioner. I did not remembered what I had pledged to do, but I had followed through. I organized a session for the

Hunter conference and, with the political scientist Elisabeth Prügl—then a PhD student—co-edited *Homeworkers in Global Perspective: Invisible No More* (1996), with essays from many participants at the 1989 and subsequent meetings of researchers that occurred prior to the 1996 ILO convention on home-based labor. Reflecting the transnational network of home work campaigners, the essays highlighted conditions in Mexico, Brazil, Indonesia, Finland, the Philippines, Iran, Pakistan, India, Canada, the United States, and Great Britain.[3]

This book grounds memory in the archive, fully understanding how partial both memory and archives are.[4] As an analysis of the making of the woman worker under global labor standards, it reflects my own history as an engaged feminist scholar. I reconstruct and interpret the words and action of others in light of their social and political locations—and my own. As an intervention into a larger transnational conversation on the status of women, I probe the past to understand the workings of power: how definitions of what counts as work and who is a worker emerge from the ability of more privileged women, along with men, to set the terms of dialogue and articulate the meaning of female difference across space and time. But such determinations rarely remain uncontested by working people themselves.

After finishing my studies of industrial home work in the mid-1990s, I forgot about the ILO for a decade. In the 2000s, as I was researching the history of home care, I became involved with another struggle that led to the ILO: the campaign in the United States, and then abroad, for rights and recognition of domestic/household workers. Doing research on historical and present labor conditions, translating scholarship into policy briefs and opinion pieces, and gathering support among academics, I came to understand the value of labor standards for grassroots campaigns—even if the remedy of state enforcement of wages, hours, occupational health, workplace violence, maternity, and other regulations appeared as precarious as the jobs themselves. But the topic of industrial home work did not leave me. Researchers at the ILO discovered my earlier feminist analysis of home-based labor when they were analyzing digital labor platforms and reconsidering the limits of home labor for the future of work.[5]

Solidarity and connection with those on the front lines has bolstered my hope, even when I became convinced that love is not enough when confronting class conflict and exploitation, conditions intensified by inequalities based on gender, race, class, sexuality, and citizenship. It is to those organizers and visionaries that I dedicate this book.

Introduction

MAKING WOMEN, DEFINING WORK

"WE ARE THE oil in the wheels. It is our work in households which enables others to go out and be economically active.... [I]t is us who take care of your precious children and your sick and elderly; we cook your food to keep you healthy and we look after your property when you are away," proclaimed the Tanzanian trade unionist Vicky Kanyoka in 2010. This representative of the International Domestic Workers Network highlighted those quotidian labors of care that economists and the general public alike too often ignore as real work even when performed for a wage. "Discrimination against us because we are women and because we are women workers employed in the home makes us even more vulnerable to exploitation" and violence, explained Marcelina Bautista of Mexico, who became a household worker as a Mixtec-speaking child some thirty years earlier. Women workers like Bautista and union allies like Kanyoka pushed the ILO "to create an international instrument that will not only protect domestic workers, but will also give us back our dignity and allow us to walk tall, just as any other workers in the world!"[1] They struck a blow for human rights by extending labor standards to millions of women who heretofore had stood outside the formal economy and the social protections embedded in ILO standards. In 2011 they won a binding international convention, known as "Decent Work for Domestics," (Convention No. 189—Domestic Workers Convention).[2]

This book explains why the 20th-century labor standard regime codified by the ILO left such workers out, and why their efforts in the 21st century have catapulted those in precarious jobs to the center of debates over the future of work—and of workers. Rather than an anomaly of the past, the woman worker has turned into a harbinger for a world of feminized labor—part-time, short-term, and low-waged—in which there are no employers but only the self-employed, able to labor as long as they can for as little as possible.[3] In the face

Delegates at the First Congress of the International Domestic Workers Federation, Montevideo, Uruguay, October 2013. Photo by the author.

of such challenges, the ILO seeks to provide an international imprimatur for national and regional struggles for economic justice. How we see, legally recognize, and protect or, on the contrary, disempower workers in the 21st century derives from constructions of the women worker over the last hundred years.

"One is not born, but rather becomes, a woman." This oft-quoted remark of the French philosopher Simone de Beauvoir frames this book. Over the course of the 20th century, global labor standards distinguished the woman worker from the male, and women in developing countries from the woman worker in industrialized regions. I turn to the conventions, recommendations, declarations, research, and technical cooperation programs of the ILO to illuminate overlapping and shifting conceptions of a classification codified through law and social policy. The resulting global construct emerged from contestations between employers, trade unionists, feminists, government officials, experts, and, sometimes, working-class women themselves.

The ILO is a definitional arena, promulgating what counts as work and who is a worker for the world. It is not a feminist space, but feminists of various persuasions have sought to use it to advance their own agendas.[4] A supranational body, it has functioned since its inception in 1919 as a location of deliberation among nations, between trade unionists and employer associations, and within

its own bureaucracy. The ILO exists to regulate employment and maintain adequate living standards and social benefits within the existing global order. It generates social knowledge about the world of work and formulates international instruments. The annual International Labour Conference (ILC) passes these conventions that, after ratification by member States, gain a treaty-like status. Founded in the aftermath of World War I (WWI) by French and British social democrats, the ILO sought to stabilize working conditions, curb revolution, and rationalize nation-state economic competition.[5] It was first connected to the League of Nations, and in 1946 it came under the United Nations. Of all the UN specialized agencies, it alone has a tripartite organization, with member States delegations and most committees divided between Government, Employer, and Worker representation. Initially, the ILO conceived of the worker as a man employed in industry, transport, agriculture, or extractive processes, most of which took place away from residential spaces. Labor standards created agreed-upon rules for the field of formal employment that were gendered, racialized, and geographically bound.

After World War II (WWII), the ILO became a terrain upon which skirmishes over the Cold War occurred. In responding to decolonization and the self-determination of newly independent states, it served as a platform where experts formulated gendered concepts of modernization, development, equal remuneration, non-discrimination, social protection, and worker rights. It sought to reform capitalism through class cooperation, becoming the humane alternative to the squeezing of poor countries through World Bank structural adjustment, but without the power to enforce full employment or living wages. Today it promotes fair globalization and decent work in the face of challenges to the very idea of standard employment (work regulated by labor law), a classification of its own making. A century after its founding, it is grappling with questions of care, gender violence at work, and women's empowerment—a new commitment with implications for the importance of women's labor power in today's political economy. Framing prominent Centennial initiatives was the claim: "If we fail to deliver on gender equality, the attainment of decent work for all will be illusory."[6]

But just "'fixing' women" would be inadequate if men maintained power to define and discriminate. The gender turn in scholarship and policy underscores the relational element in thinking about equality. In addition, the meaning of equality has remained contested: Do we reach equality when men and women achieve the same results, or is it enough to obtain unhampered opportunity no matter one's biological sex or gender identity? Do we stop with women entering jobs traditionally held by men, or must men take on unpaid family and care work associated with women to gain equality? Or does equality require

the end of the sexual division of labor itself? How should equality be measured? Equal to whom? Speaking of women and men is not enough after the intersectional and gender turns in scholarship that question universal and unity categories of analysis. But governments and international agencies have long kept their records using such terms, presenting the historian with a challenge to sort out just which people were their subjects and objects of concern at a given time.[7]

During the first half of the 20th century, the woman worker (as idea and living presence in the industrialized West) appeared to threaten the wages and working conditions of her male counterpart, leading to calls for workplace restrictions (as with night work) but also equal remuneration (sustaining the rate for the job). The need to attend to housework and children justified limits on women's hours. While the eight-hour norm allowed women to get through both halves of a double day, men won time to rejuvenate through leisure and rest. In response, women in multiple locations throughout the century fought discrimination and championed workplace justice by demanding accommodations for maternity and other unpaid family labors. They asked that no work be hazardous, no laborers be overworked, and no caregiver be penalized. They argued for equal treatment that extended single-sex protections to men as well as women. But activists and lawmakers would not treat all working women the same: they addressed the condition of women from colonialized, "non-metropolitan" and/ or indigenous regions through distinct terms, and they neglected inequalities between women based on race/ethnicity, religion, age, class, disability, and employment sector. Over time, women workers were at a distinct disadvantage for being less organized and, when home-based, often isolated from their counterparts. Others—whether in unions, NGOs, or governments—spoke in their name.

From the start, ILO conventions were to include all workers, regardless of sex. But few women labored in covered occupations, except for textiles and plantations, and even there they were subjected to their own protections, such as restrictions on night work. The woman worker emerged as a special kind of worker who required targeted instruments that addressed bodily functions and social circumstances—such as maternity and family responsibilities—that were thought to distinguish women from men. While labor protections regulated the excesses of capitalist and colonial exploitation, women (and some classes of men) also came under cultures of protection based on perceived difference from the male industrial breadwinner. Such measures expressed concerns over sexuality, marriage, the family, proper behavior, and dependent status. This dual agenda—universal standards and special protections—stayed with the ILO until the 1980s and 1990s when it embraced the Convention on the Elimination of All

Forms of Discrimination Against Women (CEDAW) and institutional gender mainstreaming. Given sexual and regional divisions of labor, though, gender neutrality never guaranteed the same impact for men and women across the globe.

Gender was only one category of difference among workers; it was embedded within a globalized system of labor relations. This system maintained the power of the Global North over what the ILO once called non-metropolitan regions—colonies that became independent nations after WWII. Women's labor became a key resource for development. This book thus charts unequal power relations between as well as within nations, along with the flows of people, ideas, goods, and capital across borders. Central to my analysis are the links between women's responsibility for care, household maintenance, and income generation, whether through transnational care and migrant domestic work, agriculture, supply-chain microenterprise and industrial outwork, subsistence production, or formal-sector employment. The organization of labor by gender and geography generated the context in which experts, bureaucrats, and activists both within the ILO and outside of it sought to address the worldwide economic position of women.

Set in the context of women's labor force participation, and revolving around the ILO, this book is about constructions, concepts, and categories. It offers an intersectional feminist analysis on the making of the woman worker, in which gender appears intertwined with other factors, such as class and race, that take structural as well as identarian forms. However, a book about making necessarily involves makers. Many types populate these pages: labor and legal equality feminists, ILO staff, social science experts, government representatives, international trade union federations, social justice and worker rights NGOs, Employer and Worker delegates to the ILC—all of whom came to Geneva to shape global labor policy. Only individuals who played a significant or recurring role get named. Others appear with a categorical tag, such as an Employer delegate from a specific nation, with their gender mentioned when known. I make this move not merely to avoid cluttering the text with a plethora and ever-changing cavalcade of names, but to emphasize positionality or standpoint: speakers usually arrived at the ILO representing governments, employer organizations, or unions. Even committees that appointed members for their individual expertise considered the three tripartite components of the ILO—Governments, Workers, and Employers—and sought balance between economic systems and regions. Only wage-earning women well connected to trade unions or governments participated in ILO discussions. The number of women delegates and technical advisers at the ILC remained dismal, ranging from a low of 1.6% in 1925 to a high of 29.8% as of 2014.[8] Too often, woman workers stood as the objects rather than the subjects of these deliberations.

Reproductive Labor, Precarious Work

The dominant feminist perspective assumes, as the sociologist Sara Farris puts it, that "work sets women free; work outside the household has thus been re-cast as the litmus test for benchmarking the level of equality between men and women in society."[9] As a laborite institution, the ILO also celebrates work as a so-cial good. It was born at a time when some women were compelled to earn, while others undertook reproductive labor for their own households without having to go out to work. Industrial capitalism, and its racialization, obscured the interde-pendency of reproduction and other forms of production, the interdependence of industrialized and colonized countries, and the connection between formal employment and the informal economy.

Post-WWII welfare states (mostly in Europe), and to a lesser extent the United States, offered a modicum of security to citizens. They provided public services like child care, education, and preventive health. Family security came from the wages and benefits that accrued to male breadwinners, especially union-ized ones. The unpaid labor of wives, mothers, and often daughters enhanced the working ability of such breadwinners; in turn, one could say that welfare states incorporated the reproductive labor of women through payments to employed workers that freed housewives and mothers to cook, clean, and care. These states could afford to reward their working class because the surplus extraction of labor from former colonies went to the metropole rather than to those in the Global South.[10] By continuing to tie benefits to breadwinners, such policies enhanced the insecurity—or precariousness—of wives and mothers even from the dom-inant race or ethnicity, who depended on husbands for security and reinforced heteronormative understandings of household and family.

By the 1970s, transformations in the larger political economy made the male breadwinner norm inadequate. The Fordist model of mass production and con-sumption with unionization in core sectors began to crack. Within a decade or two, neoliberalism became the dominant social and economic policy.[11] It glorified the market and the individual, while championing deregulation of corporations and financial institutions, the inscription of free trade agreements, and privati-zation of state and public resources. To be sure, neoliberalism has transformed the means of living in the industrial world, as well as the nations of the Global South, which during the early 1980s increasingly had to service debt payments to outside creditors rather than provide services for their peoples. The need to se-cure livelihoods hastened global flows of goods, capital, and people, marking new geographies of work that are frequently characterized by contingency at all levels, from the "creative class" and service workers to warehouse and manufacturing

assemblers. With neoliberal reordering, the dual breadwinner/female caregiver organization of family and employment came to the fore, which left poor single mothers having to make do on their own with increasingly inadequate social assistance. Meanwhile, market fundamentalism, business flexibility, financialization, and structural adjustment encouraged a number of transformative factors, including intensified dispossession of people from land and transference of wage work from offshoring and outsourcing of manufacturing and the introduction of new technologies. Complex supply chains circled the globe.[12] In this environment, the deconstruction of women's labors became central to a larger feminist project of dissolving social constructions, especially the dichotomy of public (work) and private (home).

Feminist theorists began a fresh discussion on the relation of reproduction to production and the place of family and domestic labor in economic life. As the Marxist domestic labor debates of the 1970s and 1980s highlighted, reproductive labor consists of activities that transform raw materials and commodities bought with a wage to maintain the worker daily and generate future workforces. Women have undertaken these tasks, often along with wage work.[13] Some would claim that such labor generates use value, but not exchange value, and thus is valueless in the Marxist meaning of value associated with exploiting labor power. Others, notably Leopoldina Fortunati, would argue that reproductive labor is already part of exchange, that both the housewife and the prostitute work for capital in reproducing the labor power of the male worker.[14]

This book considers reproductive labor as work that exists as a counterpart, but often prior, to other forms of productive labor. One might argue that it is a form of production. Also referred to as "social reproduction," such work is about the making of people through the tasks of daily life. These activities are both material (like feeding), emotional (like love), and assimilative (like transference of norms and values), whether occurring in the family, school, church, or community.[15] In its commodified form, reproduction has moved out of the home to institutional settings and returned to the home when workers perform such labor for a wage. In global cities, otherwise employed women in the last decades of the 20th century began to hire migrant mothers from Asia, Spanish-speaking America, and Eastern Europe to take up their slack in a new international division of (re)productive labor.[16]

Feminized labors, such as those associated with social reproduction, have much to teach us about precariousness.[17] Certainly in an increasingly globalized and technology-driven marketplace fueled by policies that promote privatization and deregulation, instability from contingent employment relationships—"fixed-term contracts, on-demand work, or bogus

self-employment"—has emerged as a central feature of working life among the waged and salaried in the West, and not only for women's work.[18] We are faced with the unraveling of the social contract between employers and the most privileged of workers in the Global North. The situation of precariousness, however, is not new, even if it appears intensified. Instability has long characterized laboring conditions in other times and spaces, such as among peasants and agricultural workers; the enslaved and other bonded people; the overeducated in colonialized states; craftworkers facing technological shifts; and the poor, outcast, and dispossessed.[19]

Precarity has come to mean more than just the erosion of labor standards. Feminist theorists like Isabell Lorey and Judith Butler see it as essential to the human condition, as well as a product of capitalist social relations. Connected to the impermanency of life itself, precarity requires interdependence and the labors of care for people to thrive as well as survive. Capitalism, under these terms, brings about insecurity. It not only generates the antithesis of care, but also makes it difficult to receive the care we all need by devaluing such labor— both the unpaid work within the family and the poorly paid jobs in the care economy that are increasingly performed by non-citizens in industrialized nations. Such labors have represented the problem of difference for the ILO: the fight to bring security to women's work in the West exists as a counterpart to the mixed response to all work in the Global South. In both cases, we'll see, the non-standard—that which is non-industrial, without contract, and subject to displacement or sudden end, that is, work usually associated with the non-Western, not able-bodied, minoritized race/ethnicity, and not male—becomes an arena for standardization. By definition, the quest to bring feminized labor and informal work into global labor standards requires a transformation of the terms of analysis.[20]

With the unraveling of standard employment in the West, the ILO has turned to formalizing the informal economy, with the gig or Uber economy and other forms of contingent work suggesting the need for new standards.[21] Global labor standards, faced with the necessity for social reproduction, can serve as a solution to precarity but may reinforce inequalities by partial coverage and exclusions. These rules for employment omitted those at the margins, a problem recognized but not solved by workers and reformers seeking their revival.[22] The social protection that the ILO embraced during most of the last century has proved fleeting because it was tied to a standard employment that has dissolved where it once was robust. This labor standards regime, born under Fordism and partially recalibrated for a service economy, maintained private and feminized care work, without curbing the import of migrant substitutes for the housewife.[23]

What Follows

Three constructs dominate global efforts to establish labor standards and define the woman worker: woman as different (from the male worker), woman in the Global South as "difference's other" to the Western woman, and all workers as different; that is, as taking on the characteristics long associated with women's lesser wages and working conditions, with the seeming spread of precarious labor and the breakdown of standard employment. Their predominant time periods—1919–1958, 1944–1996, 1990s–2010s—overlap because the making of conceptual categories is messy and occurs unevenly.

The first section of this book, "Difference: The Problem of the Woman Worker, 1919–1958," considers a world in which the white male industrial worker was the norm, the white female industrial worker in Europe and America required special protection, and colonized and subordinate men and women of color were available for the extraction of productive and reproductive labor power. It builds upon the robust scholarship on the interwar period in order to shift the historical discussion on protection and equality.[24] Chapter 1, "Protection," begins with the first meeting of the International Labour Conference and the parallel International Congress of Working Women in 1919, revisiting interwar conventions in which the characteristics of the worker seem more salient than the hazards of the work. I differentiate between protective standards for workers and cultures of protection that sought to police sexuality and other behaviors. I then turn to arenas where the culture of protection became paramount: the problem of women emigrants and male seafarers, in which sexual conduct enters ILO debates despite institutional reluctance to address sex as work, and the question of "native" workers, in which the civilizing mission and the effort to control colonized labor led to lesser standards for such regions.

With WWII ending, the United States helped reconstitute the organization for the postwar era. Geopolitical conflicts between the imperial North and decolonizing South, and between state socialist and market economies, would help to shape the possibility for economic justice regardless of sex or gender, even as they reflected inequalities between men and women, and between women whose work and family circumstances varied by class, region, and other demographic and social factors. The next chapter, "Equality," compares general measures for women in postwar employment with gendered social welfare for colonies and how a worldwide need for womanpower led the ILO to shift its emphasis from women-only conventions to equal treatment and non-discrimination. Women as both the same as and different from men remained central to ILO policymaking. The ILO addressed equal remuneration in the context of two sets of rivalries: a geopolitical one from the Cold War, and an

institutional one between entities of the United Nations. Attention to equal pay pushed aside consideration of those home-based employments associated with women, industrial home work and domestic service, that labor feminists inside and outside of the ILO promoted. At the same time, new instruments on maternity and family responsibilities emphasized the reproductive labor of the woman worker, re-inscribing women as different from men because of their role in the family.

"Difference's Other: Women in 'Developing' Countries, 1944–1996," the second section of the book, interrogates the construction of Third World women as distinct from a universal, Western woman. This definitional framing assumed that integrating women in the Global South into development projects would raise their status, thus enhancing their ability to generate income and protecting their childbearing capacities. These women exemplified what feminist transnational theorist Chandra Mohanty has named "Third World difference." Ideology had constructed women in developing countries as a timeless entity, the particular to Western universalism outside of "a global economic and political framework."[25] These chapters cover the transformation of the world order through national liberation movements, the Cold War, and attempts to modernize the Global South along Western industrial lines without transforming power relations between nations. Chapter 3, "Development," ranges from the late 1940s, when the ILO increased its technical cooperation efforts, to the 1975 UN World Conference on Women, which represents the birth of a new global feminism. It highlights how ILO consultants in Asia, the Andes, and elsewhere offered handicraft production as the form of labor most appropriate for women assumed to be homebound—which raised the problem of exploitative home work.

In the 1970s and 1980s, the Programme on Rural Women—the focus of chapter 4, "Reproduction"—argued for improving women's household and family labors as an essential component of world employment. Women would benefit from state fulfillment of "basic needs," such as access to clean water, adequate shelter, and household equipment. Its staff of feminist development economists generated the very terms of subsequent academic and policy discussions, while seeking to transform the process of producing knowledge by commissioning studies by scholars from the Global South and listening to rural women themselves. The Programme on Rural Women simultaneously engaged with feminist NGOs on projects to empower subsistence producers. Chapter 5, "Outwork," analyzes the road to the 1996 Home Work Convention (No. 177). It highlights the evolving position of international trade union federations and recovers the efforts of SEWA and other campaigners, who challenged usual definitions of employee and worker in their demands for recognition. This effort to extend labor standards to what was called the new putting-out system

occurred at the same time that the ILO undertook gender mainstreaming; that is, increasing the number of women working for the organization in high-level positions and updating women-specific instruments to cover men in order to promote gender equality.[26]

A final section, "Difference All: Centering Care, 1990s–2010s," brings this book into the 21st century in light of the precarity at the heart of being human, as well as the instability of employment. These two chapters address a world in which more and more work stands outside of the standard employment relationship. A transformed labor landscape has led the ILO to seek regulatory norms for the informal economy. The section explores the paradox of our time: workers previously excluded from labor standards, in part because they performed care work, seek coverage under labor laws just as the employer-employee relationship has fissured through the reclassification of labor as self-employed, the deployment of temporary contracts, and the development of supply chains that obscure employer responsibility for a given workforce. In chapter 6, "Home," working women themselves seize a platform through the convention-making process. Domestic workers built upon the legacy of the industrial home workers, who broke through the idea that the home could not be subjected to labor standards. They developed new tactics in response to the obstacles that the ILO placed upon participation in its deliberations by groups outside of its tripartite structure. Men dominated the leadership of most national labor federations, from which governments selected delegates, and thus workers from the informal and less recognized sectors, like household laborers, lacked a say at the ILO. This chapter recalls their struggle amid stepped-up attention to the informal economy and migrant labor.

The concluding chapter, "Women's Place (in the Future of Work)," revisits reproductive labor and home workplaces as the ILO becomes one hundred years old. As that venerable organization studies the impact of legal, economic, and technological disruptions to the employer-employee relationship, the evolving 21st-century world order also emerged from the 20th-century making of the woman worker. Though still reluctant to move on some forms of intimate labor, like the "sex sector," the ILO has elevated care, in its paid as well as unpaid forms, as one key pillar for the future of work. It has highlighted combatting gender violence at work for men and women. The chapter ends with an assessment of the ILO approach in relation to codes of conduct forged through consumer campaigns and other efforts to make corporations more responsible for working conditions. The question remains whether international standards that rely on national implementation offer enough protection to workers in a changing global political economy, and whether workers can push back to win better conditions by using global instruments for local ends.[27]

ILO 101

Before proceeding, a discussion of the ILO structure is in order. The ILO has maintained this basic organization for a century. Day-to-day work occurs through the International Labour Office, which consists of a staff of global civil servants in an ever-shifting number of departments devoted to specific questions, occupations, and worker characteristics, overseen by a Director-General (elected by the Governing Body) and his deputies (so far only men have held the Director's commanding position). Located in Geneva (except when it moved to Montreal during WWII), the Office gathers information, compiles reports, and generates knowledge on labor issues that governments and researchers alike have relied upon. It undertakes assignments from the Governing Body, which determines items for the ILC, usually a few years in advance. The Office then develops a report on the item and sends questionnaires to governments to inform convention making. In 1927 the ILC began its double review procedure, with a first discussion on a proposed instrument and a final consideration the next year. After ILC passage, member States were to ratify conventions and use them as guidelines for labor standards legislation.

The ILO's constitution suggested, rather than mandated, that governments appoint women as advisors when the ILC discussed issues relevant to women's work. There would be representatives from colonies as well. As we shall see, these clauses were often ignored. Over the years, the institutional location of a unit devoted to women workers shifted, reflecting current thinking about whether women should be treated the same as or distinct from men. Beginning in the 1930s, the Office dedicated a section on women's work, the name and influence of which varied over the years depending on the Director-General (who generally shapes the orientation of the Office). Initially known as the Section on Conditions of Employment of Women and Children, in the early post-WWII period it became an upgraded Women's and Young Workers' Division. In 1959 it turned into the Office for the Coordination of Women's and Young Workers' Questions under the Director-General—a demotion of sorts. By 1965 its head became the Coordinator of Women's, Young Workers' and Old Workers' Questions. A decade later it took the form of an upgraded Office for Women Workers' Questions, or FEMMES, a nomenclature that finally uncoupled women from children. In 1988, still another reorganization returned work on women to a special advisor, who reported to a Deputy Director-General. In 1999 the Bureau for Gender Equality replaced a women's section. It became part of a new unit: Gender, Equality and Diversity, part of the Conditions of Work and Equality Department. The ILO/AIDS office came under this unit.[28]

The section on women workers investigated conditions of employment; promoted training, education, and the establishment of Women's Bureaus throughout the world; and developed specific directives about women and young workers—another group seen as being in need of protection, and thus often programmatically joined with women in labor departments. With the input of a transnational group of experts, it prepared studies and annual reports, based on questionnaires sent to member States, that various ILO conference committees examined. It sometimes helped draft conventions and recommendations. The section was not the only locale within the technical branches defining the woman worker, and it could find itself in conflict with other units within the Office whose efforts impacted women, like the World Employment Programme.

DESPITE A GROWING acceptance of formal equality, the ILO found it difficult to overcome women's assumed responsibility for homes and families. Its legacy for human rights, expressed in the right to decent work, reflected a basic contradiction: women were equal to men except when they were different. Including women in formal expressions of economic rights ran up against social and cultural definitions of gender. Women were mothers or potential mothers; they were the ones who left factories, fields, and offices for their first shift, the reproductive labors of housework and care work.[29] Equal treatment on the job, including equal pay, non-discrimination, safe working conditions, and freedom to join a union, did nothing to relieve unequal burdens of what the ILO came to call "family responsibilities."

Women everywhere have engaged in family and market labor, but their housework and care work have interfered with their own ability to generate income. They have stretched inadequate resources to cover family needs. Among wage-earning households, their unwaged labor has allowed employers to pay less to maintain a workforce. Informal sector and rural household laborers have not only sustained families and communities, but they also made cheap goods and raised future migrant workers benefitting more industrialized areas. Social custom and public policy has made it difficult to navigate between family labor and employment.

ILO instruments, whether focused on equal treatment or special protection, encouraged its member countries to deploy women's labor as needed—in the labor force or in the family. It wasn't that women-specific protections were wrong, or that they inevitably promoted inequality in employment. Given most national legal instruments, labor feminists felt that they would help relieve class oppression until organized workers gained power in order to cover men under equivalent protections (against dangerous work or long hours, for example). In

championing wage labor in the formal sector, the ILO until recently overlooked care as work and thus undermined conditions in the paid as well as unpaid care-work economy, where women have predominated in most places. In this regard, it reflected hegemonic understandings of trade unionists, governments, and even most feminists that reproductive labor was not work. Recognizing care as work offends those who argue for a realm apart from commodification, who offer love as an antidote to work. We need love. Until we rid the world of precarity, we also will have work.

PART I

Difference

The Problem of the Woman Worker, 1919–1958

I

Protection

AT THE FIRST International Labour Conference (ILC) of the ILO in Washington, DC, the British trade unionist Mary Macarthur observed: "When the man comes home at night his day's work is done, he can sit down by the fire and read his newspaper, or dig in his garden, if he wishes to." In contrast, she found, "a woman's work is never done, and when she leaves the factory she usually goes home to begin a new day's work." The woman in industry needed time to care for children and perform housework. Her male counterpart claimed a right to leisure, but the necessity of reproductive labor justified limits on her workday, especially when it came to childbirth. Rather than encouraging idleness, leave from employment still meant "the working woman will be more occupied out of the factory [with housework and daily tasks] than the average woman of the leisure classes will be."[1] In distinguishing between the sexes and the classes, McArthur underscored the conflicts over women-specific labor protections that divided feminists and trade unionists then—and historians since.

Demands by trade unionists shaped the first ILC in 1919. Wartime gatherings of the socialist and syndicalist International Federation of Trade Unions (IFTU) promulgated more extensive platforms of labor rights and social welfare than organized labor had previously embraced. These declarations included freedom of association (to join a union), equal treatment of migrant labor, international factory inspection, extensive social insurance, and woman-specific protections.[2] Up for discussion at the ILO's first conference was universalizing the eight-hour day and forty-eight-hour week, relief from unemployment, consideration of maternity leave, more restrictive night work for women and children, creation of a minimum age for employment, and keeping women and children from "unhealthful processes."[3]

Under the soaring Beaux-Arts hall of the Pan-American Union, over 250 representatives from some forty nations deliberated for nearly the entire month of November. They breathed life into the provisions adopted at Versailles,

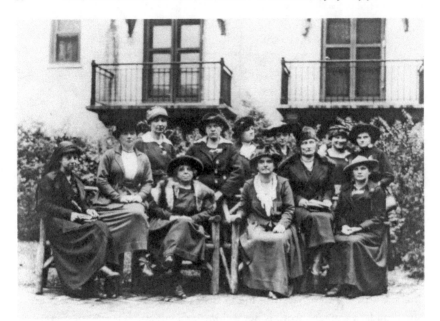

FIGURE 1.1 "A Group of Delegates" at the International Congress of Working Women, 1919. Left to Right, sitting: Mlle. Yadwiga Lukasiuk, Poland; Mlle. Georgette Bouillet, France; Mlle. Jeanne Bouvier, France; Mrs. Raymond (Margaret Dreier) Robins, President of the National Women's Trade Union League of America; Dr. Melanie Bornstein, Poland; Mlle. Konstancja Olszewska, Poland. Standing: Mlle. Victoire Cappe, Belgium; Mlle. Sophie Dobrzanska, Poland; Mlle. Berthe de Lalieux, Belgium; Mme. Marie Majerová, Czechoslovakia, and Mme. Luisa Landova-Stychova, Czechosolvakia. Library of Congress.

developing protocols for the operation of the ILO as well as crafting its initial labor standards. Typifying women's involvement was Macarthur, the daughter of a Scottish manufacturer who had embraced socialism and the labor movement. She headed the National Federation of Women Workers and served on the executive board of the British section of the International Association of Labour Legislation. She was one of a handful of women who traveled between the ILC and the International Congress of Working Women, simultaneously meeting in Washington, DC.[4]

The women who participated in both conferences were an impressive group. They had extensive expertise in politics as well as factory inspection, like Norway's Betzy Kjelsberg and Sweden's Kerstin Hesselgren. Margaret Bondfield belonged to the Parliamentary Committee of Britain's Trade Union Congress and would be the first woman elected to Parliament. Jeanne Bouvier of the French Federation of Clothing Workers fought for the rights of home-based workers.[5] These women came to the ILC as advisors to national delegations; they could speak, but could

not vote unless substituting for official delegates, who determined access to the podium. Nonetheless, they made their mark through service on committees, including, significantly, the Commission on Women's Employment, which drafted the conventions on maternity policy and night work. Over the next two decades, some of these women continued to participate in the ILO.[6]

Under the neoclassical dome of the Smithsonian Institution's National Museum, where the women met, the advisors joined with other prominent women trade unionists and labor allies from nineteen countries to create their own resolutions. They conveyed their planks to the ILC in the hope of influencing what came to be known as the Washington Conventions. Margaret Dreier Robins of the cross-class National Women's Trade Union League of the United States, along with Bondfield, had invited women from unions, suffrage organizations, and social democratic parties to create their own international organization.[7] Travel was expensive, and only those with resources (their own or those of an organization or personal sponsor) attended. Though there was sporadic translation into French, English was the conference language, further restricting participation.[8]

Despite national differences, Dreier Robins believed that a sisterhood could generate social justice. She shared the dominant notion that motherhood gave women unique insights into the human condition, but she never reduced women to their maternal function. She was a labor feminist—a group that fought for industrial democracy and women's equality, embraced trade unionism, and advocated for women-specific labor laws when they advanced such goals.[9] Labor feminists rejected any equation of womanhood with incapacity, whether in politics or working life. Variance from a male norm should have nothing to do with women's right to make their own decisions—what a later generation of feminists would shorthand as "choice." During the conference, they voted for paid maternity leave, equal pay, shorter hours, and better working conditions for men as well as women.[10] They accepted special protections for women that improved working life when being treated the same as men meant intensified exploitation. As Rose Schneiderman, also of the National Women's Trade Union League, decried, "equality of women to kill themselves by night work is no equality to us, that we have had for hundred years."[11]

The International Congress of Working Women served multiple functions. It was compensatory: it gained momentum from the failure of governments to select women as delegates to the ILC despite the ILO's constitutional recommendation to do so.[12] It generated networking: it provided an opportunity to strengthen ties between socialist and labor feminists in unions, governments, and women's organizations. It was definitional: whether judged as "'The Other ILO Founders'" or as lobbyists with radical propositions ignored by their male

counterparts, and whether seen as bounded by national aspirations or forgers of a feminist transnationalism, the women who journeyed to the United States that fall offered complex, sometimes contradictory, principles on women and work.[13] Their successes and limits tell us much about the initial making of the woman worker through global labor standards. Their understandings of "protection" complicate any simple dismissal of the term as detrimental to the interests of women, while their debates underscore the difficulty of speaking about a common womanhood.

Historians of women usually narrate the quest for women's labor standards as a story that pits trade union and other labor feminists against advocates for legal equality. Without denying clashes among women, something else was going on that is captured only by moving beyond the dominant interpretation within women's and gender history that dwells on these divisions and, given the politics of "second wave" feminism, usually sides with legal equality over labor feminism.[14] Both groups helped develop global norms. Moreover, no simple dynamic of gender versus class interests, or more precisely the gender and class interests of working-class women as opposed to professional or elite women, shaped the promulgation of labor standards.

It is important to recognize that labor standards are a distinct kind of "social rights," as a male Uruguayan Government delegate explained at the first ILC.[15] They are by definition protective legislation for workers, formulated to counter harmful conditions on the job—including wages too low for sustenance and hours too long for anything else, and exposure to work processes that bleed dignity as well as blood. Countering the vicissitudes of the market, labor standards set perimeters to exploitation associated with employment. But some standards applied only to certain workers, singled out by gender, occupation, or geographic location, with the latter standing for workers racialized by white Western Europeans in colonialized places, as well as indigenous peoples facing dispossession of land and livelihoods. Thus, one must differentiate protective labor standards from cultures of protection.

Cultures of protection appear to be about work but actually address other factors, such as morality, sexuality, family structure, and gender norms. Behind such regulations lay fears of moral lapse, sexual deviance, gender inappropriateness, and illicit acts. Men as well as women were subject to these safeguards, which disciplined in the name of the state, market, and family by controlling and tracking the body, ostensibly keeping it from hurt, some of which came from the larger surroundings, and some of which individuals presumably brought on themselves through bad behaviors like laziness or drinking, all of which experts (rather than the beneficiaries) defined. These protections were not necessarily gender, class, or race neutral, and they could be targeted toward a specific group,

like seafarers, migrants, or entertainers, which sometimes overlapped with the predominance of one gender over others.

Cultures of protection as a framework further connect the rescue ideology and civilizing mission attached to special standards for another category of workers: "native" or indigenous peoples in the Global South. The ILO allowed colonial powers to have lesser standards in these areas. It also adopted specific conventions directed toward colonies, later referred to as non-metropolitan or dependent territories, and their workforces. The positions of the colonized and the woman worker of the Global North were not equivalent, even if both were deemed in need of special consideration for distinct reasons. In general, Western women, like their male counterparts, benefited from the fruits of empire. Feminist advocates, whether legal equality or labor, supported a universality that matched their lives, speaking for all women and pushing for general rights by defending the most oppressed. Thus, colonized women represented a double difference, distinct from Western women and from their own men, super-exploited by local as well as imperial powers, and within the family. The ILO justified protection for colonies and nations judged as "backward" or "tropical" through a civilizationist lens that projected difference as cultural rather than political, thus masking how its standards reified inequality and upheld colonialism.[16] In doing so, it judged success by whether forced or bonded labor had evolved to the norms of free labor, and whether free labor represented decent work; that is, work regulated by global labor standards based on the achievements of the Western male industrial worker. In practice, such men won what were classified as labor standards; other groups received protection.

This chapter explores the legacy of the interwar period for the making of the woman worker by focusing on the contested meaning of protection. It probes standards for workers who deviated from the adult male industrial norm by their gender, age, occupation, or geographical location, categories inherited from earlier international regulation of labor. It analyzes the ILO's originary embrace of protection in 1919, and then illuminates cultures of protection by comparing two ILO proposals that elicited pushback from both social purity advocates and legal equality feminists: instruments regulating (1) migrant women traveling alone on ships and (2) the social welfare of seafaring men in ports. It then turns to interwar conventions for non-self-governing areas. Amid regulation of forced and contract labor, Western women justified their own quest for equal rights by intervening to save "native" women from multiple kinds of violations. The daily reproductive labor of women, maintained by colonial policy and reinforced by ILO conventions, not only enabled the work of others, but also reinforced the economic, political, and cultural hegemony of the colonial powers.[17] The making of the woman worker, and the allocation of female labor, was global.

Founding the ILO

In the late 19th century, an overlapping coterie of academics, unionists, and socialists sought to establish universal labor standards. They built on earlier considerations among European states to provide a level playing field for economic competition as advocated by employers, some of whom found a model in the abolition of the slave trade.[18] Meetings on factory conditions followed, with the International Association for Labour Legislation established in Basel, Switzerland, at the turn of the century. In 1906 policy experts, government officials, and unionists generated conventions prohibiting night work for women and banning white phosphorus from the manufacture of matches (a female-dominated, low-waged industry), later referred to as the Berne Conventions after their meeting place. They would recommend a ten-hour day for women in 1913.[19] Many feminists denounced such distinctions, insisting on equal treatment and equal pay.[20] Nonetheless, many European industrial nations signed onto these agreements, as they did for protocols prohibiting sex trafficking, out of a general belief that both women and children required state protection.[21] International treaties to control sexuality complemented measures to regulate industrial work, both of which were deemed necessary to maintain reproduction of the labor force.

Formed along with, but distinct from, the League of Nations, the ILO originated as a peacekeeping mechanism, a solution to knotty problems at the end of WWI: how to control inter-capitalist economic competition by creating new international rules, and how to stymie the Bolshevik threat through more humane treatment of the working-class, but without putting into question the colonial order or compromising national economies. The big three Entente leaders—Woodrow Wilson, Lloyd George, and Georges Clemenceau—agreed that the inclusion of social and labor rights in the peace treaty was just what was required. Along with setting the perimeters of an international "parliament," the League of Nations, they formed the Commission on International Labour Legislation to figure out the structure and principles of a standard-setting body devoted to work. The legacy of the International Association for Labour Legislation appeared in its composition: male government officials and experts from Belgium, France, Great Britain, Italy, Japan, Poland, the Czechoslovak Republic, and the United States. Few trade unionists were directly involved, though Samuel Gompers of the American Federation of Labor (AFL) served as chair, and Léon Jouhaux of the Confédération Générale du Travail (CGT), who subsequently would head the Worker group at the ILO, attended.[22]

Commissioners sought to reconcile contrasting philosophies. The British and Europeans accepted state involvement in labor relations, the opposite of the US model of "volunteerism," or collective bargaining between unions and employers independent from government. While Gompers's antipathy to the state had lessened through alliance with the Wilson administration during the war, he sought to reduce both the power of the ILO as a supranational authority and the impact of governments within it. The trade unions demanded equal voice in standard setting as well as specific standards.[23] The founding constitution left implementation of standards with states. The ILO issued two major forms of international instruments. Treaty-like conventions came into force upon member ratification, while non-binding recommendations served only as guidelines. Within both types, delegates added provisions to account for national variation, which usually functioned as loopholes for exceptions to these agreements. Thus, specific planks allowed federal states, like the United States and Australia, to treat conventions as if they were recommendations. Before WWII, most conventions allowed states to modify specific articles for "colonies, protectorates and possessions which are not fully self-governing."[24] In short, the drafters of the ILO provided nations with avenues to avoid enforcement of international instruments.

The ILO constitution was therefore a compromise that favored less radical but also more statist elements, with the Commission devising a tripartite structure—with each nation appointing Government, Worker, and Employer representatives—and offering general principles rather than specific standards.[25] It constructed the ILO as a deliberative body whose multiyear processes and consultative procedures made for slow responses. It hedged whether labor was ever a commodity by announcing that "it should not be regarded merely" as one. It called for the right to form unions, known as freedom of association. Rather than developing a universal number, it supported "a wage adequate to maintain a reasonable standard of life" appropriate for national circumstances. Other provisions highlighted the eight-hour day or forty-eight-hour week, a weekly day of rest, abolition of child labor, equal remuneration between men and women, equal legal treatment of all workers residing in a country, and women's participation in enforcing labor protections, especially for those involving women workers. Existing standards higher than the proposed ones would remain in force.[26]

In keeping with the notion that woman's organizations could represent all women, the International Woman Suffrage Alliance (IWSA) won permission from the Allied powers to speak before "commissions occupying themselves especially with questions touching on women's interests." Broader in scope than

the Women's International League for Peace and Freedom (WILPF), which or-
ganized during the war against war, the IWSA formed in 1904 out of feminist
discontent over the refusal of the International Council of Women to endorse
suffrage.[27] Composed of elite, well-connected activists, as were most interna-
tional organizations, the IWSA asked the Labour Commission to ensure all
positions at the ILO be open to women, and to allow membership in the new or-
ganization to vanquished Germany, because "disease and labour problems know
no frontiers."[28] It advocated for general principles, which resembled those of the
trade unions in terms of living wages, equal pay, and maximum hours, but the
women emphasized a ban on child labor under age fifteen and called for paid
maternity leave. Unlike the unions, the IWSA representatives did not ask for
freedom of association. Another women's delegation to the Commission on the
League of Nations requested support for women's suffrage, self-determination of
nationality (a problem for women who married men with another citizenship),
and establishment of a committee on education with women appointees. The
international women's organizations obliquely addressed questions of labor by
asking the League Commission: "To suppress the sale of women and children";
"To respect and apply the principle of woman's liberty to dispose of herself in
marriage"; and "To suppress the traffic in women, girls, and children of both sexes,
and its corollary, the licensed house of ill fame."[29] In doing so, they emphasized
cultures of protection over labor standards.

The limited access of the women's organizations anticipated the constricted
place of non-governmental organizations at the ILO. They sometimes found
allies on the staff of the International Labour Office, who served under the elected
Director-General. Tripartism meant that member states appointed Government,
Worker, and Employer delegates, choosing representatives from the main labor
and business associations of the country. There was little place for other entities
in this apparatus; members of expert committees served as individuals, not as
representatives of organizations. Even within tripartism, states had greater clout,
with two delegates to one for each of the other constituent groups. This ratio of
2:1:1 carried over from the annual ILC to the Governing Body, which set agendas
with the Director-General, and to committees charged with the study of issues
and drafting of conventions.[30]

Neither were all governments equal. European governments were the first
members and long controlled the organization. Nations deemed the most indus-
trial had guaranteed spots on the Governing Body, while the British Empire had
a separate membership given to India.[31] US critics from the left judged the ILO
undemocratic; they joined with isolationists and more conservative elements
to block US entry until 1934, the same year that the Union of Soviet Socialist
Republics (USSR) first joined.[32]

The Washington Conventions

A century later, irony surrounds the conferences of 1919. US President Woodrow Wilson invited the ILO to hold its first meeting in Washington, DC, but the United States was unable to formally participate because it did not belong to the League of Nations. Days before the close of the ILC, on November 19, the Senate rejected the Treaty of Versailles. Nonetheless, Americans presided over the founding conferences: US Secretary of Labor W. B. Wilson over the ILC, and Dreier Robins over the International Congress of Working Women. While the nation's elected representatives shunned internationalism, women attendees enjoyed American hospitality, with a steady stream of receptions, recitals, and outings. They toured Mount Vernon, the home of the nation's first president, and went to the Department of the Treasury, where the staff of the US Women's Bureau led a programmatic discussion on wage-earning women.[33]

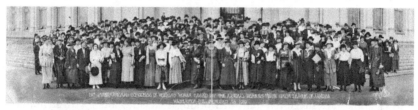

FIGURE 1.2 1st International Congress of Working Women, Washington, DC, October 28, 1919. Library of Congress.

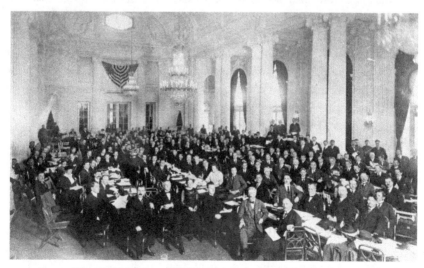

FIGURE 1.3 First ILC Session, Washington, DC. Photo from International Labour Organization, with permission.

Conference resolutions and ILO conventions displayed an overwhelming faith in facts, the arena of the new social science disciplines. Delegates sought the authority of medicine, offering alternative assessments either to bolster their arguments or to suggest a reasoned path out of political impasses. Sessions would end with a request for a fact-finding commission (e.g., on workplace dangers for men), or the establishment of an information-gathering bureau (e.g., on unemployment and migration). Delay and research would become the common way that the ILO resolved conflicting positions. Women persisted in demanding the placement of women on boards and as factory inspectors.[34]

The Washington ILC addressed the meaning of women's work, especially the centrality of reproductive labor for the health of children, maintenance of families, and functioning of society. Cultures of protection entered into these deliberations when it came to night work's threats to proper homes. A male Italian Worker delegate justified limiting working hours for women as leading to "better moral conditions, so that not only will she be a good worker but also a good mother."[35] But more than proper motherhood was at stake. Danger lurked at night, especially for women alone on the streets after leaving the factory. Shift work, closely connected to night work, was particularly troublesome. It led to "a disorganization of the family," with even greater problems for women, claimed a male Swiss Worker delegate. In contrast, a male Belgian Employer adviser, who ran a glass factory, suggested splitting working hours into shifts, with an hour rest so that village women could go home for lunch, presumably to have more rest, but certainly to catch up on their chores.[36]

Much like the men across town, speaker after speaker at the National Museum insisted on lengthening the night ban so women actually had time for family labor.[37] Bouvier defended the forty-four-hour week as "indispensable to all working women and to the mothers in the home." Shorter hours allowed for more than fulfilling "their marital or conjugal life as home keepers," another trade union woman explained. Women could "live a full, intellectual and spiritual life."[38] Further lamenting "the overwork of women in the home," Czechoslovakian Marie Stivinova Majerová of the Prague Municipal Council passionately chided workingmen for ignoring "the endless labors of the domestic slave." Women advocates, she insisted, "intend to see that the women in the home get justice in the matter of length of working hours."[39]

By work in the home, Majerová did not mean industrial home work, a practice much on the minds of delegates. A translator clarified her remarks: "They are speaking of the burden of the domestic work which is done in some homes by servants, where the homes are capable of supporting a servant, but they look for a chance to redeem these conditions by dividing up some of the work and taking it in a community way . . . so it would not all have to be done by that one woman in

the home."[40] For decades, feminists and home economists had dreamed of moving laundering and cooking out of the home; mechanization, others believed, would end the heavy duties of maintaining daily life.[41] Domestic labor (care as well as housework), therefore, justified shorter hours and restrictions on night work. When performed for a wage, however, such labor was unthinkable as a proper field for standards—though it remained one of the chief occupations for women.

On the topic of maternity benefits, the Congress of Working Women crafted a resolution that the men of the ILC could understand. Labor feminists differed among themselves on the form of benefits—whether they should come as a state endowment or through private insurance. But they agreed that the amount should at least match the minimum wage appropriate to each nation. A minority would restrict the wealthy from receiving such aid, but the group emphasized universal need. Their resolution extended support for pregnancy and childbirth to all women, no matter their employment or marital status, and thus anticipated future proposals deemed radical.[42] With the animosity that grew over the meaning of equality among activist women, this legacy was lost in the late 1930s when Equal Rights International, an opponent of women-specific labor standards, asked the ILO for health insurance that would reward the housewife "for her work in the home . . . on equal terms with other employed women."[43]

References to "women" never meant that all women who generated income would be treated the same under the emerging labor standards regime. Coverage first depended on the employment sector. Before the war, women throughout the West and in Japan had made inroads in manufacturing, especially garments and textiles. They composed over 30% of the industrial workforce in Britain and France in 1920. But more women continued to labor in agriculture and in homes, even as they entered office and other white-collar jobs in increasing numbers.[44] Trade unions provided the logical path for labor feminists to gain access to the ILO. But the majority of the world's women labored in sectors without union representation, including African Americans, whose memorial to the Congress of Working Women was entered into the record without discussion. Thus, labor feminists, like trade union men, could not democratically speak for most women workers, even if they claimed to represent them.[45]

The Congress of Working Women focused on industry for strategic reasons, though labor feminists generally wished to extend protections to commerce and professional trades, like telephone and telegraph. Bondfield explained that their resolutions should "strengthen the hands of those women who have got to act on the commission in the main conference," whose goal was to increase signatories to the Berne Conventions. Such international agreements existed to manage international trade, particularly textiles.[46] Bouvier championed a broader

perspective: if the law was for women, then those in commerce certainly should come under it. At the ILC, her countryman Jouhaux of the CGT offered a definitive reason for covering additional occupations, noting that "standing is much more dangerous for a pregnant woman than the sitting position which they occupy in industry."[47]

The labor feminists influenced the 1919 Maternity Protection Convention (No. 3), which guaranteed time for confinement without job loss.[48] Amid pronatalist and health justifications, the ILC listened to the women and included "commerce." The women prevailed when it came to the length of leave, gaining six instead of four weeks both before (upon a medical certificate) and after childbirth.[49] The convention made no distinction on the basis of marital status, age, or nationality. It allowed for nursing breaks on the job.[50] Families of migrant or foreign workers were to have access to these standards, a principle that the ILC further underscored through the Reciprocity of Treatment Recommendation (No. 2).[51]

Kinship and marriage produced a huge loophole: family undertakings were exempt from all conventions. A male Greek Government delegate to the ILC expressed the prevailing wisdom: "[I]n those enterprises where the father is at the head, or where only near relatives are employed, family sentiment will prevent the illegal exploitation of the child worker."[52] As a place impossible to regulate, the home haunted the formulation of labor standards, including regulation of working time. It stood as a space of family privacy, the realm of reproduction, where women's responsibility for the quotidian aspects of life, and life itself, defined her difference from the male breadwinner, who protected those within its confines. So even though unionists like Jouhaux condemned the "shameful exploitation" of home work, the ILC extended the hours convention only to commerce because the home was a man's castle, as the old adage went.[53]

For nearly a century, the ILO would judge outwork as an evil, pushing for its elimination rather than the recognition of the home worker as a worker like any other. Labor feminists asked the ILO in 1923 to research the practice as a first step toward drafting standards. The postwar employment crisis had increased the numbers of home workers.[54] While the French organized garment home workers, US labor feminists fought to prohibit industrial home work for undermining living wages, but also for disrupting home and family life.[55] The ILC responded by drawing upon the well-established concept of the wage board to regulate sweated industries. The Minimum Wage-Fixing Machinery Convention, 1928 (No. 26) and its accompanying recommendation (No. 30) were to counter the "evils" of industrial home work. This instrument applied to those trades with "exceptionally low" wages without collective bargaining.[56] It addressed women's precarious labor through a gender-neutral mechanism that everyone recognized

was about women's low-waged work. Employers had wanted to restrict the wage-fixing convention to industrial home work, which was hardly a concession to the workers, since the practice was impossible to regulate, and so the convention would be moot in practice. Such a limit in coverage would maintain employer control over the organization of work in other locations, such as factories and offices. The employers lost: the resulting convention covered workplaces more broadly.[57]

The Congress of Working Women had sought to extend occupational health and safety protections to men. It called for removal of workplace poisons for all, but was willing to only prohibit women from trades too difficult to clean up. Research showed that lead exposure caused premature delivery, stillbirths, and developmental delay in children. However, other studies suggested that anthrax and lead poisoning affected men more than women.[58] Men were in industries that were more likely to use dangerous substances. The ILC responded with non-binding recommendations that reflected the general reluctance to restrict men's labor through legislation. The Anthrax Prevention Recommendation, 1919 (No. 3) called for disinfection of wool, and the White Phosphorus Recommendation, 1919 (No. 6) asked countries to ratify the Berne Convention. In contrast, the Lead Poisoning (Women and Children) Recommendation, 1919 (No. 4) suggested banning or curtailing employment of groups judged vulnerable. As with earlier women-specific legislation, it treated every woman as a potential mother. To the extent that ventilating and cleaning workplaces impacted all, men benefited from sites made suitable for adult women, but their freedoms—and jobs—remained unregulated. Male workers were to risk health, while potential mothers would be protected. To implement these measures, the ILC further recommended that countries establish health services within labor inspectorates.[59]

The most contentious standard limited night work for women. The Congress of Working Women sent the ILC a broad resolution to stop the practice for all workers except in "essential public services." To counter exploitive conditions in their countries, a few delegates insisted on immediately ending night work for women. Japan's Tanka Taka declared that "the protection of women, the protection of the home and the protection of the national health" depended on it. The Swedes and Norwegians already treated men and women the same. For labor inspector Kjelsberg, the need of all people for sleep justified a ban on night work. Speaking at the ILC, she poked fun at consumers in offering as a model the Norwegian law, which curtailed the practice for men as well as women. Night work prohibitions in bakeries first led to "a wave of protest . . . especially from well-to-do housewives, because they were thus prevented from getting hot rolls in the morning." But consumer sacrifice, she concluded, knows no gender: soon men would "lament the loss of the morning papers" from

a prohibition of night work in printing.[60] The delegates may have laughed at her examples, but they failed to extend the earlier Berne Convention to men. Instead, they expanded the ban on women to cover small as well as large enterprises.

"Special treatment of countries with special conditions" added another layer of distinction to the one generated by the sexual division of labor and gender norms.[61] The politics of location shaped rules between women as well as between men and women. Not only were employers used to cheap labor, but many countries, especially those under colonial rule, lacked the administrative capacity to enforce labor standards. Tropical weather, Europeans believed, required accommodation. The Washington ILC discussed special consideration for China, India, Persia, Siam, and Japan, along with war-devastated Greece and Romania.[62] Representatives from these places disagreed among themselves. A male Japanese Worker delegate urged the ILC to take "away any special treatment provisions from the autocrats' hands" and place his nation under European standards where it belonged.[63] Asking for more stringent standards, a male Indian Worker delegate argued for lessening the overall work hours of women in the Global South. Not only did they perform more domestic work, but they also labored for longer hours. While less economically "advanced" nations would be allowed gradual compliance with the new conventions, he pleaded to "let the factory women in India reach the western standard of hours of work a little earlier than men."[64]

"Western safeguards," however, were for Western industries, not the majority of workplaces under local control, family businesses, or the informal sector. Partaking in a generalized British Orientalism, Bondfield spoke of crafting the child employment convention "to refer only to those industries which are being modeled on western ideas, which are to some extent under control of factory legislation . . . mainly supervised by western people." Limiting child labor, it was generally thought, would help convince parents to send children to school.[65] The first conventions on youth employment allowed India and Japan to lessen the age and delay application of standards, which were set lower than what the Congress of Working Women advocated.[66]

More ominous was the objection of the Secretary of the South Africa Industrial Federation, another male Worker delegate, to universal application of the maternity leave convention. He deployed a long-standing racist stereotype: the provision "without age or nationality distinction" could mean "without respect to any degree of civilization," which he felt didn't make sense, because "there are women in South Africa belonging to the native tribes for which the performance of the function . . . is not a matter of hardship or difficulty at all."[67] Pregnant agricultural workers—mostly employees on plantations—would wait until 1921 for their own standard, which, like the recommendation on night work in agriculture, would

take a non-binding form. Such distinction exemplified the differential place of colonialized nations and "dependent" territories in a still imperial order.

Class and Gender, Together and Apart

Despite the lack of formal power within the ILO, women's organizations sought to influence the global labor standards regime forged during the interwar years. In 1919, before disagreement over national equal rights legislation and international treaties pitted supporters of legal equality against upholders of women-specific protections, lines between feminists were less distinct. Take the case of social scientist Mary van Kleeck, the wartime director of the US Women in Industry Bureau (predecessor to the Women's Bureau of the Department of Labor). In the 1930s, this investigator into industrial conditions from the Russell Sage Foundation would help craft an alternative to the broad Equal Rights Amendment: the Women's Charter, which offered specific solutions to distinct discrimination. She brought Communist supporters together with laborite social democrats in opposition to the legal equality National Woman's Party (NWP). She became part of the network of labor feminists advising the ILO. Back in 1919, however, she promoted equality at work, announcing to the International Congress of Working Women, "We seek not the protection of women against the evils of industry, but we seek . . . to remove the evils of industry as they affect either men or women workers! (Applause)—so as to change the conditions of working life and industry that there will be no question of work either by a man or a woman as being detrimental to the home or to the welfare of children."[68] Labor feminists would transform the nature of work rather than open "the evils of industry" to women on the same terms as men.

After suffrage in the United States and Britain, debate swirled within as well as between women's groups over strategies to end discrimination and advance equal rights. New formations formed to reflect personal as well as political differences. Out of the 1919 women's conference came the International Federation of Working Women. Funded initially by Dreier Robins and her cross-class Women's Trade Union League, it became a casualty of international labor politics: the US League found itself ineligible for membership after the AFL left the IFTU. New leaders ran the federation out of the British Trade Union Congress; within years the Women's Committee of the IFTU, with the support of British and German women unionists, took over the group. These women generally shared a class and gender approach to questions of women's work. They judged mixed-sex unions to be a better vehicle for working-class power than the women-only form of organization exemplified by the Women's Trade Union League.[69]

For those fighting for working-class advancement, better conditions on the job, and higher living standards, protecting women offered an entering wedge to improve wages and hours and eliminate workplace hazards for all workers.[70] Those holding this position believed that some industries, like textiles and electronics, would have to reduce men's hours to comply with restrictions on women's to maintain plant efficiency. Certainly ILO Director Albert Thomas, a French socialist and wartime cabinet minister, believed "that historically special measures for the protection of women have never constituted a serious obstacle to their employment, but have rather paved the way for the protection of workers in general." (He also defended such measures as necessary to adapt industry to "women's special physical and mental conditions"—a perspective that undoubtedly fueled feminist ire.)[71] German Gertrude Hanna, who would participate in the ILC in 1921 and 1931, was among the socialist women who promoted protection as a vehicle for better conditions for workers and opposed separatist women's organizations. Instead, she fought for integrating women into trade unions and establishing women's committees, rather than building autonomous organizations like the International Federation of Working Women.[72]

There were class-first adherents who would restrict women's employment. They conflated men's power at work and in the home and family with the good of the working class. German Carl Legien of the IFTU, Belgian Emile Vandervelde of the Second International, and American Samuel Gompers of the AFL—the latter two on the commission that created the ILO—sought to protect adult men by ending competition from lower-waged women and children. They believed that employers would refuse to hire women at a man's wage. They had no objection to equal pay for equal work, because that principle was necessary to maintain the rate for the job for men, but were skeptical about placing women in jobs dominated by men. The long-held equation of women with the family pervaded such discussions, denying woman the freedom that feminists believed all individuals deserved as their birthright. Protective laws gave "the mother back to the family," claimed Catholic trade unionists. Labor laws for women, from this standpoint, protected men's jobs.[73]

In contrast, staunch advocates of equal rights judged women-specific protections as leading to gender subordination and workplace discrimination. From the 1880s, international congresses of women rejected single-sex protections, insisting instead on women's right to engage in all professions throughout their lives. Some proposed the inclusion of men in hours limits, including night work. Setting opportunity as the opposite of protection, others limited their support for women-specific laws to pregnancy and infant nursing. The Catholic St. Joan's Social and Political Alliance pushed suffrage and acted in tandem with legal equality feminists in protesting ILO women-specific protections.[74] By the

interwar years, the most tenacious demanded strict equality at work and equality of opportunity to work. They often counted only the disadvantages that could stem from gender, rather than considering the interaction of other structural or social inequalities with the gender order. They were fearless in defending women's equal citizenship, whether political, economic, or social.[75]

Previously united in the pursuit of suffrage, these feminists created a plethora of organizations during the interwar years. Some turned to peace and social welfare, while others pushed to end forms of unequal citizenship, notably in the areas of married women's nationality and access to education and the professions. Spurred by the IWSA's refusal in 1926 to admit the NWP, the legal equality champion from the United States, Britons Lady Margaret Rhondda and Helen Archdale of the Six Point Group withdrew their own application for membership. Instead, they would create Equal Rights International (ERI) in 1930, with the NWP and its leader Alice Paul among their adherents. The Quaker Paul, who had brought the tactics of civil disobedience to the US suffrage campaign, introduced the Equal Rights Amendment in 1923. The NWP previously had affiliated with the Open Door International for the Economic Emancipation of the Woman Worker (ODI), established by Elizabeth Abbott of the British Open Door Council in 1929. Abbott, another daughter of a Scottish manufacturer, took classes at University College, London and was the one-time editor of the IWSA newsletter.[76]

Chrystal Macmillan, who would head the ODI from 1929 until her death in 1937, typified the kind of educated professional of middle- and upper-class origins who dominated the equalitarians. That her organizational history and causes were expansive questions any simple class-based judgment of legal equality feminism. She was a daughter of a tea merchant, a Scott like Macarthur and Abbott. Macmillan, who became a lawyer in the mid-1920s, was a breaker of gender barriers: in 1896 she was the first woman to graduate from the University of Edinburgh with a degree in science, and in 1908 she was the first woman to argue before the House of Lords (for the right of women graduates to vote for university seats in Parliamentary elections.) Ardent about equal pay, she early on joined the Scottish Federation of the National Union of Women Workers. A founding member of WILPF, part of the women's delegations to the Versailles Peace Conference, she would abolish the trafficking of women while defending the rights of prostitutes. Rejection of regulation in this regard was consistent with her anti-statism.[77]

The ODI and the NWP targeted the ILO as the main enemy upholding discrimination, and hence inequality, in the world. Britain's Harold Butler, who would serve as the ILO's second Director from 1932 to 1938, rejected their claims. In 1927 he called the "regular campaign against all protection for women . . .

unfortunate at a moment when the general tendency is retrogressive rather than progressive in the matter of labour legislation."[78] Legal equality feminists, however, saw themselves advancing women's rights rather than retarding those of workers. The founding "Manifesto" of the ODI in 1929 expressed their credo: "True protection can only be given by the same status, the same freedom; and the same opportunity for a woman as for a man. And this entails legislation and regulation based on the nature of the work and not upon the sex of the worker." The Open Door demanded that the ILO live up to its charter and enact equal pay. Rather than maternity benefits, women should receive compensation like any other incapacitated worker. She alone should determine her fitness for work, not some restrictive regulation. Any compulsory stipulations would prejudice the hiring of women, whether for the professions, civil service, or shop floor.[79]

The various legal equality groups would come to disagree over tactics, as was the case with a proposed Equal Rights Treaty at the League of Nations. In 1938 Paul started her own World Woman's Party "to make a world movement to give women more power and to abolish all discrimination of rights on the ground of sex."[80] Three years later, with the European war, the World Woman's Party merged with ERI. Organizational vanguardism and individual aspirations for leadership undoubtedly intensified strategic and ideological disagreements. US-based legal equality and labor feminists continued to battle each other into the 1950s. But feminists in Latin America and elsewhere often embraced both equal and special treatment of women, offering another vision of feminism that judged such an opposition as false.[81]

Legacies of Protection

The status of labor standards as protective legislation appears in the very terms of conventions subsequent to the Washington conference. Though genderless, the presumed worker was an adult male unless the convention targeted women and children. Given the concentration of work by sex and age, the universal often applied only to adult men. Conventions for agriculture covered minimum age, right of association (unionization), and workmen's compensation; recommendations addressed unemployment, maternity protection, night work of women and children, vocational education, accommodations, and social insurance—all in 1921. That year the ILC passed the White Lead (Painting) Convention (No. 13), which prohibited employment of women and children in industrial circumstances but not in artistic painting. It allowed for the use of lead paint by adult men under controlled circumstances. Other conventions and recommendations addressed working conditions in specific sites, like docks, fisheries, offices, and theaters. Still others began to sketch social security protections; these instruments named

outworkers and domestic workers in specific titles but provided loopholes for nations to exclude them from coverage.[82]

During the interwar years, the ILO initially assigned staff from the Office to address questions of women and work and to liaison with women's groups. In the 1920s, German Martha Mundt handled these inquiries. Recommended by Social Democratic leader Eduard Bernstein, she defended the ILO position on women-specific protections in her interactions with feminists. In 1933 French feminist and pacifist Marguerite Thibert would head the new section on women and young workers. She had become a single mother when her husband died during the war. After receiving a PhD from the Sorbonne, where she wrote on the mid-19th-century socialist Flora Tristan, Thibert joined the ILO in 1926 to research international migration. After years of temporary contracts, she gained a permanent position in 1931. Thibert promoted women's civil, political, and economic rights within the confines of the ILO.[83]

With support from Director Thomas, who died suddenly in 1932, Thibert was able to finesse opposition within the Governing Board to develop a Correspondence Committee on Women's Work. Women advisors and sympathetic male delegates to the ILC, along with Office staff, understood the need to address the impact of the worldwide Depression on women's livelihoods. While they held various views on women-specific standards, they were leery of proposals to restrict married women from the labor market as a way to save jobs for men, assumed to be the family breadwinners. The Chief of the Employment section, for one, floated the idea of reducing hours for all workers, which had the added benefit of allowing the woman who combined household care with employment to undertake both, even if "paid help" was unaffordable.[84] The need for women to mix reproductive with other labors remained a persistent concern. The resulting Correspondence Committee on Women's Work, with some hundred members, disappointed international feminists. It provided expertise on the cheap, since it never met as a group before WWII. In constituting the committee, Thibert managed within the ILO's framework to balance the demands of a wide range of stakeholders and still ensure sufficient expertise and input. The committee included individuals, like Chrystal Macmillan, who were actively lobbying against the women-specific measures that were the legacy of 1919, as well as an array of unionists, government officials, and leaders of women's groups.[85]

Two women-only conventions—a 1934 revision of the 1919 night work measure and a new 1935 instrument on underground mines—highlight the contested meanings of protection. The Depression intensified the need to address female unemployment, which in Europe ranged as high as 35%, and to study the impact of poverty wages on families, men, and women themselves.[86] These conventions restricted women from manual jobs, but exempted women managers

and, in the case of mining, allowed for the employment of women health and welfare workers even if they ventured underground.[87]

While supporters of restrictions believed they were protecting the home, opponents argued that such barriers pushed women to migrate for jobs and subjected them to moral hazards.[88] In sending numerous letters, memorandum, and petitions, the "absolute equality" groups challenged the tripartite system, aggravating Thomas and other subsequent directors, their staff, and many members of the Governing Body. These groups sought to use the committees of the League of Nations to bypass and outflank the ILO. Thibert acted as an intermediary between such feminist organizations and the ILO, explaining each to the other and maintaining communication.[89]

Competing feminisms sparred over women-specific standards. Dismissing trade union women as unrepresentative of the unorganized and beholden to the men who dominated mixed-sex organizations, legal equality feminists claimed to speak for all women.[90] Male unionists certainly gave them ammunition. One such British Worker delegate displayed precisely the kind of reasoning that legal equality feminists protested: He charged that changes to the night work ban risked having employers substitute women for "men with family responsibilities" as a cost-cutting measure.[91] But as German Worker advisor Hanna announced during 1931 deliberations, "If it had been only men who opposed this, we should have thought it was because they objected to the competition of women workers, but women workers refuse to accept the competence of the Open Door International here." She claimed that trade union women understood the class benefit of women-specific protections.[92] Fierce antagonism clouded any possibility for compromise among activist women.

The British government became the champion of the legal equality feminists, who were particularly strong in that country.[93] In June 1930 it asked the Governing Body to exempt women engineers from the Night Work Convention.[94] Its delegate raised the issue of whether the convention should apply to any managers. Legal equality associations wanted no restrictions for any woman worker, not merely middle-class ones. Abbott of the British Open Door claimed the convention would fling women "to the bottom of wage market and keep [them] there." Legal equality feminists would accept only a ban targeting specific trades or processes harmful for both sexes—actually the kind of gender-neutral provision inherent in most ILO conventions.[95]

Did the convention really apply to all women? The Office determined that the drafters followed the Berne Convention, which understood women as "ouvrières," or working women.[96] However, exempting managers in some countries with weak inspection would "lead in fact to depriving unjustifiably considerable numbers of women of the protection afforded by the Convention."[97] After

the British proposal for revision in 1931 failed to receive a necessary two-thirds vote at the ILC, the Governing Body sought the advice of the Permanent Court of International Justice.[98] When the Court ruled that "women" referred to all women, either the ILO had to revise the convention, or signatory nations that had allowed supervisors and managers to work at night had to amend their laws to ban all women.[99]

Workers and Employers vigorously debated the merits of night work during the early 1930s. At the 1931 deliberations in the Committee on the Partial Revision of the Convention Concerning Employment of Women during the Night, all Employers favored exempting managers, defined as those "who do not ordinarily perform manual work." They would change the hours of night to extend from 11 p.m. to 6 p.m. for specific processes. All Workers opposed revision as a backward step, with the Government delegates divided.[100] Three years later, only the British Workers opposed exempting managers, while all Worker representatives rejected a change in the span of hours. A Spanish Government advisor summarized the impetus of many, stating that "it is our duty to legislate socially, but to make that legislation conform to the actual conditions which prevail." The change in hours would open jobs to women, who then could work the second

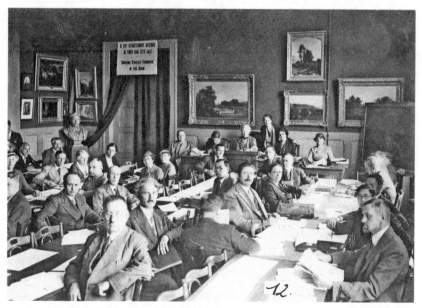

FIGURE 1.4 Committee on the Night Work of Women, ILC, 1934. At the back table: Committee Chair Kerstin Hesselgren (Sweden), Marguerite Thibert (ILO), reporter Milena Atanatskovitch (Yugoslavia), and Worker Vice-Chair Julia Varley (Great Britain). Photo from International Labour Organization, with permission.

shift and compensate for male unemployment within families. During the final vote, again only the British Worker delegate opposed the hour amendment. In this consideration of women's work, Kjelsberg and Hesselgren alone served as delegates to the ILC, while another dozen women attended as advisors, most as part of Worker delegations.[101]

Questions of reproductive labor pervaded these discussions. Explaining Worker rejection of a proposed hours change, Hanna had evoked women's household tasks, but not along the lines used by defenders of shift work. The extra hour in the morning would go "to help their husbands or their younger brothers or sisters or their children to get ready for work . . . the change does not mean that they will have an hour extra for rest," she insisted. Similarly Swedish Worker advisor Karin Nilsson emphasized harm to the home and family life for men as well as women. She cited the conditions of textile workers, one of the major industries employing women, where an 11 p.m. end time would exacerbate overwork: these women earned too little to hire domestic help and would have to undertake household duties after midnight. "There is a difference between going to a cinema at night and working an hour later in the factory," she argued. Like other Workers, Nilsson suggested reorganization of work processes rather than squeezing workers to fit into existing contours of production. Polish Worker advisor Eugenia Wasniewska, who represented salaried employees, chastised the Office for not making an extensive study of the impact of night work. She used the occasion to suggest building the section on women's work, establishing an Advisory Committee, and having more women at the ILC. That year the numbers of women reached twenty, including secretaries to delegations.[102]

The removal of women from underground mine work generated less disagreement within the ILO, but still caused consternation among legal equality feminists, who urged the conference to reject the proposed convention. Whether India and Japan alone had significant numbers of women in such undertakings depended on the definition of underground, which was so general as to possibly ban women from working on sewers and tunnels. As with night work, the delegates sought protection only for industrial workers.[103]

Mines were dangerous for those within, but concerns over proper families and gender norms pervaded discussions. The consequences of any ban, according to the All-India Women's Conference, would be more devastating than women remaining in the mines, with "dislocation of home life," "increase of immorality," and "great decrease in family wages." If no longer able to work in customary family groups, the women would remain in villages with "no proper home for the miner," who would be tempted "to spend his earnings at the liquor shop." ODI quoted to the labor conference an article in the ILO's own *International Labour Review*, which reported that Japanese men "prefer, on moral grounds, to have

their women folk underground with them."[104] Such moral arguments paralleled ones used by supporters of the convention. With feminists on all sides of the protection debate deploying cultural rationales, the place of women's reproductive labor in determining employment, its role in maintaining her difference, appeared as a central ingredient in the making of global labor standards.

Sex and the ILO

The study of sex and the ILO during the interwar years best illuminates a gendered culture of protection that pervaded standard setting. The ILO didn't want to get involved in such questions, but it found itself embroiled as part of the League of Nations and from protests by both moral reformers and feminists. Debate was less between legal equality and labor feminists than between activist women of various persuasions and the male-dominated ILO. Women and girls subject to sex trafficking and men prone to venereal disease were both caught in the vise of illicit sexuality: one to be kept from engaging in the trade, the other to be insulated from health risks associated with its offerings. Both emigrant women and seafaring men would fall under international regulation. Yet the nature of those protections reflected cultural constructions of womanhood and manhood. Men could fail in their role as breadwinners, as proper family men, who instead of safeguarding their wives and children jeopardized their health and welfare through reckless, selfish behaviors. Women could debase their very being through commercial sex even while being victimized by exploitative wages and procurers.

The social standing of seafaring men was not separate from that of women who labored along the waterfront—or of those men who by their class (employers), race/ethnicity (white, Anglo, or French), or nationality (imperial state) wielded more power. These statuses were relational. The protection of men required the containment of women, who could contaminate them, but seafaring men—the archetypical international proletariat—needed their own restrictions to safeguard public health and public order. Men and women on ships and in ports were described as "untethered" or "unmoored": both existed outside of the watchfulness of family and community, out of place, and thus in a place unknown and no longer subject to restraint. They were homeless, uprooted. Emigrants had sold their possessions, trekked to consular ports, and set off on ships seeking a better life. Seafarers plied a trade that confined them on ships as part of a motley crew under a captain's law rather than a nation's. In the discourse of the ILO, these men had become "vagrant(s) of the sea," to whom family was only "a memory or a hope."[105] As such, women on their own and men apart from family were potentially as dangerous as they were in danger.

"Unaccompanied" women and children sought to embark on ships that brought laborers with work contracts out of Europe to the Americas and Antipodes, and from Southern and Eastern European villages to Western European cities. They disembarked as foreigners, sometimes without prior arrangements, other times with plans that evaporated. Whether they traveled for employment or to join family who already had resettled, reformers felt, they were ripe for procurement and subject to being led astray, unless watched over by a conductress or woman matron of high morals and practical knowledge, "competent to handle the most intricate and delicate position," or so explained Bondfield, the labor feminist who represented workers on the 1926 ILC Committee on Simplifying Inspection of Emigrant Ships.[106]

The plight of these women first raised the specter of sex. How to treat immigrant workers remained an unsettled component of international law. Many countries had special legislation on women emigrants that treated them as dependents who had to obtain permission to migrate from husbands (Portugal and Spain), parents (Spain), and municipal authorities (Hungary). Some strictures belonged to colonial regimes of control, with racial overtones. The Belgian Congo forbade employment of "Natives who are under the guardianship of official or private organisations, and married native women . . . except with the authorization of their guardianship authority or husband." India fined "an Indian immigrant who has received a free passage under a promise to labour and who fails to proceed to his place of employment." It sent home female counterparts unless they could "furnish security that [they] will not be disposed of as prostitutes, or for immoral purposes."[107]

Concern with trafficking continued the late 19th-century mobilization against "white slavery" and the regulated brothel system.[108] The Advisory Committee on the Traffic in Women and Children, formed in 1921, oversaw the League's monitoring of prewar international treaties. It became a place where nongovernmental organizations wielded power. Appointed as "assessors," delegates from the various protective societies, like the Jewish Association for the Protection of Girls and Women and the International Bureau for the Suppression of Traffic in Women and Children, and from women's organizations, like the International Council on Women and the World Young Women's Christian Association (World YWCA), challenged governments reluctant to dismantle their own systems of prostitution but willing to expel "foreign" women from the nation. While the women's groups sought to end prostitution, they insisted on the dignity of women, rejecting proposals that targeted women for certificates of good conduct and any other barrier to mobility. They fought for a kind of gender equality, going after procurers along with prostitutes and restricting boys as well as girls from morally dangerous trades.[109] While governments initially confined the scope of

their inquiry to the question of trafficking, by the 1930s the Traffic Committee confronted, however tentatively, "general questions of prostitution."[110]

The ILO had a limited interest in trafficking as a byproduct of unemployment and poor labor conditions. It refused to regard sex industries as under its "competence." It accepted the moral discourse of the Traffic Committee, whose members declined to dignify prostitution by designating it a "trade."[111] In 1921 the Office had brushed off a resolution on trafficking by the International Emigration Commission, which it helped establish, by claiming "the abuses . . . are of a criminal character and a special section of the League exists for the study of the Question."[112] Nonetheless, it entered the conversation on sex trafficking as part of its overall protection of migrant workers, with experts on emigration the first representatives to the Traffic Committee. Only later would it send staff familiar with the situation of women workers.[113]

Conventions and recommendations sought to keep young woman from sex work. One convention regulated fee-charging employment services, feared as a place for procurement. Other instruments scrutinized labor contracts, such as those covering women and girls working abroad in music halls and other entertainments, also thought to be covers for prostitution.[114] Another recommendation called on governments to police working conditions in theaters and amusements, including the extent of hours and "conditions of contact," so as to subvert any "attempt by . . . management . . . to induce the girls to lead immoral lives." The Minimum Age (Non-Industrial) Employment Convention, 1932 (No. 33) covered occupations judged to be morally as well as physically dangerous, including establishments serving alcohol. The ILO promoted alternative recreation. It further demanded vigilance over jobs that involved lodging, like domestic service. When it came to prostitution, it spoke of "moral protection" rather than protective labor standards.[115]

Previously, ILO officials held moral reformers at arm's length by deflecting their demands. In 1921 the Director tabled the request of the Association for Moral and Social Hygiene, the British abolitionist group founded by the then legendary Josephine Butler, that the ILO reject both the inspection of alleged prostitutes for venereal disease and the licensing of brothels.[116] But the presence of concerned women delegates and advisors ensured that the ILC would have to confront the trafficking of migrant women. The intervention of Uruguayan feminist Dr. Paulina Luisi, a delegate to both the ILC and the Traffic Committee, reconfigured data collection on emigration to better assess the number of those trafficked.[117] Fanny Ulfbeck, head of the Migration Committee of the YWCA of Denmark and a Government advisor in 1926, defended the proposition that women emigrants required women supervisors aboard when the ILC considered simplified inspection of ships.[118]

In the mid-1920s, the ILO sought to reduce the cost of travel for migrant workers by reducing the number of inspectors on ships. It surveyed governments as to whether there should be women inspectors, a question that reflected the influence of the Traffic Committee.[119] The male German Government delegate objected to the appropriateness of a woman supervisor for "male young persons over 16 years of age." Bondfield retorted that the issue was not one of overseeing school children, but one of protecting the morals and guarding the sexuality of women and girls.[120] A vote for the women inspectors, Bondfield insisted, was a vote "against any dangers or temptations arising out of the traffic in women and children."[121] Since the final instrument in 1926 was the non-binding recommendation preferred by governments, implementation depended on the will of the same governments that rejected including this provision in a convention. For the Traffic Committee, any recognition of its position by international agencies was "a success" that might lead to changes in law and practice.[122]

The Problem of the Sailor in Port

During the interwar years, the ILC passed more conventions on the maritime sector, an occupation gendered male, than any other. Shipping was the most important global industry, crossing the boundaries of the public and private, and of the national and global. Workers manned vessels under flags of countries not their own. The particular circumstances of the sector, with its isolated workforce and an employer-employee relationship grafted onto a hierarchal, military-like social order, required distinct instruments.[123] Separate conventions set the minimum age of employment at fourteen (later sixteen), except for family-only operations, and required that youths receive yearly medical examinations.[124] No matter their age, seamen came under conventions that guaranteed labor rights, including written agreements that specified terms of work. Employers had to provide the name of the vessel, length and time of service, jobs to be performed, ports of voyage, nature of hours and leave, amount of wages, and procedures for termination. One convention specified conditions for repatriation, or the return of a worker to his home country if a trip ended elsewhere.[125] Ships had to give adequate medical care and daily maintenance, acts necessary to sustain the workforce (and thus a form of social reproduction), and continue to pay wages to the worker and his family upon injury. A different convention fixed social welfare and health benefits, though access to treatment could be refused if incapacity came from "the insured person's willful misconduct."[126] All safeguards were subject to national law, which led to struggles between workers and employers on two fronts: the international and the national.

The seaman, like the woman, required his own form of inspection, similar to but different from factory inspection that served as a lynchpin of workplace regulation. His lot might parallel but was not the same as industrial workers. So the ILO established a Maritime Commission, because nations regarded seas as coming under international deliberations. No matter his nationality or race, he stood out from the citizen in ports of call by virtue of his transience. He was a special type of man, one who lived on the ocean and in close quarters with other men, apart from the usual patterns of social life.[127] On the question of seamen's welfare in ports, a culture of protection targeting men threatened not only the abolition of prostitution but also the rights of women. The men of the Joint Maritime Commission and its Committee on Seamen's Welfare in Ports would regulate women's bodies and restrict women's employment for the betterment of male workers and their distant families. Sex—in terms of sexuality, but also in regard to "the politics of presence" or the representation of women by women— complicated the making of labor standards for seafarers.

In 1920 the first Maritime Conference in Genoa addressed a widespread concern over venereal diseases within merchant marines, which lead the ILO to consider social welfare for this "special class of international workers." Five years later, pushed by Norwegian Employers delegate T. Salvesen, the Joint Maritime Commission concluded that governments' neglect of foreign seamen required international action. A Norwegian chaplain summarized the prevailing sentiment: "His work is of so great an importance in the economy of society that he has a claim to be considered equal to any other class, and if he is easily influenced and weak against temptation there is a double reason for stretching out a strong arm to help him." But vulnerability alone did not justify protections. Unlike women and children, the seaman was "a grown man, . . . able to take care of himself," Salvesen declared in a statement that sought to retain the manliness of this occupation even as he pushed for protection. Rather than weakness, "heroic" service warranted efforts to enhance "the economic welfare of the seaman of to-day and his family."[128]

While the Welfare Committee was careful to insist that most seamen strove for high moral standards, it emphasized harms, such as robbery and drink, which the "weak" among them extended to communities, passengers, and the entire shipping industry. The most dangerous threats came from exposure "to strangers and persons of bad character," who "cause the ruin of many men and boys." Tempted by bars and places of cheap amusement, seamen could succumb to "a more or less public street traffic carried on by loose women and the activities of the keepers of houses of ill-fame." Presented as sources of contagion, spreading disease as they moved from Europe to Asia along trade routes, such women

required "public control." Their services appeared destructive, not useful or he-roic, like the seafarer's.[129]

To mitigate vulnerabilities, the Welfare Committee discussed a series of proposals in 1929. It considered enforcement mechanisms, such as port committees and policing, and restrictions and regulations, in terms of sales of drinks, persons boarding and lingering around ships, and dock safety. Particularly important was social welfare, including "suitable" lodging and recreation, avail-ability of hospitals and treatment for venereal disease, and mechanisms for the remittance of wages.[130] Most provisions, albeit in a modified form, went into the Seamen's Welfare in Ports Recommendation, 1936 (No. 48). But two ini-tial articles provoked outrage—a call for "strict medical control of women who have illicit intercourse with men," and a "prohibition against the employment of female attendants in places where strong drinks are served, and the lodging of seamen."[131]

Abolitionists (who would end regulated prostitution) had vigorously protested the medical inspection of prostitutes ever since Josephine Butler's campaigns against the British Contagious Diseases Acts in the 1870s.[132] By the late 1920s, medical authorities and social hygienists alike had decried inspection as ineffective. As George A. Johnson, the ILO's liaison to the League's Section on Social Questions and later an Assistant Director-General, reported to the Office, "there is a _de facto_ majority of States against licensed houses"—an obser-vation that was central to his argument for dropping the proposal of the Seamen's Committee.[133]

Dame Rachel Crowdy, the British moral reformer who headed the League Secretariat on Social Questions, brought the force of her office to the task of blocking inspection of presumed prostitutes. She understood that if the ILC conveyed such a recommendation to governments, "the whole question of regu-lation might be prejudiced, and that, further, the Governments would be placed in the very awkward position of having committed themselves to two very dif-ferent policies"—ending regulation but inspecting women in licensed brothels. To fight the proposal, she drew upon both the politics of League jurisdiction and a shared faith in the power of social investigation. In making a case to Director Thomas, she argued for maintaining the "spirit" of previous proposals of other League bodies. She also threatened "great criticism." Thomas responded by in-viting her "to prepare an objective memorandum" describing the "actions" of the Traffic Committee and the findings of its 1927 Special Body of Experts, run and financed by the Rockefeller Foundation's American Social Hygiene Association.[134] This investigation had concluded that licensed brothels actually encouraged the trafficking of women from one country to another.[135] Thomas sent her materials to the Joint Maritime Commission, with the promise that it

would study them carefully. It was important, he reassured Crowdy, that units of the League of Nations come to compatible views.[136]

As the Traffic Committee spread the word of the proposal, the ILO received letters of protest that warned of dire consequences. The IWSA and the British section of WILPF passed resolutions of disapproval. The British Medical Women's Federation argued, on scientific grounds, "that prophylactic measures against venereal disease would be completely ineffectual under the conditions of the seamen's life in port." It assumed that seamen, becoming intoxicated, were less likely to use condoms, and, being nomadic, were less likely to obtain treatment if they became infected. Alternative recreations and better accommodation would provide greater deterrence.[137] The ILO backed off, insisting that the Traffic Committee had misunderstood its process.[138] In the end, pushed by the shift among governments from the regulation to the abolition of prostitution, the Welfare Committee responded to "so much misunderstanding" over their proposals by deciding to call for protection of seamen from venereal disease without elaboration.[139] The Office decided to offer an overall plank on seafarer access to hospitals and medical treatment rather than single out venereal disease. But this provision raised the question of equal access of Indian and other racialized and colonial men to such services.[140] Sex thus became a proper concern only under the rubric of health.[141]

The ILO continued to face widespread feminist ire over another proposal: to prohibit the employment of women in portside taverns. Some found such restrictions ridiculous. A male British Employer delegate admitted back in 1926 that "it does not seem to me to be a very dreadful thing that at the end of a long voyage a seaman who goes ashore should have his glass of beer handed to him by a member of the opposite sex. Seamen are a gallant race of men and they are peculiarly susceptible to the influence of the other sex. I believe that influence is a refining one whether on seamen or on the members of this Conference."[142] Other delegates noted that "young girls employed in public houses and similar establishments frequently acted as decoys for seamen." Young women were particularly desirable, with eighteen presumably the age with the highest prevalence of syphilis among women. Thus, "the object of imposing a minimum age limit in such employment was to protect seamen from the danger of infection"—not the young women from the seamen.[143]

For the International Alliance of Women for Suffrage and Equal Citizenship (a new name of the IWSA), the Belgian Association for Women's Enfranchisement, and the ODI, this prohibition was "unjust and ineffectual." Each condemned the assumption that women were to blame for "illicit intercourse"; that all barmaids were prostitutes; and that women should be barred from a "trade which in itself is only immoral through the fault of the men frequenting these establishments,"

as the International Alliance charged, or, as ODI explained, "because it seeks to impose prohibitions on the right to paid employment of a whole sex, on account of undesirable conduct shared by members of the other sex." The ban would be "ineffectual" because it could not "prevent" prostitutes from entering taverns as customers or block seamen from "promiscuous intercourse." In short, such protective legislation "seeks to protect men by placing restrictions on women's liberty."[144] Legal equality feminists labeled such protection for what it was: harm to women's right to a job in the guise of safeguarding morality.

The International Alliance and Belgian Association offered a solution and a rationale. A regulation might prohibit employment of underage persons regardless of sex. Feminists, even the abolitionists among them, balked at limits on adult women's choices, but found it appropriate to protect those below the age of consent. Boys as well as girls needed shielding from predators. After all, the Belgian Association warned, "the danger of sexual perversion must not be forgotten." Moreover, the proposed ban reflected a larger problem: women's organizations "have no means of making their opinions known directly" at the ILO, as the International Alliance lamented. The appeal for consultation had legs, given ILO rules. The ILC would rationalize its move away from a ban on women attendants by asserting "that it would scarcely be advisable to attempt to regulate the work of women in a particular occupation when no women were present on the Committee." Delegates nodded to another point made by feminists—that restriction "bore on the problem of unemployment as affecting women." While ODI stressed that prohibitions would "drive" women to prostitution, the Seamen's Welfare Committee explained that regulating women's work was beyond its charge. However, when it came to child labor, it had no qualms about setting a minimum age for employment in places serving alcohol. Few boys worked in such jobs, so, in the end, limits on children curtailed the work of young women.[145] ODI took credit for changes on the basis of its lobbying of an earlier Maritime Conference.[146]

Arguments defending the appropriateness of employment restrictions illuminate the larger question of protective standards. Seafarers fell under the disciplining gaze of moral reform, medicine, and the state. As with women emigrants, seamen would be protected despite their own behavior. But protection of seamen, to reemphasize, did not extended to protection of the women they frequented for sex. Prostitutes appeared as obstacles to the welfare of men, rather than workers deserving of their own occupational health and safety. Feminists were thus partially right. Protection of women workers in taverns restricted employment. Given the occupational segmentation of the labor market, it was unlikely that male youths or men would replace women in jobs for which female sexuality, or appearance, was a crucial criteria and low wages the norm. Such

measures displaced moral opprobrium from behavior to essence. They served not to alleviate the conditions of labor but to restrain the social dis-order heralded by sexual danger. Protective laws, then, maintained the gender order not by restriction but by suppression of alternatives to gender constructions of good and bad women and manly men. As a male Finnish Employer delegate explained, "female labour was universally employed in public houses in the northern countries, and, therefore, the suggestion would be incapable of adoption."[147]

The cultural work of protection shadowed the protection of labor standards. Conductresses for emigrant women and children traveling without men and provision of barriers (social, institutional, and physical) to venereal disease among seafarers stood apart from regulations against long hours, low wages, and destructive conditions on the job. Measures proposed for transient outliers, seemingly separate from standards developed for the factory worker, underscored the gender of protection. At the same time, they complicate our understanding of labor protections: improvement of work demanded addressing the larger circumstances of working-class lives.

The Gender of Forced Labor

In 1948, the year of the Universal Declaration of Human Rights, ODI claimed, "It is easily recognized in the case of men, that the most fundamental of human rights, the first great civil liberty, is the right to sell one's labour for gain.... This is the right which distinguishes the freeman from the slave."[148] Such sentiments had led Thibert to charge in 1929 that the Open Door promoted economic liberalism in a new form.[149] During the 1930s, with labor standards for colonized peoples on the ILO's agenda, legal equality feminists demanded that women have the same freedom to contract as men, even if it meant agreeing to conditions of extreme exploitation.[150] Rejection of different standards for "native" or indigenous women under colonial rule highlights the problem of equality under systems of unfree labor, where authorities—whether tribal leaders, colonial administrators, military commanders, or private contractors—compelled work. It also exposes the lengths to which some Western feminists would promote their own rights by campaigning to improve the status of women in the Global South.

When the League of Nations passed a Slavery Convention in 1926, it left to the ILO the task of "studying the best means of preventing forced or compulsory labour from developing into conditions analogous to slavery."[151] The Office already had commenced an investigation into what it variously called colonial, native, and indigenous labor in non-metropolitan and dependent territories or possessions. Through "the colonial clause" of its constitution, the ILO permitted members to modify conventions or refuse their relevance to areas of the Global

South under European control. The dominance of colonial powers—Great Britain, France, Netherlands, Belgium, and Portugal—during the interwar years ensured an uneasy application of universal standards in which cultures of protection justified a two-tier system. The result was a series of special conventions targeted to places without sovereignty and where unskilled labor lacked organization, in which the Forced Labour Convention, 1930 (No. 29) was the first, and the Contracts of Employment (Indigenous Workers) Convention, 1939 (No. 64) generated the most feminist backlash.

Civilizing discourses dominated ILC discussions. The remarks of a male Government delegate from the Irish Free State in 1927 captured the meaning of labor protection under empire: "Hitherto it was the practice of successful statesmen to send out missionaries with a Bible in one hand and a sword in the other to bring the blessings of civilisation to those who had got the things they wanted. We all hope, I am sure, that for the future the missionaries will carry with them the propaganda material of the International Labour Organisation." He sought to insulate workers in the "highly industrialised countries" from unfair competition from "backward" or undeveloped areas.[152] A Government advisor for the British Empire stood out for defending traditional and customary practices that included local elites exacting tribute labor from villagers; he would preserve " 'native' culture," rather than replacing it with "all our western ideas, including that of the conflict between capital and labour and political parties."[153] Two years later, a male Indian Worker advisor named such comments for what they were. Speaking of "the sacred trust of civilisation" obscured "the main point for this Conference to grasp . . . that forced labour is essentially a vicious system from its foundation. It is a legacy of an imperialist form of government" to protect white settlers.[154]

Forced labor was pervasive in European colonies, especially in Africa and the Pacific, and among territories of "concessionary companies" that were private employers with government grants. Militaries, colonial administrators, and "tribal" leaders compelled men to work with various degrees of remuneration, often at a distance from their residence. Such entities commandeered men for cultivating crops, erecting damns, building roads, responding to fire and floods, moving supplies, and carrying government officials on tour. In British East Africa, the time owed for such public projects was sixty days a year; the Belgian Congo kept men for five-year stints. Forced labor served as a form of punishment for those convicted of a range of crimes, much as with chain gangs under the Jim Crow racial system in the United States. "Natives," who refused to work as specified by contracts, could be forced to do so.[155]

Some ILO delegates lamented how forced labor disrupted family life, but it was international women's organizations that highlighted the crisis of

reproductive labor—the maintenance of families, villages, and individuals.[156] In the late 1920s, Western women's suffrage, peace, and social welfare groups sought to influence ILO deliberations on "native" labor. They sent a memorandum to Director Thomas, which he circulated to the Committee of Experts on Native Labour, that demanded "the total abolition of every form of forced labour." Like the men deliberating in Geneva, the women's organizations assumed that the worker obliged to labor was a man. Women and young workers, along with "the unfit and aged," should be "exempt."[157] The British section of the WILPF, the initiator of the memorandum, worried about "[g]reat evils, both moral and physical, [that] resulted from the break-up of village life involved in the removal of men for long periods of time."[158] This and the other women's organizations thus recommended regular visits home, which had the added advantage of making men available to perform their customary tasks in agricultural regions.[159]

The convention would abolish forced labor only from private enterprise. Even the memorializing women accepted compulsion for public emergencies, especially when no volunteers were available. Still there had to be regulations. Workers should receive the same pay as free labor as well as proper housing and food ("of a kind approved by the worker").[160] Health care was a necessity as well, since men could become sick and spread disease (a euphemism for venereal infection). The Forced Labour Convention contained such provisions, presumably to satisfy the likes of the male Australian Government delegate who had claimed that if the inhabitants of Papua and New Guinea "were not compelled to grow sufficient crops to feed themselves the crops would not be grown."[161] Rather than ban forced labor, the convention established labor standards for coercive work, reinforcing the power of European rule.[162]

Exclusion from direct compulsion protected women. As non-workers, they stood as dependents, men's companions. "In some cases women have been allowed and even compelled to go with such gangs of workmen, but the difficulties and dangers of this are obvious," explained one British women peace activist in 1927. "Where the men remain at home or are taken away only for very short periods of time, difficulties of this kind are avoided." In pleading for the appointment of a woman to the ILO Committee of Experts, British Quaker reformer Kathleen Inness chastised a male ILO official for even "suggesting as one of the remedies that the wife should go with the man." Women advocates and experts, she told him, would realize "the possibility that [the wife] might not want to; or the anger that doing this might actually lead to a real breakup of the home."[163] Along these lines, a Council of British Women's Organisations insisted, "No provision of prostitutes should be countenanced or permitted."[164] Unlike these suffrage, peace, and social welfare women's organizations, the ODI highlighted another kind of danger: the exclusion of women from paid labor. Their relegation to the

unpaid but "essential work on the land and in the home left undone by the man" would set a discriminatory precedent for when free replaced forced labor.[165]

A decade later, feminists mobilized in their own countries and through their international organizations to protest limits on the employment rights of indigenous women.[166] The League's Liaison Committee of Women's International Organizations (which included some supporters of women-specific labor laws), along with the ERI, ODI, and the NWP, objected to a proposal that would have restricted women's ability to contract for work, "except when accompanying and for employment with their husbands or adult male relatives, or for employment as domestic servants." Women could independently enter only the one occupation for which they were indispensable, and which Western, if not indigenous, men shunned for its servility and low wages. Domestic service, after all, was the chief employment outside of agriculture in most of these territories. The Office asked states whether a convention should restrict women's contracting, justifying the request as an attempt to ascertain measures to shield individuals from abuse. Feminists observed that such proposals gave husbands and fathers inordinate power, reinforcing such "tribal practices as forced marriages and inheritance of widows against their wills," while restricting a woman's ability to purchase freedom from marital contracts.[167] The result of any limit would be "eventual segregation of the woman worker at the bottom of the Labour market, and . . . a bar to her continued development as an independent and respected person within her own community."[168]

Alice Paul saw an opportunity to advance the equal rights agenda. Her World Woman's Party carried on this campaign. The NWP sent letters and delegations to the US Department of Labor asking the government to oppose such restrictions. Married women in the United States had the right to contract their own work, but what about indigenous peoples on reservations, or inhabitants of Hawaii, Puerto Rico, the Philippines, and other US possessions? The NWP found the reply of Labor Secretary Francis Perkins unconvincing. Perkins reiterated that the convention applied not to "natives of a self-governing, independent state," but only "to conditions in tropical and subtropical territorial possessions of European countries," and thus the United States would not participate in these deliberations. Questioning the meaning of "native" and "indigenous," the NWP asked, "How, then, can American women feel secure when our Government takes the position that an International Labour Organization proposal applying to 'indigenous women,' does not apply to all women who are natives of the United States?"[169]

If this argument proved ineffectual, it also raised the specter of the ILO meddling in internal US conditions. Paul found a champion in Republican Senator Arthur Capper from Kansas. He didn't much like the Roosevelt

administration, which had brought the United States into the ILO, nor did he like the idea of foreign entanglements. A conservative and isolationist, Capper introduced a Senate resolution in late February 1939 for the United States to oppose the convention.[170] He would have little impact on the US government position, but he helped to fan publicity against the proposal.

While feminist objectors offered the universal claim of women's rights, defenders of the ILO process justified special treatment of native women because of their particularities. Perkins told Capper that "native women in tropical countries are not at a stage of civilization comparable, say, to the women residents of any of our 48 States, and practically speaking it is necessary to take cognizance of this in talking about employment conditions and contracts for work." She was echoing the talking points of the Office, which justified protection because these married women "know nothing of life outside of their family and village." The convention would shield such women from "serious disorganization of native life and . . . [from] recruitment serving immoral ends"; that is, from sex trafficking. The Assistant US Labor Commissioner in Geneva confidentially told Washington that omitting this provision would expose women to abuses. Women were central to indigenous economies; at stake was "tribal degradation, as well as individual."[171]

The Contracts of Employment (Indigenous Workers) Convention, 1939 (No. 64) sought to protect such workers in "dependent territories" from unscrupulous conditions of labor by setting forth procedures for entering into contracts. It omitted the requirement that adult women secure permission from male family for such contracts, but retained this restriction for non-adults, the term substituted for girls and boys or children. While feminists continued to campaign against limits on women's right to contract, the Office decided to drop the section after receiving government comments to its questionnaire, which asked member States to distinguish between married and single women in their replies. The colonial powers were divided, but governments were generally not very concerned. Belgium was against curtailing women's right to contract, but it was also against the entire convention. The Netherlands and South Africa favored the restriction. While Great Britain had pushed for equality between the sexes during ILC deliberations, it preferred to leave the decision to individual nations, as did France. The ILC passed the entire convention without additional comment in 1939.

Feminist critics took credit for defeating the objectionable measure, but the process by which the ILO came to such wording suggests a more limited influence.[172] Women in the Roosevelt administration, supportive of women-specific protective laws, long battled the NWP over such legislation, so Paul's protests at best had an indirect impact. More plausibly, British feminist opponents had

a greater sway over their delegates, who spoke for modification during the 1938 deliberations. What began as a discussion over a protective labor standard for workers turned into a debate over women's equality, with the plight of indigenous women symbolizing the condition of all women. In rejecting protection for themselves, legal equality feminists acted as the protectors of other women in this fight for the right to contract. The ILO also accepted this right, but wanted to encase it in written rules "to define the rights and obligations of the parties."[173]

AFTER WWI, EUROPEAN social democrats, joined by US New Dealers in the mid-1930s, sought to craft a humanitarian capitalism through the standard-setting process of the ILO. Issues introduced during the interwar years, like minimum wages, social insurance, and industrial home work, would persist over the next decades, but none more so than efforts to distinguish those judged different from the Western male industrial norm. Both the Office and the ILC generated special conventions for women, non-adults, and colonized men and women, groups considered too vulnerable to improve their conditions without help from organized workers, good employers, and government experts. The ILO advocated protection for dependent workers or those faced with sexual dangers, like emigrant women and seafarers, by evoking cultural difference or deficiency. It promulgated targeted labor standards to relieve exploitation and correct abuse for workers with less power than unionized men. But such special treatment risked reinforcing existing hierarchies based on gender, age, race, geography, class, caste, and other statuses that reinforced, even as they reflected, the interwar international division of labor.

2

Equality

BERTHA LUTZ WAS pleased. She had gone to Philadelphia in April 1944 to
represent women as a Government advisor from Brazil at a crucial meeting of
the International Labour Conference (ILC). A few months before, Katherine
Bompas, the British Secretary of the International Alliance of Women for Suffrage
and Equal Citizenship, had sent an urgent request to the Pan-American feminist
leader to get appointed to her country's delegation. The ILC would consider the
future of the ILO and "the transition from war work to peace time conditions."
A Sorbonne-educated zoologist, with a British mother and a Brazilian-Swiss fa-
ther, Lutz was the founding mother of the Brazilian suffrage movement. She was
President of the Brazilian Federation for the Advancement of Women, part of
the ILO's Correspondence Committee on Women's Work, and a pioneer woman
member of Parliament before its dissolution in 1937. During the 1930s, she
witnessed how women-specific protective legislation led to job loss under depres-
sion and dictatorship. Her coming to the United States offered an opportunity
to renew contact with other American women and strategize for countering any
backlash against women's rights after the war.[1]

"Well, we got the equality through," Lutz reported back to Bompas and
Alliance President Margery Corbett Ashby, a suffrage leader and British lib-
eral. But there was a catch: a "torpedo from a huge dutch [*sic*] military man
who wanted differences (natural disposition) between men and women indeed
as a restriction. The office jumped on this to make a substitution tying women's
rights up with their 25 year old conventions"—that is, the maternity, hazardous
substances, and night work measures first passed in 1919.[2]

The ILO's same but different agenda generated Lutz's scorn. This vision held
that "women should have full opportunity to work and should receive remu-
neration without discrimination because of sex" and, simultaneously, that there
should be "legislative safeguards against physically harmful conditions of employ-
ment and economic exploitation, including the safeguarding of motherhood."[3]

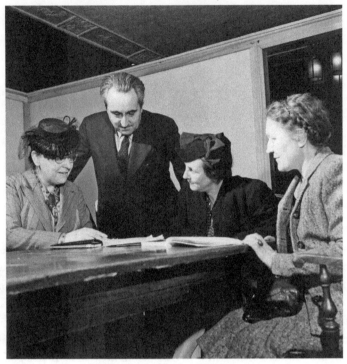

FIGURE 2.1 ILC, 1944, Philadelphia. Eleanor Hinder (ILO), Robert Lafrance (ILO), Bertha Lutz (Brazil), and Marguerite Thibert (ILO). Photo from International Labour Organization, with permission.

Such a declaration, crafted in 1937 by US social welfare expert Grace Abbott, presented an alternative to the Equal Rights Treaty before the League of Nations, much as labor feminists in the United States hoped their Women's Charter would counter the Equal Rights Amendment by eliminating specific harms rather than offering a blanket resolution against discrimination. They would safeguard civil and political rights while maintaining women-specific labor protections.[4] Such a formulation faced structural hurdles, particularly occupational segregation by race and gender that left sectors dominated by women, and especially women of color, uncovered by labor law or difficult to monitor. Though hardly focused on such factors, Lutz expressed the skepticism that many feminists held for single-sex standards. Conflict over the path toward women's rights would soon offer another terrain for Cold War and national liberation struggles.[5]

Lutz was among seventeen women who attended the Philadelphia ILC in 1944. Only US Labor Secretary Frances Perkins, who had convinced Roosevelt to maintain the ILO during the dark days of the war, came as a delegate rather than as an advisor. Despite the pleas of women's organizations and the ILO's

Director himself, governments still appointed few women.[6] Still, women had an impact on "women's issues." According to Frieda Miller, a Government advisor soon to head the US Women's Bureau, support for equal pay was "the outstanding gain for women."[7] Not only did "the Declaration of Philadelphia" reaffirm the ILO's constitutional equality standard, but key committees of the conference, in which Lutz played a deciding role, incorporated equal remuneration in their recommendations. This historic assembly reconstituted the ILO for the postwar world.

"Equal remuneration for work of equal value" stood as a founding principle of the ILO.[8] As we have seen, "remuneration without discrimination" reflected a dominant trade union position that sought to maintain men's wages and discourage employer use of cheaper female labor. In contrast, feminists cast equal pay as essential to women's rights. The Open Door International (ODI) had drafted an equal pay convention at its founding convention, while labor feminists long had demanded equal remuneration, which they often interpreted as equal pay for comparable worth.[9] With the increased need for womanpower and growth of female labor force participation following WWII, the ILO shifted its emphasis from women-specific conventions to measures promoting equal treatment and non-discrimination, exemplified by passage of the Equal Remuneration Convention, 1951 (No. 100) and Discrimination (Employment and Occupation) Convention, 1958 (No. 111). The turn to rights-based instruments subsequently appeared to some as a step away from the labor relations framework embodied in ILO tripartism. But for women workers, rights adhered not to individuals, but to the entire class.[10]

The equal remuneration instrument would become one of the most ratified, with sixty-eight signatories by 1969. While celebrating this progress, the ILO nonetheless found nations lacked legislation, collective bargaining agreements, and, most importantly, enforcement mechanisms to fully implement the rate for the job regardless of the identity of the worker.[11] Women's wages lagged behind men's—placing women at an economic disadvantage. Looked at from another standpoint, the convention inspired action. As with many ILO instruments, the one on equal remuneration gave ammunition to advocates in member States. Italy in the 1950s used ratification campaigns to win national laws. Even proponents in countries that did not sign, like the United States, deployed this convention to lobby for legislation. Miller would leave office before winning federal equal pay, but her successors in the Department of Labor cited the example of the ILO before Congress in pushing for what became the Equal Pay Act of 1963.[12]

The Philadelphia conference stands as a neglected prelude to the passage of equal remuneration. As with "protection," analysis of equal pay must confront the politics of ILO conventions and their discursive import in light of the geopolitical

context in which terms like "equality" gained salience.[13] At play remained the division between Western industrialized regions and "women in developing countries," a group that was already a distinct category in global governance. Multiple meanings adhered to equality in the face of this double difference—between the sexes, but also between the metropole and "non-metropolitan" regions, the latest term for colonies that bore the burden of those lesser labor standards promulgated before WWII.[14]

This chapter explores discourses of equality in the making of the woman worker, when equal remuneration and non-discrimination came to stand for universal progress for women at work. Women inside and outside of the ILO pushed for these measures. As Mildred Fairchild, the head of the renamed Women's and Young Workers' Division, informed a committee of US women trade unionists in 1952, "thinking has been moving from primary interest shown earlier in the protection of women, to primary interest in the development of employment opportunities for women."[15] In the early post-WWII years, the ILO focused on items that appeared genderless, like "free association" and collective bargaining, which disproportionately benefited male workers, who were more likely to be in unionized occupations. Non-discrimination represented a negative rather than a positive liberty that the ILO sought to activate through inclusion of women in vocational education and training, cooperatives and small businesses, and other assistance to improve human capital.

To confront the limits of equality requires not only analysis of accomplishments. We must recover the discussions displaced by equal remuneration and non-discrimination—ILC deliberation on the home as a workplace, the focus of later chapters. All of these considerations occurred amid persistent belief in the male breadwinner ideal and the assumption that women would tend to a household that stood apart from the world of work. Thus, the Social Security (Minimum Standards) Convention, 1952 (No. 102) assumed a woman to be a dependent wife rather than a wage-earning worker deserving benefits on the basis of her employment.[16] The question of family responsibilities and housework was already present in a 1947 "Resolution Concerning Women's Work" as a "hope" that the Office would investigate these issues.[17] Holding men to their share of family labor remained elusive until 1981 when the Women Workers with Family Responsibilities Recommendation, 1965 (No. 123) became the Workers with Family Responsibilities Convention (No. 156).

Labor feminists like Fairchild and Miller continued to grapple with the impact of family labor on employment. They won a revised maternity protection convention, a victory that underscores how women's labor remained tied to its distribution between unpaid family maintenance and waged work. In contrast, their quest for standards for domestic service and industrial home work stalled.

Precisely because home labors signified family labor, it was harder to gain traction on the idea of the home as a site of commodified work.

The legibility of equal pay and dismissal of home labors as work are insufficient to explain why success at passing labor feminist measures stopped with equal remuneration and maternity protection. "Equality," we shall see, generated its own Cold War. After looking at battles during the 1944 ILC and the efforts of Fairchild and Miller, this chapter turns to rivalries within the new United Nations system fanned by geopolitical conflict. The contest between the ILO and the UN Commission on the Status of Women (CSW) over which entity was responsible for women's economic rights influenced agenda setting. Their uncomfortable cooperation set the stage for the achievement of the Equal Remuneration Convention.

The Promise of Philadelphia

In May 1944, bolstered with funding from the Roosevelt administration, the ILO reaffirmed its commitment to social justice by linking labor standards to human rights. The resulting "Declaration of Philadelphia" reasserted that "labour is not a commodity," and upheld that "all human beings, irrespective of race, creed or sex, have the right to pursue both their material well-being and their spiritual development in conditions of freedom and dignity, of economic security and equal opportunity." Among social welfare measures, it confirmed the right to maternity protection, one of the markers of female difference.[18] When faced with demands urging "full opportunities for women," it qualified such support with reference to previous special treatment.[19] The work of two committees exemplify the ways that equal rights and concepts of female difference remained central to thinking about labor standards in a global context. They also show the difference that having expert women at the table made for the defense of women's rights.

Reconversion of wartime economies loomed large as the delegates gathered. The Committee on Employment provided the space for nations to commit themselves to full employment to avoid dislocations from the transition from war to peace. Rather than consider economic policy, the committee accepted a narrower mandate to recommend mechanisms to systematically match workers with jobs. Productive capacities differed among nations depending on the extent of wartime destruction. To this end, it focused on gathering information on human capital (such as education and skill), occupational needs, and labor force participation among so-called atypical workers—older and younger ones, people with disabilities, and women. It further advocated for establishment of employment services or bureaus, public works, and vocational education and training to

mitigate unemployment. It assumed that useful work "is essential for the preservation of human dignity as well as for the proper support of physical existence."[20] That is, it maintained a productionist *mentalité* in associating life with work, relegating housework and other reproductive labors to the category of social welfare.[21] Those classified as old, young, disabled, or female remained other to the adult male worker, as they had before the war.

The International Labour Office (the Office) supplied sufficient rationale for a strong commitment to equality between women and men. It highlighted a generalized (and prescient) concern that improvements in wages, working conditions, and skill made during the war would evaporate when women returned to the household or to lesser-paid "women's work." Women would then serve as a reserve army of labor to be "tapped into or neglected" as the need for their labor arose or declined.[22] Job evaluation would determine the rate of pay, which required the setting of wages in terms of "the value of the work done in the various occupations in each industry." The rate for the job would sidestep gender and thus serve as a tool to ground an emerging demand for comparable worth that actually would allow more wage-earning women to earn equal pay without moving into "men's work." The Office insisted that maintaining overall rates required similar compensation for jobs "which differ only slightly from each other and require a similar standard of skill."[23] Comparable worth assigned equal pay to different jobs on the basis of the same valuation, even if components differed.

For some proponents of legal equality, comparable worth was as just another attempt to treat women differently from men. Australian left feminist Jessie Street was such a critic. A veteran of the battle for suffrage and defender of indigenous rights, she was one founder of the Women's International Democratic Federation (WIDF). This multi-issue organization addressed peace, poverty, and national self-determination as well as women's rights and social welfare. Consisting of Communist as well as other antifascist leftists, it would become the largest global women's formation, with strength in Latin America as well as Europe and Asia.[24] Its consultative status at the UN became a causality of the Cold War, ending between 1954 and 1967, when it won reinstatement from an expanded General Assembly membership.[25]

In the process of castigating the ILO for maintaining special conventions for women, Street dismissed the efficacy of "equal pay for work of equal value." She was not satisfied with giving women higher wages if they stayed in sex-segregated occupations; any formulation other than equal pay for the sexes invited the closing off of jobs currently dominated by men. At the UN CSW, she called for "the rate for the job and equal pay for the sexes."[26] In contrast, labor feminists in the Office sought to improve jobs dominated by women, whether or not comparable to

positions held by men. Domestic work provided the prime example of women's work ripe for upgrading. Their proposed resolution on postwar employment articulated this goal: "[W]ithout prejudice to opportunities for the employment of women in other occupations, the employment of women should be facilitated by action to raise the relative status of industries and occupations in which large numbers of women have traditionally been employed."[27]

The Committee on Post-War Employment would devote three paragraphs of its chief recommendation to "The Employment of Women." Underlying rhetorical differentiations lay a series of unexamined notions of male worth and women's place. Delegates brought their understandings of gender, forged in distinct national contexts, to the ILO. Committee deliberations occurred under the belief "that nothing should be done which would weaken Government responsibility for the re-establishment of demobilized men in civil life."[28] To anticipate objections, the Office Report distinguished between the principle of equality and the possible behavior of women, many of whom would leave the labor force after the peace. With full employment, men could support them. Moreover, generous social welfare should be available for those women who needed to stay home with children but lacked other sources of income.[29] The male breadwinner ideal—with the state as a backup for an absent man—framed the claims of men who represented Governments, Workers, and Employers. This perspective shaped contemporaneous formulations of social security, which focused on maternity insurance when it came to women, and consideration of the rights of migrant workers—assumed to be men who would bring families with them.

Committed to the male breadwinner, Employer delegates called for deleting the whole section on "The Employment of Women." Sir John Forbes Watson, the Employers' Vice-Chairman of the Committee from the Council of the British Employers' Confederation (and a frequent participant at the ILO), contended: "The situation in a number of countries is governed by industrial agreements and by legislation which will inevitably entail discrimination against women after the war." It was impractical to demand equality of opportunity, but there could be "an evolutionary improvement."[30] The British Empire Government delegate, Labour MP George Tomlinson, agreed in eliminating a paragraph that supported "complete equality of opportunity for men and women on the basis of their individual merit, skill and experience." Reasoning that the ILO constitution and proposed new declaration already addressed the principle of equal pay, he would omit that section as well.[31] Parliament was grappling with questions of women's place in the demobilization and leery of the cost of applying equal pay to the public service. In this climate, Tomlinson lacked instructions to judge a new proposal. Still, he was quick to assert for the record that his nation was fully appreciative of women's sacrifices for the war. That admission did nothing to keep

him from the patronizing claim that "the women of Britain are not anxious to take the places of men."[32]

Most Government and Worker representatives rejected the Employers' gambit. Mexican Government advisor Paula Alegría Garza, the Chief of the Women's and Children's Bureau, defended the Office text, which never suggested "that women fill men's jobs." She explained, "The question is one of maintaining the status won by women through work and proof of merit. Women will remain in industry whether we like it or not." Other representatives praised "the value" of women's work or cited the ILO principles of equality. Worker delegate Jef Rens, the Assistant General Secretary of the Belgian General Confederation of Labour and later a Deputy Director-General of the ILO, argued in terms of necessity: some women had to work even if most wives wished to remain home. But he admitted that still other "women . . . prefer to work." His conclusion—"it would be unjust to discriminate against them merely because of sex"—underscored a common conflation of equality with absence of overt discrimination.[33]

In the end, the committee overwhelmingly rejected the Employers' amendment after Lutz, who appeared as Brazil's substitute delegate, suggested "a small sub-committee of women be set up to try to find a compromise text acceptable, with a little good will, to all of the groups."[34] Her proposition was in keeping with the ILO's constitutional suggestion that women advisors be present for issues involving women. She strongly defended the work and sacrifices of British women during the war to highlight women's worthiness for equal treatment.[35] Other women showed up for this debate, including Canadian MP Cora Casselman, who served on the related Committee on Social Security. Yet Lutz stood out as the spokesperson for international feminism; in a few years she would push for a separate commission on women at the UN. As Brazil's representative to the parallel Committee on Dependent Territories and a member of its drafting sub-committee, she added an article on the use of women advisors, "whenever possible . . . drawn from the local population," in setting policy for colonies. She also addressed the welfare of young workers, an issue promoted by women's organizations.[36]

At the Committee on Dependent Territories, Lutz was on a rescue mission. She exemplified the savior perspective that more privileged feminists continued to bring to discussions on the status of women and children in colonized areas. When it came to the administration of welfare for "juvenile" workers, Lutz reflected the superiority of Western feminists in proposing duplication of "practices successfully adopted in metropolitan or independent countries," such as women matrons to monitor institutionalized or incarcerated juveniles.[37] She represented Brazil as "an independent country" without "dependent peoples," ignoring the regional inequalities that made indigenous people dependents within that

nation-state, much as the United States ignored Native Americans. She argued that Brazilians could "form an independent judgment as they don't represent any of the parties concerned"; this alleged impartiality perhaps explained her election to the drafting committee.[38]

But being nonpartisan never meant that Lutz was neutral. She would defend "native" women as strongly as did her friends in the international suffrage movement. What had changed from earlier feminist objections to outrages was her access to ILO decision-making. "There are many parts of the world where women still live in conditions of slavery having no right even to their own persons," she announced. Her amendment on women advisors embedded a clause—"Native laws and customs which maintain or reduce women to the position of chattels or slaves shall not be applied in any dependent territory"—which after discussion and redrafting became the weaker "All practicable steps shall be taken to improve the social and economic status of women in any dependent territory where, whether by law or custom, arrangements survive which in effect maintain women in or reduce women to a condition of servitude."[39] The male delegates from the colonial powers shared a belief that the status of women indicated the less advanced nature of colonial areas and saw uplifting women as part of their "white men's burden," but they did not wish to enact restrictions.

Lutz's explicit proposals sought to affirm women's legal equality. "There should be no difference in minimum rates of pay based on sex only," she wanted to add to the non-metropolitan/dependent territories resolution. She supported maternity leave, but claimed "women should have the right but should not be compelled to absent themselves from employment." A number of male representatives thought otherwise, believing that women must stop employment. Rather than listing a specified number of weeks that pregnant women were to remain out of the workforce, the final wording spoke of "the right" "to be absent from employment before and after childbirth."[40] Like most ILO standards for women workers, these provisions covered only industrial and commercial sectors, neglecting the dominant home-based occupations of domestic work and agriculture. The committee postponed Lutz's wording for equal pay for the future, content with the Office text that, like the one on Post-War Employment, included it as part of a long list of objectives to improve the employment of women.[41]

An Anglophile, Lutz defended the British men for taking the heat on women's rights. Lutz judged these men "very intelligent," chosen carefully by "the great powers . . . to look after their colonial interests."[42] She attacked the French and Belgians. She didn't like the fanning of "anti-British feeling" by German and Jewish refugees either—or by delegates from India. The Canadians she judged to be "more immune than the Americans from racial non Anglo Saxon groups." She reserved her greatest scorn for Marguerite Thibert, whom she described as

"very timid and very much under the thumb of the Belgian sub-director [Robert LaFrance]. She does not approve of feminists and I don't approve of cardinals behind the throne." Equating feminism with opposition to women-specific protections, Lutz wanted more feminists, including some "good" ones in the Employer group, otherwise any establishment of a more robust women's section in the Office would become a "Dunkirk for Women if the French women are in charge."[43] She did not appreciate Thibert's considerable diplomatic skills nor credit her earlier efforts to save women at risk from the Fascist onslaught—which she may not have known about. Her interest in the ILO was "from the women's point of view rather than from that of Labour," she reflected.[44]

Sustaining "Third World" Difference

The colonial powers had written their own hegemony into the ILO constitution, as we have seen. As the war ended, they sought to "reward" loyalty and sustain influence in the face of independence movements. Understandings of "Third World" difference led European delegates to prescribe proper gender roles to maintain social reproduction. For the Committee on Dependent Territories, like that on Employment, the migrant or contracted worker remained the man who required adequate income to maintain the family during his absence.[45] It approved a paragraph on supporting the family "needs" of Europeans in the colonies drawn up by Office experts.[46] Subsequent discussions sought to sustain marriage among colonized peoples. The Office proposed a savings plan from the French Colonial Ministry "to encourage the marriage of unmarried Native workers." The British government would extend compulsory saving for the purchase of land. It also stressed family formation. Worker opposition, led by male British, Nigerian, and Canadian delegates, eliminated the section that forced deductions from paychecks as a form of savings. Other proposals addressed the need for "native" thrift.[47] Delegates assumed that the family absorbed the unemployed, and thus that "native" workforces required less social welfare.[48]

The colonial powers excused their inaction by claiming they were deferring to "native" elites. One British Government delegate suggested the necessity of consulting colonial governments on the shape of maternity leave. He refused to "express any view" on minimum wage-fixing machinery, citing both ongoing discussions in the metropole and "local practices and customs of the people of some of the territories."[49] The Netherlands most often evoked the best interests of local peoples and economies. According to a magnate from the Java-China-Japan Line Shipping Company representing Employers, "male indigenous workers" in the Dutch West Indies would not agree to women receiving equal pay; other male members of the Netherlands delegation concurred. The President of the Union of

Plantation Officials and Employees of the Netherlands Indies, a Worker advisor, warned of evasion. After all, he asserted, "the prohibition of the employment of children on light agricultural or domestic work when it is of a light character would constitute a serious injury to the native economic system."[50] Delegates accepted weaker standards for child labor than allowed in the Global North by lowering the allowable age and permitting home-based work.

These nations did not necessarily accept the ILO's authority to survey them on social questions with only an "indirect" relation to labor issues.[51] Such procedural objections provided diplomatic cover for doing what they wanted. In the mid-1940s, despite a discrediting of supremacist discourse in response to Nazism, racial inequality pervaded answers to ILO inquiries. The reply of Netherlands Guyana illuminates the language of civilization that embedded racial superiority in thinking about social reproduction. To a question on housing standards, this government claimed that "indigenous people prefer to live in their own-built, often very primitive, houses, where any healthy life is impossible, which causes many diseases." It justified courses in home economics on the basis of the low housekeeping skills of indigenous women.[52] White supremacist Rhodesia asserted that, given the discrepancy in living standards "between the educated European artisan and the uncivilized African artisan, the payment for equal work could not be considered in the interests of the average African artisan at the present stage of his advancement on the road to civilization."[53] Belgian and Dutch delegates echoed such remarks. France was writing equal pay between the sexes as a general labor principle in its colonial codes but insisted that remuneration for (white) expatriates would be higher.[54]

In 1947, as the ILC prepared a new convention for the non-metropolitan territories, it remained unclear whether equality for women could be addressed similarly to race, religion, and tribal status. The condition of indigenous women for Westerners still symbolized extreme exploitation and lack of agency. Delegates sought to retain legitimacy in the face of grassroots challenges to colonial rule through some recognition of the humanity of subject peoples. By then, the ILO had become part of the United Nations system as a specialized agency, keeping its structure but not wholly independent from mandates of the General Assembly or the Economic and Social Council (ECOSOC), to which it reported. It had a reduced portfolio, with trade and migration policy given to other agencies.[55]

The Office proposal for what became the Social Policy (Non-Metropolitan Territories) Convention, 1947 (No. 82) separated employment of women from non-discrimination, creating two distinct sections. "Provisions concerning Women Workers" repeated the clauses of the earlier 1944 recommendation: "safeguards" against hazardous substances, especially those that could impact motherhood; "protection against any special forms of exploitation";

and equal remuneration—if local conditions permitted. The section "Non-Discrimination on Grounds of Race, Colour, Religion or Social Groupings" covered non-discrimination in public and private employment in terms of opportunity, promotion, training, and other factors; equal wages for work of equal value; and "effective equality of treatment . . . in respect of discipline, working conditions and welfare arrangements."[56]

An organized feminist campaign, again involving various branches of ODI, sent objections directly to the ILO. Complaints charged that the convention was "at variance with the principle of the equality of the sexes" inscribed in the UN Charter. Legal equality groups deployed the UN as they had previously used the League as an authority to push the ILO to change its course. British and Anglo Commonwealth women dominated these communications, joined by Scandinavians.[57] When the International Alliance of Women learned that sex was absent from the non-discrimination section of the proposed convention, Secretary Bompas deplored the result in terms that echoed prewar complaints, arguing that "male workers are to have the protection of the law, while in a separate section, women workers are only recommended to the 'competent authority.'" But those very local conditions, she argued, led to "women of native races [being] frequently depressed and even enslaved by tribal custom."[58]

Feminist commenters sometimes brought race into their comparisons.[59] They certainly understood advancing equality for indigenous women as reinforcing a universal principle that would benefit European and other Western women as well, as did the World Woman's Party and National Woman's Party before the war. The Danish branch of ODI complained, "After your proposal all native men shall be given full status as workers, the status of the European workers. But no native woman is to receive this status." Exclusion would only reinforce the current position of "native" women, canceling "many excellent missionary and other efforts, so that the task of eventually raising them to equality of status and liberty will be put off till the millennium." According to the British Commonwealth League, an organization founded by Australians involved with the suffrage movement, "Although at the present time there may not be many women in these areas ready to enter industrial life, . . . inequality of treatment between the sexes places a handicap" on current and future generations.[60]

Experts knew that, for colonized territories, neither legal equality nor prohibitions against discrimination could improve the status of women. In 1947 the US Women's Bureau confidentially admitted that tribal customs, as Global North commentators referred to local practices, could interfere with women entering certain occupations. Only positive actions, bringing "decent standards of employment and freedom from abuse," would advance women's status.[61] ILO discussions rarely considered how colonial policies reinforced the customary

sexual division of labor. At best, countries recognized that most women were not in the same jobs as men, and that many labored in family economies in subsistence production or as agricultural workers. South Africa, which would institute its notorious apartheid regime of racial segregation in 1948, pointed out that "native" women worked in domestic service more than men.[62] Its racial attitudes and practices led members of the 1947 Committee on Non-Metropolitan Territories to insist that its Government delegate abstain from voting on the draft convention. But South Africa spoke truth when noting that most women would not benefit from ILO standards because they labored in uncovered occupations or venues.[63]

The Cold War shaped the US response. The Soviet Union had left the ILO and the League of Nations in 1939; it would not return until 1954. Meanwhile, the USSR sought to restrict the ILO and shift responsibility to the new United Nations, where it was a member of the Security Council and on equal footing with the United States, Britain, and France. It used UN platforms as a forum to assault the United States for unequal treatment of women, lack of federal equal pay, and segregation of African Americans. The United States, in turn, sought to position itself at the ILO as the leader in women's rights by "claiming for women everywhere not only freedom from discrimination but further, an active program to improve their status." In relation to the non-discrimination clause for colonies, it would finesse objections of the international women's movement by retitling the section on women as "No discrimination based on sex" and offering it as a parallel, but separate, section to the more general non-discrimination clauses. It believed that discrimination against women, including those from racial minorities, was distinct from discrimination on the basis of race or ethnicity. Thus, some different treatment—women-specific protections—helped to improve women's status. A separate section would allow for strengthening commitment to protective measures. In general, the United States preferred the concept of "equitable," but if "equality" were to be used, than it proposed a proviso: "equal treatment . . . does not preclude such distinctions in practice as are necessary to compensate for differences in their physical structure or maternal function." Gender differences could override identical treatment without leading to discrimination.[64]

The politics of convention making illuminates operative concepts of equality. Government advisor Faith Williams, director of foreign labor conditions in the Department of Labor, brought the US position to the Committee on Non-Metropolitan Territories. She had to maneuver around both British opposition to women-specific protective laws and concerns of the ILO legal advisor that the equality provisions could negate national legislation protecting women. Citing the objections of women's organizations in his country, UK Government

delegate Sir Guildhaume Myrddin-Evans, the elected chair of the Governing Body, contended the separate section would be unnecessary after adding sex to the non-discrimination clause. His Employer counterpart from the Colonial Employer's Federation argued that such provisions were impracticable for "own account" (self-employed) workers, the majority of women in such places, as well as for those paid by time-rates, who risked losing their jobs if they had to be compensated the same as men.[65]

Worker delegates supported a separate section on women, but Myrddin-Evans controlled the agenda. He discontinued the discussion on women until after consideration of the non-discrimination provisions. The legal equality feminists had their way when the committee eliminated the separate clause and added sex to the non-discrimination one.[66] Assessing the direction of the debate, Williams moved to include protection of motherhood in the non-discrimination section, allowing for "competent" authorities to bypass equality provisions for "safeguarding" motherhood and "ensuring the health, safety, and welfare of women workers."[67] On reflection, she found the resolution "satisfactory," since the substance of the separate clause remained.[68] The success of the international feminist organizations rested on their continuing influence on British delegates and the dovetailing of their interests with those who still controlled colonial territories.

This outcome disappointed some delegates from colonies. French Worker advisor Charles Assalé, the future Prime Minister of Cameroon, announced his "disillusionment as to the results of the work we have done here . . . that it was no more, in fact, than a matter of replacing the whip by presents and sweets; but the result is the same." He not only judged the social policy convention as "altogether inadequate to ensure . . . the well-being and liberty to which they [people of these areas] are entitled," but also deemed inadequate "the insertion of the word 'sex'" in the non-discrimination provision for protecting women. Indian Worker advisor Shanta Mukherjee, the Assistant Secretary of the All-India Trade Union Congress, also called for liberation of colonial peoples, though she expressed "satisfaction" that sex was added to the non-discrimination clause. "Such an invidious distinction of omitting women from non-discrimination, had it existed, would have continued unabated the exploitation arising from a cheap supply of women's labour," she concluded.[69]

Definitions of Equality

The stakes were high in the wording of resolutions and conventions, no more so than in the use of "equality" and related terms. The fallout persisted from over two decades of controversy among feminists. Writing in 1946 to the US Women's

Bureau "in a spirit of friendly co-operation," Thibert admitted to "a certain anxiety when I see American women engaging in a serious struggle against a measure which tends to establish equal rights for women," when "conditions prevailing immediately after the war may perhaps induce some persons to deny certain rights to women," as happened during the Great Depression. Thibert knew what she was talking about, having issued in 1939 the major compendium on the status of women, *The Law and Women's Work*.[70] Women needed a campaign for equal rights in family law, she argued, in order to gain equal rights in employment. She didn't think the Equal Rights Amendment would harm social legislation (though she didn't account for the record of the US judiciary when it came to labor rights). What kept the feminist camps apart boiled down to "our desire to maintain the legal provisions for the protection of women." She declared, "We also claim equal rights." Echoing the labor feminists of 1919, she proclaimed, "To speak of the right to be exploited is an obvious distortion of the meaning of the word. It is not a right for a human being to work in bad conditions; it is, on the contrary, an obstacle to the enjoyment of legitimate rights—the right to a healthy life, to moral development, etc."[71]

Frieda Miller appreciated these observations. Still, she let Thibert know that "our great National women's organizations," presumably the League of Women Voters and middle-class federations of Catholic, Jewish, and Black women, were busy attacking "specific discriminations [to] establish equality of opportunity in all fields."[72] Miller was on her own crusade. She had come to the Women's Bureau after decades researching labor conditions and working on behalf of low-waged women. She never finished a graduate degree at the University of Chicago, but a fellowship from Bryn Mawr landed her in Philadelphia, where she became the executive secretary of the local branch of the Women's Trade Union League. There she began a lifelong partnership with Jewish immigrant and garment worker organizer Pauline Newman. Miller also would give birth to a daughter, whom the two women portrayed as adopted. While same-sex relationships were not uncommon in their reform circles, they carried stigma in the larger society, as did out-of-wedlock birth.[73] With the election of Republican Dwight D. Eisenhower, Miller joined the exodus of New Dealers from Washington who took their vision of social welfare and labor rights abroad.[74] Miller's unconventional life never became a public issue, though her progressive politics did. She would come up for investigation during the "second" Red Scare. After she left the Women's Bureau in 1953, the US government delayed, but did not torpedo, approval of her appointment as a consultant to the ILO.[75]

Miller carried on the program of the labor feminists who convened in 1919, but without their rhetoric of female difference. She would make her mark in New York under the tutelage of Frances Perkins, succeeding the first woman

FIGURE 2.2. Mildred Fairchild, Chief of Women's and Young Workers Division, 1947–1954. Photo from International Labour Organization, with permission.

cabinet member as New York's Industrial Commissioner of Labor and following her into the orbit of the ILO.[76] After WWII, Miller was a mainstay of the Correspondence Committee on Women's Work, served as the reporter for the drafting committee of the Equal Remuneration Convention, and chaired the meeting of the Experts on the Conditions of the Employment of Domestic Workers. With Mildred Fairchild, she developed a set of interrelated initiatives on the status and rights of women workers: the regulation/abolition of industrial home work, the coverage of domestic workers under labor standards, the revision of the maternity convention, the counting of household labor, recognition of the constraint of family responsibilities on women's employment, the movement of "Third World" women into income generation, and the definition of equal remuneration. These two labor law administrators recognized that equity on the job had to account for labors in the home, unpaid as well as remunerative.

In 1947, Fairchild, then the Chair of the Department of Social Economy and Social Research at Bryn Mawr College, became director of an upgraded section on women's work. Within a year, she married Robert Woodbury, chief of the ILO's statistical office. A Bryn Mawr graduate herself, Fairchild came from a prominent

Harvard University, Schlesinger Library on the History of Women in America, 20004623_1

FIGURE 2.3 Frieda Miller, Director, US Women's Bureau, 1944–1953. Photo from Schlesinger Library.

family of educators with ties to Oberlin College. She subscribed to a social science that deployed research on poverty and other circumstances of working-class lives to bolster calls for reform. A recognized expert on women's labor, she had co-authored a favorable study of Soviet women in 1935. Her name appeared on the masthead of the left-feminist Congress of American Women, the US affiliate to the WIDF, even though she would deny membership in the Congress—an organization smeared as Communist by the US House of Representatives. When her husband reached retirement age in 1953, Fairchild also left the ILO, but they departed under the cloud of McCarthyism. Previously, she had had trouble with her security clearances. Fairchild returned to Pennsylvania, where in subsequent years she worked on migrant child labor and established standards of aid for poor unmarried mothers.[77]

Even though the United States rarely ratified ILO conventions, claiming that the states and not the national government held jurisdiction over such issues, it helped to formulate them. With Miller and Fairchild crafting policy together, the US government obtained another avenue of influence at the ILO. (Already in 1948, David Morse, a New Deal labor lawyer with stellar international credentials,

headed the organization, which he would continue to do until 1970.)[78] Their interaction illuminates the barriers women insiders, along with feminist outsiders, faced from the ILO tripartite structure. As largely unorganized workers, women the world over had less formal clout than their male counterparts; into this vacuum stepped labor feminists like Fairchild and Miller. They were more attuned to the problems of wage-earning women than male trade union leaders, even if they were not industrial or home-based workers themselves.

These women strategized on policy and frequently exchanged information. They also displayed a level of collegial intimacy that perhaps made for smoother working relations. Fairchild's correspondence with other nation-based "experts" lacked such personal ties. In one three-page letter, Miller addressed the state of equal pay legislation in the United States, the training of "Far and Near Eastern" women "who are making the very revolutntary [sic] transition from a home economy to a status of paid work outside the home," issues of industrial home work and maternity protection, and the proposed Red Cross Convention on prisoners of war. At the end, she remarked, "I was glad to learn from your letter and the Christmas card that you are [sic] last have a united family for I am sure that both of you are enjoying thoroughly that very pleasant apartment in which you had established yourself last summer."[79] They discussed when they would meet officially and privately and shared reflections on vacation spots, as colleagues might. Miller ended another letter with two even more personal comments: notice on her daughter Elisabeth's plans—"she may even be sailing next Saturday and one of the things that make me very content and confident about her going is your presence in Geneva and the interest I know you will take"—and an update on their aging Bryn Mawr mentor Susan Kingsbury, a pioneer social investigator.[80]

Fairchild also consulted Miller on key policy proposals. Responding to the resolution on women's work that Fairchild drafted and the United States would introduce at the 1947 ILC, Miller provided detailed editing, based on discussions within the Women's Bureau and State Department, including their legal counsel. She explained to Fairchild, "You know our problems in the United States with respect to the words 'equal,' 'equality,' 'equal with men,' and the like. In suggesting these changes we have attempted to take out phrases that imply equalitarianism as a desideratum in itself. We have attempted to substitute phraseology which will encourage the elimination of hampering tradition and practice based solely on sex."

The US stood firm in support of "special legislation for women," and wanted a document that allowed countries on both sides of the debate on women-specific protections to be able to sign on to the resolution. Fairchild responded that she had to develop phrasing acceptable to Scandinavians (against special treatment) and "less industrialized areas" (present and former colonies) where questions of

women's equality were much contested as well. She also had to find "language that will catch the imagination of nontechnical people."[81]

Anticipating problems with again revising the Night Work Convention, Fairchild regretted that Miller would be at a UN meeting rather than the 1948 ILC. "I have had recently long conversations with the representatives of the women's organizations and I hope they will not press their demand for the abrogation of the Convention," she confided. "I told them that I thought such action might well endanger revision since it would arouse trade union opposition to any change. The leaders of the Alliance and the Liaison Committee seem to accept that argument. . . . Our greatest danger, I think, lies in lack of qualified persons to speak with expert knowledge at the Committee sessions because of small delegations."[82] If the revision failed, Fairchild predicted, countries would end up denouncing the convention (retracting their ratification)—as had the United Kingdom. For these labor feminists, amending a convention that restricted women's hours of work would maintain the idea of protection but limit the instances where it applied. They sought to enhance gender equity by taking into account systemic disabilities that no one convention could address.

Discussion on this second revision of the Night Work Convention in 1948 addressed problems with implementation. Fairchild represented the Director-General; Clara Beyer of the US Department of Labor chaired the committee. Another expert who had taught labor economics at Bryn Mawr and belonged to the network around Perkins, Beyer was an experienced champion of working-class women, knowledgeable on social welfare, and an advocate for universal labor standards. By the 1940s, she was more inclined to support equal treatment of men and women than many in her circle.[83] She served as the reporter for the Committee on Employment in 1944. Five years later, as part of the drafting committee formulating a new convention on migration for employment, she introduced planks on the health of migrants and their families and hygienic conditions during travel.[84] Beyer connected social welfare with labor standards to forge a comprehensive program for working people.

Transport was among the occupations considered during the revision of night work hours. What about married women who worked with their husbands on barges on inland waterways, asked one male Indian delegate? A US Government advisor from the Women's Bureau proposed that the convention include blue-collar workers, like ground crews of airlines and cleaners of rail cars, but exclude "specialized occupations" like stewardesses on airplanes and nurses on trains. Her distinction in the US context would have covered the work of Black women more than White ones, given the racial division of gendered jobs. The Revision Committee deferred any decision on exclusion of transport from night work restrictions for lack of technical information—always an expedient rationale.[85]

The old questions of women's health, family responsibilities, and social mores shaped these deliberations.[86] Danger to women and to the nation remained. A male Argentinian Government delegate felt that the revision was "in the interests of industry [rather] than in the real interest, i.e., that of procreation." Of particular concern was safety of travel. Before the ILC, an Indian Government delegate revealed fears of sexual danger: "It is quite possible that women here in the West find it very convenient to go back home—and quite safe, too, with the aid of their buses, taxis, trams, and trains—at night time, and there is plenty of electric lighting here," he claimed. "But in the East it is not so for women . . . It is . . . not safe, and it is not good or wholesome." He insisted that "women in the East, even today, do consider it necessary that protection should be offered to them."[87]

The 1948 Night Work revision exemplified both the persistence of cultures of protection and the slow movement of the ILO toward gender-neutral standards. Restrictions would no longer apply to managerial, health, and other professional women. The revision increased the flexibility of the definition of night, requested eleven consecutive hours of rest without specifying the hour interval, and allowed for geographical and occupational variation. Driving this revision was the increased use of multiple daily shifts in industry.[88] The ILO continued to treat the Global South as different: the revision established special provisions for India and Pakistan that covered only enterprises under factory and mine acts. These changes fell short for international feminist groups, which continued to attack night work restrictions on women.

Just as gendered family labor proved a problem for setting the hours of night work, the home provided a challenge for advancing women's rights at work. Family responsibilities—or, more accurately, the lack of private or public provision to accommodate them—interfered with women's labor force participation. It wasn't clear what could be done besides urging crèches, canteens, and household appliances. But an additional problem came from conflating unpaid with paid work in the home. In 1949 Fairchild had before her a request from the Director-General's office to study the economic value of women's work in the home. She was unsure how to proceed. She could attach questions about unpaid housewifery onto either an ongoing study of domestic workers or the one on social services developed to lessen the family responsibilities of wage-earning women. But the results would be imprecise.[89] She turned to Miller, who recalled an old study on time-costs of various homemaking activities as a possible model for such research. For "the narrower economic question of costs of community services which employed women might require to aid them with their family responsibilities," Miller suggested, the ILO might compare "those costs and the cash earnings of employed women." But she questioned the rationale for the

original request, wondering "whether the underlying thought was that woman's place is in the home and that such information would be of use in rationalizing this position." After all, the official US policy after WWII was "that women should be quite free to decide whether they wish to seek outside employment or devote their full time to homemaking and we believe both they and the community are the better for that freedom."[90]

Politics motivated requests for research. Top administrators hoped that Fairchild could develop numbers that they could deploy to forge voting blocs at the UN. In 1950, for example, R. A. Métall, the Chief of the ILO's International Organizations Section in New York, asked Fairchild to figure some way to accommodate the ILO's friends on ECOSOC with a study of "women's work in the home." Perhaps Fairchild might estimate the economic value of such labor by figuring the costs of replacement on the market, or by linking estimated wages for housewives to those actually given to people employed to perform similar tasks—procedures that seemed "unscientific" to Fairchild, but that a later generation of feminist economists would deploy.[91] Métall cautioned that "the philosophical and sociological considerations about the importance of women working at home and playing their part in family life would need to be brought in on the lines of the speeches of the Belgian, French and Lebanese Members in such a way that the various organisations concerned could have the satisfaction of quoting in their periodicals excerpts which would please them." Recognizing the charged nature of this request, he admitted, "I do not mean, of course, that the Office should necessarily fall for their views," to which Fairchild reacted, "ha??"[92] The bafflement of this trained social economist that she would be asked to generate anecdotal evidence for traditional Catholic women's groups to undermine the rationale for women's employment illuminates the instrumentalism behind many ILO investigations.

The problem was greater than a similarity of tasks between home-based jobs and family labor. Family responsibilities disrupted employment, which served as a corollary to the claim that home work interfered with domesticity, threatening the family through disease and dirt and unhealthful conditions. Many feminists would come to assert, with Marxists, that development required women to enter production, which would lead to liberation, as later chapters will explore. But working mothers required aid. In stipulating areas for the ILO to frame its deliberations on equal remuneration as early as 1947, the UN CSW flagged "provision of measures to lighten the tasks that arise from women's home responsibilities, as well as the tasks relating to maternity."[93]

The ILO slowly responded to that challenge in the 1950s. It began with revision of the 1919 maternity convention, which had excluded industrial home work, domestic work, and agriculture. Only years later did officials speak of maternity

leave as part of women's economic rights rather than as a protective measure.[94] Countries found the maternity convention provisions daunting. Between 1919 and 1952, the number of ratifiers expanded from six, all European, to thirty-five, with a disproportionate number from Latin American nations, which tended to sign most conventions. While less than a third originally paid benefits to women compelled to leave employment, forty nations had some sort of social insurance for maternity two decades later. But, when the ILO addressed revisions in 1952, national practices fell way short of dictates.[95]

There were wide discrepancies. Urban workers in large enterprises came under provisions, but rarely did peasants or professionals. Contributory burdens hit stakeholders unevenly. The Dominican Republic had a scheme that required women employees to make payments for over a year prior to pregnancy, with husbands giving double the amount to insure spouses. Uruguay, though a ratifier, lacked compulsory social insurance. Many states had inoperable laws, including Bolivia, Colombia, Costa Rica, Guatemala, and Venezuela. Cuba and Argentina had "a special scheme of compulsory insurance for maternity benefits alone." Cuban workers contributed .25% of wages, and employers .5% of payroll, in 1944. The wives or common law partners of male workers could obtain funds to meet delivery costs, while pregnant workers, upon ceasing employment, received a cash benefit for six weeks before and after delivery, and also qualified for obstetrical aid. Along with Costa Rica, Guatemala, and Panama, ratifier Chile continued to place the burden of benefits on the employer. Chilean feminists denounced this arrangement as a disincentive to hire women, contrary to the convention. In 1952 they were able to obtain legislation that switched from employer to state subsidy of maternity leave. Legal challenges against wayward employers rarely recovered lost jobs, however.[96]

Most states only replaced part of the wage after a qualifying period. Public funds kicked in for Denmark, France, and Great Britain. Medical care also diverged from ILO directives, though some national insurance schemes included it, and Britain, a non-ratifier, provided care through the National Health Service. Latin American nations allowed for shorter but more frequent nursing breaks, and many also mandated provision of specific places for nursing. In general, huge gaps existed between standards and practices. Rather than an enabler of women's employment, maternity policy served other ends, with the health and fitness of the population being foremost.[97]

The United States, prodded by Miller's Women's Bureau, was only one of five nations to comment on the proposed revision. Changes, it argued, were imperative to meet the needs of the two-thirds of US wage-earning women who were married, "who carry the double burden of a paid job and motherhood."[98] To her superiors at the Department of Labor, Miller noted the challenge from "Iron

Curtain countries," which "have recognized the importance of this question as far as building up a healthful and secure labor force," such as East Germany with its law "for the Protection of Mothers and Children and the Rights of Women" that included paid maternity leave. Here *realpolitique* entered the equation: "If the ILO now sidesteps this important matter," she advised, "this action may well be taken up as one more propaganda item against the ILO and against the U.S. as a leading policy maker in that organization."[99] Indeed, during ILC deliberations in June 1952, the Polish Government delegate Fryderyka Kalinowska mocked the gap between the aspirations of labor feminists and conditions in the United States—"that highly industrialised country which spends billions of dollars on armaments and yet possesses meager maternity protection in only four out of its 48 States and, as is well known, has even up to the present no social health insurance."[100]

In 1952, the same year that some domestic workers won Social Security coverage in the United States, its Women's Bureau asked the ILO to broaden the scope of the maternity convention "to all employed women, including domestic workers, farm workers, and employees of non-profit . . . organizations." Along with Guatemala, which sought protection of its predominantly agricultural workforce, the United States allied itself with Worker delegates on this question. Inclusion of home-based labor generated resistance for being difficult to regulate but, as it was central to the organization of less "developed" economies, enforcement was costly if carried out. In its typical search for compromise, the ILC produced a text that allowed for states to temporarily ignore these extensions to meet national circumstances. The revision also provided greater flexibility in the amount of leave and widened the basis for such benefits to include either compulsory insurance or publicly financed services. The US proposal generously interpreted its own public-private system by having those ineligible for social insurance "be entitled to adequate benefits under social assistance."[101] It also sought a stronger right to job security and greater safeguards for pregnant workers when on the job.

The goal was to maintain women's employment by providing time off for maternity. Preferring compulsory insurance, the US Women's Bureau insisted that methods of financing "avoid discrimination against women workers," rejecting schemes that levied payroll taxes on employers alone or on the basis of number of women workers. To tax employers directly would threaten female employment, hindering equality of pay and opportunity.[102] This argument echoed sentiments embedded in the Equal Rights Amendment, a plank still rejected by the US Women's Bureau for undermining women-specific labor laws. "Any tax that may be imposed," the US government commented, "should have general application, *without distinction as to sex*" (italics added).[103] Despite its embrace of protective

labor legislation for women only, the US Women's Bureau sought to promote women's equality at the workplace while taking into consideration those factors, like pregnancy, that could differentiate women from men. But unlike countries that covered the wives of male workers, maternity payments remained tied to female employment.[104]

The revised ILO convention embraced the major suggestions of the United States, but also resembled European accommodation for pregnant and nursing mothers. State socialist members claimed to have already met its provisions.[105] While agreeing with World Health Organization standards for the length of leave and workplace conditions, the United States emphasized "free choice" of physicians in keeping with its private medical system.[106] On the question of workplace facilities for nursing, the United States voted against the provision, having originally had "no suggestions" because "this aspect of maternity is not closely related to U.S. experience."[107] The final document contained the ideals of US labor feminists. However, during the next decade, under a Republican administration, these activists lacked the clout to translate best practices into national social policy.[108]

As with the 1921 recommendation for agriculture, women workers on plantations represented a special case of maternity. Specific measures for these women reflected the centrality of their subsistence labor for the sustaining of plantation societies. With a long history associated with colonialism, plantations produced commodities for the world market: tea, coffee, sugar, bananas, and cotton. They stood as a special form of economic activity prone to exploitative and harsh working conditions dependent on a resident, often originally migrant, labor force. The subsequent Plantations Convention, 1958 (No. 110) promoted improved living and working conditions for domiciled agricultural workers, including maternity protections, standards for family housing, and medical care. In the end, only ten nations ratified this convention, compared to nearly fifty signatories for the revised maternity one. The Plantations Convention proved nearly dead on arrival, given the disinterest of governments and employers in regulating the making of goods that consumers relished for their affordability and Global South nations depended on as a source of revenue.[109]

The Home as a Workplace

The parallel fates of industrial home work and domestic work suggest the difficulties of having home labors other than maternity recognized as a proper subject for global standard making in the early post-WWII years. The ILO took up equal remuneration rather than the employment conditions of domestic workers, despite resolutions on both topics presented to the 1948 ILC.[110] The

Cold War and interagency rivalries within the UN system shaped this outcome. It didn't help that that household workers were unable to speak for themselves, being less organized than many other sectors at both national and international levels, and many women reformers who championed their cause were their employers who often found it easier—and more comfortable—to push for better conditions for workers in factories and offices.[111]

The meeting of the Correspondence Committee on Women's Work in 1946 had recommended that the ILO conduct research on both domestic work and "the new international aspects of industrial home work (resulting from the development of transport facilities)" with the goal of regulating such labor. Behind this request stood questions of trade and factory conditions, as well as global competition, but the place of home in culture and society pervaded discussions.[112] During the interwar years, the ILO often had discussed the two together, along with farm work, as forms of labor made difficult to regulate because of location. The ILC sometimes considered their inclusion in various instruments, but either allowed for their subsequent exclusion by members or omitted them altogether as being outside the framework of international exchange.[113] Delegates at the 1947 ILC categorized home work and domestic work as part of "the problems of the employment of mothers of families," and as areas for study and future action. They made this connection while passing a US-initiated "Resolution Concerning Women's Work" as a "tribute" to the wartime labors and sacrifices of women worldwide.[114]

Both types of home labors seemed to belong to a prior organization of production, one that sociologists and policymakers alike predicted would wither away with modernization.[115] That was not the case. A decrease in outwork during WWII came from a general decline in European manufacturing and a lack of materials, but it returned in the early postwar years. During the war, women in the Global North had fled domestic work for factory jobs; certainly the job changed from live-in to live-out in many regions afterward.[116] But in the 1950s and 1960s, wage-earning women turned to household workers for help with combining unpaid family labor with employment. While labor feminists around the ILO's Women Worker division differed on whether to prohibit industrial home work, debating the possibility of extending existing labor regulation to the practice, they agreed on the need to modernize what many still called "domestic service," as we shall later see.[117]

In the late 1940s and early 1950s, the ILO would research home work and domestic work, but the Director-General and Governing Board dismissed efforts to do anything else. For home work, the Director-General felt that "it would be premature for the Office to submit this question pending the actual collection of further information," Deputy Director Rens informed Fairchild in 1947.

Instead, he suggested that they publish research authorized by the Governing Body in the *International Labour Review*. Rens was signaling that the agency was not ready to act.[118] Similarly, the Governing Body delayed consideration of domestic work for years after British Worker delegates, led by Trade Union Congress leaders Alfred Roberts and Florence Hancock, won approval in 1948 for putting the sector on the ILC agenda. Hancock took a special interest in domestic workers; her Transport and General Workers' Union represented them, and she had co-authored the British government's "Report on Post-War Organisation of Private Domestic Employment." Starting out as an unskilled factory worker, she had become an effective unionist and moved through the ranks to chair the Trade Union Congress—the third woman to do so. Hancock closely monitored the situation among delegates and strategized with Miller and Fairchild, but to no avail.[119]

Equal remuneration was more legible to the men who ran the ILO than domestic work was. UN demands further pushed domestic workers off the ILO calendar. In 1949 Fairchild expressed "very real regret" to Dorothy Elliott, who chaired the National Institute of Houseworkers, a London-based training school for servants and home aides. Elliott would serve on the Experts Committee on Domestic Work appointed in 1952. The ILO had postponed discussion of domestic work because the UN asked it to address equal pay. Trying to find something positive, Fairchild explained to Elliott, "[W]e shall have more time not only for gathering information but for developing experience in the handling of these problems prior to the adoption of an international regulation."[120]

The backstory to this shift involved the interagency rivalry between the ILO and the UN CWS, which had initiated the request for a convention on equal pay through ECOSOC, to which both the CSW and the ILO reported. The CWS resulted from feminist lobbying in 1946 during the organization of the UN—by delegates from Central and South America, with Lutz playing a key role, and from Australia and Denmark. US representatives opposed formation of a separate women's commission; Eleanor Roosevelt wanted to continue a women's subcommittee under the Human Rights Commission. She argued that "separate" would mean "ignored and unequal" within the UN system.[121] But US women delegates also objected to creating another arena for their National Woman's Party opponents to demand legal equality.[122] They managed to limit the role of the CSW to passing resolutions without the power to implement them. With governments determining representatives, political appointees dominated the CSW, though they often belonged to major women's organizations.[123]

The CSW concentrated on political and civil rights, including marriage, suffrage, and independent citizenship, but it also regarded economic rights as part of its mandate. International women's organizations of various persuasions sent

observers, and many feminists saw the CSW as an arena where they could amplify their messages.[124] The leadership of the CSW embraced the legal equality perspective, which led Fairchild to assess the commission as "thoroughly antagonistic" to the ILO.[125] The CSW regarded the ILO as a research arm that would do its bidding rather than treating it with the respect that it deserved as a large specialized agency within the UN complex. Over the years, it would ask the ILO for yearly reports on compliance by states on the equal remuneration and maternity conventions; it also called for studies on part-time work, vocational training, and community services.[126]

Fairchild feared that the CSW was meddling with the ILO's portfolio on economic rights. ILO participation "has not been at the request of the I.L.O.," explained Fairchild, but rather, ILO presence was necessary "to have the studies requested by the Commission referred to the I.L.O. as the competent international body to deal with them rather than to have duplication of effort arise between the U.N. and the I.L.O."[127] To stem encroachment, its representative to the CSW had friendly delegates introduce resolutions that the UN body would not duplicate efforts undertaken by another agency.[128]

The Cold War fanned the conflict, which had ideological as well as bureaucratic dimensions. The CSW served as a staging ground for the Cold War, as did the United Nations generally. Within the commission, the United States supported the ILO, while the Soviet Union, still outside of the ILO, and its allies joined the legal equality feminists in objecting to women-specific protections. Delegates in both camps threw statistics back and forth on wage differentials and prevalence of social supports to undermine the credibility of their rival. State socialist nations sought to move jurisdiction over women's economic rights away from the ILO to the UN. ILO compliance with ECOSOC failed to neutralize conflict. In 1948 the Communist-led World Federation of Trade Unions, Poland, and the Soviet Union brought the question of equal remuneration before the UN. ECOSOC then asked the ILO to place the topic on its agenda. In 1949 the same triumvirate again sought to move the question of equal pay from the ILO to ECOSOC. In order to control the content of equal pay as well as affirm its jurisdiction, the Governing Body complied by scheduling discussion of equal remuneration for 1950 and 1951.[129]

Discussion at the CSW was fierce. Soviet-aligned delegates asserted that "some of the most pressing inequities were to be found in the most highly industrialized countries," chastising the United States and the United Kingdom for the persistence of "flagrant discrimination." Pointing to the need to solve questions of child care and training, they demanded a broader understanding of remedies than found with the ILO. Elinor Kahn, a US woman representing the World Federation of Trade Unions during meetings in New York City, charged

that the ILO "unduly restricted" the concept of equal pay.[130] Russia's Elizavieta Aleskseevna Popova, a trade unionist and lawyer, claimed that "the position taken by the ILO showed that it was acting not in the interests of workers but in the interests of those who exploit them." Speaking directly to the US delegate Olive Remington Goldman, a Democratic Party activist from Illinois who defended equal pay "in principle," Popova made a challenge: "We'll see how you support it in practice."[131] Countering Popova was Britain's Mary Sutherland, then the highest woman official in the Labour Party, who claimed that women trade unionists in her nation "did not look to the Commission" in matters that belonged to the ILO. Jabbing her World Federation rival, she underscored "the necessity of safeguarding the right of collective bargaining in countries where this democratic method of wage-fixing was practiced." The ILO agreed: equal pay was not merely a women's issue; it was a "wage procedure" central to determining rates of compensation.[132]

How nations came down on this issue varied according to internal factors as well as geopolitical ones. Democracy was no indication of national stance. Prominent legal equality feminist Minerva Bernardino, appointed by the Dominican Republic's dictator, favored a convention. Indian representative Hansa Mehta, a key figure in the progressive All-India Women's Conference, thought a recommendation on equal pay would allow more countries to sign. Delegates from the USSR, Poland, Byelorussia, and the World Federation of Trade Unions would continue to assault the ILO on its methods and speed of deliberation throughout the early 1950s.[133]

Convention or Recommendation?

Would equal remuneration become a convention with treaty-like status or merely a non-binding recommendation? Employers' associations claimed to support the principle just like the Workers', but they argued that women's work had less value than labor performed by men. It cost more to employ women, who required workplace amenities and called in sick more often than men, and such expenses alone justified differential rates for identical work.[134] With governments split, Fairchild urged organized women "to 'lobby' their countries' delegates to pass an international regulation acceptable to the majority but on no condition are they to leave this question unsettled." The old women's organizations had turned into Geneva-based lobbying groups that sought to influence the ILO and national delegations through personal contacts. Fairchild advised that they could more easily transform a recommendation into a convention than move the ILO to reconsider a failed convention. Women's groups, however, feared that an all-out effort for only a convention would lead the Employers' delegates to "band themselves to fight

the text clause by clause and prevent a decision." The International Alliance of Women wondered whether women again would find themselves "frustrated" in obtaining equal rights at work even as the expectation remained that they would "provide social welfare services for the future nations of the world";[135] that is, undertake familial and public reproductive labors.

International feminist federations particularly cautioned against watering down any resulting convention. They were leery of "equivalencies" because they wanted identical treatment.[136] The International Council of Women affirmed support for a convention, further calling for "equal opportunities of access and promotion to all posts in all occupations."[137] The International Alliance, International Federation of Business and Professional Women, and other feminist organizations preferred gender-neutral discourse, such as rates of remuneration, over phrases that referred to men and women.[138] ODI voiced the most skepticism. "Until job classification systems are introduced everywhere," it argued, "the definition 'rates established on job content' has no practical meaning in countries where job classification is not introduced and thus many fictitious reasons can be given in order to delay for a long time the implementation of the principle 'the rate for the job.'" Since classification depended on "the objectivity and integrity of the job classifiers," it questioned whether assessors would retain "traditional prejudices." Would assessors be "free from unproven erroneous conceptions of women's skill and abilities?" Rate for the job was the only way forward, but that could not succeed without improvement of general social conditions that impacted women's place in the labor market. Nonetheless, equal rates might entice women to improve their skills, reduce absenteeism, and become more efficient laborers, leading "to higher universal prosperity."[139]

Political and economic forces divided states over the form of an equal pay instrument. Much to the chagrin of British feminists, the United Kingdom would agree only to a recommendation, because it feared inflation from applying the principle to the civil service.[140] Other market economies claimed that their federated political structure made a convention unrealistic. Scandinavian nations cited the workings of collective bargaining to justify a recommendation.[141] Luxembourg felt that foreign competition in sectors dominated by women workers negated the possibility of implementing a convention.[142] Those less supportive of a convention were concerned about increased costs of production, which rose, as Netherlands explained, "with the natural characteristics of women."[143]

Others worried about the impact of equal pay on the family wage. Women still worked for pin money, lowering rates, argued Belgium. Christian trade unionists agreed that women would undermine a sufficient wage for the lone male breadwinner.[144] In contrast, Finland contended that social services financed by general taxation, like low-cost housing and family allowances, actually made the family

wage less necessary.[145] The US Employer advisor Lena Ebeling, a human resource administrator from the paint firm Sherwin Williams, offered reasons for equal pay resembling those of her labor feminist counterparts: women workers also had families dependent on them or supported themselves, their cost of living was the same, and their purchasing power was crucial for mass production industry. Nonetheless, she came down for a recommendation in keeping with Employer opposition.[146]

In contrast were state socialist nations. Poland embraced the concept but judged the proposed texts "a surrender to pressure by capitalist employers and Governments."[147] It framed the question as one of human rights, citing the Universal Declaration of Human Rights of 1948 and a 1949 resolution of the UN CSW.[148] Similarly, Czechoslovakia associated equal pay with anti-discrimination on the basis of "sex, religion, race or political conviction."[149] For women to become more productive, they not only needed training, as proposed in the draft recommendation of the Office, but also required "social facilities which would enable the employment of women who take care of their households, especially of mothers."[150]

Former colonies, like India and Egypt, evoked the language of development to support only a recommendation. "Associations from the East" of the International Alliance of Women similarly saw "their countries' economic difficulties and the lack of technology for job-evaluation" as barriers to a convention.[151] India claimed that it lacked appropriate wage-fixing mechanisms and the personnel qualified to make such deliberations.[152] It suggested removing from coverage "family undertakings, domestic work, unorganized industries [non-unionized], and employment where the output of women was as a rule less than that of men"—that is, jobs where women concentrated.[153]

The notion of female difference pervaded these discussions. France justified restricting women from the building and metal trades out of concern over their fitness for strenuous work and danger to their health.[154] Feminists worried that employers would include the cost of maternity leave under remuneration and thus reduce women's wages. Social good arguments countered cost of production claims when the International Alliance of Women called for socializing reproductive labor. It contended that "the child is considered to be the responsibility of the state and an asset to the nation and it would be the merest social justice not to penalize one section of the population for the provision of welfare services which would benefit both men and women of the future."[155]

Miller played a crucial role. She served as the reporter for the Committee on Equal Remuneration, drafting the convention with an accompanying recommendation. She offered three specific contributions to the norms being established. The first linked some form of job measurement to wage determination, so as to

facilitate greater accountability. The second combined methods of application with general principles. The third allowed for various techniques for determining wages, including national laws and private collective bargaining agreements.[156] The final convention specified a number of methods: national laws, wage-setting machinery, and collective agreements.[157]

Pre-ballot discussions exposed the different viewpoints between Workers and Employers. The Office, meanwhile, worried over the harm that the CSW could play. Assistant Director-General C. W. Jenks informed Thatcher Winslow, head of the ILO Washington Office, "it could cause us the most serious embarrassment in the Conference if . . . [the CSW] were to throw such weight as they may have in favour of a Convention." Winslow set about intervening at the 1951 CSW meeting, whose final resolution made no mention of the form of an ILO instrument.[158] The CSW staff person Mary Tenison Woods, an Australian lawyer and activist, complained that consultant NGOs "became furious . . . when it became known that a very weak resolution had been adopted . . . [and] had been enthusiastically supported and promoted by the ILO representative." The NGOs expected more of the CSW—and thought, albeit erroneously, that they were strengthening ILO action by calling for a convention over a recommendation.[159]

Once the actual vote occurred, the British, Swiss, and Indian governments—all of whom had expressed opposition—abstained. The largest bloc advocating for a convention came from Latin America, where constitutional guarantees of equal pay prevailed but where the urban working-class remained small.[160] Poland and Czechoslovakia pushed for the an enhanced legal commitment. These Soviet allies complained that the final outcome of the drafted labor codes provided no precise measures and no firm obligations.[161] Conscious of its international reputation, the United States in the end approved a convention with a recommendation. Though Miller admitted that her government wanted a recommendation, she told the drafting committee that she was going to vote with the majority—which turned out to be for the dual instrument. Subsequently, the Committee of Experts on the Application of Conventions and Recommendations interpreted the signatory obligation as applying the principle only where states had control, as with public services and government-determined wages.[162]

The ILO reported periodically on the status of this convention to the CSW. By 1959, it concluded, "equal pay for work of equal value" had increased over the previous half century, with millions of women worldwide covered by way of collective agreements or civil service regulations, including state socialist nations and occupational sectors in Latin America and Asia.[163] The problem remained that women faced cultural discrimination in hiring for better paying jobs dominated by men, such as meat processing in Argentina, or suffered from

lack of enforcement, as with small enterprises in Japan.[164] Entrenched notions about fit work for women stymied the impact of vocational education for placement into male-dominated jobs. Structural factors thwarted the implementation of equal remuneration.

Adoption could lag. Miller sought to extend her victory in Geneva to the United States. During the Korean War, she convinced some federal agencies to implement equal pay, but progress in the states lagged. After she left government in 1953, Democratic Congresswoman Edith Green of Oregon introduced an equal pay bill every year. A decade later, in the midst of civil rights struggles, one passed, with Department of Labor officials citing the ILO precedent. By the 2000s, the United States was still not among the 173 nations that had ratified the Equal Remuneration Convention.[165]

Non-Discrimination for Equality?

The 1950s were a transitional period in which the older international feminist organizations were less vocal at the ILO and the new global feminism had yet to emerge. Women's organizations sent no comments on the proposed non-discrimination convention, unlike their lobbying on the terms of the 1947 proposal on non-metropolitan territories or the 1951 one on equal remuneration. The resulting non-discrimination instrument in 1958 reinstated the duality of ILO constitutional principles when it came to women—treatment like all other workers except for sex-targeted measures to account or compensate for biological and social difference; that is, reproductive labor. This persistence existed despite the observation of Belgium that "such differences seem scarcely compatible with present day industrial and technical development."[166]

The Discrimination (Employment and Occupation) Convention, 1958 (No. 111) seemed to be more about race than sex, but appearances were deceiving. Discussion certainly focused on race discrimination, only mentioning sex discrimination in passing.[167] The ILC rejected "any distinction, exclusion, or preference made on the basis of race, colour, sex, religion, political opinion, national extraction or social origin," that impeded "equality of opportunity or treatment." Yet delegates agreed that distinctions "inherent" in the requirements for specific jobs could allow gender preference to be claimed as a "bona fide occupational qualification," the name subsequent US law gave to this loophole. Deliberators rejected naming such policy dualities contradictions, defining as acceptable "special measures designed to meet the particular requirements of persons who, for reasons such as sex, age, disablement, family responsibilities or social or cultural status, are generally recognised to require special protection or assistance."[168] A Czechoslovakian Government advisor displayed such reasoning in announcing

how women in her country had both equality, including equal pay for equal work, and social security "better" than men, including coverage for maternity leave.[169] Latin American feminists throughout the century also had argued for legal equality and targeted benefits for mothers. The opposition between equality and difference came from Anglo-American and some European definitions of non-discrimination.[170]

Normative understandings of gender encouraged most states to treat sex discrimination apart from the racial/ethnic categories. The causes of discrimination differed, they insisted, with sex stemming from "social and economic" reasons, while race came from "hatred and prejudice."[171] Canada, for example, stressed how equality of opportunity between the sexes required programs other than legislation. Its male Government delegate contended that the question of sexual equality "should be dealt with special measures, separate from those designed to prevent discrimination on other grounds."[172] However, Canada's Worker advisor demurred, asking, "[H]ow could this International Labour Conference adopt a document and exclude from the grounds of discrimination the question of sex?"[173] He cited the Declaration of Philadelphia and the Universal Declaration on Human Rights as precedents for covering sex as well as race.

Restrictions on women nonetheless remained acceptable—and not only those deemed protective. During deliberations on the final convention in 1958, the Irish Government delegate admitted that his traditional Catholic-dominated country at the time, which would wish to ratify the convention, would be unable to do so. To curb high unemployment, he explained, "women were required to retire from the public service on marriage and, in the private sector, some agreements provided that married women would not be employed." Hiring men, single women, and widows while barring married women "should not be termed discrimination."[174] Other nations would privilege the male wage or base responses to women on their status as wives and mothers. Netherlands accepted discrimination that "conform[ed] with national views regarding the contractual capacity of married women, minors and mental defectives"; that is, discrimination need not exist for legal dependents.[175]

THE MEANING OF equality, as with protection, depended on whose equality and whether legal equality was enough in a world of substantive inequalities. Could equality encompass positive or affirmative actions, special or distinctive treatment? Could equal treatment of men and women within a nation be enough in a world where some places remained dependencies of colonial powers that benefited from the fruits of empire? Equal pay as rate for the job following the war threatened employers enough that they wished to eliminate such guarantees to women in industrial nations. Trade unionists were formally in support of

equality as long as protections that often had led to disparate treatment of women remained. Labor feminists, like ILO Office staff, claimed that identical treatment could lead to unequal results. But the ILO sidestepped these questions when treating "non-metropolitan" or "dependent" territories as distinct entities that came under global labor standards when suitable to local authorities. Indigenous peoples would remain subject to special standards that only gradually would reflect their struggles for self-determination.[176]

Equality lost its meaning when equal rights led to women, just like men, having the freedom to labor under exploitative conditions, producing goods or reproducing the labor force for the benefit of those with greater resources. Colonization had generated an equality deficit. Women in the Global South, who theoretically could gain from equal remuneration, had less possibility to do so than those in industrialized regions; rural women especially had fewer opportunities to enter jobs comparable to, if not the same as, those held by men. Instead, the labors of racially or caste subordinate, "native," or indigenous women would relieve the household burdens of more prosperous women, especially in the Global North, both indirectly by producing cheap goods and directly by caring for children as migrant household workers.[177]

It was difficult to relinquish the wages of inequality. Structures mattered; it would take the sometimes bloody movements for self-governance and national liberation to shape future worlds of work. The women question remained, with the woman worker seen as different and women in "developing countries" as difference's other. Such distinctions would frame the making of the woman worker when the ILO and the entire UN system sought to promote worldwide economic and social development.

Difference's Other

Women in "Developing" Countries, 1944–1996

3

Development

ESTHER PETERSON COULDN'T be in Washington, DC, to speak with Director-General David Morse when he visited in October 1961. So the US Women's Bureau head wrote to her countryman about "the imperative need for the International Labor Organization to develop a broad, continuing program on the employment of women." Women in industrialized economies faced employment challenges from automation, international trade, and the necessity to balance wage earning with family life. But Peterson argued that "women of newly developing countries need assistance in changing from farm to city, in industrial employment" and governments ought to do more to enhance their work under "realistic labor standards." That insight came from her interaction with delegates at the last ILC, where she served on the Committee on Technical Co-operation.[1] Throughout the world, she decried, "women are economically disenfranchised, untrained, immobile, and cannot participate effectively in economic life." As a modernizer, this labor feminist believed "that lessons from the history of the economically developed countries can be passed on, and that women, as a country develops, will not be used as a source of cheap labour."[2] Though the ILO might lack funds to have a meeting of what had become the Panel of Consultants on Problems of Women Workers, Peterson reminded Morse, it could initiate "some long-term research and to make policy decisions" for developing as well as industrialized nations. "These are critical times for men and women, and as always special attention must be paid to women if their employment situation is to be included in the various programs," she argued.[3]

Morse listened. In November 1962 the Governing Body followed his recommendation to place the question of "the employment of women in a changing world" on the agenda of the 1964 ILC. The Worker members favored discussion of this item because of the rapid increase in women's labor force participation, which made timely questions of "family responsibilities, child-care facilities for

women workers, and part-time arrangements," along with the issues of working hours and effective administrative mechanisms.[4] Framed as "women's problems," such responses to a growing chasm between the organization of social reproduction and labor markets illuminate the ways that gender operated in social policy to reinforce the sexual division of labor. In continuing that other division between industrialized and new developing countries, the charge to consider "Women Workers in a Changing World" reflected the persistent legacy of uneven and unequal relations among nations as well as between the sexes.

By the early 1960s, according to the ILO itself, women composed about a third of the world's enumerated workers, with great disparities between regions. In Eastern Europe and the USSR, 40% of women were in the labor force, consisting of nearly two-fifths of all workers, in contrast to Latin America, where less than 15% of women were formally employed, making up only a fifth of workers. About a third of the labor force was female in Western Europe and North America. While not even 4% of Iraqi or Pakistani women belonged to the counted workforce, the ILO classified more than half of women in Haiti, Rumania, and Thailand as working. Where women labored varied as well. In developing countries with high and medium labor force participation, they clustered in agriculture, but Latin American women more often were found in handicrafts and domestic work. In North America and some European nations (Sweden, Switzerland, Norway, and United Kingdom), women concentrated in sectors outside of agriculture, while in some state socialist nations (USSR, Poland, and Hungry), Japan, and other European countries (Austria and Finland), they participated in agriculture and non-agricultural sectors alike. Both the percentage of married women and that of women overall in the workforce had expanded over the course of the 20th century. Not all nations saw the same increases, but the upward trajectory of change—even without counting the informal sector—was straining structures of work and family. Women remained concentrated in low-waged jobs, "subject to abuse because of their lesser bargaining power and their greater willingness to accept inferior conditions of employment," the ILO concluded.[5]

Despite such variation, the ILO was hardly willing to relinquish the notion of a universal woman. Elizabeth Johnstone, the Programme Coordinator for Women's, Young Workers', and Older Workers' Questions, claimed in 1968 that "while women in the developed countries may have different immediate preoccupations from those of women in the developing countries, and those in socialist countries may have differing areas of emphasis from those in free-enterprise countries, their problems are not fundamentally dissimilar."[6] In expanding from one binary (developed vs. developing) to two (developed vs. developing and socialist vs. free enterprise), and to multiple categories of nations, she more accurately reflected power blocs at the ILO and the UN system. The ILO was in the

process of updating its hybrid conception of the woman worker—what it began to refer to as its "twin principles" of women the same as men but targeted for compensatory or additional treatment—for a world where the challenges of global inequality stood at the center of debates over the meaning of development, and in which women and men from newly independent states across the globe demanded action.[7]

The ILO had already moved from women-specific protection to non-discrimination, but by the mid-1960s it more directly faced the problem of family responsibilities and, for rural women in the Global South, income generation. It had reorganized the Office to integrate women's issues into other sections, which meant replacing a specified division with a coordinating office. Integration had its perils. As Johnstone noted, "the need for technical work in fields not now covered by any technical division or department (e.g. child care, home aide services) and . . . where responsibilities are divided amongst several divisions or departments (e.g. maternity protection)" demanded co-ordination, or else neglect was possible.[8] Hers was a continuing worry. The default worker and participant in training programs were male. As Frieda Miller noted back in 1949, "While this is not surprising it is something that I am afraid is likely to continue . . . unless a very definite and deliberate effort is made to emphasize training in some of the fields that are especially women's."[9]

The making of "women in developing countries," as with struggles over the meaning of "equality," reflected and facilitated larger geopolitical shifts. This chapter turns to the development of development to consider the construction of a category within a category, "women in developing countries," as the other of the woman worker: the woman whose difference from the hegemonic Western norm defined the severity of her oppression. With development linked to equality, and both to peace, at the 1975 UN World Conference on Women, there was no easy sorting of distinctions between women on the global stage. The meaning of development, like that of equality, was up for grabs in the ideological contest between state socialist and newly independent states against the old colonial and market economies (Johnstone's "free enterprise" category). Thus, this chapter intertwines the story of the ILO's opposition to the Convention on the Elimination of All Forms of Discrimination Against Women (CEDAW) with efforts to "develop" the Third World woman.

Women faced a changing world, but so did the old colonial powers, the market economies, and state socialism. "Development" proved to be one staging ground in which women's rights and global wrongs coalesced. During the UN's first (1960–1970) and second (1971–1980) Decades of Development, and the beginning of its Decade on Women (1975–1985)—the years of the Cold War, in other words—development and modernization represented twin goals. Under

Morse, the ILO came to emphasize technical cooperation; that is, the aiding of governments to establish mechanisms to enforce standards, enhance vocational training and education, create cooperatives, and improve overall conditions of work. It promoted urbanization, agricultural mechanization, and state administrative capacity. Such assistance became more robust than efforts at standard setting, while newly independent nations sought better-trained manpower, more infrastructure, and large-scale industrialization.[10]

Development was an expansive concept.[11] Mainstream thought focused on technological and infrastructural change, such as hydroelectric projects and up-to-date financial systems, directing efforts toward sectors dominated by men. Ensconced in the family, and engaged in subsistence and reproductive activities, women represented both a drag on productionist goals and underutilized labor power. However, ILO actions were never singular. The Director-General pursued modernization along with other UN agencies. ILO modernizers assumed that training would lead to permanent labor market participation by women, even if as early as the mid-1950s some recognized that "this has not . . . been the regular pattern of evolution in most economically less advanced countries, at least in the early stages of industrialization."[12] Sections within the Office promoted what came to be known as community development through cooperatives and small-scale industry, often recommended as transitional schemes for developing nations. In this regard, it was essential to distinguish between industrial home work, condemned as undermining labor standards, and handicraft, seen as suitable for women in less industrialized regions. But relegation to sectors designated as backward and conflated with leisure pursuits or unpaid family labor hardly enhanced women's economic independence or status.

Compared to other UN affiliates, the ILO addressed women's place in development as income earners and not only as mothers. The Food and Agriculture Organization (FAO) stressed nutrition and mother-child health. The United Nations Educational, Scientific and Cultural Organization (UNESCO) was more concerned with cultural and family issues. The World Bank did not consider women until the 1970s, and then mostly in terms of overall economic productivity. By 1970, when a new generation of feminists began reconsidering the meaning of development for women, the ILO led general trends through its focus on basic needs. Depending on one's standpoint, it lagged behind calls for equal rights in clinging to older understandings of special treatment, or it was most attuned to the actual situation of Third World women.[13] While the ILO emphasized equality of opportunity, non-discrimination, and equal remuneration, it continued to speak of the "social protection of women in relation to their maternity function." Efforts "to assist women with family responsibilities" represented its form of "progressive social action," much in

keeping with the decades-long quest of labor feminists to reconcile caregiving and breadwinning.[14]

Development, it turned out, benefited the ILO, driving its growth. During Morse's first decade at the helm, the ILO more than doubled its size: from 52 member States, 606 staff, and a gross budget around $4 million in 1948, it expanded in 1961 to 101 States, 1,638 staff, and an overall annual budget of around $20 million, fueled by its Programme of Technical Cooperation and various UN special contributions.[15] Whereas in 1950, it spent 80% of its budget on standard setting, by 1967, 84% of its funds went to technical cooperation.[16] In comparison, the regular budget of the UN during this period rose from slightly over $39 million in 1948 to over $72.5 million in 1961, while the FAO had a regular budget of around $8.5 million in 1946–1947, expanding to nearly $31 million, including special contributions, a decade later. The ILO grew but was never funded to the extent of direct service agencies.[17]

A regional structure of offices and meetings made operations truly global, with locations initially in Bangalore, Sao Paulo, and Istanbul (there were already offices in London and Washington).[18] The Office hired nationals from member States; these became more diversified as Africans, Asians and Latin Americans joined Europeans in responsible positions. Chilean diplomat Anna Figueroa succeeded Mildred Fairchild as the third chief of the section on women and young children in 1954, and became the first woman Assistant Director-General in 1960.[19] She exemplified a predominant form of Latin American feminism. As head of the Chilean delegation to the 1949 Inter-American Commission of Women, she introduced a resolution that "asked the governments to strike out of their labor legislation all protective laws for women workers except maternity," on the basis that such laws hurt women's employment, and "on the theory that night work and other hazardous occupations are harmful to men as well as to women."[20] Equal treatment dominated her years in charge of women's work, but so did the turn to development.

By the time that Figueroa ascended the organizational ladder, ILO representatives and consultants had identified key concerns that would soon come to define the conversation on "women in development": the hardship of rural labor, including food preparation and precarious access to water for household use; the negative impact of mechanization and modernization of agricultural production on women's employment and income; the shortage of social services; the necessity for education, ranging from basic literacy to vocational training and higher skills; and the preference for community-run remedies. They proffered handicrafts, small-scale industries, and cooperatives as solutions to the un- and underemployment of rural women, measures that the ILO continued to promote for the rest of the century.[21] In contrast, according to Indian feminist economist

Devaki Jain, a UN activist and sometimes ILO consultant, until the 1960s, "within the CSW [Commission on the Status of Women] there was an opinion that development was not really a women's issue and that too much attention to economic development would divert the commission from its primary goal of securing women's equal rights."[22] It was precisely this separation between human rights and economic rights that the ILO now rejected in theory, but that the Cold War did so much to solidify both in the division of tasks between international agencies and with UN convention making itself. US opposition kept economic rights separate from the UN's 1953 Convention on the Political Rights of Women, for example, and the ILO continued to protect its economic justice portfolio from CSW interference.[23]

ILO development initiatives became entangled with its responses to the recent surge in equalitarian feminism, and no unitary position emerged. In the mid-1970s, former colonies and non-aligned nations called for a New International Economic Order against Western market economies, with state socialists seeing an opportunity to reshape the postcolonial moment through championing substantive rights for women, which often contrasted with Western feminist understandings of legal equality. The ILO's originary women-specific protections proved to be a stumbling block when it came to transforming the 1967 Declaration on the Elimination of Discrimination Against Women into a convention. By 1979, when the UN passed CEDAW, the ILO was considering replacing women-specific protections with gender-neutral ones for everything except maternity. As with UN meetings themselves, deliberations on CEDAW pitted the United States against the USSR, though the terms of opposition had shifted from the late 1940s. The ILO's 1975 Declaration on Equality of Opportunity and Treatment for Women Workers reiterated its long-standing positions as a response, with "women in developing countries" targeted for special consideration based on substantive inequalities that CEDAW would not fully address.

Looking at various branches in the Office underscores the divergent positions at the ILO itself. While liberal Western feminists dominated the "women in development" (WID) approach, the ILO came to foster class-based perspectives grounded in the material circumstances of the Third World through its Programme on Rural Women (the subject of the next chapter). It would integrate women into development in a manner that redressed their reproductive subordination and fostered income generation that women could control. By the 1980s, promoting self-employment and self-organizing, its development programs joined with feminist activists seeking to empower rural women in the Global South, an effort that advanced grassroots organizing and worker rights, as we will see.

Asian Difference, Handicraft Offerings

Concepts of female difference informed ILO policy even before the arrival of "women in developing countries" as a solidified, though never quite unitary, object that pervaded resolutions, technical cooperation, and research. In the 1950s, ILO staff recognized the operation of multiple standpoints grounded in region, culture, and social circumstance when it came to the woman worker in Asia, the main arena of early post-WWII concerns. They would later apply such concepts to Africa; with Latin America, the focus remained on indigenous regions (along with industrial workers). The ILO juggled a commitment to equality with the designation of Third World women as the most in need of distinct programs to overcome their deficits.

"Orientalist" portraits contrasted with an understanding that women activists in the Global South had different priorities from feminists in the Global North. Some commentators lamented "problems . . . peculiar to the East," highlighting the plight of Hindu widows "forced to depend upon their own resources for obtaining a livelihood." Without job opportunities, they feared, these widows would become street beggars.[24] But even those with a favorable opinion of the region cast their thoughts in reference to their own circumstances. "The urgency of concrete problems and needs seems to give these matters heavy precedence over more theoretical considerations of women's 'rights,'" observed Frieda Miller, acting as an ILO consultant in the mid-1950s. In this regard, the organized women of Asia seemed preferable to "the acid and pugnacious strain of 'women's rights'" of parts of the women's movement "of the West," a reference to the National Woman's Party and similar groups who, we have seen, sought to block ILO protective conventions for women.[25]

Dominant colonialist perceptions of women from outside the West circulated within the Office, though staff from those regions offered more subtle analysis. When first investigating the employment of Asian women in 1953, the ILO planned to send its findings to governments, regional meetings, and women's NGOs— such as the All-India Women's Conference, All-Pakistan Women's Association, and the All-Ceylon Women's Association. Deputy Director-General Raghunath Rao from India asked the Women's and Young Workers' Division "to make sure that the tone of the article is politically satisfactory and tactful." He confessed, "I am myself a little disturbed by certain very candid statements which Mme. Brunn [the author] has made which I think sound a little western in approach." Indeed, the published article prefaced its compilation of statistics and laws with a declaration: "The religious and social traditions of the Asian countries together with their social structure are most disadvantageous to women, and serve to keep them in a situation in all respects inferior to that of men." Brunn proceeded to label the

conditions of home labors as "primitive" and "arduous and lengthy," and their practitioners, "ignorant and unskilled." Rao certainly felt the need to defend the progress of the region against such formulations, though he argued that "political discrimination against women as such has not been a marked characteristic of recent development in Asian countries." Yet he too asserted a prevailing approach to development that, even when taking account of women, denied their significance by reifying female difference. The sexes, he believed, were equally in need of employment, but his larger claim—"the problem is mainly that of economic development generally"—was one that delegates from emerging nations would continue to assert into the 1960s as a rationale to ignore issues the ILO associated with women, like the difficulty of combining family responsibilities with wage work. The pressing issue, after all, was men's employment.[26]

What supposedly distinguished women in the region was the embeddedness of their labor within households. Such a perception cast women going out to work as an act that by definition separated them from the family without recognizing that family economies operated in the industrialized North as well. Employer members on the Asian Advisory Committee in 1952 held onto such a dichotomy when making regional comparisons. Unlike women in the "West," itself an essentialist category in these discussions, they asserted, Asian women "were not isolated units but part of their respective families," and thus no practical reason in Employer minds existed for the ILO to conduct special studies on these women workers or take up the question of protective labor legislation—the subject of an extensive ILO report prepared for Advisory Committee deliberations. Still, Employers generally agreed with Government and Worker representatives that training would enhance the productivity of women. Seeking to allay the concerns of Employers and Governments alike, the ILO explained that women already had entered Asian labor forces. Including women and girls in its Technical Assistance Programme would help "not only in diverting female labour to occupations for which they were most suited but in solving the general problem of unemployment in Asian countries."[27]

This understanding—women as part of the whole and women as a special case—justified the mission of the Women's and Young Workers' Division. In 1953 Mildred Fairchild framed her arguments for helping Asian nations address women's employment "not simply in the interests of the women but in order to deal with the total manpower and social welfare question of these countries...of which, I think, the practices now prevalent with respect to the employment of women are vital." Her linkage of women's employment, labor standards, national health, and demography anticipated future initiatives in which feminists inside the ILO and related agencies tried to empower local women through family planning. They found funding for their overall program from those who promoted

population reduction as a central development strategy, a seizing of the means of reproduction that appeared to critics as a form of Western-initiated population control.[28]

Questions of suitability were indeed fraught, as they were full of cultural assumptions. Asian countries banned women from occupations deemed unsafe for them. The ILO suggested that states could restructure work to take account of culture, such as "the floating garments which many women wear [that] can easily involve them in accidents."[29] Women's dress on the job was hardly a new concern. European nations and the United States had long pointed to the danger of dress in offering restrictions on women's wage work or in requiring women to accommodate attire to the workplace, as with the use of hairnets and pants when producing armaments during WWII.[30] Early ILO conventions on underground mines and hazardous substances embedded related cultural concerns over "safety" and women's proper place. But dress also symbolized a lack of freedom. Displaying an ethnocentrism that ignored the ways that Western women's outfits might generate sexual objectification, Miller rhetorically asked, "If you lived your whole life in a sort of tent with slits in it, . . . how do you think you would feel?" Dress connected to the power of patriarchy, in which the oldest male dictated marriage as well as the site of women's labor. Miller reported, "Women aren't just told that certain occupations aren't very feminine, or are expected to be back home at a certain hour. They don't go out at all." Nonetheless, the ever optimistic Miller saw change, with Asian women able to teach their US counterparts that individual choice depends on "a square deal for everyone."[31]

For cultural and social reasons, handicraft emerged as the sector most appropriate for women in Asia and other developing areas. Planners and promoters sought to build upon existing structures. Women experts in 1951 recommended that non-industrialized places include homemaking and handicraft instruction in elementary education. Given the limited luxury market for handmade goods, they called for reduced teaching of needlework and embroidery and more courses in the manual skills required for "modern" industry. For areas without much industry, however, handicraft could facilitate "self-sufficiency and rais[e] the living standards of low income groups, in providing supplementary income for the underemployed through production of traditional crafts goods for the luxury trade." Women should gain some acquaintance with machinery that would allow for greater productivity and learn to act as independent producers, though education could enhance female-identified handicrafts.[32]

ILO research had discovered that women disproportionately were handicraft producers, though estimating numbers in this mostly informal sector was daunting. They were 85% of hand weavers in Thailand. In Ceylon (Sri Lanka), after service, they dominated all branches except metalwork. In Burma (Myanmar),

women were nearly all the hand spinners and weavers. Half of all Japanese peasant households engaged in handicrafts, such as mat weaving and textiles. Indian women wove silk, wool, cotton, and other materials. Throughout the region, urban as well as rural workers undertook pottery, lace making, and basketry. But the conditions of work were abysmal: long hours, hazardous materials, cramped quarters, and economic exploitation by middlemen.[33]

Because crafts production happened in the household, such work posed no challenge to purdah or other cultural or religious practices that secluded women from contact with non-family. Assumptions that religion, rather than economic structures or more general gender systems, shaped the location of women's labors pervaded ILO discussions. This hidden quality allowed for the obfuscation of women's labor and thus the denial of their status as a worker.[34] The ILO's own reports in the mid-1950s on "Development of Opportunities for Women in Handicrafts and Cottage Industries" reinforced this perception by referring to women as engaged in handicraft during "spare" time or "leisure hours," underscoring women as supplemental family earners or as unpaid workers in family-based cottage industries, usually on a part-time basis.[35] Women emerged from such reports as disadvantaged compared to other workers: they were weighted down by child care and housework, social customs (that is, confinement to the household and family), illiteracy, and low status in the community. Thus, in a telling reference to the impact of family labor, the ILO recommended "specific measures to mitigate their handicaps."[36]

The promotion of handicraft occurred in a context in which tripartite ILO committees called for exploring "handicrafts and small-scale industries . . . for combating underemployment in Asia."[37] Other UN entities also asked for documentation on women and part-time labor, with the Pakistani Representative to the CSW in 1953 requesting that the ILO study women's work in handicraft and seasonal agriculture "in the economically underdeveloped countries of the world."[38] The ILO divided its reports between women and part-time work (in industrial countries) and women and handicraft/cottage industries (in less developed ones)—another indication of the conceptualization of women in the Global South as different.[39]

For men, handicraft loomed as an alternative development trajectory that offered a solution to underemployment through a "small is beautiful," Gandhi-inspired philosophy. Even before WWII, the Preparatory Subcommittee on Handicraftsmen concluded that "through the medium of artisan workers the I.L.O. would be able to understand and influence the labour conditions of a large number of workers and to deal with social questions which had escaped investigation, statistical treatment and regulation."[40] In the 1950s, the Co-operation and Handicrafts Division of the Office targeted men as the proprietors of small-scale

and cottage industries, the latter in which women labored as unrecognized family members. In these discussions, women's work often became subsumed in plans for the development of rural villages. It became hard for the ILO to report precisely on female participation because most data did not break down that way. The ILO's 1950 Asian Technical Conference on Co-operation in Karachi, for example, supported handicraft and cottage industries, but such recommendations faced an uphill battle as nations concentrated on industrial and infrastructure modernization.[41]

The phrase "handicraft and cottage industries" belied their separation. Experts distinguished between small-scale industries, handicraft, and cottage industry. The lesser status of home industries associated with women came through in this post–World War II development approach. Small-scale industries capable of adapting modern methods of manufacture and organized around full-time labor in distinct workshops, which could increase productivity and thus reduce costs, promised to advance Asian economies. The results had to appeal to local consumers in price and style. Though cottage industries were "of such less importance than small-scale industries," to the extent that they could "provide a source of income for women . . . compelled to work at home," one expert concluded, "they are not without their advantages."[42]

Handicraft brought perils in an industrializing world. Handloom weaving, for example, left many rural Indian families in "hardship" because of the lack of local markets and restrictions on export. Additional women workers would further undermine hand industries, an ILO official in Bangalore reported, "unless there is coordinated action from a central source."[43] Training did not always match markets. ILO investigators lamented the instruction of schoolgirls in embroidery, lacemaking, and other decorative crafts that failed to prepare them for producing items for local use. In contrast, they applauded the efforts of women's groups, like the All Pakistan Women's Association and the Muslim Industrial Home in Karachi, to improve techniques for female-dominated trades. The investigators encouraged what was already happening by sending technical advisors and experts to survey country needs, upgrade design and techniques, enhance marketing, and develop sources of credit.[44] Despite much talk about and some action on improving methods of production and quality of goods, and despite efforts to establish cooperative marketing, handicraft as a mode of production could not escape association with backwardness and inefficiency—that is, as fit work for women, who were marked by their gender as unproductive labor.

As part of these initiatives, Miller found herself on a mission to seven Asian countries in 1955 and 1956 to study women's employment. She carried instructions to attend to "the development of opportunities for women in handicrafts and cottage industries and on the distribution of the female labour force in industrial

FIGURE 3.1 Frieda Miller with Indian women. Photo from Schlesinger Library, Liberty News.

home work."[45] Though a long-time critic of home work, Miller was more open to home-based industry under the right conditions in Asia—that is, with the safeguarding of labor standards.[46] Many governments promoted decentralization of production to stem migration from villages to the cities, recommending cottage industry to augment seasonal agricultural economies. She told the *Manila Times*, "Every woman in a farm should be able to supplement the farm's income by spending her leisure hours profitably."[47] Nonetheless, the "subsidiary role" of women as family workers in handicraft bothered her. Men reaped the economic benefits, and they mostly possessed "the higher, more esoteric and rewarding skills." With women barred from the best training, she found "training for earning" programs distressing because they lacked "any examination of the salability of articles" made from inferior materials, with inadequate skills, and without "beauty or utility" for "a place in any market."[48] Indeed, conditions of women's labor reflected the evils of home industry: "exploitation, over-long hours of work, health and safety hazards, as well as reduced earnings," all intensified from the home's standing outside of labor law.[49]

By definition, the home defied regulation. As a French correspondent replied to the ILO's request for information on industrial home work in the late 1940s, "labour inspectors are barred from inspecting the homeworker's actual place of

work by the principle of the inviolability of private domicile which French so-
cial legislation has apparently not modified to any extent."[50] Variation in practice
across the globe intensified such barriers. As Miller recognized, the line between
handicraft and industrial home work was a moving one, especially when the goods
produced by independent artisans and self-employed people resembled those
made for an employer on "materials belonging to the employer and undertaken
on order, tending to turn the home into a sweatshop."[51] This wording, from the
1946 Meeting of the Correspondence Committee on Women's Work, for which
Miller served as the reporter, reiterated the common distinction between home
and workshop that manufacturing in the home appeared to defy. With its ir-
regular hours, starvation wages, and proclivity to involve child labor, industrial
home work was certainly no solution "to relieve mothers of young children from
the necessity of work outside their homes by means of providing paid work they
could do in their homes."[52]

Miller retrospectively explained the distinction between pre-WWII indus-
trial home work, which she sought to prohibit as New York's labor commis-
sioner, and Asian home-based industry. The first "was a sort of parasitic growth
on an established factory system whose purpose it was to escape certain legiti-
mate costs of in-plant production, especially by undercutting wages and escaping
the requirements of labor laws regulating hours of work, child labor, safety and
similar standards." But Asia's "small scale and cottage industries . . . related to cap-
ital shortage which makes plant and elaborate equipment hard to get or impos-
sible while the small scale enterprises substitute under employed or unemployed
workers with a minimum of capital." The Philippines were an exception, with
their garment industry connected to the US economy, rife with home work to
evade factory law through "exploitative standards."[53]

Home work's dangers pervaded most discussions of handicraft. Such labor
was ripe for abuse from being scattered in "private" homes, unregulated and un-
organized, and performed by women (often joined by their children) without
other options for income, who found it "convenient" to work from home. ILO
staff worried about how to protect handicraft workers "against exploitation by
middlemen and against sweated conditions."[54] They would eliminate the mid-
dleman by developing local supplies of raw material and alternative sources of
credit, such as through cooperatives. They further advised bringing home work
under national laws, despite being "easily evaded."[55] They were not alone. In 1956,
for example, Pakistani and US delegates to the CSW asked the ILO "to give spe-
cial attention to methods found useful to organize on a sound basis handicrafts
and cottage industries products, and to avoid the evils of industrial home work."[56]

Conditions of Women's Work in Seven Asian Countries, Miller's report to the
governments of Ceylon, India, Indonesia, Japan, Pakistan, the Philippines, and

Thailand, astutely documented the region's small industrial and even smaller professional sectors as well as dominant agricultural ones. It recognized national variations and differences between urban-rural locations and among social classes. Amid generally low living standards, Miller observed, women crowded into unskilled work and concentrated in agriculture, earning far less than men. These rural dwellers lacked adequate water, tools, and other necessities to perform household labor without "physical hardship" and faced the "constant threat of famine." More married women worked than in the West, a situation that she judged made their lack of maternity protection especially harmful. They rolled cigarettes by hand, wove yarn of variable quality on handlooms, and generally labored in decrepit buildings "in small-scale industries which lie outside the scope of labour legislation."[57] Law thus stopped where it could make a difference: women were to be protected from heavy loads, but not if they were unskilled construction workers and other casual laborers because such sectors lacked regulation. Even when covered, exemptions, such as needlework in the Philippines, excluded women from equal pay, while cultural attitudes, as in Japan, impeded enforcement of laws for those who continued in the formal labor force after marriage. She argued for extending labor standards to industrial home work, small-scale industry, and agriculture—sectors in which women toiled.[58]

Miller recommended types of enterprises that women could engage in along with agriculture, modeled after the best practices found in the region. These home-based industries included luxury food preservation, like cashew nuts made for the world market in Travancore-Cochin; home economics projects, like a residential training center in Indonesia where girls learned to improve family diets through local harvesting; and handicrafts training focused on creating quality goods and marketing them.[59] Though usually classified as outside of the ILO's competency, health programs offered a growing area for action; they would generate jobs for women, as would social welfare projects. She did not explicitly address questions of reproductive labor, though the burden of responsibility for the household influenced her findings.[60]

The ILO responded slowly. By the time Miller's report appeared in 1958, "the time-gap between your mission and the publication of the findings made it difficult to strike while the iron was hot and that a good deal of the interest stimulated by your mission dissipated," reported Deputy Director Rens a year later. The ILO claimed it could not commit finances to follow-up with a special regional meeting on women workers; it could only have its Asian Field Office incorporate her results during individual country visits. The possibility for a broader definition of technical cooperation, one that would address social conditions as well as employment projects, was not out of the question, even if it might overlap with other UN agencies. But government action to improve the conditions of women

at work was "one of relative priorities," as it was for the ILO itself.[61] During the 1970s, various ILO consultants gave technical assistance to projects throughout the Asia-Pacific region, including the Philippines, India, Thailand, Sri Lanka, and Indonesia—countries that sent experts on women's issues to the ILO.[62]

The concern with researching "opportunities for women in small industries" remained—and not only in relation to Asia. In 1949 the Fourth Conference of American States Members in Montevideo had asked the ILO to consider the conditions of indigenous peoples, including "equal pay for equal work" and "recognition of the family as an economic unit in the extension of social insurance benefits and other forms of social assistance." It tasked the ILO with coordination of activities by other UN entities for questions of land tenure and ownership, labor inspection, recruitment of migrant labor, protection of indigenous handicrafts, and occupational safety in mining. From the early 1950s, the Andean (Indian) Programme, the ILO's largest assistance effort, encompassed Ecuador, Bolivia, and Peru, and later Argentina, Colombia, Venezuela, and Chile, at a cost of over ten million dollars during its first decade. With the goal of integrating indigenous peoples into national economies without destroying their cultures, it would replace subsistence production with more profitable enterprises, including cottage industries. It offered women handicraft as part of vocational training and included a midwife, nurse, and woman social worker at each "action base." Women received lessons in food preparation, baby-care, and other aspects of domestic science, as well as training in health assistance and social work. The Andean Programme sought to bring the region's inhabitants into social insurance and trade unions as well as improve health and welfare. But it maintained the sexual division of labor.[63]

The ILO would continue to promote handicraft as part of self-employment initiatives throughout the world. Seeking its advice in 1961, the Inter-American Commission of Woman planned on exploring women's role in handicraft and cottage industry. The crafts provided "a national economic resource that offer women and families the opportunity to contribute to the raising of the standard of living of the whole population," the Latin American women agreed, with the added advantage of helping "to preserve the traditional . . . culture of the people."[64] In 1963 yet another study considered boosting what then was known as "women power" on very much the same lines as Miller's report: production and marketing systems, training, cooperative organization, improvement of working conditions, enforcement of laws, and participation of voluntary organizations, government, employers, and organized labor in promoting such processes.[65]

The African Advisory Committee was already looking into bettering the situation of independent contractors and own-account workers; that is, self-employed, petty trader, and family or household members, who often overlapped

with handicraft producers. However, the thrust of ILO Africa activities were initially more urban: to bring vocational education, labor standards, and social protection to the continent—to encourage modernization, in other words. By 1966 projects training women for clerical work were underway; some thousand women (a miniscule number given the overall population) had learned to work with typewriters, calculators, duplicators, and other machines. Training for hotel and catering industries also prepared women for the commodification of various aspects of housework.[66] For the next twenty years, the ILO evaluated the potential of various African countries for handicraft.[67]

Integrating Women into Development

In deciding to discuss the overall conditions of women workers at the 1964 ILC, the Governing Body reaffirmed that "the problems of women workers are indistinguishable from those of men," but that women face additional challenges from maternity, motherhood, and their "social status." Thus, it called for "an instrument" to address the balancing of employment with family responsibilities as part of a general consideration of the economic and social changes in women's place. Attention to reproductive labor, ILO officials assumed, was necessary to bring women most efficiently into the labor market. The Governing Body justified its agenda by referring to a claim by the head of the UN Special Fund "that the status of women was a sure indication of the level of a country's national development"—hardly a new truism, but one that took on added urgency as nations sought to tap womanpower to solve various labor shortages and promote economic growth. "Women workers in developing countries" emerged as a special problem within the overall question of the woman worker. It represented a response to UN resolutions on development and the advancement of women within such programs. Delegates from developing countries who sought to speak for women workers embraced this designation, as did those from the Global North who could deploy the category to distinguish their situation from that of the Global South.[68]

The report compiled for delegate deliberations, *Women Workers in a Changing World*, circulated throughout the UN system. As Gladys Avery Tillett, a Democratic Party leader from North Carolina who served as the US representative to the CSW, told Johnstone in 1964, "all of us concerned with women's status are very appreciative of the major role you have played in focusing new ILO attention on employment problems of women." She judged useful the materials on women in developing countries. She also found ILO "information" helpful for the President's Commission on the Status of Women, which Eleanor Roosevelt

headed until her death, to shape recommendations on social welfare and community services, like home aides and other household workers.[69]

Women Workers in a Changing World vacillated between universalism and the particularism that long marked ILO engagement with the non-male, non-industrial, and non-metropole. It ultimately reinforced the portrait of women from the Global South as distinct. "Problems of Women Workers in the Developing Countries" stood as a separate section, apart from "The Present Situation and Trend," "Employment of Women with Family Responsibilities," and "Administrative Arrangements for Handling Questions relating to Women Workers." The first section compiled statistics and offered general trends, concluding that women's employment was on the upsurge worldwide, but that discrimination and unequal opportunities for education, training, and treatment curtailed income. The "force of tradition and conservatism" impeded women everywhere, but the nature of those cultural impediments differed, as did the contours of economic life. The section devoted to developing countries emphasized an overall inability to provide social supports that coexisted with the new "urgency" toward "the development of human resources." If women in Europe and North America faced barriers, those in Africa, Asia, and Latin America had even higher hurtles. Their "needs and problems" were "vast and urgent. "[70]

Despite acknowledging variations in material and historical circumstances, *Women in a Changing World* listed a series of priorities shared across nations. These needs mixed improvements in human capital with social advancement: access to more and better education and training for women and girls, expanded employment opportunity beyond agriculture, "efforts . . . to raise the status of women in rural areas," inclusion of the self-employed in labor law, and completion of protective measures for maternity and overall social welfare. Some recommendations for developing countries paralleled those offered to women in industrialized regions, like promotion of equal opportunity, equal remuneration, non-discrimination, and expansion of job possibilities through training and fair treatment. As usual, training was a vague concept that veered into sloganeering. Other proposals accommodated to cultural expectations and existing sexual divisions of labor, as in the call "to develop suitable forms of vocational guidance, counseling and employment service assistance, adapted to the particular needs of girls and women in the country concerned and to the cultural pattern."[71] The section devoted to developing countries further emphasized the integration of women into national development. The subsequent resolution on "women in developing countries" garnered the support of women activists in the International Confederation of Free Trade Unions precisely because it reinforced the desire to bring women from Africa into their orbit, a challenging goal given regional politics and the paucity of women in organized sectors.[72]

FIGURE 3.2 A student at Dar Atayad, Syrian Arab Republic where the ILO trained carpet weavers, 1961. Photo from International Labour Organization, with permission.

Following very much the lines of the Office report, the 1964 ILC cast "women in developing countries" as a special type of women worker, who suffered from "particularly unsatisfactory conditions," as the Workers' Vice-Chairman Rosa Weber from Austria stressed.[73] The conference passed without opposition a separate resolution on "The Economic and Social Advancement of Women in Developing Countries." Introduced by governments from the Global South (Algeria, India, Iraq, Libya, Mexico, Nigeria, the Philippines, Sierra Leone, Tunisia, the United Arab Republic, and Venezuela), this resolution called upon

"developing countries ... to give special priority in their national plans to assisting women to integrate themselves into the national economic life." It suggested a strategy of gender integration, what became the hallmark of "women in development" (WID) theory and practice, asking for full inclusion in social security programs and non-discrimination in employment, while maintaining the customary sexual division of labor.[74] When it came to other resolutions, some European delegates questioned occupational segregation by sex as undermining gender equality. Only the resolution on women in developing countries held the idea of advancing women's status through eliminating cultural and social barriers with maintenance of appropriate work for women, trying to accommodate those societies with separation of the sexes. The ILO's own technical focus on income generation for rural women—its response to the resolution's article to improve "agricultural, cottage industries and marketing"—overshadowed a push for integration by pinpointing special needs in an action plan for women. It included a cautionary approach to reproductive labor, foreshadowing later efforts to improve women's unpaid family work through technology and limited social supports like child care. It would turn household labor into a source for income.[75]

The lack of opposition to this resolution on developing countries buried divergent standpoints on the advisability of part-time work. The United States, explained Government advisor Peterson, advocated such reduced hours, if fully under labor standards, as a realistic "utilization" of female labor power that allowed for the balance of care work and labor market participation. The male Liberian Worker delegate saw in women's part-time work a solution for staffing during peak hours in sales and transport to offset men's preference for full-time employment. But Worker delegates from Europe and Latin America rejected such a measure for offering employers an excuse to replace full-time workers, the majority of whom were men. Malagasy Republic Worker delegate Dorothée Raharison cautioned that part-time work "is not generally applicable in developing countries." It would just reinforce the marginality of women's employment. The Indian Government advisor Mr. M. Dube called attention to what came to be known as "Third World difference," asking, "How can we raise our standards regarding part-time employment when millions of people in the developing countries cannot find employment on any basis?" The persistence of under- and unemployment for men as well as women informed his stance. Dube judged their deliberations "to be rather unrealistic as far as the developing countries are concerned. They [proposals] seem to have been drawn up in the context of the conditions prevailing in highly industrialized countries where most people live in urban or semi-urban communities, the economics of which are characterized by labour shortage and where educational, child care and housing facilities, etc., are well developed." [76] Neither could the Committee on Women's

Work resolve the issue of part-time versus full-time employment. It took the ILC thirty years to pass (in 1994) both a gender-neutral convention and a recommendation guaranteeing coverage of part-time workers under the full range of labor standards and social protections.[77]

"Third World difference" turned into an explanation for the lack of worker or employer organizations to relieve the family labor of rural women. When it came to family care work, Raharison doubted the wisdom of having special legislation for wives and mothers, but agreed that crèches and other facilities, which women's organizations could establish, enabled equal opportunity. In contrast, Nigerian Government advisor Norma Nelson-Cole from the National Council of Women's Societies judged women's rights to be essential. Speaking in terms of complementarity, she declared, "I am a wife, mother, and a gainfully employed person and I do believe that man is the head of the house. However, I also believe that woman is the heart and that the one cannot function without the other . . . giving woman the rights she asks for does not mean she will suddenly turn into an Amazon warrior." Having rights would signal "that she is an integral part of a world labour force receiving her just reward with dignity."[78]

In its proposals, the ILO prefigured what feminist lawyers would call "family responsibility discrimination" as a barrier to women's equality.[79] To be sure, the male wage ideal still pervaded deliberations in the early 1960s. Take the comments of a male Spanish Worker delegate, who explained, "[O]ur goal must be to ensure that men will earn enough to live decently, to be able to bring home what the woman of the household deserves to have as a mother who perpetuates the human race and assumes the tremendous responsibility of bringing up our children and the no less important responsibility of distracting us from the worries that fill our minds when we behold the sometimes bad or oppressive conditions of employment." Peterson, in contrast, understood that "while the goal towards which some countries are striving is shared family responsibilities, for women workers in the world as a whole this is not today's or tomorrow's reality."[80]

The non-binding Employment (Women with Family Responsibilities) Recommendation, 1965 (No. 123), suggested an array of aids to maintain women's employment. Along with child-care facilities, necessary services included vocational education and jobs counseling geared to the entry or re-entry of women into employment, coordination of transport and school hours with work schedules, and public facilities to lighten household tasks.[81] The recommendation finessed employer reluctance to support guaranteed re-entry to jobs. Johnstone explained that to maintain women with children in the workforce, "society as a whole has to adapt realistically to a new pattern of needs in their work and life."[82] Women delegates at the ILC generally connected this recommendation to conventions on equal remuneration, the protection of maternity, and non-discrimination as

necessary for real equality. Peterson proudly explained that the United States had passed legislation that carried out the purposes of the equal remuneration and non-discrimination conventions (even though it would not sign onto them), the 1963 Equal Pay Act, and the 1964 Civil Rights Act (especially Title VII).[83] Some representatives offered a broader equalitarian claim. "[R]esponsibility for the children and the family is, in general, the same for the man as for the woman," explained Worker advisor Sigrid Ekendahl, Parliament member and former Secretary of the Swedish Confederation of Trade Unions. Disappointed in the form of the instrument (a recommendation rather than a convention), USSR Government advisor Raïssa Smirnova of the African Institute of the Academy of Sciences insisted that governments had to fulfill guarantees of women's right to employment. Smirnova would lead the ILO's Office for Women Workers' Questions in the early 1980s.[84]

At the same time, women in developing countries offered a reference point for those delegates opposing a recommendation on workers with family responsibilities. Given unemployment among men, some delegates rejected facilitating women's labor force participation. Assuming industrializing nations to be in transition from "a patriarchal, static society," a male Government delegate from Cyprus urged that women's entrance into the workforce occur "without too much disruption of the traditional family structures and without detriment to a woman's responsibilities and duties vis-à-vis her family and her children." A male Worker delegate from Italy expressed such sentiments more strongly: "In this developing world, development certainly should not mean the dissolution of the family." Against women's right to work, he posited the rights of families to women's labor and argued "for preparing and adopting efficient measures to lessen the economic necessity requiring women to seek work outside their homes." Though "the social emancipation" of women was a worthwhile goal, morality and social necessity should propel ILO instruments "with a view to defending the family in a developing world." The ILO's continued emphasis on handicraft and cottage industry, which allowed women to remain at home while contributing to the family economy, responded to such attitudes among member States.[85] Some consultants on women's issues recognized the dual position of women in society, holding onto continued training of girls in "the elements of home-making and home management," even as women would "prepare themselves for economic activity outside the home." Development was happening "too slow to give employment opportunities for all"; under such circumstances, women tended to fare worse than men.[86]

The discussion of family responsibilities in 1965 intermingled women's status with questions of global inequality. A Kenyan Worker delegate exemplified this trend when he used the occasion to repudiate racism and colonialism. "Women

workers, mostly in developing nations, need great help," he admitted. "There are laws that were enacted before and these laws have become very poisonous to our women. I know of a law in a certain country which says that a woman must earn less than a man, but if a white woman is employed together with an African black man, the white woman gets more and the black man gets less. This is happening in Portugal, South Africa and other places. . . . We refuse to accept this and we shall fight against it."[87] Such talk became commonplace in the 1970s when the UN system confronted South African apartheid and Palestinian dispossession with intensified urgency.

Sixteen years later, the recommendation on family responsibilities morphed into the Workers with Family Responsibilities Convention, 1981 (No. 156) and accompanying Recommendation No. 165. The impulse to change came from understanding that men should participate more in family labor, but also that equality should extend to those doing care along with other forms of work. The new recommendation updated the impact of family responsibilities on social security and unemployment and added both job relocation for trailing spouses and adoption of parental leave.[88] While some delegates claimed that discrimination derived from the sex of the worker, others argued that equality would be pyrrhic if employers could dismiss any worker because they had to attend to a child or other immediate family member. Justifying passage were ILO instruments that promoted "equality of opportunity and treatment for women workers," including the Declaration of Philadelphia, the 1951 equal remuneration and 1958 non-discrimination conventions, and the 1975 Declaration and Resolution for the UN Women's Year—as well as CEDAW, the UN measure that the ILO initially sought to block.[89]

The ILO against CEDAW

As the ILO was considering family responsibilities and pondering the plight of women in developing countries in the 1960s and early 1970s, the CSW was drawing up a declaration on the elimination of discrimination against women. The push in 1963 for such a document built upon the ongoing efforts for a UN International Convention on the Elimination of All Forms of Racial Discrimination, which passed in 1965. The USSR, Hungary, and Poland demanded that the CSW draft its own anti-discrimination instrument. Twenty-two nations from the Global South and Eastern Europe brought this request to the General Assembly. Poland presented to the CSW a draft declaration that imposed legal obligations to end discrimination, while the United Kingdom countered with general principles on political and legal rights similar to the Universal Declaration of Human Rights.[90] The ILO explained that it had no problem with a restatement of "basic

principles" in terms of access and maintenance of equality in employment, training, working conditions, and remuneration. It accepted appropriate reference to ILO instruments, but cautioned against duplicating existent measures and introducing discrepancies with legally binding obligations.[91] In 1967 the General Assembly approved a Declaration on the Elimination of Discrimination against Women that included general rights that suggested legal obligations, but did not mandate them.[92]

In private, ILO officials spoke of having to "defend our competence and ensure that the U.N. does not claim the primary responsibility,"[93] as was tried twenty years before. The USSR demanded additional consideration of "the social rights of women," including maternal and child welfare, protection of wage-earning women, and measures to relieve the double day. Market economies wanted no state interference with such concerns. India tried to weaken the marriage and family clauses. Most CSW delegates found the USSR proposals redundant because other UN entities addressed social rights. According to Johnstone, delegates believed "that such action [proposed by the USSR] was contrary to the purposes of the Commission . . . which existed primarily to abolish distinctions in the treatment of men and women in all fields, not to develop special policies and measures 'on behalf of women.' "[94] Johnstone in essence embraced a position consistent with legal equality feminism in order to uphold ILO conventions that embodied women-specific protections.

A confluence of factors pushed the subsequent drive for CEDAW: tepid response to the 1967 non-binding declaration, the growth of global feminisms, a twist in US foreign policy to retain prestige at the UN through promoting human rights, and the concerns of the non-aligned nations whose influence at the UN was at its height. US representatives would become central to the construction of CEDAW, though they often worked behind the scenes. Allies, like the Philippines, presented drafts and amendments to avoid pushback from political adversaries of the United States.[95]

Though a thaw in the Cold War may have helped the process, ILO officials still responded to state socialist nations with skepticism. Johnstone, a US citizen who had been with the ILO since the 1940s, dismissively reported in 1971 that "within the Commission the only members to urge a Convention during discussions on the Declaration have been those from the USSR and the socialist countries of Eastern Europe; there was no general support for the idea at all." She surmised, "The fact that the suggestion was also made at the Gabon regional seminar on women in economic life is an indication of [UN] secretariat influence: I am convinced that the participants did not originate or press the idea and that they did not have before them, orally or in writing, an indication of the ground already covered by existing Conventions."[96] These observations reflected the

institutional lens—what was good for the ILO—through which Johnstone made interpretations, rather than anti-Communism per se. She was willing to place the Women's International Democratic Federation (WIDF) on the ILO's list of registered observers from international organizations in 1968, a year after the UN restored its consultant status. That left-feminist organization "shows some real concern with the problems of women workers." Though it "is politically aligned," she admitted, "it does undertake activities related to I.L.O. concerns."[97]

During the 1970s, the UN Secretariat asked member States and specialized agencies to comment on the concept of a women's rights convention. While the CSW drew up drafts, the ILO sought to block a "catch-all" convention through back channels as well as formal replies. It offered procedural objections: What about conflicts and duplications with existing conventions that nations were legally bound to uphold? What impact would the ability to ratify UN instruments with reservations have on ILO measures that had to be accepted as formulated? The ILO feared creating disincentives for states to ratify its own conventions with their "more precise obligations," and it worried that wide coverage combined with unspecified terms when it came to social insurance, like "retirement privileges," would undermine ILO provisions without addressing nuances that were essential for equality. It noted that a general convention "would mean the transfer of international obligations from an organization in which employers and workers play a direct role in ensuring their observance at all stages to an organization in which they have no direct representation."[98] The International Confederation of Free Trade Unions would echo this concern when defending ILO instruments during a 1972 ECOSOC meeting, because "workers had participated in the elaboration . . . and they covered areas affecting workers most."[99]

Behind procedural concerns were substantive differences. Should occupations of a "dangerous and arduous nature" be without any protections? During the 1966 drafting of the declaration, Johnstone had reported, "There was the usual difference of opinion about protective standards (particularly as regards the night work of women), some taking the view that these were as necessary now as in the past, others the view that they should be revised and made more flexible." She was critical that the section on maternity benefits omitted the public funding and collective bargaining mechanisms that the ILO had long considered essential to avoid employer discrimination.[100] Nearly a decade later, she pinpointed the tension as "protection versus equality, with the USSR and others from this bloc proposing detailed provisions to protect women, especially mothers, and the developed countries of the west seeking a simple statement of principles . . . on the ground that protection of women as a special category, except for maternity, was an obstacle to equality of opportunity and treatment for them and led to discrimination against them."[101] Abstract norms of equality here substituted for concrete

standards, reflecting a more general tension in the convention-making process that delegated specifics to recommendations and national practices.

State socialist countries promoted their own form of legal equality, though they stressed the need for welfare policies to relieve the double burden of paid and unpaid labor that most women shouldered.[102] The remarks of a Hungarian Government adviser from the Foreign Ministry captured this complexity at the 1975 ILC: "[S]pecial attention should be given to working mothers and to women who are giving birth to the new generation," she declared, before questioning, "but can we bring about the *de jure* and *de facto* equality of women workers in this way, and thus contribute towards social progress and happiness for all mankind?"[103]

By the 1970s, many CSW representatives generally wanted equal standards for men and women, with women-specific protection limited to maternity.[104] Commentators used the idea that men should have the same protections as women, sometimes as an argument against the promulgation of CEDAW. In what might have appeared as an about-face on single-sex protections, the ILO's Committee of Experts on the Application of Standards objected to CEDAW because "the rights in question are of equal relevance to men and women, and there seems no reason why they should be guaranteed separately to one sex."[105] The UK delegate to ECOSOC in 1972 similarly discovered "an inconsistency in the fact that whereas the activities designed to improve the status of women were an attempt to make women the equals of men, the draft resolution was intended to grant women special protection." His Finnish counterpart objected to privileging only women with a yearlong leave after childbirth.[106]

The language emerging from the CSW sought to finesse competing discourses of maternal value, shared responsibility, equal rights, and non-discrimination. Drafters sought to balance the interests of "advanced industrial nations"— Sweden, Denmark, Canada, the United States, and France—which saw protectionist disadvantages lurking "under the guise of a fight against discrimination," with those of the USSR and its allies—Hungary, the German Democratic Republic, Cuba, and Guinea—and "developing" countries, which sought the elimination of discrimination but wished to recognize motherhood, reproduction, and women's social responsibilities. Hence, Tatiana Nikolaeva, USSR delegate to the 1976 meeting of the CSW, "considered the right to equality of treatment with men as regards working conditions to be unacceptable, since it did not take account of the physiological difference of women and their role as mothers."[107] In defending motherhood over equal treatment, Nikolaeva expressed what had become an apparent switch in the positions of the United States and the USSR. In the 1940s, Dorothy Kenyon, a New York City judge associated with the New Deal and labor feminism who served as the United States' first delegate

to the commission, defended the ILO and its women-specific standards.[108] By the 1970s, US women promoted legal equality. The USSR stressed substantive results rather than touting how equal women had become to men.

An interchange between the ILO and the USSR representatives during the 1976 drafting of CEDAW displayed these tensions, despite the USSR's apparent switch in position. The ILO supported an alternative text to the article on economic rights proposed by the United States. This text emphasized covering all workers under occupational health and safety along with guarantees of equal pay, equal opportunity, non-discrimination, and maternity provisions. The ILO explained that, "as far as the labour protection of women was concerned, ILO had requested Governments, in the light of scientific and technological progress, to reconsider labour protective measures on an individual basis, not on the grounds of sex." Its representative claimed "that labour legislation was now oriented towards labour protection of workers irrespective of their sex." But the USSR did not buy that analysis, calling out the ILO for having "omitted reference to the respective ILO conventions aimed at special labour protection of women workers."[109]

On top of this tension stood the persistent one between CSW and the ILO. The latter organization called for only the most general convention if there were to be one, highlighting to the UN Secretariat how its "texts emphasize positive aspects of equality of opportunity and treatment, while the draft UN convention aims at the elimination of all kinds of discrimination," essentially a negative approach. The ILO wanted "more scope to the need for change in men's role and attitudes to achieve equality and to their responsibility side by side with women in the upbringing of children."[110] It conceived of instruments less in terms of the gender of the worker than the conditions of the work, which meant that it could ignore barriers constructed around gender, race, age, nationality, and disability. Thirty years after the Second World War, the UN Secretariat judged the CSW more inclined to special treatment of women than the ILO.[111]

To include men as well as women, the ILO was already reconsidering occupational health and safety standards, including night and underground work. "We are perfectly conscious of the eventual drawbacks, incompleteness and outdatedness of some provisions of our conventions," it informed the CSW, but insisted that it alone had the technical competence and deliberative process to undertake revision.[112] The Office, though, could only move as quickly as its constituent groups. Calling together experts; consulting with governments, unions, and employers; and hashing out changes took years. Revised instruments came into force over the next decades, with the Night Work Convention, 1990 (No. 171) extending protections to men. But in that neoliberal moment, with labor standards crumbling, the new convention ended up undermining protection

through flexibility, thus condoning the twenty-four-hour/seven-days-a-week economy emerging in many nations.

Changing perspectives of men's roles would also impact questions of social reproduction. In 1966 CSW representatives embraced the Employment (Women with Family Responsibilities) Recommendation as "a great step forward in the field of women's rights" for providing the supports necessary for women to fulfill the right to work. Indeed, the CSW advised, "the efforts of the ILO should be concentrated on the problems of women with family responsibilities, and not on the question of women's employment in general, bearing in mind that it should be possible for both parents to continue working outside the home, without lowering the standards of the care of the children." Echoing the ILC debate that led to the recommendation, some cautioned "not to place female labour in such a special position on the labour market as to make equality of status for men and women more difficult to ensure."[113] This latter concern would dominate calls for an actual convention, which the ILO passed in 1981, as we have seen. This shift from women to gender came as the concept of gender mainstreaming reached the ILO. Gender mainstreaming dictated the opening up of jobs throughout an organization regardless of sex, which meant moving women into positions previously dominated by men.[114]

The final drafting of CEDAW occurred when the ILO was in flux. Johnstone retired in 1975, leaving the ILO without a seasoned representative to the CSW who knew the players and the procedures. Some in the ILO's Personnel Division regarded her retirement as a loss of expertise, but others saw an opportunity during "the year of the women," as one official put it, "to appoint someone younger who might be more aware of the new trends in the field and of the aspirations of younger generations of women," which could "show that the Office wants to embark on a dynamic policy in this field and is ready to attach more importance to the problems of women and young people from the developing world." In a blatant display of discrimination, he did "not think that the problem of developing new polities for the employment of women and young people should be dealt with any more by old ladies." Despite a request that she leave by April, the Director-General kept her on until after the ILC's Declaration on Equality of Opportunity and Treatment for Women Workers and the UN conference in Mexico City.[115]

With Johnstone's departure, amid International Women's Year (IWY), the ILO could no longer hold off change; equality discourses triumphed within international circles. However, FEMMES (Office for Women Workers' Questions), the unit on women reorganized in 1976, sent to the CSW not a new generation but Marion Janjic, a Swiss national who had worked in the Office since the 1950s. Janjic did not see what the fuss over equality was. She was new to the commission

when the delegates finalized the wording of CEDAW. Janjic "never claimed to understand conflict between conventions," and thus "did not intervene" when the USSR introduced an amendment in the drafting committee that the ILO's Legal Division found threatening to existing conventions. This amendment may very well have been a maneuver around the ILO, for it affirmed the validity of other international instruments under CEDAW, "if they provide for more extensive rights of women." Such a clause implied that the new UN convention would supersede ones with lesser rights—presumably the case with the ILO's women-specific protections. Felice Morgenstern from the ILO's Legal Division judged that the outcome went terribly "wrong" and lambasted Janjic. Though Morgenstern and other officials involved with the development and application of standards strategized to rid the CEDAW of this offensive clause, they failed.[116] CEDAW passed the General Assembly in 1979, with the possibility that it could invalidate women-specific conventions.[117]

The new UN convention brought together non-discrimination with positive social and economic rights. Addressed to the actions of states rather than individuals, CEDAW incorporated earlier instruments on women's political rights and independent nationality, along with elements of the previous UN Declaration. It connected the fulfillment of equality between women and men to the eradication of poverty, racism, colonial occupation, and war, thus advocating a new international economic order and peace in line with state socialist and non-aligned concerns. Specific articles covered law, political participation, education, employment, health care, rural women, and marriage and family. It called for the elimination of the traffic in women and prostitution. Article 11 on employment echoed many ILO pronouncements in affirming an inalienable right to work; the right to employment opportunities, equal remuneration, social benefits, and occupational health and safety; and the prevention of discrimination on the basis of marriage and motherhood. It asked states to periodically review protective laws "in the light of scientific and technological knowledge."[118] For industrialized as well as developing nations, changing laws to conform to CEDAW would prove daunting. Spotty enforcement revealed the limits of such instruments. However, the CEDAW Oversight Committee evolved into a forum where grassroots activists held governments accountable for women's rights—a positive outcome.[119]

Toward Mexico City and Beyond

A new global feminism pushed for women's advancement within the UN system and member nations. Emerging as more women entered both higher education and the workforce, spurred on by the contradictions in women's lives

between their social contributions and legal impediments, groups of women demanded inclusion and non-discrimination. University-age women especially sought liberation from reigning gender norms and restrictions, like the double sexual standard and heterosexual marriage. Multiple networks influenced each other, though a truly global movement only developed after the UN's Mexico City conference in 1975. Connections flowed South-South, as well as North-South and East-South. The Mexico City meeting followed in the steps of earlier international formations, like the WIDF and Pan-American Union, to bring the status of women and conditions of their lives into focus as a worldwide concern.[120]

In the mid-1960s, members of the CSW proposed UN-sponsored seminars on women's civil and political rights.[121] In 1972, WIDF, then led by the Finnish parliamentarian Hertta Kuusinen, suggested a "Women's Year" (the IWY). This proposal came at an opportune time, when women within the UN bureaucracy were pressuring the new Secretary-General to appoint women to higher positions.[122] That same year, the CSW and the Commission on Social Development organized an experts meeting on "The Integration of Women in Development," which featured discussion of the 1970 *Woman's Role in Economic Development* by the Danish civil servant Ester Boserup. This book shaped how development practitioners thought about the impact of technology and training on women's status in Africa and Asia; it became essential to the emerging academic field that evolved from the concept of "women in development." Boserup accepted the inevitability and benefits of modernization but contended that women ought to have the resources to profit from such processes.[123] Women activists and experts in and outside of the US government in 1973 successfully lobbied for a policy that further emboldened the worldwide women's movement—the Percy Amendment to the Foreign Assistance Act, which "mandated" that aid programs include women.[124] Regional meetings and other UN conferences further set the stage for the first UN World Conference on Women in 1975.[125]

The ILO maintained its combination of equality and difference. It finessed this dichotomy in the June 1975 Declaration on Equality of Opportunity and Treatment for Women Workers, promulgated for the UN Conference. This statement named as unacceptable restrictions on equality, but then qualified what counted as restrictive: "Positive special treatment during a transitional period aimed at effective equality between the sexes shall not be regarded as discriminatory."[126] FEMMES would refer to the declaration and accompanying resolutions as "The New Mandate."[127]

Again the ILO constructed "women in developing countries" as a distinct category. Though discrimination existed everywhere, delegates insisted, many industrialized nations accepted women's employment out of the home and

sought to address work and family balance for both men and women. But, as Tamaro Diallo-Touré, a Government adviser from Senegal and the reporter for the Committee on Equality for Women Workers, explained before the 1975 ILC, "In the less developed countries, the position is different because of their economic, sociological, demographic and other problems." Reflecting the relational analysis deployed by delegates from former colonies, she warned that "these countries are dependent on the foreign world, ... they are not very industrialized and that agriculture is predominant." This political economy explained women's concentration "in family activities, that is to say, in farming, home work, small industry or a family business." Lacking education, women find themselves "in an inferior position where they are particularly exposed to the risk of exploitation."[128] The 1975 declaration would serve as a charter for women everywhere, but she especially invited "developing countries" to have rural women gain "an equitable share of all resources available for development and are closely associated, with development planning and implementation."[129]

The Group of 77, the UN's "non-aligned nations" from the Global South, took advantage of these discussions to assert their critique of the existing world order. They proposed a New International Economic Order.[130] As Mexican Government advisor Mrs. Esponda de Torres explained, unemployment, underemployment, and exclusion from social benefits were made, not natural. She announced, "The women workers of the Third World are fully aware of the fact that their opportunities and sources of employment cannot be opened up to them while systems of exploitation exist which limit their possibilities." Members of the drafting committee from the Central African Republic, India, Niger, Nigeria, and Senegal underscored deteriorating conditions in agricultural regions from "the introduction of the market economy, which had a damaging effect on women's traditional status without providing them with opportunities for education, training or employment." The USSR Government advisor Smirnova, then editor of the WIDF's *Women of the World*, pledged support for "developing countries which are striving to establish their sovereign rights, to use their own national wealth and heritage and at the same time to lay sound economic foundations for the solution of many social problems, including the establishment of real economic and social equality for women." To the chagrin of the United States, Canada, Great Britain, and Employer delegates, the ILC adopted a preamble clause to its IWY declaration that reflected the position of the non-aligned nations embraced by the Soviet Union and its allies. Asserting redistribution of the world's wealth as a precondition for improving women's lives, the resolution declared that "establishment of a new social and economic order ... will contribute towards ensuring better employment, conditions of work and life for women, especially in developing countries."[131]

The same tensions played out in Mexico City at the World Conference of the International Women's Year. Mexico's ambitious President Luis Echeverría questioned the efficacy of asking "to recognize solemnly that all women have an equal right to education and employment if these requirements cannot be satisfied in most parts of the world." Instead, this champion of the New International Economic Order asserted that "to speak of equality of rights and opportunities for women is to speak of equality of responsibilities in the task of overcoming hunger, ignorance and ill health, and eliminating the ever present threat to the political, economic and cultural independence of nations." Such official decrees subsumed women into the overall class or nationalist project. A similar conflict in emphasis between women's rights, including abortion and sexual self-determination, and class-based economic justice, including support of mothers, pervaded the parallel NGO "Tribune" meeting. Despite clashes over a range of geopolitical issues, this meeting also embraced a development ethos, stressing employment of individuals rather than social welfare. By bringing together government officials and UN bureaucrats with grassroots activists, it launched global feminism even while disrupting the universalism of woman as a category and an object/subject of social justice.[132]

Following Mexico City, the ILO again stressed integrating women into the development process. It continued to promote vocational guidance and training, employment and self-employment, and self-organization into cooperatives and trade unions.[133] This inclusion strategy, shared with feminists leading UN efforts, not only encompassed allocating equal resources to women and accounting for women in national development plans, but also having women participate in decision-making. Presence through participation constituted a goal of US women when it came to the UN and its related agencies; liberal and development-oriented women's groups stressed equality, opportunity, training, and anti-discrimination. [134] In creating a forum for women from the Global South, however, the Decade for Women allowed for a distinct feminism to emerge that demanded action to combat structural and intersectional inequality and discrimination. This feminism recognized the centrality of reproductive labor for national development.[135] It linked poverty to macroeconomic legacies of colonialism, reflecting a feminism beyond the hegemonic strand in the West that emphasized individual agency and culture.[136]

The First Expert Group Meeting of the newly formed UN Asian and Pacific Centre for Women and Development exemplified tensions within global feminism. Such feminists judged the ILO, though a many-sided organization, by programs most relevant to their own agendas. In December 1977 the UN Centre gathered a distinguished (and elite) group of women to formulate a program of work "on the Identification of the Basic Needs of Women." Although many

had trained at prestigious Western institutions, they brought local knowledge and committed advocacy to the project of women and development. Included were Jain, whose Institute of Social Studies advocated for poor women workers; Kumari Jayawardena, the Sri Lankan political scientist of Third World feminist thought; and Rounaq Jahan, a Bangladesh political scientist who in the mid-1980s would staff the ILO's Programme on Rural Women. Organizing the effort was the head of the UN Centre, the Australian femocrat and development pioneer Elizabeth Reid, who had played a key mediating role between the NGO Tribune and the formal UN meeting in Mexico City.[137]

Reflecting the feminist consensus at the time, the resulting "Guidelines for a Work Programme" issued a clarion appeal for assessing development "from women's perspectives" through holistic rather than fragmented programs. The ILO wasn't alone in offering "basic needs" as a strategy to improve the lives of the world's peoples, but it became identified with it. The concept of basic needs, these feminists argued, was inadequate, because it left intact the sexual division of labor. A focus on "material objects" alone, as with basic needs, "might still-birth the social revolution which women need—the change in community attitudes and the structural changes in power, economic, social and psychological relations—which would enable them the freedom of choice." They saw women's movements encouraging such "social revolution." To go beyond basic needs, then, these experts called for empowerment of women and their collective mobilization. Only then would control over "lives and bodies," or self-control with choice, be feasible. Replacing "basic" with "critical," these feminist experts called for "provision of basic goods and services, conscientisation [consciousness raising], attitudinal change, mobilization and structural change" as applicable to "all oppressed groups," of which women were the largest.[138]

The framework of women's liberation generated an ambiguous legacy for Third World women. On one hand, the Western-oriented feminism of the 1970s understood individual lives as products of larger structures and historical legacies. On the other, by elevating paid over unpaid labor, production as distinct from social reproduction, the new feminism sought to bring women into employment without necessarily challenging the configuration of global economic inequalities.[139] Its emphasis on choice and individual freedom offered a template that neoliberal planners would draw upon by ignoring the collective and social context of the mobilization that liberation required. Such a realization came later. In 1977 the assembled Third World experts understood women's status as comingled with that of the social whole. The question remained whether the ILO could conceive of the woman worker as a revolutionary force.

BY THE SIGNING of CEDAW in 1979, the ILO had changed. With Morse's departure in 1970, the United States had lost its controlling role. Its brief withdrawal during the 1970s made the ILO more dependent on having donor nations fund specific projects. Heading FEMMES was Ekaterina Korchounova from the Soviet Union, who had served as a USSR adviser to the ILC in the mid-1950s. She was excited to attend meetings of the WIDF, which Johnstone had bypassed for being political rather than technical. Smirnova succeeded her in 1983.[140] By then, no longer committed to maintaining outdated protections, the ILO listed CEDAW among the tools available to fight workplace discrimination.

4

Reproduction

"RURAL WOMEN ARE often the most forgotten participants in the economy," lamented economist Lourdes Benería in a 1977 internal memo on ILO efforts to implement women's equality. "Rather than being 'marginal' participants in the stream of economic activities," she asserted, "they are an 'integral' part of it." After all, "they work long hours in domestic and agricultural jobs, and . . . perform es-sential activities to the economic system, namely those related to production of foods and services, either in the fields or at home, and those related to the repro-duction of the labour force."[1] They processed rice and other staples into meals. They collected firewood and greens and fetched water. They cared for animals as well as people. Rather than lacking employment, they suffered from overwork. But when the market defined development, their essential subsistence activities lacked value; they became uncounted and thus unrecognized. They remained in-visible in the global surge of women's labor force participation, which constituted some 35% of all workers by the mid-1980s.[2] In standard accounting, rural women became casualties of underdevelopment and victims of traditional society.

The Spanish-born Benería, then a professor at Rutgers University, was one of a group of talented women economists who ran the ILO's Programme on Rural Women during its first decade, which coincided with the UN Decade for Women (1975–1985). Through research, project construction and evaluation, training, and other assistance activities, the program sought to counter impediments to-ward women's advancement. It insisted that "technical assistance without the necessary knowledge base can be disastrous."[3] Beginning with the insight of Ester Boserup that development programs often worsened women's status by providing technology to men and displacing women's previous forms of income generation, ILO researchers went beyond Boserup. Not all of them embraced the name "feminist," but their analysis advanced feminist perspectives within devel-opment circles. They probed social relations within the household, the centrality of women's domestic and non-monetized work for the economy, and the signif-icance of both for capitalist accumulation. They often became outraged at the

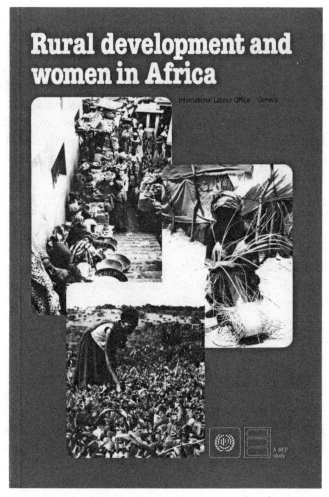

FIGURE 4.1 Cover, *Rural Development and Women in Africa* (Geneva: ILO, 1984). Photo from International Labour Organization, with permission.

exploitation of poor women and objected strenuously when their unit received less funding than required.[4]

In highlighting reproductive labor—which this book has defined as all the activities that sustain people daily and generationally through meeting bodily and emotional needs, replicating culture, institutions, and ways of being—the program recast development as a concept and practice. Its staff learned how domestic labor directly facilitated capital accumulation. Such work "provided the necessary backstopping needed for maintaining the low wage levels absolutely essential if the goods produced can effectively compete in the world market," explained Pakistani Zubeida M. Ahmad, who earned a PhD in economics from Harvard in 1949 and

spent nearly thirty years at the ILO. Unrecognized reproductive labor allowed for the low wages of the global supply chain.[5] Reproduction came to be understood as a form of labor when work replaced employment as the key term of reference.

ILO development feminists rejected the standard counting of the household as a unified unit. As Berkeley-trained economist Martha F. Loutfi from the United States, who staffed the Programme on Rural Women from 1980 to 1985, noted, "If one's view of economic processes and production stops at the household and does not consider the individuals inside ... improved standards of living will be lacking." Arguing that "inequality and inequity between male and female household members have been expanding in much of the world," she proposed that the ILO act to enhance gender equality. It wasn't just that men had greater resources, but that there was little incentive to use hard-won cash to purchase kerosene or charcoal when women could still gather wood for cooking. Giving cash to men rather than to women too often led to falling "nutritional levels ... while wristwatches, transistor radios and bicycles (all largely utilized by men) find their way into the household," claimed Australian development expert Ingrid Palmer, who initially set goals for the program in the mid-1970s.[6]

The program was a prefigurative initiative that could operate below the radar precisely because its small staff in Geneva belonged to a larger branch, Employment/Rural (EMP/RU), of the Employment and Development Department (EMPLOI), a key technical component of the Office, whose head gave critical support. It sought to change projects "from planning development for a target population (in this case, women of the poorest strata, especially landless peasants) to the active involvement of these groups in the design and implementation of income generation and employment schemes." According to Ahmad, the goal was "to work with the women rather than for them" and to bridge " 'basic needs' " and " 'felt needs.' " Combined with social or communal services, including child care, laundry, food processing, health, and family planning, such projects could counter the usual "overwork" that modernization brought when "women are obliged to combine wage or self-employment with their already very heavy burden of domestic responsibilities."[7] Its long-term aim was nothing less than changing the definition of the worker, "to abolish the separation of the so-called 'productive' work from 'reproductive' work, eventually resulting in defining 'housework' as work."[8]

In the process, the program incubated foundational studies in the field of women and development that sought "to increase knowledge about the actual condition of rural women" and raise "consciousness in respect of women's conditions and inequality between the sexes."[9] It convinced the Nordic countries, Germany, and the Netherlands to fund its projects, which included, in

1979–1980, "impact of land reform on women in Ethiopia; the situation of rural women engaged in household industries (beedi making) in India; female migrant workers in labor-intensive industries in Singapore; the effects of rural modernization on sex roles in Morocco; and, women working on plantations in Sri Lanka." It would study the putting-out system in greater detail, energy resources throughout Africa, single-headed households in Latin America, massage parlors in Singapore and Bangkok, and rural organizations throughout Asia.[10] (See Appendix 2.)

In providing "guidelines and principles for policy makers and planners," the program offered an alternative model to mainstream development, even within the ILO.[11] It not only stressed the significance of reproductive labor, but, as Ahmad's remarks emphasized, promoted a participatory methodology. Eschewing desk studies reliant on statistical data, its staff commissioned fieldwork and surveys by women researchers from the very Third World (the contemporary term for the Global South) places under investigation, some of whom also conducted educational and consciousness-raising workshops. Program staff sought to decolonize knowledge by going to rural women themselves as experts on their own lives, generate action research with local women's NGOs, and empower poor women collectively through enhancing leadership and decision-making skills.[12] They had the precedent of the Rural Workers' Organisations Convention, 1975 (No. 141) and its accompanying Recommendation (No. 149), which protected self-organization. Under circumstances where the sexual division of labor existed alongside of "class oppression," insisted Loutfi, "[t]he more space that is allowed for the participation of poor rural women, the closer they will come to obtaining a fair share of life's benefits."[13] The Programme on Rural Women pushed the boundaries of the possible by having project teams interacting with women members from organizations of the rural poor, aided by a "special fund" written into grants for such collaboration.[14]

Such community engagement would become a standard feminist practice in the social sciences.[15] The ILO thought of itself as "probably the only UN agency which is promoting" participatory research.[16] At the time, ILO procedures for technical cooperation seemed restrictive in requiring government partners and approval from national authorities.[17] In hindsight, autonomous NGOs, promoted by foundations and development practitioners to maneuver around the state, proved less sustainable than envisioned.[18] Empowerment without structural change or political power was not enough to redirect the rising tide of deregulation and privatization; indeed, it would become apparent that empowerment shorn of its collective framework reinforced the neoliberal ideology of individual self-help.

ILO development feminists viewed the path to gender equality as distinct for poor rural women in the Global South compared to women in industrial nations, whether market or state-socialist. Like feminists elsewhere, they argued that "inequality and inequity between male and female household members have been expanding in much of the world."[19] Rather than promoting universalized platforms, they offered solutions from the context-specific standpoints of poor rural women. Thus, they would find themselves at loggerheads with FEMMES not just over institutional domains, but also over priorities for ILO action, including the meaning of equality itself.[20] These two units within the ILO both focused on the woman worker. While FEMMES was to coordinate the activities of all divisions, the Programme on Rural Women concentrated on a specific constituency. It was to share its findings with FEMMES.

In this regard, the old conflict between the women-specific and gender neutral, the location-specific and universal, took new institutional and programmatic forms. Many feminists from industrial nations sought inclusion or gender mainstreaming into structures defined by men, though others argued for targeting women even if the sexual division of labor remained intact. The parallel move to gender mainstreaming during the UN Decade for Women would lead the ILO to revise its instrument on workers with family responsibilities to make it gender neutral, even if women still undertook the bulk of such labor.[21] Despite claims to embrace "all categories of workers," the ILO still concentrated on labor force participation for women in legible occupations. It cast reproductive labor as a barrier to work rather than as work itself. Family labors, even with mechanical aides, had intensified with new norms for cleanliness and attentiveness, remaining a drain on female employment.[22] Relief for rural women in the South, then, required additional effort, including access to cash income. Equal remuneration remained a goal but was rarely relevant to regimes of informality and self-employment. Projects for rural women became part of the fight for world employment rather than an aspect of the struggle to end discrimination on the basis of sex that dominated most universalist agendas.

The program noted the sexual division of labor as a reality, even as it exposed the ways that the male breadwinner/female housewife model undermined income-generating projects directed to women. As previously noted, the housewife role led developers to promote handicrafts, often without markets, rather than addressing "basic roles in agriculture."[23] An earlier generation of labor feminists offered measures that allowed women to undertake their two roles, in the family and in employment, but focused more on urban workers than rural ones. Some trade unionists deployed worker education as a vehicle for democratic participation, but most development programs were top-down rather than bottom-up.[24] Socialist feminists like Benería illuminated the double, and

sometimes triple, oppression of women that came from exploitative labor under capitalism, but which also existed in non-democratic planned economies.[25] Reflecting these divisions were ILO discussions over "[e]qual opportunity and equal treatment for men and women in employment" that marked the end of the UN Decade for Women in 1985. That women in developing countries had distinct concerns never precluded inclusion in labor standards, as the next chapters show. Campaigns for recognizing reproductive labor as work like any other, despite unique characteristics, would challenge the very protocols and organization of the ILO. The Programme on Rural Women laid the groundwork within the ILO for informal sector struggles for visibility and rights waged by home-based and domestic workers.

In explicating the vision of the Programme on Rural Women, this chapter turns to the moment of its formation. Three impulses were key: the ILO's institutional response to the 1975 UN World Conference on Women that highlighted employment (discussed in the previous chapter); the recognition in 1976 of women's centrality under the "basic needs" agenda of its World Employment Programme (WEP); and the attempt of its staff to decolonize research. These efforts underscore the weight of institutions forged under colonialism and capitalist globalization, as well as inequalities between men and women—struggles that formed the subject of investigation even while shaping the knowledge produced.

Intellectual Context

Scholarship is never neutral; reigning paradigms derive from their social circumstances, of which available ideas and discourses as well as modes of circulation and financial support form a larger matrix of creation. In staffing the Office and its various branches, the ILO sought to hire jurists and economists—who were thought to be scientific and the least subjective in the positivist framework of post-WWII/Cold War social science. In the early 1970s, modernization theory still held sway, but theories of underdevelopment from the likes of Andre Gunder Frank and Walter Rodney were challenging its reign. As with many disciplines, a radical branch from the left asserted itself, drawing in feminists and New Leftists, and reviving Marxism of various sorts. Some departments—for example the New School, American University, and University of Massachusetts in the United States—became known for their heterodox approaches. Nonetheless, they were a distinct minority. Institutional economists and political economists with a theoretical bent actually found their foothold in the profession unstable with the rising prominence of monetary and rational choice theory. Tensions within the field of economics played out in debates over development.[26]

Neither was there a single perspective on women. Mainstream feminist economists usually thought from a less theoretical basis, both more culturalist and more market-driven than radical economists like Benería and the women she commissioned to undertake studies for the ILO. Development economists and practitioners had discovered the rural woman as inefficient from her antiquated methods and hand tools, labeling her a drag on production.[27] A growing number of women working within the UN system defined women in development (WID) as "simply the taking of women into account, improving their status, and increasing their participation in the economic, social, and political development of communities, nations, and the world."[28] They pushed for legal equality, equal rights in divorce, child custody, property holding, credit, equality, voting, and civil rights. A focus on women, however, could let men ignore the ways that gender operated, relegating gender to a separate box labeled "women's issues," while the equality approach did not necessarily reduce poverty without tackling other structural factors.[29]

WID, according to US formulator Irene Tinker, derived from initiatives in the early 1970s that linked women who had engaged in fieldwork for various international and national agencies in the Global South. These networks solidified in Mexico City at the UN World Conference on Women. They understood "that globally most women, especially poor women, work. But this economic value of women's work was overlooked because subsistence and farming activities . . . or processing food, are not paid and so are not included in national accounts."[30] To development planners, women were invisible, and so projects often made their situation worse by increasing men's power over them and removing their access to income generation. That was Boserup's lesson. With the notion of inclusion, liberal feminists rarely disavowed modernization; instead, they wished to move its boundaries to encompass women. Critics, like Benería and other leftist WAD proponents, charged that liberals failed to account for the roots of women's subordination in the sexual division of labor and the gendered discourse of development itself. A later generation turned from Marxism to deconstructive thinkers like Michel Foucault and Judith Butler, naming their field "gender and development." In the 2000s, transnational feminist critics returned to a materialist analysis, questioning disembodied forms of post-structuralism.[31]

Critiques of mainstream development began in the 1970s with feminists who sought women's liberation from traditional patterns of male dominance in the private as well as the public arena, especially in the realms of intimate relations, the household, and marriage. Such scholars and activists situated the position of women in terms of larger socioeconomic forces. The leftist feminists among them further questioned the legacies of dispossession and appropriation, the theft of primitive accumulation, from colonialism and imperialism. The Subordination

of Women Workshop (SOW), located around the Institute of Development Studies at the University of Sussex, United Kingdom, started from Marxism but did not end there. According to SOW, "the theoretical object of analysis can not be women, but rather the relations between men and women in society," which required analysis on marriage as well as the market.[32] Among researchers that Benería convened during her stay at the ILO to help shape the program were SOW member Kate Young, a research fellow at Sussex, and Maria Mies, a German located for many years in India. Mies became part of the Bielefeld school of radical feminist thinkers who emphasized the interaction between patriarchy, capital accumulation, and colonialism. She produced work that would prove foundational.[33]

The ILO Context

The initiative to empower rural women in the Global South began at an inauspicious moment. The United States stopped funding the ILO, formally withdrawing from the organization at the end of 1977.[34] The loss of US monies was crippling, since they constituted about a quarter of the budget, which then amounted to nearly 144 billion dollars.[35] Added to that blow was the mid-decade worldwide economic downturn. Internal memos spoke of "their present crisis," not only for the ILO, but also for the UN system. "The financial situation has affected all of us and there appears little likelihood that it will let up this year," a staff person told a prospective consultant in 1976.[36] Although the United States would return in 1980, the ILO became more dependent on UN special funds and grants from donor countries or institutions. Extramural funds would pay for projects.

Though committed to technical cooperation in the Third World/Global South, the ILO increasingly lacked the resources to compete with the World Bank or the Organisation for Economic Co-operation and Development (OECD). The ILO found itself stymied in an era of structural adjustment. As one official warned in 1985, "unless the ILO can be actually associated with [World Bank] policy reforms and structural adjustments in planning and assistance, it will be left with little scope to provide policy advice to its member countries . . . even in such areas as employment, training and labour relations. In such a situation, its knowledge and experience would at best be used to execute special projects, the main thrust and contents of which may well be predetermined elsewhere."[37] Though never a unified entity, with multiple kinds of programs housed in the Office, the ILO sought to remain intellectually relevant as a neoliberal policy consensus emerged within international agencies, which the United States still dominated. It had always contained multiple constituencies, employers as well as workers. Thus, it came to promote a variant of liberalism for the Global South

encapsulated by the phrase "self-organization and self-employment," even as it reaffirmed commitment to social insurance, labor market regulation, and decent standards of work. It remained state-centered rather than market driven, and social rather than individual in orientation. That orientation was fitting for an agency representing often conflicting groups, some of which spoke in terms of efficiency, growth, and market power.[38]

Back in 1969, the ILO marked its fiftieth anniversary by initiating the WEP, solidifying the turn toward technical cooperation and away from standard setting. It focused on full employment, harkening back to the 1944 Philadelphia Declaration. The WEP combined research, analysis, and operational programs that drew the link between unemployment and underdevelopment. Partnering with experts all over the world, WEP staff promoted employment-generating strategies for poor countries as the best way to reduce poverty. "Basic Needs" defined this approach, which advocated for jobs that would provide "certain minimum requirements of a family for private consumption: adequate food, shelter and clothing, as well as certain household equipment and furniture" and "essential services provided by and for the community at large, such as safe drinking water, sanitation, public transport and health, educational and cultural facilities."[39] In other words, public and private reproduction, which basic needs allowed for, was central to enhancing income-generating production. As Ahmad would put it, "Basic needs strategies, in particular, should by definition be women-oriented strategies."[40]

The ILO certainly was not alone in efforts to generate income from women's reproductive labors. The UN Food and Agricultural Organization (FAO) provided food for household consumption if women would use family lands to produce for the market as part of its World Food Programme. But the WEP was skeptical of such exchanges as a form of welfare. It insisted on employment as the surest path to ending poverty. The problem, as Boserup first highlighted and feminists of all sorts understood, came from undermining women's traditional subsistence labor, thus deteriorating their economic position and status even further by encouraging sectors dominated by men.

Pushing for a program on rural women was economist Keith Griffin, a specialist on poverty and inequality in developing societies. He encouraged a flexible, non-dogmatic interdisciplinary approach for an area without standard procedures or robust theories at that time. "It may be that the issues they raise are unimportant, or even invisible to those who see the world through different lenses, but questions of the 'official' perception of women and their work (via census classifications of women), class differences in rural areas, social factors which affect the motivation of rural women, etc. are central to the problem" of development. To WEP director Louis Emmerij, a Dutch economist who

complained about a dearth of research on women, Griffin shot back, "The 'thrust' of WEP—in terms of its professional staffing, the consultants it hires and the nature of the research it sponsors—has been preponderantly male. I thought it was agreed, however, that this was one of the things that needed to be changed quickly."[41]

Born in the United States, Griffin left Oxford, where he had received his PhD and was a fellow and tutor, to head the ILO's Rural and Urban Employment Branch in 1974. From fieldwork in Pakistan, he had come to reject the standard "trickle down" notion that economic growth would uplift the poor. "If one were serious about reducing poverty, . . . one would have to tackle it head-on," he believed. As an architect of the ILO's basic needs approach, he proposed that "development policy should be given not to accelerating growth in general but to satisfying specific 'basic needs' of the population, such as the needs for adequate food, clothing and shelter as well as basic education and primary health care"—that is, the building blocks for social reproduction. State intervention was essential; the market could not adequately "allocate resources" or "redistribute income in favor of the poor." Rather than in opposition, equity and growth could occur through job creation which provided adequate income that the informal sector suppressed.[42] Raising labor productivity included tackling the problem of the woman worker.

To proceed, the WEP first hired Ingrid Palmer on temporary money from the Swedish International Development Agency (SIDA).[43] Trained as a neoclassical economist at Australian National University, Palmer had taught in Australia at Queensland and in Britain at Birmingham and Hull, where she had been a fellow of the Centre for Southeast Asian Studies. She had taken "an eighteen month sabbatical" to finish two projects, one of which was on the Green Revolution for the United Nations Research Institute for Social Development (UNRISD). Interested in women's health, she had specialized on the impact of changes in rice varieties on nutrition in Indonesia. She would spend her career consulting on development issues for international agencies and organizations.[44] Palmer laid the basis for the Programme on Rural Women through concept papers, proposals, commissioned research, and overtures to scholars in Africa and Asia. (Benería would extend the program to Latin America.) After a year, she returned to the United Kingdom.[45]

During her time at the ILO, Palmer made the case for addressing the situation of the "majority of women in developing countries" rather than the minority in the "formal, highly-visible employments where the employer is easily identifiable and can be influenced by the law." Equal rights legislation—"equal remuneration, maternity leave, anti-discrimination, and other protections"—were "the natural demands of women who are in calling distance of conferences,

ministries and the judiciary system." But they were inappropriate for those in the informal sector or self-employed. She claimed that "if the majority of African women are agriculturalists self-provisioning for the family from land husbands own or have the usufruct of and are struggling to meet their family responsibilities, then it is difficult to see how this kind of legislation is a priority at all for them until other things have happened." Her position papers would more graphically portray rural women as drudges, burdened by overwork, incessant childbearing, and intensive reproductive labors—what she named "physical oppression." Relying on a sensibility central to 1970s radical feminism, she would analogize the relation of men to women within the household as a " 'north-south' situation of unequal exchange" similar to the "dichotomy ... existing between the developed and developing worlds."[46] During a period of skepticism about the efficacy of standard setting for development, Palmer offered that "the solution to this distress lies in devising a new strategy of development rather than in enacting legislation."[47]

Such an analysis was both patronizing and pragmatic. As a later debate between gender theorist Butler and philosopher Martha Nussbaum underscored, that poor women in the Global South struggled to fulfill their basic needs did not preclude their right to rights, including rights of sexual freedom and gender identity.[48] Likewise, equality should apply to rural women no less than to urban ones. The question revolved around what path led to equality, and was equality enough when the goal was a higher standard of living and collective determination of social life.

Central to Palmer's position was a critique of the ways that the ILO and other agencies produced knowledge, both in terms of methods deployed and the people who wielded them. "At present the ILO is not geared to satisfying this new awareness," she charged. "Persons [staff] involved in establishment of standards by conventions or legislation, in training schemes, or in handicrafts promotion for women workers are scattered thinly throughout the ILO." Research on fertility and labor force participation was too "mechanistic" to address substantive issues. Thus, the ILO needed a unit to facilitate an exchange of ideas for integrating "investigation and action" through pilot projects that could provide models, be a center for information for nations and within the ILO, and even identify areas for legislation. EMPLOI, Palmer argued, was the place for this, because it combined research and action projects, covered central specialties (such as migration, technology, and demography), and housed the basic needs strategy, "which must of necessity include women's welfare and work conditions."[49]

However, EMPLOI suffered from "ethno-centrically based desk research," Palmer charged, that could not truly capture women's situation. Economics—reliant on official statistics and GNP measures that excluded much of women's

labor (for not being monetized)—undercounted women's work and its value. What was needed were fieldwork and evaluation of development programs, with yardsticks derived from women's expressed concerns. Palmer called on economists to become ethnographers to craft new frameworks based on going to and listening to the women involved. They should engage in investigation rather than research. Putting the study of rural women in a larger technical branch might overcome the consequence of having placed women's issues with FEMMES directly under the Director-General, the relegation of women to "an exotic minority group."[50]

The Programme on Rural Women was Palmer's institutional solution, and she provided a long list of areas for investigation. Most international efforts sought to lower fertility, improve skills, and instruct women in nutrition and health. Palmer proposed to ask the women involved to discover the impact of commercial crops on their economic role, technology on their agricultural work, and migration and absence of men on their households. She would probe water-carrying and food storage practices, self-organization and social activities in villages, and the use of commercialized products, like baby foods.[51] Research could study women's place in the basic needs strategy, the role of land inheritance and other factors in agricultural work, the nature of discussions of family planning, and women's position in urban and informal sectors. She further recommended evaluation of ongoing projects in handicraft and rural development programs, as well as cooperatives, along with monitoring legislation and assessing the UN Decade(s) of Development. The new unit should engage in promotion activities touting women's contribution to economic life; determine the evolution of their work in various sectors with modernization; and pinpoint remedies for "low productivity, poor conditions of work and other undesirable features of women's employment."[52] Instead of "flat vignettes of kinship relations and some of their effects," she encouraged portraits of "what it is like to be a poverty-stricken, tired, anemic, overburdened rural woman, and how this woman sees her options. . . . Her physical conditions of work, which need to be appreciated and which are the proper concern of the ILO, have not been described in developmental literature." In other words, researchers had to gain "authentic material . . . straight from the mouths of rural women" to overcome existing stereotypes and avoid creating new myths.[53]

Despite their value, Palmer labeled reproductive labors as burdensome. Women's provision of food, water, and fuel were productive, economic acts, she insisted, but rural women required better means to carry out such tasks. Palmer, like Boserup, would redirect technology to lighten women's work, distributing solar cook stoves for more efficient and productive labor—and thus free women's labor power to be redeployed for earning income. In future years the program

would support projects on energy and cooking technology. However, technology was only a means. Palmer also wanted to understand women as full people—how they looked when talking, whether they laughed, what they thought, and what ideas they had for improving productivity.[54] As with the overall basic needs approach, Palmer recommended participation by those involved in decision-making, but questioned how to make that happen without equalizing power relations within the household.[55] Rejecting integrating women into men's interests, she called for placing women's interests alongside of men's "in the *design* of higher productivity employment."[56]

Women investigators were the best choice to carry out the proposed research. "The ability to identify with a group of persons comes from experience of common discrimination," Palmer claimed. A development scholar like herself should have known better than to deploy such universalistic rhetoric, but it derived from the same assumption that an earlier generation of women reformers drew upon—the belief that women were devoted to service to other women: "While many men are sympathetic to the relief of women's extra physical and social oppressions, far fewer men are committed to doing anything about it." This economist noted, "In the absence of appropriate intellectual training, hunches have to be played and a real use of imagination and empathy made. Those who are merely sympathetic have a much harder time doing this than those who are committed." While the ILO should recruit qualified women, going beyond the usual channels to feminist professional associations of anthropologists and economists, "it will not be easy to find suitable women." Her letters to international agencies, university departments, research centers, and government ministries generated only scattered interest. Perhaps reflecting on her own peripatetic career, she added that "where recruitment of professionals has been by informal channels women are not often taken seriously as candidates. They often do not move in circles where the subject of appointment is raised and men rarely think of making any effort to see that they are informed."[57]

Nonetheless, Palmer began the process of commissioning research from women through contacts in Nairobi, Manila, Dakar, Copenhagen, Stockholm, and London, as well as India and the Philippines.[58] She attended conferences abroad, including "Women and National Development" at Wellesley College in June 1976, papers from which appeared as the Autumn 1977 issue of *Signs*, the foremost journal in the new interdisciplinary area of women's studies. This was a period when US researchers were focused on the Third World but, to the chagrin of women from those regions, were not serious about addressing "the third world within."[59] With the aid of Griffin, Palmer received $43,000 from the Swedish government to fund two projects, one on Bangladesh, the other on Nigeria.[60]

Monies remained tight, connected to success in pitching projects to donors. Program development was slow. Palmer reported to a colleague at the University of Nairobi, stating, "New winds are certainly blowing through the agencies but they have not yet led to firm commitments." Discussions with donor governments and agencies remained at the "memoranda exchange stage."[61] Despite proposing a multiyear program with an increasing budget for field studies, consultants, and seminars totaling around a million dollars, the program would operate on a cobbled combination of donor monies and meager allocations from the ILO's regular budget.[62]

Palmer remained self-reflective, explaining to a correspondent from the Agricultural Development Council, "My own inclination is against the pure, static analytical research and in favour of thinking along lines whereby the researcher might be part of the catalytic process itself so that she could analyse what might be, as well as what is." She was well aware of the dilemma of whether they were "studying what women can do for development or what development can do for rural working women."[63] To a colleague researching Ghana, she lamented the possibility that moving women out of the home would lead to a backlash from their men. "For us to burn their fingers would create extra obstacles for the second time around. And quite right too! After all, they have to work out their own economic and emotional survival tactics in a situation over which they have precious little control."[64] As she advised a graduate student from London off to conduct research in India, "I am convinced that the difference lies in the way (male) economists have always looked at household work. In the end, of course, it doesn't matter a hot [*sic*] what you call an activity, but raising consciousnesses about concepts of production and clarifying ideas of individuals contributions to the total supply of wanted goods and services help to change developmentalists' ideas on what development is all about."[65]

Without using the term, Palmer was forging a feminist methodology by refusing to see subjects as objects and creating a participatory process. She spoke of "the feminization of the development process."[66] Yet by casting her analysis in terms of women as a sex class, she universalized the particular. She believed that substantive improvements would emerge from accounting for domestic labor even when regarded not as subsistence production, as it usually was, but as household work. Benería was certainly among those who placed reproductive labor at the center of her analysis. Palmer may have lacked the language that Benería would bring from her involvement with women's groups in New York City and from her involvement with other radical economists, but she understood the necessity of recovering the economic contribution of reproductive labor, empowering women themselves.

Fostering Research That Mattered

Lourdes Benería did not arrive at the ILO as a feminist economist. "Despite my increasing interest in women's issues, I thought of myself as a development economist and as a labor economist," she confessed. "It was really the ILO job that finally shifted the main focus of my work towards gender issues." She began teaching at Rutgers in 1975, a recent PhD from Columbia. Helen Safa of the Anthropology Department told her about the ILO opening. Given that her then husband was about to lose his academic job in New York City, Benería decided to apply. Rutgers was reluctant to approve a leave, delaying her arrival, and at the end insisted that she return for the Fall 1978 academic year if she wanted to retain her position there. Benería finally set off for Geneva after classes at the end of May 1977. "Geneva was difficult at the personal level, but it was very interesting professionally," she remembered. There she gained direct experience with the Third World and discovered the inadequacy of economics "to ask and analyze questions that I felt were important for a program on rural women."[67] She would reflect that "it was not enough to look at labor market factors to understand women's incorporation in the labor force; other aspects of this process needed to be taken into consideration, such as the limitations placed on women by cultural practices affecting gender constructions, women's and men's work and women's mobility." So she turned to anthropology, sociology, and other interdisciplinary approaches for answers.[68]

When Griffin hired Benería, for which he had received an exception to a recruitment freeze, the World Employment Conference had just concluded. But he soon came to believe that the prospect for serious action was disintegrating. In Fall 1976, he resigned "in protest against proposals to relegate the plan [programme of action] approved by the World Employment Conference to a lesser priority." Indeed, the allocations to carry out the conference's mandate would amount to only 5% of the ILO's regular budget for the next biennium.[69] He explained to the British newspaper the *Guardian* that "the day of the white expert going out to tell the black man what to do is thankfully coming to an end." Instead, "the ILO can best contribute by providing analyses and research to help the developing countries solve their own problems." But opposition, especially from the United States, was stymieing that "reorientation."[70] His position reflected a shift in the UN system that put the capitalist economies on the defensive by both advocating for a more equitable division of the world's resources, but also by placing the power to make decisions about their own needs in the hands of Third World/ Global South countries.

Griffin felt compelled to reveal to Benería, who was still waiting for Rutgers to approve a leave, that "the situation at the ILO in the last two weeks [of November]

has been ghastly." The British and US Worker representatives attacked him at the November 1976 meeting of the Governing Body, higher-ups revoked his permission to go on a mission and attend a conference abroad, and the Director-General was asking for changes that his team would be "likely to find unacceptable" on a major project on landlessness in the Philippines that threatened to delay if not suppress publication.[71] "When I spoke with you on the telephone four weeks ago and urged you to come, I did so in the belief that despite the protest of my resignation it still was possible to do honest and useful research at the ILO and have that research published," he explained. "I no longer am confident that that is so." He warned, "This is not a good time to be a progressive person in the ILO, particularly if one refuses to keep one's mouth shut." On the other hand, his successor, Dharam Ghai, "is a truly splendid person," while "rural women remains a high priority area, as does rural development in general."[72] Ghai, an "Asian" Ugandan, became a fierce advocate for the program, pushing for resources and advancing its principles. Previously the head of Development Studies at the University of Nairobi, he left the WEP in 1987 to direct UNRISD for a decade before retiring.[73] He firmly believed "in the oppressed speaking for themselves."[74]

Behind ILO problems was "'our'" government, Griffin insisted, but Benería herself would find that the ILO's sensitivity over its relations with the United States also made for a tense atmosphere. The Washington Office complained to Geneva about her ILO affiliation being listed in the program for a non-ILO economics conference in 1977, because she was "attending the meeting in a purely private capacity." However, she was also on a supported mission to discuss collaborative studies with researchers on Latin America who happened to be at the same New York City event. Though she specifically had requested that her affiliation be omitted, she then had to ask the program chair to write to the ILO "to set the record straight."[75]

By then, Benería was deep into planning a consultants' workshop that would bring together researchers from around the world to discuss rural women and development. Soon after her arrival, in June 1977, she presented the case not only to members of EMPLOI but also to the staff of FEMMES. They agreed that her unit should compile work already being done and coordinate such findings, identify gaps for future research and "stimulate or launch such research," advise governments on the basis of such findings, and consider the "impact of internationally financed projects on status of women." These undertakings would occur in relation to various resolutions, including those on basic needs and "the proposed draft Convention on the Elimination of Discrimination Against Women," which had an article referring to rural women "in the lower strata" upholding their right "to <u>participate</u> fully in the formulation and implementation of rural development plans and the right of women to equal treatment in land and <u>agrarian reform</u> as

well as land settlement schemes."[76] Benería reached out to the authority of the International Women's Year and the ILO's World Employment Conference to underscore the necessity to study "women's participation in domestic production," "women's participation in the subsistence sector and family agricultural production," "rural women and wage labour," and "rural women's organisations."[77] Her proposals to ILO superiors became less academic, more specific and policy oriented, and generally feminist, but without the Marxist feminist terms of her more academic writings.

Long-term ILO staffer Antoinette Béguin, who served as chief of EMPLOI, facilitated the workshop that occurred in May 1978. She justified special consultants by stating that the "Standing Panel of Consultants on Women Worker Questions" was too large and lacked appropriate specialization.[78] She convinced the Dutch Foreign Ministry to fund the travel of thirteen researchers. Along with ILO staff and a few other observers, these academic experts set an agenda "for research, policy and action" that reverberated for the next decade. They further sought "to make the ILO's work better known to individuals and institutions concerned with rural women in the Third World."[79]

The assembled group included scholars whose work proved foundational for the study of women and development. Joining Maria Mies, still researching in India, was Gita Sen, an Indian feminist economist then teaching at New York's New School for Social Research. Sen would co-author with Benería key critiques of Boserup and would become a founder of the Third World feminist group Development Alternatives with Women for a New Era (DAWN) in 1985.[80] Also present was Moroccan sociologist Fatima Mernissi, who had published *Beyond the Veil: Male-Female Dynamics in Modern Muslim Society* in 1975.[81] Mernissi's conference paper was not included in the subsequent publication, *Women and Development: the Sexual Division of Labor in Rural Societies*, edited by Benería.[82] Neither were those of African scholars Filomina Steady from Sierra Leone, who then taught at Boston University, and Senegalese social scientist Marie-Angélique Savané. Best known for her cross-cultural analysis of Black women, Steady would chair the Africana Studies Department at Wellesley College between 1999 and 2009; she also held a number of UN positions.[83] Savané, a founder of the Association of African Women for Research and Development, would produce a technical cooperation report for the program in 1983. Ethiopian development specialist Zenebeworke Tadesse published her article in the collection; she served as the first executive secretary of Savané's group and had a prominent career with the United Nations.[84] Social anthropologist Kate Young, whose essay derived from Mexican fieldwork, was a mainstay of the Institute of Development Studies at Sussex, though she later left for foundation work in London.[85] Also present but not in the collection were Eastern

European researchers: Barbara Tryfan, who served as the long-term head of the Department of Rural Sociology at the Institute of Rural and Agricultural Development at the Polish Academy of Sciences, and Ruza First-Dilic, a sociologist from the University of Zagreb.[86]

Other anthology contributors also became distinguished academics. A new anthropology PhD at the time, New Zealander Elizabeth Croll ended her career as vice-principal of the School of Oriental and African Studies at the University of London. Her work on women, feminism, and socialism in China was pathbreaking.[87] Carmen Diana Deere, who recently had earned a PhD in agricultural economics from UC Berkeley, had begun a distinguished career at the University of Massachusetts, Amherst, where she remained until moving to the University of Florida in Latin American studies in 2004. An important figure within feminist economics, she held many visiting teaching and research consultant positions in Latin America, while publishing on rural poverty, peasantry, and women and land rights. Her collaborator, Colombian sociologist Magdalena León de Leal, became a prize-winning author of books on Latin American women, the sexual division of labor, and the new international division of labor. León de Leal's studies on domestic workers formed the basis for their inclusion in Colombia's social security system.[88]

Along with sharing empirical research, the consultants grappled with four central topics. Under "Modes of Production, Agrarian Structures, and Women's Work," they addressed the question, "Should we expect that more equalitarian productive structures will automatically result in equality between the sexes?" Croll argued that socialism had facilitated "women's access to productive resources," but that other factors, especially within the household division of labor, still led to a subordinate position. A case study on Yugoslavia found that women remained in a "marginal" position. The second set of discussions on "Sex Roles and the Division of Labour in Rural Economies" emphasized the "under-rated" quality of women's agricultural and domestic labors.[89]

Workshop participants considered two additional topics: "Effect of the Penetration of the Market on Women's Work Load," and "Rural Development and Women." León de Leal and Deere traced the ways that capitalist agriculture impacted the labor process and the sexual division of labor, creating a reserve army of women wage workers who still performed subsistence and family maintenance. Capitalist penetration transformed structures of production, Mies showed, so that middlemen rather than women in India determined the crafts they made. Most significantly, the gathering questioned the meaning of "integration of women in development," because women were already part of communities and economies. The real issue was "how" and under what sorts of conditions their participation occurred. These scholars wondered whether

Bangladesh or China would set the course for the future: the former generated low-wage incorporation; the latter sought economic transformation that would uplift women.[90] In the late 1970s, left-feminist circles cast China as an alternative socialist formation in which women held up half the sky.[91] Reporting on the meeting, Benería asserted, "it is far from clear that wage labour 'liberates' women. To be sure, it might provide a source of financial independence, but to the extent that women are exploited and subject to wage and other types of discrimination it represents the creation of a new form of subordination which must be understood as such."[92]

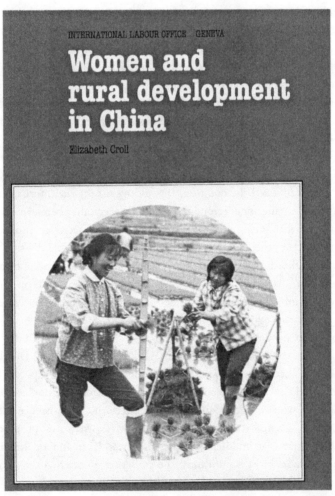

FIGURE 4.2 Elizabeth Croll, *Women and Rural Development in China* (Geneva: ILO, 1985). Photo from International Labour Organization, with permission.

In calling for special women's programs in local, national, and international arenas, the consultants asked the ILO to maintain the work of the Programme on Rural Women. They predictably validated the promotion of research to develop "clear analysis" as a prelude to action. There was need for country studies and reports on specific topics, such as the means of control over labor in agrarian production, both legal and de facto; women as agricultural wage workers, even if seasonal or part-time, and the nature of wage discrimination; the activities of traditional women's organizations; better estimates of women's economic contributions in and away from the home; and women's own responses to oppression.[93] This agenda shared with Palmer's a focus on the household and women's reproductive labors. It differed from her—and Boserup—in its concern with the accumulation process, or the ways that capital grows and concentrates. A month later Sen noted, "It was one of the most stimulating and productive meetings on the subject that I have any knowledge of." She "hope[d] it provides a strong impetus for further work on women—rural and urban—at the ILO."[94] Dissemination of this research and later papers occurred at regional workshops in Latin America, Africa, and Asia.

What kinds of women workers emerged from these case studies? As we have seen, the ILO cast "women in developing countries" as a special kind of woman worker, as difference's other. A synthesizer like Palmer portrayed the rural woman as a drudge, whose reproductive tasks became more difficult with technological changes that redistributed control over the means of production to men. Structural analysis predominated among the authors in Benería's anthology, which the ILO published with Praeger in 1982. Researchers sought the facts of women's work rather than their subjective experiences. Chapters presented matter-of-fact findings without emotive language, but contributors on occasion highlighted the dignity and agency of women over their subordination. The rural woman emerged as a resourceful survivor, willing and able to perform tasks necessary to maintain her household.[95]

The case studies charted shifts in the sexual division of labor, underscoring its variation over time and place. Sen, for example, compared labor supply in two regions in India impacted by the Green Revolution to show how in one "the narrowing of the range of tasks done by women . . . and the relatively large surplus army of labor" led "toward a reduction in women's employment," while the break-up of plantation obligations required purchase of more items for daily life. Scavenging for fuel and water took women further away from home, "involving more labor, time, and effort." Simultaneously, women became the most militant agricultural workers, organizing "against their oppression." In the Sierra Mexican village studied by Young, capitalist reorganization of production and consumption disrupted subsistence economies, generating a different pattern: girls were

redundant, migrating in their early teens to become domestic servants, while young men remained longer on the land.[96]

Puncturing myth, these studies cast secluded women as workers. Richard Longhurst from the University of Sussex charted men's and women's work without explaining why the practice of seclusion increased over time in Muslim Hausaland in northern Nigeria. Women's income earning, including selling food, cleaning, and hair dressing, extended domestic activities. Mies argued that seclusion among the Kapu caste of agriculturalists in southern India "had changed its character," turning women into "domesticated housewives and workers who produce for the world market." Ideologically, they were " 'woman sitting in the house,'" whom men thought just "eat, doing nothing," but whose labor power men thought they owned.[97]

During a time when some Western feminists were celebrating women's culture, the Third World woman worker maintained her own admirable sphere in these accounts. Longhurst caught the economic benefits of women's friendships with other women, but not their affective content. Singaporean sociologist Noeleen Heyzer, on the other hand, captured how friendship groups countered the difficult conditions and authoritarian supervision that young Chinese Malaysian migrants faced in Singapore's factories. They broke rules by wearing bright colors, leaving their hair long, and taking time to return home for festivals. Despite engaging in such acts, this semi-skilled workforce was a docile one, kept in place by fear, a culture of obedience, and lack of alternative work.[98] Mies particularly emphasized women's self-organization and the "women's culture" in the villages of Andhra Pradesh, where women would share songs and stories as they labored together in fields and households.

Decolonizing and Policing Knowledge

The consultants' meeting was only one attempt at diversifying the face of research. Benería actively participated in the decolonization project that African researchers promoted at a December 1977 workshop in Dakar, Senegal. Palmer had recommended to Branch Chief Ghai that attending such events would allow Benería to "correct any imbalance of her interests towards Latin America" and allow the ILO to make contact with the best of African women scholars "before they are snapped up by Rockefeller, USAID, etc." But Benería needed little prodding. She sought to "establish contact with them in order to (a) know what they are involved in (note the very interesting objectives of the programme); and (b) investigate the possibilities of co-operation."[99] She first attended a workshop organized by FAO in Accra, Ghana, where around twenty-five traders, though illiterate, "participated very actively by explaining their own problems

and commenting on some of the papers which were translated to them into their two local languages." Benería highlighted their contribution in a meeting more notable for making contacts than for the quality of the papers. In contrast, well-known and respected researchers, like Savané and Tadesse, came to Dakar for "African Women and Development: The Decolonisation of Research." There they "launched" the Association of African Women for Research and Development, which gained "close ties" with the continent-based Pan-African Council for the Development for Economic and Social Research. So many women expressed interest in collaborating with the Programme on Rural Women that Benería judged the problem would be finding funds, not researchers.[100] A 1985 compilation of studies commissioned under the program showed the majority of seventy-five publications involved women from the Third World, including Africa.[101]

Benería continued Palmer's task of expanding the network of researchers. She explained to Mies that the program sought "to facilitate and promote the functioning of women's organisations so that women can collectively express their own vision of what they need and organize their actions." Evaluating Mies's research proposal, "Market Economy on Women's Productive and Reproductive Work in the Rural Subsistence Sector in India," Benería admitted, "I am writing to you about a problem that we are facing. We are in the process of reaching as many women from third world countries as possible in our research programme on rural women. In your case, would it be possible to include one (or more) collaborator(s) in your study? Or could a part of the study be carried out say by an Indian woman?" The funders wanted to involve "as many non-Western women as possible."[102] Reported Ahmad, "The main problem, if there is one, concerns her [Mies] nationality. As far as I know she is a German married to an Indian, a professor at Hyderabad University." But Mies spoke Hindi "well so that during our field trip in the tribal areas in India she was questioning the women in the villages without the use of intermediaries."[103]

Mies found local collaborators. She reported to the ILO that "it was absolutely necessary that the field investigators and research assistants were women, because rural women will not speak freely and openly to male investigators from the city." An additional problem came from the reduced mobility of middle-class women with academic credentials, still subjected to "patriarchal norms that women have always to be under male protection."[104] In the end, she recruited "two young women, Lalita and Krishna Kumari who were courageous enough," as she would characterize them, "to live in the villages among the lace-making women and share their life." A founder of a pioneer feminist organization in the area, Lalita spoke the local language; she communicated politics through song, a medium that historically has proved quite powerful among laborers of all types. These students "had enough enthusiasm, empathy and commitment to the cause

of women's emancipation to be able to establish a relationship of trust and friend-ship between the lace makers and ourselves."[105] Such local researchers indeed were rare. In Latin America, "most research on women is carried out in <u>urban</u> areas by <u>urban</u> women," complained Mexican sociologist Martha Roldán, who briefly staffed the program in 1979. A proposal by researchers "willing to leave Belle Horizonte to live in the countryside during the period of field work," she noted, was a rare find.[106]

Going to the women, sitting "with them in front of their mud houses," Mies, Lalita, and Krishna Kumari sought to close the gap between researcher and researched. "First the lace making women did their own research on us," she recalled. "'Who are you? Are you married? Do you have children? Where do you come from?' They began to talk about their work, the lace making as well as their housework . . . several of them also told us freely about their husbands and men in general." Over thirty years later, Mies remained "impressed . . . by the openness and clarity of their thinking," reflected in the life histories that she gathered.[107] The separateness of men's and women's work and social lives allowed her team to chat with the women. When the men were around, "they either acted as mouthpieces or as interpreters for the women."[108] But the lace makers had their own instrumental goals; they "were very keen themselves to discuss their situa-tion and their problems with us and asked for our help." A 1985 report on the program boasted that "dissemination of the ILO's research findings" on their ex-ploitative conditions—that is, Mies's work—encouraged the National Union of Working Women to organize the lace makers.[109]

Ahmad recognized this methodology as "participatory research." It became a means to promote self-help and self-reliance through collective action, an alter-native to structural adjustment and other market-based or neoliberal responses. Rather than behaving as a detached observer, the participatory researcher en-gaged in "a joint inquiry" with local people, "a partnership in which the dis-tinction between the researcher and the researched does not exist." This process allowed the researched "to clarify their own understanding of their problems and helps them to take decisions on difficult issues." Some 3,000 lace makers decided to form their own cooperative organization and secured 1,000 loans; with access to credit, new designs adapted from Chinese samples, and direct marketing to Western consumers, they improved their position in relation to the middlemen contractors who previously had rewarded their labor with a pittance. Some commentators proposed removing production from the home and placing the women in workshops under formal labor standards. In that way, it was thought, the women could gain the identity of worker as a first step toward collective ac-tion. The women already acted collectively, Ahmad countered. The women had breached the home barrier to obtain worker identity.[110]

Dialogue workshops became a standard practice, bringing together researchers, workers, and government officials. A 1983 workshop in Kathmandu amplified women's voices. According to Ahmad, it "created quite a stir . . . never before have policymakers and high level officials been exposed to a face to face dialogue with poor rural women, who could not only intelligently describe their problems, but could even coherently argue against the suggestions put forward by two high-level (male) officials on the integration of women into men's groups." The women "gave very concrete reasons on the need for separate programmes and action groups for women."[111]

This kind of fostering targeted the poor, including tribal women. The program was well aware of class differences within rural regions. Reporting on a 1979 meeting in the Philippines, Ahmad explained that most participants "were from urban-based organisations and they were inclined in their statements to lecture to their less fortunate rural sisters and advise them on how to overcome their problems. . . . It was essentially a community development or social welfare type of approach, with no appreciation or understanding of the feudal class structure which burdens rural society generally, and women, in particular." She concluded that "poor rural women may actually be worse off as a consequence of interference by the do-gooders who are converging on them from all directions. Substantial sums of money are now becoming available for rural women's projects and women's organisations all over the world are becoming increasingly conscious of this." But too many of these projects reinforced the advantages of the better-off women in an area. In contrast, the ILO sought "to encourage and assist organisations of poor rural women struggling to fight for their rights." It would evaluate "development programmes by governments and women's organisations," Ahmad concluded, citing "handicrafts and other income generating activities [that] could prove disastrous in the long run, especially if dependent entirely on foreign and touristic demands."[112] She recognized the problem with promoting handicraft that the ILO itself had encouraged. Microfinance as a poverty alleviating strategy responding to but compatible with corporate controlled global supply chains differed from these early experiments in worker control.

The Politics of Knowledge

In funding Mies's research to nearly $10,000 from Swedish monies, the ILO played midwife to a pathbreaking study, *The Lace Makers of Narsapur*. Ghai facilitated an affiliation with the Administrative Staff College in Hyderabad to conduct research.[113] ILO staff encouraged Mies to write a separate book on the home producers. Ghai argued that "because of the wide range of themes, richly illustrated with historical material and personal interviews . . . and its

methodological contribution," a book-length work was appropriate, beyond the anthology essay.[114] The ILO disseminated the findings in a working paper, and then arranged for outside publication through Zed Press in 1982.

Not everyone at the ILO was happy with Mies's particular mixture of Marxism and feminism. In the ideological context of a "neutral" ILO, trying to balance market, state socialist, and postcolonial economies, some staff objected to the terms in which Mies cast her analysis. A later review suggested that Mies twisted her data to fit her Marxist framework and distorted what the women wanted through a "messianic" message that asked the women to "renounce their view of themselves [as housewives] as a dangerous illusion and recognize that they are exploited."[115] Initially, Benería raised questions that displayed her adherence to mainstream social science standards—like asking about the number and representativeness of interviews—even as she promoted the need to question the adequacies of official data, analyze the relationship between productive and reproductive work, and probe the rationales behind a given sexual division of labor.[116] Going over the essay produced for the 1978 consultants' meeting, Benería explained, "My anthology is viewed as 'a contribution to knowledge' not necessarily with 'action-oriented' prescriptions ILO style, but we still have to get it through an ILO reading committee." Thus, she advised:

> I think that you could say the same things without sounding as explicitly Marxist as you do. My impression is that, as the paper is written now, we would have problems in getting it through. Yet I think that your thesis can be just as clear even if you mention Marx a few less times or find different substitutes for the word 'capitalism.' I know that it is a nuisance to do that; I find it restraining, but to some extent it is possible and you should take this for what it is worth to you.[117]

Despite reluctance to make changes, protest on "terminological exercises to obfuscate matters," and appeals to Ahmad to intervene with Benería, Mies eventually revised her chapter for the anthology.[118]

A few years later, Director-General Francis Blanchard, a Frenchman who during his career as a global civil servant championed both technical cooperation and human rights, objected to the description that Zed placed on the cover of *Lace Makers*, causing consternation and much discussion in the Advisory Committee on Publications. His reaction perhaps explains the "over-zealous" response of the Advisory Committee "in suggesting changes" to a second manuscript that derived from Mies's research.[119] Political scientist Rounaq Jahan, then heading the program, reported to Mies, "Some quarters of ILO's tripartite constituency have recently objected to an emotional [i.e., political] use of the

term capitalist picked up in some ILO publications. Hence the careful scrutiny of the publication branch." EMP/RU colleagues found "this controversy ridiculous." Still, Jahan requested "minor" substitutions of the word "capitalist" and asked Mies to "understand the particular constraints a tripartite body such as the ILO operates under." To this Mies replied, "The ILO is an organisation of the United Nations, not of the capitalists. Moreover, its aim was to defend the interests of the workers." To change the word "capitalist," she argued, "seems to be very much in the line of Orwellian Newspeak." ILO funding, the amount Mies underscored as only a third, "does not give the . . . right to demand that I should sacrifice my theoretical and political integrity," she insisted.[120] The Chief of the Policy Reports Branch refused "to be apologetic" about Mies's analysis. Taking refuge in scholarly standards of seriousness and robust empirical support, he added, "in such cases [of exploitation] we should not hesitate to call a spade a spade." An official from the ILO's India branch reminded distractors that *The Lace Makers* was "so widely quoted in other ILO material." The second monograph, *Indian Women in Subsistence and Agricultural Labour*, would appear in the ILO's Women, Work and Development Series, and, like its predecessor, it was in such great demand that the Office ran out of copies.[121] Those who sought to police Mies's Marxism gained little traction, since the question of home-based labor had entered the ILO's agenda, as the next chapter considers, dramatized by her pioneering research.

Mies was not the only researcher whose analysis the Director-General and other gatekeepers sought to tone down prior to publication. In the 1980s, most ILO staff still believed that commercial sex was "on the fringe of the ILO's competence," and thus not worth the risk of negative publicity or pushback from governments implicated in the "flesh trade."[122] But Ahmad and Loutfi, with the support of Ghai, disagreed. They supported the study of Thai economist Pasuk Phongpaichit on rural women who migrated to Bangkok from the agricultural regions of Northern Thailand that were on the losing end of market-based development. These women entered the city's flourishing exotic tourist and sexual services sector as masseuses. Phongpaichit found that they "were engaging in an entrepreneurial move, . . . making a perfectly rational decision within the context of their particular social and economic situation," and that the working conditions of the massage parlors offered "an environment often safer and more comfortable than other forms of organized prostitution" for they operated without pimps. The women worked in the vicinity of each other, which gave an added layer of protection. Ghai endorsed the preliminary working paper, released in 1980 as *Rural Women of Thailand: From Peasant Girls to Bangkok Masseuses*, as "a highly publicized but under-researched dimension of women's work."[123]

Others had their doubts. According to one detractor, "the sensitive nature of the subject could lead to trouble; a similar report, on the harlots of the Lebanon, published by UNESCO some 20 years ago was taken up by the popular press in the United Kingdom and used to criticize the Organisation (waste of tax-payers' money, etc., etc.") Another commentator thought the conclusion would generate reaction from "an alert US Government official and probably the Employers' group" due to its critique of Thai development policy "under the tutelage of the United States," rather than from its portrayal of prostitution. Such a reaction, however, could not "be a decisive one," he claimed, "otherwise the ILO would never publish anything not palatable to particular governments." While there would be attention from the popular press, no one could be sure of its tone; the ILO might even be praised for "courage to study a sensitive problem."[124] The United States had just returned to the ILO, and no one wanted to risked another withdrawal of its funding.

In calling the work "informative and insightful" and "original and pioneering," Ghai defended his feminist staff, who had lobbied for release. But even he agreed that parts of it required redrafting, as was typical for any manuscript.[125] The Director-General, who "took a personal interest in this matter," eventually approved publication after the manuscript was revised on the basis of his comments to remove "sensitive or offensive" passages. No official signed the "Preface," which appeared under the name of the division. Perhaps Ghai did not want to appear to usurp the prerogative of the Director-General, given his interest, to introduce the report—which was floated but not acted upon.[126]

The ILO released the report in part because the original working paper generated much press, including an unauthorized condensation published by the Southeast Asia Resource Center in Berkeley, California, from a copy sent to them from Bangkok.[127] It did not want to appear to have hidden anything. Nonetheless, removed from the published version were detailed passages that blamed commercialized sex on Chinese merchants, Thai generals, the US military, and German travel agents. However, Phongpaichit kept her overall economic analysis, which saw a solution only "in a massive change in the distribution of income between city and country, and in a fundamental shift in Thailand's orientation to the international economy."[128]

Palmer's Binary

Ingrid Palmer classified programs for women into two distinct types: standard setting and equality measures for urban women in the formal economy, and other efforts directed toward rural women, often self-employed or in subsistence production. The ILO tried to move beyond that binary but tripped over

it institutionally. FEMMES, with its mission to coordinate all work on women, interpreted "women in development" as part of its portfolio, but defined its goals in terms usually associated with industrial nations. It wasn't that the objectives of "equal access to employment," "provision of vocational training, retraining and further training," "improvement of conditions of work and life," or "increasing the role of women in trade unions and co-operatives" were outside the needs of poor rural women. It was that specific tasks reflected occupational structures in the industrial world, such as the predominance of formal employment and the possibility of advanced training.[129]

Blanchard, who had assumed the post of Director-General in 1973, formed FEMMES to liaison with the UN and other international organizations. It would study and disseminate information, promote action by governments, worker and employer organizations, and NGOs, and assist ILO research and technical units, like EMP/RU. Its new informational magazine, *Women at Work*, summarized research in standard-setting areas at the ILO and elsewhere, such as maternity leave, equal pay, child care, and non-discrimination.[130]

Collaboration with the Programme on Rural Women was sometimes tense, and conflict ensued when either unit felt the other was encroaching on its responsibilities or hoarding information. By the late 1970s, relations between the two units had deteriorated. FEMMES's Marion Janjic had invited EMP/RU to send a representative to larger UN meetings and projects. Ekaterina Korchounova from the USSR Institute of State and Law, the next head of FEMMES, appeared more territorial. In May 1979, as the Programme on Rural Women was seeking greater resources, Korchounova objected "that various ILO technical units have been presenting project proposals (multi-bi) and formulating programmes on women workers without communicating with us." She described such actions as an infringement on her office's coordinating role. "This manner of proceeding does not only create confusion on the part of donor agencies, UN organisations and the general public, but also jeopardizes the implementation of the programme of this [her] unit."[131] Reporting to the CSW in 1980, for example, FEMMES featured its own work in describing the ILO's response to the Decade for Women. It then included World Employment Program efforts to meet the basic needs of women in developing countries and listed technical cooperation activities, which still mostly addressed training in crafts and agriculture. What emerged as prime evidence for ILO progress, however, was its own existence.[132]

EMP/RU certainly did not always seek FEMMES's opinion in formulating its plans, because it found FEMMES added a layer of unnecessary approval to its proposals. By May 1984 it had concluded that relations would never improve, because FEMMES was "increasingly overstepping the coordinating role . . . to overshadow the competence of technical units."[133] The head of EMPLOI judged

a FEMMES report for the 1985 ILC as unbalanced and "untenable" for stating "that full equality in all spheres has been achieved for women workers in one part of the world, while everywhere else the situation of women is bad and getting worse." Cold War rivalries and assessments shaped the report, supervised by FEMMES's third Chief, Raïssa Smirnova. But so did a lingering reluctance among many Office staff to address the condition of women vigorously.[134]

Divergent orientation heightened the institutional conflict between the Programme on Rural Women and FEMMES. Commenting in 1982 on a classification scheme for *Women at Work*, Ahmad and Loutfi dismissed proposed headings as "rather weighted toward Western industrial country problems." They objected to the listing of "employment," "family responsibilities," and "housework" as separate sections. They would knock "house" off of the category of "housework," which others recommended be changed to "unpaid housework;" they eventually recommended, "unpaid work . . .since the issue of unpaid housework is of relevance primarily to industrialised countries." Moreover, the definition of "management" also implied "rich and Western." "Promotion of Equality" headings they found "reflected developed countries, while missing were the efforts of women themselves through their own organizations." They advised changing references from "jobs" to "work," since women in the Third World concentrated in the informal sector and often were self-employed. At the heart of the issue was what should count as work. As Loutfi commented on another report, "Inadequate definitions can affect the documenting and understanding of men's work as well as women's (with 'work' being broadly defined by me), but the distortions are in some cases extreme with respect to women."[135] The 1983 Expert Meeting on Employment, in contrast, judged that associating women with "dependent, secondary, domestic, non-productive and centered on reproduction" generated a barrier "to reaching and supporting women as producers," which remained the goal of the ILO.[136]

The division of portfolio between FEMMES and the Programme on Rural Women never meant that the WEP studied conditions only in the Global South. In the mid-1970s, its researchers found that the worldwide recession hurt women in Western Europe more than men because of slower growth in retail and light manufacturing, the sectors where women's concentration made them more vulnerable to unemployment in the first place. The substantial increase in women's labor force participation had not expanded their employment beyond female-dominated occupations, which remained "often boring, repetitive, requiring little skill and having little scope for advancement." The resulting policy prescription went to the heart of gender inequality: the male breadwinner/female homemaker ideology and the designation of women as secondary wage earners, given their responsibility for reproductive labor. As one WEP official explained, "the issues at

stake are much broader than the problem of 'equalising opportunities'—a rather ambiguous and ill-defined objective." Needed were Herculean efforts toward "a new society in which all its member, workers and non-workers (not just in the conventional sense), at home or in the enterprise, female or male, would be given improved opportunities for fuller and happier development of their personalities, along the lines they themselves select."[137] In hindsight, those addressing the plight of the woman worker lingered in a realm between utopianism and reformism.

The Office as a whole continued with a more general engagement with women's issues. It recognized a range of challenges, including the surge of women into the service sector, job loss from computerization, and the persistent employment of women after marriage and motherhood. It investigated the dangers of multinationals and free trade zones for furthering women's precarious labor. It conducted training programs in every region, provided advice on establishing women's bureaus, and monitored existing standards. It responded to various ILC resolutions, the most important of which called for investigating the maintenance of women-specific protections and the possibility of extending these to men, along with revising instruments on equal opportunities and family responsibilities. It would take another decade before night work or hazardous substances restrictions became gender neutral or maternity protection was updated, but the Office started gathering information from member States in the early 1980s.[138] The most significant new standards impacting women regulated nursing, a form of professionalized reproductive labor, and family responsibilities, which substituted worker for women.[139]

In noting the progress during the last decade on "equal opportunities and equal treatment for men and women in employment," the 1985 ILC discovered in the plight of rural women evidence for the work that still had to be done. It embraced the description that Benería had offered in referring to such women as delivering "essential goods and services for their families." Yet "increasing poverty and deteriorating living standards" marked their lives. Women in industrialized areas found "hard won gains" eroded from disproportionate unemployment and economic recession, but those in the rural areas were impacted the most. They stood out as a specific group requiring aid, along with those in the urban informal sector and multinational free trade zones, and migrants, refugees, and people with disabilities.[140]

Passed just prior to the 1985 UN World Conference on Women in Nairobi, another ILO resolution on equality revealed the gap between legal equality and practice as well as the persistence of Third World difference. Its wish list included access to all occupations, training and education, decent and safe working conditions, equal remuneration, and targeted social protections. New was a clause on sexual harassment, declared "detrimental to employee's working conditions

and to employment and promotion prospects." Employers had championed building individual human capital through education and expanding economic growth, which they assumed would increase opportunities for all qualified workers. Their platform for developing nations emphasized "preventing starvation, alleviating poverty, improving primary health care and eradicating illiteracy" over "occupational mobility and equality." Progress, they argued, depended on population control. In contrast, the Workers' group flipped cause and effect. Workers believed "the implementation of equality of opportunity is essential to put an end to poverty and unemployment." Women wanted child care and access to family planning; "they . . . considered themselves responsible enough to decide on the number and spacing of their children if only the means and information were at their disposal."[141] The desire for flexibility—whether from employers needing continuous production or women workers juggling employment with family labor—encouraged lobbying for increased part-time work and weaker night work restrictions.

In the mid-1980s it was unclear whether the conditions of the rural woman would foreshadow wider precarity. But all agreed that family labor—and a generalized belief in women's responsibility for social reproduction—created a barrier to full labor force participation. As a Nigerian Government delegate announced in 1985, "Because of their multiple role as mothers, housewives and workers, their working time has to be arranged in such a way that it does not conflict with their role as mothers and housewives."[142] He didn't sound much different than ILC delegates in the early post-WWII years.

AFTER 1980, THE Programme on Rural Women focused on technical cooperation. This shift was in keeping with an overall curtailing of pure research and institutional pressure to produce concrete results. Coordination fell to Loutfi, who left an Associate Professor position at McGill University to consult for the Centre for Arab Integration Studies in Beirut and came to the ILO by way of the Brandt Commission on International Development Issues. In May 1984 she confided to a correspondent from India about "venting our new ideas in the face of restricted or even declining resources for rural development. . . . [W]e seem to be growing (intellectually and in terms of output, but not staff) in many worthwhile directions." However, the next year Loutfi transferred to the Employment Restructuring Unit and more general work for the WEP; she would become editor of the *International Labour Review* in 1993, retiring seven years later.[143]

Shortly before Loutfi left, Ahmad, the mainstay of the branch, retired in December 1984, though she continued to undertake technical missions. Among the program's protectors, Antoinette Béguin, who became an Assistant Director-General, also retired, and Ghai left a few years later. Bangladeshi political scientist

Jahan, who participated in the UN World Conferences on Women, ran the program from 1985 through 1989.[144] She noted in 1988 that the program had expanded from five projects in six Asian and African countries and a donor-derived budget of two million dollars in 1986–1988 to ten projects in twelve countries and a budget of five million dollars for the next biennium—but without increasing personnel. This was a relatively small budget for multiple tasks.[145] After she left, various staff from EMPLOI focused on women's issues. But it was difficult to implement projects on time, with "special local circumstances" and difficulties with staffing taking their toll.[146] In this regard, the ILO was hardly alone. As many as half of the technical cooperation projects initiated by UN entities and NGOs "petered out" without a continued inflow of external resources, even with an emphasis on sustainability.[147] Donors often went onto new priorities.

By the early 1990s, the official description of what became a "subprogramme" of EMPLOI did not mention the research into reproductive labor that its formulators judged essential for action. But other components remained: "to increase the capacity of governments and employers' and workers' organisations (including organisations of rural women) to design and implement policies and action programmes to improve the employment and incomes of rural women, to extend their social and legal protection, and to promote their organisations." Particularly important was monitoring the gendered impact of structural adjustment as well as external projects for income generation and employment. Issues that came into focus over the previous decade persisted, including "access to land in Africa, migration in Latin America and the social and legal protection of home-based workers in Asia." The program had addressed conditions on plantations, urban migration, rural wage labor, and female-headed households. However, resources remained limited for a project that could be limitless. For the entire department, which had the equivalent of twelve professional people, the budget stayed comparatively small, under $3 billion a year.[148] Geopolitics—especially the rivalries between East and West and North and South—certainly interfered with this attempt to transform development from a feminist standpoint. The program, like all of the ILO, remained beholden to member States, who asked the ILO for aid even as the ILO requested that members pay dues.

The attempt to decolonize knowledge, however incomplete, perhaps was the most important legacy of the Programme on Rural Women. As Ahmad explained to Benería in late 1982, "Slowly we are succeeding in winning over a few colleagues to questioning the basis of the existing sexual division of labour," while pinpointing the "elimination of women's subordination."[149] Ahmad would attend the preliminary meeting of DAWN and was on its initial steering committee. That South-South initiative, aided by the Ford Foundation, brought together many of the researchers supported by the program. She helped to forge

a "post-Boserup Manifesto" for the 1985 Nairobi UN meeting, "reconciling feminism and development," that would address women's situation in terms of the global political economy, critiquing growth without environmentalism, and repositioning the rural woman as "a symbol of strength rather than submerged under exploitation."[150] As one DAWN founder announced, "unless there is a better understanding of how patriarchy and economic systems propagate oppression, no effective or inclusive work on bringing about a new order can be done." Feminism provided the basis for a global solidarity among women in the fight against all forms of domination.[151]

In seeking to empower participatory women's organizations, the program found one model in the Self Employed Women's Association (SEWA) of Ahmedabad, India. Training its members to be researchers of their own lives, basing its proposals for legislation and organization on the aspirations and needs of garment sewers, incense makers, rag pickers, and others in the informal economy, SEWA led the coalition pushing for labor standards for home-based workers, urban as well as rural. Their efforts marked a breakthrough in treating the home as a workplace subject to labor standards. In mobilizing a transnational feminist coalition in alliance with ILO staff and international trade union secretariats, SEWA won the Home Work Convention, 1996 (No. 177), despite Employer opposition. As the next chapter shows, women in the Global South had moved to the center of debates over the nature of work; they were no longer difference's other.

5

Outwork

"ISN'T THIS GOOD! The backing of ICFTU," SEWA Secretary Renana Jhabvala handwrote on a May 1988 letter to Rounaq Jahan of the Programme on Rural Women. Jhabvala attached a resolution "in favour of home-based workers" passed the previous March at the 14th World Congress of the International Confederation of Free Trade Unions (ICFTU), the major trade union partner of the ILO. SEWA General Secretary and founder Ela R. Bhatt, a delegate to the Congress from the International Union of Food, Agricultural, Hotel, Restaurant, Catering, Tobacco and Allied Workers' Associations (IUF), had navigated "this big step forward for us" as part of a larger effort to generate "global links with other organisations, trade unions, media and concerned academicians and research scholars." The goal was to spread a campaign begun in India to enhance "awareness among the workers, Govt. officials, the labour movement and policy makers of the degree of exploitation and the lack of protective legislation in homebased industries." Jhabvala also conveyed the resolution to a Deputy Director-General, reminding him of their previous discussions on "how ILO can help."[1]

A few months before the Congress, Jhabvala stopped by Geneva to speak with Dan Gallin, the progressive head of the IUF. Gallin championed "pressure from below," a form of bottom-up power that sought to heighten the stakes for employers for rejecting worker demands. The IUF had a distinguished record of solidarity with Third World labor; in particular, it fought violations of freedom of association under apartheid and coordinated interventions against abusive multinational corporations. It valued the ILO for its "propagandistic effect and the repeated stressing of the universality of fundamental trade union and human rights."[2] Sitting in the kitchen of the IUF headquarters, Jhabvala and Gallin strategized the best ways for advancing protection of home-based workers through the ILO. He suggested using the ICFTU. With Jhabvala listing talking points, Gallin drafted a resolution. Then he set about gaining the support

of IUF affiliates and the ICFTU itself. The all-powerful Germans proved to be sympathetic: the Deutscher Gewerkschaftsbund would place the resolution on the ICFTU agenda. Educated by women from their own organizations who led campaigns to place outworkers under labor protection, the Dutch Federatie Nederlandse Vakbeweging (FNV) and British Trade Union Congress signed on as well. At a seminar for women workers preceding the Congress, Bhatt mobilized Swedish, British, and Dutch women unionists. In the end, no opposition materialized. In all likelihood, Jhabvala recalled, the issue just wasn't a major one for most male-dominated unions.[3] A resolution on home-based labor was solidarity on the cheap: compatible with the confederation condemnation of global inequality, it required no resources. But there was more than solidarity involved. As a German woman explained, "the resolution on the Indian women workers could well work to our direct advantage in the near future," as outwork threatened unionized workers in industrialized countries.[4]

The ICFTU resolution reflected the viewpoint of home workers themselves, who wanted their conditions improved rather than their jobs abolished. It noted the significance of home-based labor for working people everywhere, including its spread within industrialized nations from deregulation and computerization. Exploitation and lack of social protection (e.g., welfare state benefits) came in its wake. Statements at other gatherings had assumed family labor as the factor limiting women's employment options to the home. This resolution moved the problem from women to larger structures—it underscored a workforce of women disadvantaged from "their weak position on the labour market and the lack of possibilities to combine regular work with family responsibilities." Drawing upon the language of rights, it called for "a world-wide census of home based workers, for the adoption of international labour standards and for national legislation" on "working conditions, wages and welfare." Home-based workers would be normalized, brought into the house of labor through "special organizing programmes" undertaken with women's sections and placed under collective bargaining and labor protections. Affiliates should resist national policy harmful to such workers and act in "solidarity" with trade unions of the home-based, like SEWA itself.[5] Hovering over this final appeal lay the fractious casting out of SEWA by the Indian Textile Labour Association (TLA) in 1981, which meant removal from the International Textile, Garment and Leather Workers' Federation (ITGLWF). But rather than crushing SEWA, the expulsion had strengthened the group, which won new sponsors and allies.

Organized workers had shifted their position toward what Western nations called "industrial home work," or what women campaigners referred to as "home-based labor" from an understanding of its myriad forms. Variations included self-employed and own-account workers.[6] Both referred to outwork. At the first ILC

in 1919, Worker delegates condemned home work as an evil, but not appropriate to rectify through international standards. Protection stopped in front of the home, especially when laborers were family members. Attempts at redress in the early postwar years proved abortive, with investigators conceptualizing problems from Asian home-based labor and home handicraft as distinct from those of industrial home work. But in the 1970s the offshoring of production from industrial to industrializing countries gained critical momentum. Transformations in the international division of labor toward the end of the 20th century paved the way for a global response. Rather than calling for eliminating home work, by the 1980s much of organized labor recognized that the only way to curb the practice would be to place outwork under protective standards. If it continued under such circumstances, home work would no longer undermine factory conditions.

Feminist campaigns, along with the naming of the informal sector as an arena of work, facilitated recognition of home-based labor as worthy of standard setting. Advancing the case was the Programme on Rural Women, which commissioned research and lobbied other units within the Office. By 1980, Zubeida Ahmad and Martha Loutfi had discovered SEWA, which they promoted as a role model for organizing through women's organizations. Over the next decade, the program would partner with this grassroots Indian group on action projects funded by bilateral donors. They would press for ILC discussion of home work.[7] But neither Office staff nor women campaigners from Europe and Asia could proceed by themselves. Home work advocates needed access to the ILC. They found a path through the trade unions, especially the IUF. Backing by the Workers' group made the passage of the Home Work Convention, 1996 (No. 177) possible. That the Employers' group obstructed the process exposed just how cracked the tripartite façade had become.

Despite intense opposition, and minimum ratifications, Convention No. 177 was important. It paved the way for workers previously excluded from labor standards and national regulations to transform the ILO into an arena to press for rights and recognition. It achieved the goal of making the woman who took in garments to sew, crackers to pack, electronics to assemble, or papers to type into a worker—even if enforcement of legal norms continued to lag in the face of a retail revolution dependent on extenuated global supply chains reliant on contracting out and the beginnings of what then was called telecommuting.[8] It remade the woman in the home into a worker like any other, thus underscoring the organization of production rather than the location of work.

Three groups produced the home-based worker as an object of international concern. This chapter looks at their efforts. It begins with changes in the global economy that led union federations and ILO sectorial meetings to call for improved conditions for home workers. It then returns to the Programme

on Rural Women, charting its efforts to induce protective measures. SEWA emerged as the most important women's group documenting the lives of home-based workers and lobbying for international redress as a strategy to enact and enforce national regulation. However, the campaign by an emerging transnational network of women's organizations required amplification by the global labor federations. Research was insufficient to gain the attention of the Governing Body or win at the ILC, though lack of statistics could serve as an excuse for inaction. Support by the Workers' group proved necessary.

Behind international initiatives was distress over the conditions of Ahmedabad residents like Shanta, a twenty-eight-year-old mother of six with a tubercular husband. She confessed her absence from a union meeting by explaining, "I didn't go because I thought if the *seth* [subcontractor] finds out, he won't give me any work. That meant no food for my children, or going back to domestic-help." As she told a canvasser from SEWA, "I prayed for the meetings success." In the 1980s, rolling *agarbatti* (incense sticks) as part of India's expanding informal sector paid better than working as a "domestic-help" and could be combined with watching one's own children. These women, portrayed as confined to the home from "social taboos" and the preferences of male kin, could be seen "breast-feeding [their] child and rolling the hand-made Indian cigarettes." They kept their daughters close by, rather than sending them to school, to aid with the housework and the home work. The majority labored longer than factory counterparts for lower wages when they received materials, which could be intermittent. Combined with family labors, they could work nearly continuously. Many suffered from myriad health problems, including back pain, eyestrain, and anemia.[9] Such women emerged onto the international stage through writings, speeches, and photographs framed by trade unionists and global feminists.[10] Though lacking voice, they were invisible no more.

The Challenge of Offshoring

At the end of WWII, textile and clothing unionists faced a dilemma: how to build international solidarity and improve worldwide living conditions, while also maintaining standards and retaining jobs in industrialized countries despite competition from developing regions, where the rag trade, with its low start-up costs, served as a motor for manufacturing. The goal was for "all the peoples of the world [to] become better clothed and enjoy the full reward of their labours."[11] As ILO Director-General David Morse intoned in 1953, "unsatisfied potential demand" in the Third World would lift the industry. "Admittedly, this demand can not become effective until the standard of living in these countries is improved, but that is exactly what the present programmes of economic development,

which include some provision for the expansion of the textile industry . . . are designed to achieve."[12]

Before the 1970s, the migration of clothing and textiles to the Global South was a worry rather than a crisis for Western industrialized nations, which still produced the bulk of the world's clothing.[13] Tensions between free trade, development, and structural displacement would lead to a controlled import-export system through various trade pacts, notably the Multifiber Arrangement under the General Agreement on Tariffs and Trade, to manage the global supply chain and control the bleeding of production from industrialized nations, while offering cheap clothes for many.[14]

This vision of development came up against the sexual division of labor and the exploitation of Third World workers, especially rural women, as the previous chapter showed. But it also met employer opposition. Subject to consumer demand and the whims of fashion, garment employers continued to seek flexibility through contracting, especially the ability to shed workers and reduce overhead during economic downturns. First with the spread of the industry to developing countries, and then with worldwide economic contractions in the 1970s, a race to the bottom jeopardized workers everywhere. Subcontracting posed a double challenge: the offshoring of manufacturing to places with cheaper labor (the run-away-shop gone global) joined the practice of outwork—the removal of production from an enterprise to a contractor who might further put out tasks to other contractors and, for clothing production, home-based stitchers and finishers. Characteristic of the garment industry from its birth as an engine of the first Industrial Revolution, the sweatshop appeared to return, though we now know that it never fully vanished.[15]

With export processing zones as a development strategy, some people's homes became extensions of factories and offices—what Marx, commenting on that first Industrial Revolution, referred to as the "invisible threads" that tied the home to the mill, or what we might rephrase as the linking of reproductive labor to commodity production.[16] As a review of the system in Latin America concluded in 1988, home work was "an integral part of modern capitalist industrial production" and "cannot be equated with independent artisan production."[17] Rationalized for allowing women flexibility to combine wage earning with caregiving and household chores, such arrangements gained employer approval for facilitating a different form of flexibility: the sloughing off of obligations when competition required fewer personnel or lower wages. In addition, capital could reduce costs by transferring responsibility for equipment and infrastructure, including utilities and the very workspace, to the woman herself, who then would enlist children and other family members to finish the task in the allotted time, a double form of sweating (the old term for such practices). Investigators found that home

workers "rarely enjoy legal status nor adequate protection" compared to formal sector counterparts. Uncounted by censuses, they were "invisible." Their inability to participate in collective bargaining, advocates argued, had negative "long-term implications for the labour movement, development, status of women and welfare of families." They remained predominantly women with children, most of who were married, as far as anyone could gather, given the paucity of statistical data and the location of the practice in what was misnamed the private sphere.[18]

Encouraged by favorable tariff and tax policies, offshore production and home work extended beyond their historical sectors to include the making of additional consumer goods, electronics, and plastics. These processes of production thrived on what Bhatt described as "increasing landlessness and poverty."[19] Where independent artisan and handicraft production persisted, skilled workers became dependent on middlemen for materials and marketing. With the computer revolution in the 1970s and 1980s, telework and home assembly of components spread, updating the tools previously used for clerical home work in Australia, Canada, and other developed nations. Telework also fed into offshoring from North to South and from expensive to cheaper labor markets.[20]

Shifting manufacturing from the center to the periphery evaded worker gains from collective bargaining and wage council determinations. Such movement impeded the enforcement of hard-won legislation covering the right to organize, wage rates, hour limits, health and safety conditions, and social security.[21] The male General Secretary of the Clothing Trade Union of Australia assessed the situation in 1984, stating, "What we now have is not a new international economic and social order, but a new corporate world economic order coupled with a new international division of labor." During the heyday of Reaganism and Thatcherism, corporate consolidation intensified "de-industrialisation of developed nations with accompanying unemployment, mass redundancy, under-utilised capacity and part-time work." Multinational enterprises simultaneously pushed the "export-oriented industrialization of the developing countries." A major lure to capital became the "free trade zone," an area that suspended labor standards and offered economic incentives.[22] Rather than "involve the social development and improvement of conditions of work all over the world" as envisioned by Global South nations, this new order empowered multinationals to initiate global supply chains, export manufacturing, and remit semi-finished goods to avoid tariffs. Increasingly, retailers became king, controlling the supply chain and demanding "just-in-time" production of global consumer brands.[23]

Offshoring to Latin America and Asia (particularly the Republic of Korea and the Philippines) impacted Western market economies. So did the growth of the clothing industry in Yugoslavia and Poland—though the European Economic Council recognized that productivity surges and general recession also

contributed to employment decline.[24] Technological improvements, innovative materials, and plant modernization resulted in fewer workers fabricating more goods.[25] In 1986, European and North American market economies produced 7% less clothing than in 1980 in contrast to developing market economies, which made 20% more, while Asian manufacturing expanded by 42%. The sector was recovering, the ILO concluded, but not in Western industrial nations.[26]

Conceptions about the woman worker bolstered these manifestations. Across the globe, the assumption was that women had a natural proclivity for sewing and embroidery, having learned such skills as girls. In the 1960s, their numbers dominated clothing production. While women constituted between 20% and 40% of manufacturing operatives in Europe and North America, their numbers doubled among enumerated clothing workers, ranging from 70% to over 90%. The same was true for Japan except for cutters and tailors, who were men. In most places, nearly half of the garment workforce was under twenty-one. Textiles offered a more varied demographic profile, ranging from women composing over 70% of the workers in the USSR to male dominance of cotton spinning in Belgium.[27]

Biological determinism persisted. Captive to reproductive duties, women appeared especially vulnerable. Notions of female difference, when speaking of health and well-being, justified weight limits in textiles and restrictions on night work. Shift and night work further threatened the family, taking women away from home duties. The presence of mothers turned the availability of child-care facilities and maternity protection into pressing issues. Observers wondered about the impact of noise, pollutants, and other occupational health and safety concerns on childbearing. The lower standards and lesser pay of women laboring in homes and other unregulated spaces threatened the conditions that textile and garment factory operatives had won. Such circumstances impeded solidarity, but also opened the way for new feminist formations to become the champions of the home-based worker.

Building Action through Committees and Congresses

Home work's threat to undermine factory conditions placed the issue on the agenda of ILO sectorial committees, which brought together Government, Worker, and Employer representatives to discuss conditions in specific industries.[28] The textile trade regularly held tripartite deliberations in the postwar years, but it took lobbying to institute a committee for clothing. In the 1950s, the International Garment Workers' Federation and the International Federation

of Christian Trade Unions of Textile and Clothing Workers asked the ILO to convene a tripartite meeting for clothing. In the early 1960s, organized US employers and garment workers, along with the ICFTU and the International Federation of Christian Trade Unions, requested an industrial committee as well. By then, the garment and textile worker organizations countered loss of membership by amalgamating their resources, forming the International Textile and Garment Workers' Federation in 1960. The ILO Governing Body responded to these requests by authorizing a special clothing meeting for 1964, inviting major producing nations to discuss general conditions of work, social problems, and the irregular employment that characterized the industry. Sixteen years would pass before a second meeting, delayed in part by the economic constraints hitting the sector that also impeded ILO operations.[29]

Despite the belief that industrial home work had "declined in recent years," the very characteristics of clothing and related industries—"low capital requirements and the ease with which part of the work can be done at home"— generated nervousness that the practice actually flourished. In response to Office inquiries in the 1960s and 1970s, nations quantified the extent of home work, but none were sure of their calculations. The United Kingdom reported home work as "widespread," especially in women's outerwear, dress, and blouse industries. Cheap imports led some firms in the United States to reduce costs through outwork. In Italy, ties, scarves, women's underwear, and corsetry harbored home work; by 1978, that country claimed 60% to 70% of ready-made clothing involved subcontracting, with the home as the last stop in stretched-out production chains. In Japan, women's and children's dresses, knitted gloves, tailoring, and scarves went into homes. Argentinean employers and workers thought home workers made half of all garments. By 1980, and the Second Tripartite Technical Meeting for the Clothing Industry, other Latin American countries and Spain listed extensive home work. Chile estimated that home workers produced 60% of the items in the women's clothing industry and 30% in the men's, though it classified these workers as self-employed. Mexico's National Chamber for the Clothing Industry figured 30% of workers labored at home. For footwear and leather, which gathered in a separate 1985 tripartite meeting, nations admitted lack of controls and regional dependence on outwork.[30] Much production occurred under the table, as a maneuver around trade restrictions, labor standards, and even worker compensation. In the 1980s, home work spread to industrializing places, including Africa.[31]

Organized workers documented similar trends. They, too, complained about lack of reliable information. All agreed that women with family responsibilities took in work to earn necessary income, but few questioned the assignment of domestic and care work to women. Some affiliates of what in 1972 had become the

ITGLWF associated home work with outcast or dependent groups. The Indian TLA pointed to "very large numbers of Muslim and other caste women," while US unions equated outwork with immigrants.[32] By decade's end, the new federation boasted five million members from 140 unions in 70 countries, numbers that were less impressive given the millions more toiling in these trades.[33] Recognizing unique national circumstances, it hoped to level the playing field through international labor standards while aiding Global South affiliates. As one federation leader insisted, "It is obvious that unions must try to organize all workers, whether they are in factories or at home."[34] But that was easier said than done, given the scattered and episodic form of the labor, the belief that such women were not real workers, and male domination of union leadership.

ILO industrial committees proceeded by consensus, with delegates formulating a shared position. When it came to home work, agreement at the 1964 clothing meeting broke down. The Swiss government, for example, believed "that homework is in the national interest" because it provided income for agricultural areas during the winter. Thus, there should be legal provisions rather than outright prohibition.[35] France sought improved conditions for a system rooted in crafts traditions and in which unions had organized since the early 20th century. Needle trades officials in the United States, in contrast, concluded that home work could never be regulated; these unionists and their reform allies sought prohibition whenever they won political power. During the 1940s, they had obtained bans in seven garment-related industries under the federal Fair Labor Standards Act and placed other restrictions in collective bargaining agreements.[36]

The outcome of the 1964 meeting was exceptional for passing a resolution by majority vote rather than unanimously. Employers, Workers, and Governments could agree with the conclusion that home work "tends to aggravate instability of production and employment." On that basis alone, it should disappear, but since some countries could not immediately abolish it, "there should be maximum governmental regulation and control," which included registration of employers, middlemen, and workers. Despite this consensus, many employers and a few governments still rejected the central claim that the practice "should, as a matter of principle, ultimately be abolished." The resolution then insisted that, prior to abolition, labor standards and social protection for home workers should match those of their factory counterparts. Meanwhile, the ILO should study the problem.[37]

The 1964 tripartite resolution provided authority for a subsequent measure passed by the Second Congress of the ITGLWF in 1976, introduced by US union affiliates and supported by the Executive Board. Until abolition, the Congress called for "the same legal status as factory workers . . . with full entitlement to social benefits." To enforce parity, it also asked for full registration of participants in

the system—that is, the "homeworkers, agents and employers." Like the tripartite meeting, it requested the collection of information. But, in contrast to the ILO committee, this document maintained the discourse of disgust and outrage that long pervaded writings against the sweatshop. The ITGLWF resolution spoke of "evils," "threat," and "pittance." It portrayed workers as "deprived," using terms like "appalling" and "deplorable" to describe their fate. The federation's 1979 *Report on Homework* further deployed coercion metaphors. It referred to "slave labour," "near-slavery," "people chained," wives and widows "forced to work," and children "trapped" and "roped into this obnoxious system."[38]

Rhetoric aside, the garment unionists were pragmatists. Work should occur in factories, they understood, but some people depended on outwork for their livelihood or could not work in factories due to disability. Their resolution laid out a "principle," announced Henoch Mendelsund, head of the International Division of the International Ladies' Garment Workers' Union (ILGWU), USA. Of course, affiliates would proceed according to the situation in their countries. Given the "untold millions" so laboring and the various circumstances of nations across the globe, home work was not going to disappear in the near future, even though "unregulated and uncontrolled home work is the worst exploitation imaginable to a civilized person." By this, Mendelsund meant that it turned the home into a factory, involved child labor, and encouraged a pace of work that left no time for anything else—all for low pay.[39] Thus, his motion asked for government regulation where allowed, so "industrial home work has some human aspect to it."[40] Apparently keeping a single standard for developing and developed nations in an era when the Cold War and decolonization challenged Western hegemony was more prudent than pushing for immediate abolition. By taking the lead, the US affiliates (ILGWU, Textile Workers Union of America, and Amalgamated Clothing Workers of America) could steer the political process of resolution making.

Demonstrating national variations, two representatives from the Global South responded to Mendelsund. They shared their strategies to combat the transfer of overhead to the worker and the persistence of low wages, long hours, irregular workflow, speed-up, child labor, and substandard conditions from poor equipment and inappropriate workspaces. Anna Scheepers, President of the segregated Garment Workers' Union of South Africa, explained their use of "'outwork' agreements" that mandated payment rates 20% higher, which led workers to the union for redress when employers paid less. Such union-negotiated provisions allowed for better protection than did difficult to police legislation. Charging employers more for home work became a standard suggestion in both union and ILO assemblies. Arvind Buch, President of the India TLA, requested that affiliate unions go about organizing home workers "in order to prevent management

exploiting them." At the founding meeting in 1972, he had noted that while "industrialization brought people to work ... operation of labour laws is now taking work to people." That is, the law encouraged employers to put out work and classify as self-employed home piece-rate workers dependent on materials distributed by a contractor or subcontractor. In calling for organizing the self-employed, Buch spoke from experience. At that moment, the TLA was supporting the efforts of its women's section under Ela Bhatt to organize home workers, the majority of whom were technically self-employed, though dependent on contractors.[41]

In 1979, ITGLWF Secretary Charles Ford reported to affiliates, saying, "We were very pleased that the ILO has been consulting the unions well ahead of the meeting, in order to ensure that their point of view is taken fully into consideration in a timely way."[42] The conclusions of the 1980 Second Tripartite Meeting for the Clothing Industry reflected that consultation. It specified items for action. Nations needed to clarify the legal status of workers and limit outwork "to specific cases where homeworkers are unable to earn income in any other way." While calling for prohibition, the resolutions also asked for equivalencies to shop and factory workers for wage determination and social security, unemployment, and health benefits, supplemented by statutory standards for health, safety, and hours. Simultaneously holding these two poles—banning and covering—was not contradictory, since the general belief was that home work persisted because it was unregulated and cheaper than factory labor. Raise its costs and its advantage for employers would disappear. Lack of direct supervision led to imperfect quality control, which would no longer be merely wasteful, but would become burdensome with regulation. Then work would return to factories or workshops. Other items addressed specialized labor inspection and recording of work; "vigilance" on child labor and "illicit" home work; "co-operation" among social partners in "control and supervision;" and trade union rights. Finally, the assembled delegates recommended the "possibility" of an international standard—a gesture toward requesting ILC action.[43] This resolution actually belonged to a multisector pattern choreographed by the Office in which impacted committees requested ILC deliberation.[44]

These tripartite meetings tended to blame ineffective regulation on unscrupulous contractors and other employers, who refused to keep mandated records and cheated workers, rather than pinpoint structural problems from offshoring and outwork.[45] But workers knew otherwise. They were acutely aware of job displacement from industrialized to some developing countries, fueled by multinationals operated from industrial centers. To avoid exploitation and maintain job security, unionists in developed and developing countries had to demand "'fair labour standards'" as part of all trade agreements and development programs,

the Assistant Director General of the ICFTU had insisted in 1970.[46] Global compacts required social clauses.

As successive inquiries revealed, nations already had regulatory laws on their books or were adding coverage, though home workers rarely came under all standards and benefits. Most nations excluded family workshops and independent contractors or the self-employed. Definitions were essential for coverage.[47] The United States and Canada prohibited many kinds of home work, though as federal systems, some states or provinces regulated the practice, usually in relation to public health, and others banned it altogether. US federal law and a few states allowed people with disabilities and caregivers of "invalids" to obtain permits to take in work. New Zealand issued permits in relation to both the size of an employer's factory workforce and an individual's incapacity for factory employment. It required equivalent pay scales, a feature of German and other European nations that sought to apply all forms of social and labor legislation to home workers. The problem was less laws, however, than the inability of states to enforce them. The scattered location of the labor posed a barrier, while the notion of the home as a private realm insulated it from inspection in most places. Thus, collective bargaining agreements with unions became essential to monitor the practice, but these were difficult to win, given power imbalances, unless state authorities stepped in.[48]

The old gender justification for home work persisted across political economies. Explained the government of Hong Kong: "Some women workers, for example, those who have to take care of their children and household duties, sometimes . . . will be occupied in industrial homework whilst others will work special house-wives shifts of about four to five hours duration."[49] A male Employer delegate from the Federal Republic of Germany expressed the prevalent view: home work was positive since it enabled women "to continue to exercise their occupation despite certain family responsibilities."[50] State socialist nations agreed. The USSR resolved a manpower problem by "attracting into social production, the unemployed sector of the population, especially women . . . who for various reasons cannot work directly in factories."[51] According to a male Indian Employer delegate, "to define a home worker is a difficult thing because even women of well-to-do families also take to this vocation." [52] Indian employers would claim home work to be "very popular."[53] This conflation of home-based labor with women's leisure exemplified the attitude Maria Mies documented at that time. Women trade unionists in the ICFTU and International Labor Secretariats (ITS) rejected such assumptions, agreeing "that part-time, temporary or homework" provided no "effective solution to the problems" surrounding workers with family responsibilities, then under reconsideration by the ILO.[54]

Employer disgruntlement at these meetings foreshadowed the contentious process that erupted when the ILO entertained standard setting for home work. Workers (along with state socialist governments) lashed out against multinational corporations and, later, worried about the impact of structural adjustment on living standards. During such a discussion at the Second Tripartite Technical Meeting, a male UK Employer complained, "We do not believe that we are being oversensitive, but the whole tenor of the presentation seems to us never to miss an opportunity to attack employers in a way which we feel generally diminished the credibility and indeed the impartiality of the ILO to the advantage of no one including the interests of workers."[55] At the conclusion of this meeting, the Employers' group rejected the abolition of home work "even in the long term." They admitted to having "strong reservations" against the previous resolution out of the belief that "home work could play an important role both for the enterprises that resorted to it, as well as for a number of workers."[56] At the Third Technical Tripartite Meeting in 1987, the Employers' group contended "that legitimate home work was a necessary feature of the clothing industry."[57]

Objections would harden into obstruction. Employers had no problem with laws that had defined the home worker as self-employed or an independent contractor, as India's Buch had warned, depriving them of minimum wages and social security and placing them outside of health, safety, and hours restrictions. Employers tried to classify these workers as both micro-entrepreneurs conducting independent businesses and housewives laboring for supplemental income. Such definitions created their own obstacles. If the home worker was not an employee, the only justification for entering her home was public health. But scattered workplaces required an army of inspectors, even with help from unions, consumer organizations, and women's groups. The ideological sacredness or privacy of the home still might create a political, if not legal, barrier.

Neither were the unions content with the outcome of ILO sectorial deliberations. In 1984 the ITGLWF unanimously charged the ILO with "retrogression" for reflecting "the demands of employers who benefit financially from homework and to governments from nations in which homework persists" and for no longer speaking in terms of abolition. Again at the urging of US unions, "the ITGLWF reaffirm[ed] its determination to fight against the evils of industrial homework as a threat to the well-being of workers throughout the world" and requested affiliates to seek abolition in their nations. This proposal occurred in the middle of the ILGWU's fight against the Reagan administration, which sought to lift all federal bans on garment home work. Unionists continued negotiating national differences by also claiming that a short-term program was necessary that would adopt the "strictest possible regulatory measures" and "equal treatment with factory workers." They were to push for ratification of ILO

conventions, especially equal remuneration, bans on child labor and hazardous substances, and the forty-eight-hour work week.[58]

The move away from abolition or prohibition represented a shift in strategy, an accommodation to the growth of home work.[59] In the United States, for example, the practice increased as a response to international competition. New York, Los Angeles, and Miami became centers of illicit home work, which took advantage of restricted opportunities for Latina and Asian immigrants and refugees. By 1991 there were at least twenty million home workers, one million of whom worked full time.[60] Elsewhere, the garment industry served as a dynamo of economic growth, generating more home work. India legislated protections. Italy included home work as part of its strategy for increasing female employment. In the Australian industry, more women labored at home than in factories.[61]

Unions sought to adapt. "The . . . original view had been that home work should be prohibited," Sonia Laverty of the Australian Clothing and Allied Trades Union explained during the 1987 ILO Third Tripartite Technical Meeting for the Clothing Industry. But both employers and workers avoided the work permit system, encouraging illegality and thus greater possibility of exploitation. Her union responded with new tactics. A campaign to organize and educate home workers, many of them immigrants, led to an industrial agreement with terms comparable to the factory, much as South African members of the ITGLWU had advocated a decade before. But it proved difficult to maintain contact with home workers once an employer dropped a particular woman. After 1990, the union argued that home-based employees be included in general workforce measures, turning home work campaigns over to community organizations.[62]

Similarly, the Canadian section of the ILGWU, the Argentinean National Union of Clothing and Allied Workers, and the UK General and Municipal Workers' Union sought to improve conditions for home workers. Home work sections or unions developed in Venezuela, Uruguay, and India. The Ontario, Canada, Homeworkers' Association of the ILGWU offered a community center, with English classes and "social teas," but lacked authorization from the Labor Board to bargain for workers, who had no common employer. By the mid-1980s, unions in India, the United Kingdom, the Netherlands, and Belgium had pushed for covering home workers under existing legislation or adoption of new laws for them. In contrast, the Belgian Confederation of Christian Trade Unions never relented from its belief that home work was "a permanent form of 'blackmail' to reduce [union] claims."[63]

The Third Tripartite Technical Meeting in 1987 advanced the question of home work before the ILO. It accepted the practice as the only possible job for some workers, though subject to abuse. So it called upon states to regulate the practice, legalize the status of home workers, and involve employer and worker

organizations to end mistreatment. It asked the Director-General not only for a "comprehensive study," but, most importantly, to also convene an "envisaged Tripartite Meeting of Experts on Home Work as soon as possible."[64] Such requests expressed the kind of global concern that the Governing Body wanted to justify action. The ILO's program and budget for 1986–1987 had included a study on forms of precarious employment, including home work in the clothing industry. But the Governing Body dropped those plans and a meeting planned for 1989 "because of resource constraints." With limited revenues, other issues had greater priority, a ranking that suggests that some quarters still were not convinced of the appropriateness of acting on home work.[65] The Workers' group demanded "urgent attention." By the end of the 1980s, as the ITGLWF's Ford explained, it was abundantly "clear not only that workers standards in the least developed countries fail to improve to reflect greater productivity and exports but standards in importing countries are being undermined by efforts to undercut imports through return to sweatshop and home-work production."[66]

Discovering the "New Putting-Out System"

Meanwhile, Office staff had discovered what they named the "new putting-out system." The February 1979 issue of *Women at Work*, the magazine edited by FEMMES, announced that the ILO was going to investigate the condition of home workers.[67] In 1982, two years after the WEP released *Housewives Produce for the World Market: The Lace Makers of Narsapur* as a working paper, Dharam Ghai explained that his unit was "initiating a whole new line of research on home-based industries, based at least initially, on the findings of this paper."[68] At the same time, WEP published another working paper by Indian sociologist Zarina Bhatty, titled *Economic Role and Status of Women: A Case Study of Women in the Beedi Industry in Allahabad.*[69] As Ghai reflected on Bhatty, her research questioned "the commonly advocated policy of seeking to create employment opportunities for women which allow them to remain at home."[70] Mies demonstrated that a home-based "strategy, by not transforming the production and reproduction relations, may lead to the impoverishment of the women, and a polarization not only between classes but between men and women as well."[71] Over the next few years, Ghai, Ahmad, and Loutfi would cite Mies and Bhatty and their findings as evidence, and thus rationale, for pursing action on home-based labor. Ahmad and Loutfi introduced women's groups across the progressive political spectrum to the issue.[72]

Mies and Bhatty documented how middlemen exploited secluded women, often their own kin. Bhatty shared the grassroots research approach of Mies. From Allahabad, Uttar Pradesh, herself, she brought an insider's knowledge to analysis

of surveys and observations made with assistance of postgraduate students of so-
cial work, mostly women, who knew the local dialect and regional culture and
spent weeks in the villages interviewing the beedi makers.[73] Unlike Mies, who
celebrated worker impulses toward organization, Bhatty offered a dour portrait
in which these tobacco rollers were unable to "defend their rights"—precisely
the action necessary for enforcement of labor legislation. They were well aware
of their individual expendability by employers who could shift production to
others. India had passed an ambitious Beedi and Cigar Workers Act in 1966,
but court challenges and employer disregard impeded its operation, even after
a 1974 supplement that levied employers for health fund and social insurance
benefits. Villagers valued the household over the individual, and family wel-
fare over income—goals facilitated by women remaining home. Policymakers,
Bhatty warned, had to avoid generating "situations which might result in social
censure or disapproval." However, she found a glimmer of hope from the impact
of earning income on the status of women. Beedi-making promised to generate
"new attitudes towards the established modes of thinking . . . the desirability of
women working, their acceptance as contributors to household income, a con-
sciousness of the value of acquiring a skill and a perception of the significance of
their work involvement to family welfare."[74]

Mies was more forthright on how "women's work in the informal
sector . . . feeds the process of capital accumulation." Lace makers, invisible as
housewives, produced not only for family survival, but also for the world market.
Mies's political economy charted increased pauperization and landlessness, de-
spite the rich soils in the area of Andhra Pradesh. Lacemaking had arrived with
colonization. She showed the transformation of the craft from "pastime" to "ne-
cessity": the poorer the family, the greater amount of lacemaking. Undertaken
between morning and evening cooking, and resumed by oil lamp, this form of
crocheting became naturalized, even as male merchants and middlemen came to
control a vast putting-out system. The "non-separation" of production and repro-
duction, despite the ideology of separate spheres, set "the precondition for the
exploitation."[75]

Deepening Marxist feminist theory, Mies documented how the subsistence
production of the lace makers depended on maintaining these "housewife-
workers" as outside of wage labor as usually configured. Capital flowed to the
informal sector. The entire strategy of profits from self-employment rested on "a
patriarchal and sexist division of labour."[76] Campaigns to improve home work thus
had to confront women's status within as well as outside the household, which
would become a central concern of feminist development thought. Evidence
from Latin America underscored the power of this analysis. By bolstering the role
of wife and mother, a later survey of the literature found, the home location of the

labor encouraged "increased patriarchal control of homeworkers by husbands, intermediaries and employers."[77]

On the basis of these investigations, Ahmad and Loutfi announced that "home-based industries in which women work as contract labour" would constitute a major initiative of the program. What to call the practice was in flux, as they spoke of cottage industry, home-based industry, home work, outwork, domestic outworkers, contract work at home, and the putting-out system. They noted, "It is clear that they [Christian, Hindu, and Muslim women making lace and beedis] are highly exploited and paid less than the prevailing wage for women agricultural labourers. They lack organisation, except where SEWA has been active."[78] Ahmad and Loutfi proposed to commission further case studies and then analyze current ILO instruments, along with national ones, to determine their relevancy for "women who are forced by social and economic circumstances to work on contract at home."[79] As Loutfi admitted to a collaborator, "Our interest in developing our work on the putting-out system has been growing, basically because we see so much concern coming to us from the field."[80] The staff in Geneva was pursuing the findings of ILO officials and researchers in regional offices in New York, Delhi, and Manila, who helped to shape multi-bilateral projects like "Self-Employment Schemes for Female-Headed Households" and "Employment Promotion and Social Protection of Home-Based Workers in Asia." Regional staff was key. As one SEWA organizer told Anita Kelles-Viitanen and Andréa Menefee Singh from ILO New Delhi, "We are colleagues and crusaders together for a common cause."[81]

The Programme on Rural Women pushed the Office to address home work. In 1981 Ahmad reported to various departments on their informal discussions to protect women in household industries worldwide, which she viewed as a long-range program. While NORMS (International Labor Standards) knew of no reason why the ILO could not adopt a convention on work in the home, its chief replied, "Is it important enough to adopt international norms that are universal?"[82] Loutfi inserted the issue in nearly every comment she made on draft reports on employment from other sections within the organization.[83]

Office action required calibrating biennium plans a year or two in advance. As early as 1980–1981, in response to the Sectorial Industrial Committees, the Working Conditions and Welfare Facilities Branch (CONDI/T) planned country monographs, though budget considerations delayed them.[84] The program placed home work in its 1982–1983 plan, but other Office units dallied. In late 1983, Loutfi recommended going through the ILO bureaucracy to bring the subject to the Governing Body and then, after a questionnaire and draft instrument that her branch targeting rural employment would prepare, to the ILC, perhaps in time for 1986. The worldwide increase in home working argued for a

convention, especially because legal or union protection omitted home workers and existing ILO standards on minimum-wage fixing and maternity failed to reach home workers. A convention was "a potentially valuable mechanism to improve the conditions of such workers," Loutfi concluded. A basis existed to formulate a convention from recent legislation enacted by industrialized nations, though the conditions of developing ones required additional discussion. The goal would be the extension of rights that workers in the formal sector enjoyed. "Basically, a convention would grant to the home worker the rights of 'employee.' "[85]

At an informal meeting in December 1983, Loutfi and Ahmad shared their findings with Office sections on laws, standard setting, convention application, women, and health.[86] They approached higher administrators, notably Assistant Director-General Antoinette Béguin. In a clarifying memo in early 1984, Loutfi noted, "Perhaps the extent of ILO capability and planned work relevant to this subject is not sufficiently known and shared." She was not one to shy away from the difficulties of confronting a system whose very organization kept workers invisible or a bureaucracy that slowed down redress. "It is our view that the few references to and weak data on home-based producers are not an indication of an unimportant, minor problem, but the contrary." If the ILO was to live up to its commitment to disadvantaged workers, what was needed was a "fresh look at possible instruments," because of "the apparent ineffectiveness of the traditional response of prohibiting home-based work and contractor arrangements." EMP/RU not only had undertaken the fieldwork to "define the problem but also [to] identity mechanisms for achieving improved protection." It had charted innovative programs. Thus, she asked her colleagues to "agree in principle to pursue the possibility of formulating a convention and recommendation in this area."[87] In 1984 Ela Bhatt also requested an ILO expert committee to study the practice. She simultaneously was demanding that the Indian Parliament appoint one as well. As she explained, the Indian Ministry of Labour should "raise the problem of home workers in the next Annual Conference of the I.L.O."—which would have the added benefit of "strengthen[ing] me in the Nairobi [UN Women's] Conference," where she planed "to bring the issue."[88]

Loutfi was able to spark an interdepartmental task force, which under the leadership of NORMS proceeded far more slowly than she wished.[89] The Programme on Rural Women planned to review instruments for home-based workers and hold several workshops during 1984–1985 on self-employment. CONDI/T started to investigate industrialized countries.[90] In early 1985, Loutfi circulated preliminary findings on legal status and papers from the Asian Conference on Women and the Household organized by Kelles-Viitanen and Singh.[91] Other departments not so subtly "suggested that EMP/RU should continue more work . . . in [its] sphere of competence." In response, Loutfi highlighted the

"encouraging" organizing of the workers, which was no reason to reject an ILO instrument as "a valuable tool complementing and supporting practical action by trade unions and other workers organisations." Indeed, worker groups had called upon the ILO to consider legal measures, including "requests" from SEWA and a recent IUF resolution (but Loutfi did not reveal the interconnection between the two).[92]

The task force determined standard setting to be premature without a more substantive research base. So the program published additional working papers on carpet weavers in rural Turkey, electronic assemblers in Kerala, and rural home work in Latin America.[93] LEG/REL (Legal Regulations) studied precarious employment in 1984–1985 and focused on home work in both industrialized and developing countries for 1986–1987 to discover if such workers came under labor legislation, collective agreements, or other measures. It questioned whether these laborers belonged to the category of persons working in an enterprise. A number of key branches, including PIACT (Working Conditions and Environment), planned to study nonstandard, including home-based, work in developing countries. Office staff drew upon various unpublished country reports for summary articles and "Condition of Work" digests. Comparative analysis, they believed, could lead to adopting new standards.[94] Meanwhile, ILC resolutions on employment and gender equality in the mid-1980s and on rural employment promotion in 1988 called for improving the conditions of home work; the 1985 resolution on equal opportunities specifically invited future standard setting.[95] Another decade would pass before the ILC began a first discussion. Loutfi had transferred to other assignments, but new staff, like Rounaq Jahan and Azita Berar Awad, pursued the issue.[96]

The SEWA Model

SEWA was not the only grassroots formation organizing home-based workers, even in India, but it became the organization cited within ILO circles. Ahmad and Loutfi certainly knew of other groups. From Mies, they learned about the Working Women's Forum in Madras, which promoted social welfare, leadership training, and microcredit circles and had assisted the lacemakers to form a cooperative. Loutfi and Ahmad boasted that this outcome "clearly illustrates the potential usefulness of providing visibility to specific groups of women workers through research, in addition to raising their own consciousness." Bhatt informed them about IRENE (International Restructuring Education Network Europe) in Tilburg, Netherlands, which was "doing wonderful work in Research and Action on home workers."[97]

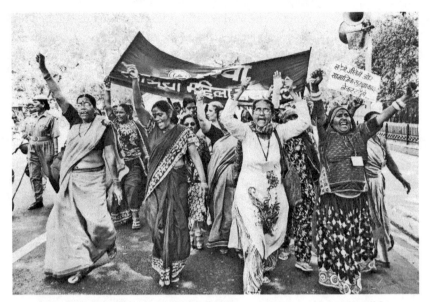

FIGURE 5.1 SEWA, women marching. Photo from SEWA, with permission.

Urban Dutch and British groups were less on the program's radar, but they were forming national networks. In 1984, the National Group on Homeworking in Great Britain brought together voluntary societies in London, Leicester, West Yorkshire, and elsewhere. These units had emerged from the efforts of feminists and women trade unionists, who gained funding from local governments and philanthropies. They undertook campaigns to bring visibility and relief to home workers, including Asian immigrants, through legislation, training, casework, education, and protest against the racism, sexism, and discrimination that limited women's options—all while facilitating home worker leadership and participation. The Dutch Vrouwenbond (Women's Union) developed local resource centers that disseminated materials and information in various languages, ran a telephone hotline, and lobbied government. Loutfi would meet with this group, which had transformed itself from a housewives' auxiliary into an advocate for shared concerns of "paid and unpaid working women." Following the Meeting of Experts on the Social Protection of Homeworkers in 1990, the ILO would highlight the Dutch efforts and ones in India (SEWA), Australia, Canada, the Philippines, Japan, and the United States as successful action programs.[98]

With urban and rural branches, savvy leadership, and demands on the state for rights and recognition, SEWA emerged as the Programme on Rural Women's preferred partner. The relationship grew quickly. Initial letters from Bhatt were formal, requesting information and consultation. She undoubtedly met Ahmad

and Loutfi at the Second World Conference on Women in Copenhagen and may have met other ILO staff at the earlier Mexico City meeting, where she discussed the SEWA bank at a preconference forum. Bhatt commanded a global reputation as the recipient in 1977 of the annual cash prize of the Ramon Magsaysay Foundation (headquartered in the Philippines) honoring the "greatest of spirit and transformative leadership in Asia."[99]

Beginning in 1981, contact with SEWA expanded. Bhatt requested that ILO join "a participatory study with it to analyse the problems of the self-employed workers" and so prompt Indian policymakers to address its concerns. ILO officials argued such a project would be "innovative" because a workers' organization was making the request rather than a government. Within a year, Marion Janjic, the previous head of FEMMES, declared that Bhatt was "well known to our Organisation." The Employment branch recommended SEWA and Bhatt for participation in various workshops and highlighted the organization as a grassroots example in a WEP brochure.[100] In 1983 Director-General Blanchard nominated SEWA for various global awards for the first, but not the last, time.[101] By 1984 Bhatt added to her typed signature "& love" and "with much love" in corresponding with Loutfi and Ahmad, an indication of the sisterhood in common purpose that she had forged with ILO development feminists.[102] They met at international worker and women's meetings, including the founding of DAWN (Ahmad) and the Nairobi Conference closing out the UN Decade for Women in 1985, where Loutfi and Bhatt discussed further projects to advance international recognition of home-based labor as work.[103]

SEWA's prominence initially derived from its place within the Indian labor movement. TLA had a distinguished lineage. In the 1920s Mahatma Gandhi and Anasuya Sarabhai, the radicalized daughter of a mill owner, founded the union in Ahmedabad, a handloom weaving area transformed into "the Manchester of India." They brought a vision of cooperation to labor relations that meshed well with tripartism. For Gandhi, "there is no employee or employer . . . both are co-trustees of society and the community as a whole." Sarabhai agreed that a union had to address the larger needs of people, building their capacities.[104]

By the 1950s, factors impacting manufacturing throughout the nation pushed women out of Ahmedabad factories. Women's labor force participation dropped due to night work and other women-specific labor laws that either restricted employment or made women more expensive to hire. Union men actively campaigned against hiring women and employers preferred men in any case.[105] Despite the rationale of protecting maternal health and maintaining household domesticity, the elimination of women from the formal sector never meant that women would cease generating income. They formed a pool of pieceworkers that converted homes into places of income production.[106] "Self-employed" women

became breadwinners, earning over half of family income. More than 20% were household heads, compared to less than 7% in the general population. But their earnings barely covered daily needs.[107] Like other national trade unions, the TLA concentrated its organizing on India's rapidly disappearing formal sector, about 11% of the national labor force by the 1970s.[108]

In previous decades, the TLA Women's Wing provided the wives of unionists with training in household skills and arts. It further offered social welfare to member families. Bhatt, a lawyer by training from a Brahmin family with roots in the independence movement, came to head the Women's Wing in 1968. She had other ideas. Rather than home economics, women needed organization as workers. She proposed to the TLA a separate women's union "so that they could enjoy the same benefits that organized labour received." She recognized that "[w]omen do not need to come together against anyone; they just need to come together for themselves. By forming a union—a bond—they affirmed their status as workers, and as a result of coming together, they had a voice."[109] But, as if to downplay its departure from the women's auxiliary, as late as 1980 the TLA categorized SEWA with its welfare and educational initiatives, "which cover the life of the workers from womb to tomb."[110]

At first, TLA head Buch served as SEWA's President, with Bhatt as General Secretary, as if it was unseemly for a woman to be totally in charge and as a remainder of ultimate control. Leaders were a mix of college graduates and local women without education. Jhabvala, who joined the effort in 1977, graduated from Harvard and attended Yale. She came from an elite family; her mother was the German-British-American writer Ruth Prawer and her Indian father was the architect Cyrus Jhabvala, whose father was a trade unionist and mother a feminist.[111] Mirai Chatterjee arrived in 1984 with a public health degree from Johns Hopkins University; she ran the organization's social security branch and engaged in participatory projects with members to improve tools, work stations, and exposure to substances even more hazardous in living spaces. The college-educated learned from the members; knowledge came from the grassroots. At every expansion, leaders emerged from the workers to rally others and strengthen the organization.[112]

As SEWA recounts its history, informal sector workers—cart-pullers, head-loaders, and used garment sellers, a good proportion of whom were migrants to the city from surrounding villages—came to Bhatt for aid. She began investigating and publicizing their living and working conditions. At an outdoor meeting in 1971, the women decided to form their own association, which would be a trade union. At first the Registrar of Trade Unions rejected their application because he did not consider them workers. After all, they lacked employers in a traditional sense. It took months before the Registrar accepted SEWA's Gandhian concept of

a union as being "*for* the workers" rather than "*against* the employer." SEWA was registered as a union in 1972. Chindi (quilt-like objects made from mill remnants) and garment stitchers, beedi rollers, embroiderers, and forest scavengers joined the hawkers and vendors.[113]

Beginning with nearly 2,000 members, on the eve of ILO deliberations on a home work convention in 1995, its membership had grown to about 145,000 women from various informal sector occupations, with about 23,000 of them home-based. By 2008 around half of nearly a million members resided in Gujarat, its home state. Overall, there were ten autonomous SEWA "sister" groups in seven Indian states. By then, some 14.45% of members were home-based workers; the majority of members were manual laborers and providers of services—a section that included domestic and agricultural workers. Many members were dependent on distributors or suppliers, even if technically self-employed. Though beginning as an urban organization. SEWA expanded in such a manner that its rural branch would dominate, consisting of some 60% of the association by the early 21st century.[114] In 2014 it had grown to 1.8 million women.[115]

Admitting their mission to be somewhat different from unionization of factory operatives, Bhatt informed a Canadian ITGLWU "sister" in 1974, "The question of victimization does not arise as they are self employed." Assistance went beyond classes on garment making. SEWA aided the home-based women in removing the exploitation of the middlemen by helping with "purchase, sale, finance, accounting, planning, etc."[116] SEWA would not only organize workers into a union, but also into alternative forms of production, like cooperatives. By generating competition, it sometimes forced employers to improve the piece rate. It used membership strength for advocacy but combined lobbying with direct protest, including a struggle by Gujarati garment outworkers for inclusion in the state's minimum wage. It pushed for coverage under social security and welfare provisions, such as health insurance, housing, and child care, demonstrating the link between reproductive and productive labor. It created its own bank, recognizing how women needed credit, and its own welfare unit, knowing that women deserved pensions and access to health care.[117] Through redesigning tools and household spaces, Bhatt understood that they could make lives "more bearable, more livable and affordable." Indian women like herself should not have to "'adjust' to the bodies of Americans," she lamented, asking, "My body to the machine or the machine to my body?"[118] This environmental humanism shaped SEWA's worker-centered projects.

SEWA became a darling of international unionists. The ICFTU displayed cloth woven by its trainees in its Brussels office so visitors could see its accomplishments, helped by "the generosity of our Luxemburg [*sic*] friends" (the Garment and Textile Confederation.)[119] In an affiliate report to the ITGLWF,

the TLA noted Bhatt's winning of the Magsaysay Award "for the meritorious service she rendered in organizing the self-employed women workers—a neglected section of the Society,"[120] a typical portrayal of SEWA's members as the forgotten. In 1980 the ITGLWF featured "the SEWA story" in *The Employment of Women in the Textile, Garment, and Leather Industries.* This document drew upon SEWA publications to argue that "if unions are to deal only with industrial workers they will not, in developing countries, reach the people who in fact contribute to the development of their countries." This meant that "[w]hoever is living on his or her own work without exploiting others should be called a 'worker,'" thus accounting for the vast informal sector and the self-employed whom SEWA defended as a trade union.[121] During the 1980 West Asian Women's Seminar in Ahmedabad, ITGLWF General Secretary Ford dedicated the new SEWA reception center, funded by the Netherlands through the ICFTU. The building stood, he declared, as "a concrete and compelling example of how to satisfy the aspirations of the poorest sections of the community;" it embodied Gandhian principles "to provide everyone with a job and to give priority to helping the poor."[122]

However, SEWA lost ITGLWF support when, a decade after its founding, it split from the TLA over strategy and focus. It chafed at being told to organize women into traditional trade unions when its membership of "own-account" and piece-rate employees needed credit, housing, social welfare, and marketing channels. According to SEWA, jealousy over international attention and the Magsaysay Award factored into the tension. Others reduced the conflict to "personality clashes."[123] The break came during the caste-based riots in 1981 that exploded in response to affirmative action proposals that would have allocated two places in the medical school to the Dalit scheduled caste and Adivasi indigenous people.[124] The riots hit SEWA members hard. Their households were starving, as all business except government-protected industry shut down; it was unsafe to be on the streets even before curfews, making it impossible for market vendors and peddlers to function.

While SEWA sought reconciliation between various ethnic and status factions, the TLA refused to take a political stand. Conflict between TLA leadership and Bhatt, who defended the "Scheduled and Backward" castes in public, finally led the TLA to expel SEWA from its umbrella. Buch was furious over charges hurled by Bhatt "that we are caste Hindu non-worker and anti-Harijans."[125] At the ouster, Buch informed the Indian National Labour Organization, "I built SEWA during the emergency days to protect TLA against Indiraji's [Gandhi, the nation's head] attacks. I built a wall of poor women around TLA. Now I am expelling SEWA because it is dangerous for TLA."[126] The union viewed these women "as enterprising housewives stepping in to work at a time of crisis."[127] Self-employed women again turned into competitors driving down the wages of mill workers.[128] SEWA, in

turn, denounced the process as a product of "the feudal attitude of male domination" and named the National Labour Organization as a hostile place for women, workers and unionists alike.[129] A pro-TLA journalist inadvertently reinforced this charge by casting the conflict as one between the TLA's "Gandhian percepts of service" and Bhatt's mass movement tactics, "a highly emotion-charged partisan approach" with the added "spice of women's liberation."[130]

Expulsion was devastating to a trade unionist like Bhatt, but it opened new directions. By combining self-help and self-organizing, lobbying and micro-enterprise, research and dissemination, SEWA appealed to a wide range of political actors. Recognition and assistance came from NGOs, like OXFAM in Britain; foundations, like Ford in the United States; and the governments of the Netherlands, Norway, and Sweden. Donors facilitated the purchase of transport vehicles, materials for income generation projects and cooperatives (embroidery, spinning, weaving, and dairying), the construction of a center and classroom for its rural wing, and the holding of training sessions and clinics.[131]

News of the parting spread throughout home worker organizing networks. The ILO was well aware of the separation, but concluded, "that has no relevance to the over-all approach to rural development."[132] The Programme on Rural Women "surmounted" the "obstacles," the fears of "complications . . . with the trade union movement" raised in late 1983 by RELTRAV (External Relations branch), to giving "(minor) assistance" to SEWA. The Indian organization had to prove to ILO officials that it was "a bona fide trade union." ILO networks helped to resolve the issue; the New Delhi office of the ILO conveyed to Geneva SEWA's certification as a trade union. The Chief of EMPLOI concluded, "even if it were not [a recognized union], . . . in view of its record of good work for poor self-employed women (which everyone seems to recognize), it deserves support from the ILO."[133]

So the ILO continued to fund SEWA projects, seeking bilateral grants from Finland and other nations.[134] Bhatt confessed to "Zubeida and Martha" in November 1984, "The meeting [with other ILO units] was productive. No need to worry about home workers. I shall, we shall have to vigorously pursue this issue, a time will come to fight headlong (not with ILO) but with employers, more with T.U.s of the formal sector."[135] Within two years, SEWA was carrying out a "Participatory Action Research Project on the Development of Effective Monitoring Systems and the Application of Legislation for Home-based Producers," with the goal of advancing the argument for ILO standard setting.[136]

Bhatt further found a new place in the international labor movement through the IUF, which counted tobacco workers, like the beedi makers, among its constituency. Despite a personal plea to "Brother Ford," the General Secretary of the ITGLWF could not admit the association as an affiliate to his federation,

especially in light of opposition by Indian unions. But Ford sent Bhatt to Dan Gallin. SEWA joined the IUF in 1983. Two years later, it also affiliated with the International Federation of Plantation, Agricultural and Allied Workers, which merged into the IUF in 1994.[137]

SEWA shared with these unionists a commitment to the informal sector and low-paid workers. In an attempt to put international pressure on national and local Indian governments, for example, the 1985 IUF Congress welcomed the home-based beedi workers. It praised SEWA for "outstanding" organizing, offered "solidarity" in its "fight to bring these workers under minimum standards of income and security," pleaded for Indian authorities to actually implement legislation to ensure decent standards; and "demand[ed] that introduction of new technology in the [beedi] industry be negotiated on a tripartite basis in order to prevent a sudden loss of income for a large number of workers who have no alternative means of earning."[138]

SEWA gained further notice as part of the transnational women's movement that the UN Decade for Women midwifed. It offered a feminist twist to Gandhian self-sufficiency. It prepared women to maintain their own independent income and move away from male power. Jhabvala often quoted the nationalistic exhortation of Gandhi: "[W]omen have to take leadership to solve the problems of the country. Women should widen their family to the whole country." As she explained during a 1989 study tour for grassroots organizers, one form of leadership development undertaken by the organization with ILO support, "If women organize there are many ways to solve the problems of rural women." Because the participants were "women working and being from the rural areas," they knew "the problems of rural women," even those who dressed differently, spoke another language, and ate other kinds of food. A common purpose could come from common problems: "drought, floods, . . . non-payment of minimum wages, domestic problems, health problems due to work, child birth." Asked what to do, attendees replied, "The only way to solve the problem of rural women is through organizing," which required "education work and food." Reflecting the participatory democracy and autonomy at the center of the SEWA approach, the women insisted that "rural women have to come together and organize themselves." From meeting village women elsewhere, one attendee learned "the power of love and unity," a lesson taught as a prerequisite for expanding into a national movement.[139]

Eager to support projects that combined standard setting with technical cooperation, ILO feminists in Geneva and the India regional office recognized that "for SEWA organizing does not simply mean joining SEWA."[140] Organizing meant "Generating Awareness,"[141] or empowering often illiterate and always "spread out" or isolated workers through gatherings, called camps, that allowed

such women "to move out of their home, visit SEWA, meet other workers and learn about their rights."[142] SEWA constructed these sessions to enable women responsible for earning enough for family survival to "draw a clear picture of their lives and their problems as working women" and provide "a better awareness of their roles in society, their rights to earn a respectable livelihood." Targeting the whole person, the camps began with prayer, song, and yoga. They covered self-care, sanitation, nutrition, and health and fostered self-confidence, leadership, cohesion, and group decision-making through games and role-playing. They further educated the women about legal rights, occupational safety, unionization, and co-operatives. The attendees visited factories, shrines, and medical clinics.[143] Presentations to often illiterate groups relied on visual and oral communication— such as posters with graphs on women's wages in relation to men's, charts on benefits and working conditions, and films depicting demonstrations and other SEWA activities.[144] In encouraging the women to speak, organizers pushed against religious blinders and socialization that "inhibits them to mix freely with one another."[145] Participants heard that "employers can fire one woman but they cannot do it to a thousand!" Learning the power of collective action, they had opportunities to practice these lessons in arguing for state protection.[146]

The camps bridged education and organizing. At one for beedi workers, the women listened to experts speak on available forms of social protection. But the women were skeptical that they would ever receive benefits from the joint employer-employee Provident fund for their trade. Despite court rulings, employers resorted to all kinds of illegalities to avoid paying benefits (like creating false names for workers and switching names every few weeks). They also withheld the ID cards that were necessary for state-funded health care and school scholarships.[147] At another one for garment workers that drew forty women from Ahmadabad, the women shared stories of wrongs in a process of being informed about their rights. Responsible for the cost of electricity, sewing machine, thread, and transport to pick up and deliver goods, at daily earnings of 6–7 rupees, they obtained only a pittance of what merchants and middlemen kept as profit. They complained about merchants who demeaned "the quality of their stitching and harassed them about the rates and invariably held back part of the money due to them." The "more aware" shared experiences of being retaliated against for marching against low piece rates or airing grievances through media.[148]

From such knowledge came action. Beedi workers prioritized an agenda: gaining a holiday bonus, ID cards, and the necessary raw materials to roll their cigarettes. SEWA would send letters to employers and government officials and the women planned a follow-up mass meeting.[149] The garment worker camp concluded that flooding the authorities with complaints, unionizing, or creating a cooperative offered viable counteractions to employer withholding of benefits

and the minimum wage. Attendees presented demands for increased wage rates and more extensive inclusion in minimum wage legislation to the Labor Commissioner, "who promised to look into the matter," but by himself could not do much. Part of "awareness," then, was gaining the courage and know-how to transform embodied knowledge into public actions. While still at the camps, SEWA instructed the women in techniques for lobbying, sharing whom to contact and how.[150]

Bhatt and her organization won personal but not legislative recognition. Appointed to the Upper House of Parliament in 1986, she headed a Commission on Self-Employed Women constituted by the Indian Government. Extensive hearings and investigation confirmed the interconnection between the burdens of reproductive labor and limits on income generation, paucity of training, lack of access to information, and community and household restraints. Two years later she introduced a private member's bill for "Protection of Home-Based Workers." Despite sympathetic local and national officials, the government never placed the bill on the docket for consideration, nor did it act on commission recommendations.[151] Its parliamentary initiatives blocked, SEWA redoubled its efforts for an ILO convention.

Convention No. 177

SEWA commanded the campaign for ILO action as part of a transnational network of home work organizers. Spearheaded by the British and Dutch, these activists had engaged in meetings and exchanges for nearly a decade before HomeNet International formally incorporated in 1994 in time for ILC convention making. They tapped into a constellation of local groups, researchers, and projects, including one for Palestinian refugees. They connected to the ILO's "Sub-Regional Project on Women in the New Putting Out System," which covered Pakistan, the Philippines, Indonesia, Bangladesh, and Thailand. In 1990–1991 this project generated the Philippine National Network of Homeworkers (PATAMABA).[152] Some of the same women, like British activist Jane Tate, participated in a European Commission Working Group on Homeworking and would form a European network that extended to Greece and Italy. Tate and other British activists met women from the embroiderer union STIBTTA of Madeira, Portugal, which organized the home workers who had come to dominate their industry. Joint conferences and visits, facilitated by NGOs like the Dutch IRENE, cemented working relationships between Europeans, Indians, South Asians, and South Africans, who shared experiences, traded best practices, and forged a common analysis. They moved to the international level to combat

a global system, but also to win national reforms through the normative value of an ILO convention.[153]

This network engaged in three practices. First, it strengthened its own group through exchanging information, best practices, and people. Women within the trade unions and international secretariats, like Barbro Budin from IUF and Laura Carter from ITGWLF, were crucial facilitators. So were staff within the ILO, especially Gisela Schneider from CONDI/T and Azita Berar Awad from EMPLOI, both involved with the actual drafting of the convention. Second, it amassed declarations of support and requests to the ILO at various regional conferences. Congresses of the IUF and ICFTU spread the message widely. Regional meetings in Asia proved fertile ground as well. Finally, gatherings of researchers and other experts provided additional venues to tell the story of the home workers and ask for support.[154] Campaigners produced a booklet with available statistics for the final discussion, under the imprint of Harvard University's Kennedy School, where development expert Martha (Marty) Chen held an appointment. Some activists later credited these statistics with convincing governments to vote for the convention.[155]

Direct appeals paid off. Director-General Blanchard returned from a visit to India "impressed by the work being done by Mrs. Ela Bhatt and the Self-Employed Women's Association in Ahmedabad." He asked the ICFTU to "bear their work in mind," even as Bhatt herself had asked him to call an experts meeting.[156] The ICFTU was among unionists that brought the home work issue before the Governing Body, which in November 1989 approved a Committee of Experts on the Social Protection of Homeworkers. This committee had a four-task charge: "to examine the nature, extent and problems of home working," "to assess national experience in the protection and organisation of homeworkers," "to advise on approaches and measures that could lead to more effective protection," and "to advise on future ILO action . . . including the possible need for new international labour standards."[157]

Members came as subject experts rather than nation-based delegates, though the slate carefully balanced developing with developed locations. Government members were from Italy, Kenya, the Philippines, United Kingdom, United States, and Venezuela. The ICFTU, with Gallin involved, nominated Bhatt as an expert.[158] She was among the five Worker members, as was the Secretary of the Women's Section of FNV. There were two other women, one from the Confederazione Generale Italiana del Lavoro and the other from the ILGWU. They were joined with a man from the Union Marocaine du Travail. The Employers were from Australia, Cameron, Colombia, Mauritius, and Panama. Reflective of the extent of interest, eleven organizations sent observers, including the ICFTU, International Organization of Employers, Commission of the

European Community, and the Division for the Advancement of Women of the United Nations Centre for Social Development and Humanitarian Affairs.[159]

The Meeting of Experts ranged widely. The Chief of CONDI/T represented the Director-General, a higher-status official than any development feminist from the Office. He asked the experts "to identify measures that would prevent the exploitation of homeworkers, while safeguarding the economic advantages for those who relied on home work to earn an income." They were not there to recommend abolition. The meeting reached consensus on additional research into conditions and types of work, with statistical comparability; the extent of ILO technical cooperation; application of relevant ILO standards, including freedom of association and collective bargaining; and nature of national action on standards and training as appropriate. It wanted to know about action programs that raised awareness, provided alternative employment, organized home workers, and enhanced worker security. What they could not agree on was the need for a new ILO instrument.[160]

Action on home-based labor came as the ILO sought to promote self-employment in the face of unemployment. In June 1990 the ILC passed a broad resolution on self-employment, recommending appropriate standards coverage and support for worker organization. The Workers' group pushed for "special measures" to protect home workers and others who were "pseudo self-employed." During general discussion, Charles Ford offered a far less positive portrait of such workers than champions of self-employment painted. He evoked the "'exploitation' of women in Ahmedabad, who spend 15 to 18 hours a day hunched over ancient sewing-machines, in order to earn 50 US cents." Repeating the historic tropes of the home as factory, childhood denied, and "family life . . . tethered to the ever-present work," the ITGLWF leader urged prompt action on a convention that would "as soon as practicable" put home workers on a par with factory ones and regulate "the health and well-being of those forced to work at home." Addressing home work represented a doable response to the intensified challenge the garment and textile sector faced from free trade zones and globalization untethered from any "social clause."[161]

The ILO also discussed home work as it confronted in 1991 what the then Director-General Michael Hansenne, a Belgium labor activist and politician, named "The Dilemma of the Informal Sector." An ILO study in the 1970s had highlighted the irregular, casual, and under the regulatory radar work of most of the world's people, bringing the concept of informal sector into development discourse. A contributor to economic growth, the informal sector by definition was ripe for exploitation and other abuses. But it also stood as the location of economic activity and generated livelihoods.[162] The Nordic countries, the nations that had funded projects of the Programme on Rural Women, submitted

to the ILC in 1991 a resolution on women workers in the informal sector. These governments asked the ILO to expand "documentation of the conditions of life and work of home-based workers and self-employed women," as well as consider extending to them social protection, training, and aid in organizing. Other proposed resolutions targeted the informal sector more generally.[163] During the ILC's first discussion on home work in 1995, the male Minister of Labor of Nicaragua would evoke this earlier consideration of informality and its relationship to structural adjustment in arguing for using home work regulation for "finally confronting the "exploitation which liberalism is imposing in all sorts of countries at this time." The cry "We are all employers here" ironically underscored the "hidden" employment relation that many from the Employers' group continued to deny.[164] The Meeting of Experts had already situated home work as part of "increasing casualization of labour" that hurt women who were engaged in family care across the generations.[165]

Definitional disagreements plagued the Meeting of Experts and subsequent convention making. The Office offered three criteria for a home worker: the existence of an employment relationship; a workplace apart from "the premises of the employer," and thus not under direct supervision; and payment by the piece.[166] Some, like the Danish Employers' Confederation, emphasized extent of supervision as the quality that separated the employee from the self-employed. Others saw the employer as one who permitted work. Such criteria were not easily measurable. The resulting convention and recommendation restricted their provisions to home workers who were employees, requesting nations that failed to count home workers as such to revise their practices. These instruments stressed the resulting output be "specified by the employer," no matter who supplied "the equipment, materials or other inputs used." This definition excluded the "own-account" and "self-employed" workers. Experts argued for application as national conditions permitted, the usual counter to universal-sounding standards. Some expressed concern that the coverage be expansive enough to include new kinds of home workers, including teleworkers.[167] Bhatt explained that they sought "to cast a wide net rather than to exclude large numbers of homeworkers because of definitional technicalities," though the Governing Body was concerned precisely with the problem of definition.[168]

Employers, for their part, attempted to obfuscate deliberations by conflating the home-based piece-rate worker with both the professional who worked from home and the start-up "born in homes or garages."[169] In committee discussions, some Employers equated industrial home workers with teleworkers, even though many understood that the convention was to address conditions in developing nations and the informal industrial sector, meaning that computer home work might require its own instrument. Employers claimed that the convention

confused "a commercial contract and an employment contract." They presented such examples to argue for the vagueness of the terms, and thus the impossibility to capture the nature of home work through a convention. An Employer member of the Governing Body from Panama fell back on the need for "more informa-tion, including statistics" to reject standard-making. Rather than a standard, ILO technical assistance was good enough for him "in parts of the world where homeworking was common or where industry was calling on homeworkers in order to increase productivity." The final definitions responded to this critique even while rejecting its conclusions.[170]

Recalling the ICFTU resolution, Bhatt declared at the Meeting of Experts that a convention was "overdue." Most unions consisted of industrial workers; "it was time to draw in the masses of workers in the informal sector." She insisted, "Homeworkers were not demanding charity but their rightful place in the labour movement." A convention could counter their classification as "self-employed" by recognizing them as workers. Worker experts concurred. Governments were mixed. The Employers dissented in a pattern that would repeat itself at the ILC. Unable to agree on a specific international instrument or even on having one at all, the Workers and Governments voted to ask for a general ILC discussion.[171] Bhatt reported to Gallin, "[W]e could not get consensus from the Employers anywhere near [a] Convention. What we got is, a feeble tool, i.e., appropriate action by ILO."[172]

Divergent discourses framed the Meeting of Experts and subsequent deliberations. Speakers recuperated tropes of invisibility, marginalization, vul-nerability, and isolation that had long defined home work. The question was often less about exclusion from rights, though that happened, than about the in-ability to activate collective bargaining or redress underpayment. Workers were uninformed and often desperate, afraid of losing access to earnings crucial for their households. Worker representatives feared "a return to the conditions of the nineteenth century" through "modern slavery, camouflaged" as independent contracting. By adopting a convention, the delegates would be "bringing a smile to the unfortunate faces of those who have never been given any hope or real face." Home work was either "the cradle or kindergarten of enterprise" and an engine of economic growth or a generator of exploitation. Bans became "an incursion on personal freedom."[173] When the European Union nations joined India and South Africa during the second discussion at the 1996 ILC to support the convention, the Employers' group could no longer argue that the proposed instrument was too limited because it addressed only concerns of the Global South.[174]

The convention confronted the problem of the home as a workplace. It offered opportunity to women who otherwise would not be able to leave their families, ending their marginalization, or took unfair advantage of customary

and employer discrimination. Like Workers, Employers also connected home and work. They too drew upon hegemonic understandings of the family, but to defend "the genius and culture of domestic establishment, particularly involving women workers," from interference by regulatory bureaucracy or to charge that "equality of treatment" would destabilize "domestic life" and "the family system."[175] Employers "stressed the positive potential for job creation, reduced costs, flexibility," while their Worker counterparts "saw the advantages as going mainly to the employers . . . often the only advantage for the homeworker was to have work and some income instead of having no work and no income at all." Rather than alleviate poverty, according to this reasoning, home work damaged the fiscal health of the state, as much of it was underground, illegal, and invisible. Employers, however, saw the convention pushing such work further underground.[176]

The inability of the Meeting of Experts to agree on the scope of the problem; the definitions of home worker, intermediary (subcontractor), or employer; and much else led to a request to the Governing Body to decide whether the ILO should engage in standard setting at all. The rancor over the appropriateness of action foreshadowed the breakdown of tripartism during the 1996 passage of what emerged from committee as a very general convention (and a detailed recommendation for implementation). Refusing to participate in deliberations over the convention, Employer delegates abstained in mass during the vote. They failed in the attempt to undermine the needed quorum.[177] Convention No. 177 brought to a head a long-simmering disjuncture between the organization of the ILO and Employer rejection of standards. In the neoliberal moment, employers wanted less, not more, oversight.

In these deliberations, the home worker assumed the characteristics of the woman worker. She would gain coverage under other conventions and become equal to the hegemonic worker of the standard employment contract. Yet she still would require special treatment because of the unique circumstance of her location that made inspection difficult. This conflation undoubtedly stemmed from the predominance of women as outworkers, despite the efforts of some experts to highlight the presence of men and people with disabilities.[178] She would have "freedom of association, protection against discrimination in employment, occupational safety and health, remuneration and maternity protection." However, to obtain these standards required additional record keeping by employers, workers, and government agencies. Despite the lingering belief in the privacy of home spaces, the state had to inspect them to ensure compliance to labor standards.[179]

Amid all the talk from 1990 through 1996, the home worker herself was mute. SEWA and other campaigners brought some workers to Geneva and a few HomeNet members were part of union delegations, but they could participate

only in Worker meetings. Employers blocked a proposal to have Bhatt address the plenary session during final deliberations in 1996. The Workers' group had allowed her to talk in committee, but all tripartite partners would have had to approve an observer speaking to the ILC. The Employers certainly feared her power to move delegates. Recalled political scientist Elisabeth Prügl, who watched the proceedings, "her symbolic power evoking the image of home-based assembly workers" challenged employer constructs of "the new flexible labor force" consisting of white-collar workers choosing their space of labor. The ILC could only view, not hear, representations of home workers hung outside of the meeting. This display, undoubtedly the one assembled by Jane Tate and HomeNet and put up by Office allies, portrayed the diversity of home workers. Passers-by viewed "the *beedi* workers in India, the garment workers in Bangkok and all over the rest of the world, the British woman assembling Christmas crackers, the tele-homeworkers in Canada and Australia, and the women in Madeira, Portugal, who do the most beautiful hand embroidery." These representations spoke to home workers standing as part of "those workers who are in need of protection," those whose plight remained the ILO's mission to relieve through standard setting.[180]

THE EMPLOYERS CORRECTLY predicted that few states would ratify the Home Work Convention, which came into force in 2000; over twenty years after passage, only ten had signed. Sometimes significance lies elsewhere. With Convention No. 177, the ILO first recognized work in the home as worthy of a labor standard of its own. It highlighted conditions that disadvantaged women's labor market participation. It ended the distinction between public and private on the basis of the nature of the work, not its location or the characteristics of the worker. Technical cooperation and standard setting on home work solidified institutional support for the informal sector, helping to redirect ILO efforts to the reproductive labor that occurs in that realm. Finally, home work activism revealed the kind of transnational networking and coordinated strategy necessary for success within the ILO system and highlighted the necessity of obtaining trade union support for admittance into its deliberative process.[181]

Should the Employers have been so hostile? SEWA exemplified "self-help," presumably a pillar of neoliberal thought. But what did that mean in the context of poor rural women? In 1983 Director-General Blanchard commended SEWA for "doing outstanding work to promote self-reliant development," and for its "inspiration for many who wish to see economic and social development of disadvantaged rural women promoted through active and participatory initiatives taken by these women themselves."[182] Such terms suggest how the programs of the group, especially its bank and empowerment activities, lent themselves to the neoliberal moment even though it sought to counter hierarchies in the

home, community, state, and society. In this vein, an International Community Leadership Project, which sponsored a South to North meeting, described SEWA as "a self-insuring credit union which has opened new markets and spawned similar organizing efforts in various parts of India," as well as "challenging exclusion of women by trade unions."[183] In advocating self-employment and self-organizing, SEWA blended into the reigning discourses of the 1980s and early 1990s that the ILO could not escape.[184]

There is another interpretation that Rounaq Jahan gave that distinguishes SEWA from the neoliberal imperative. "It is obvious that the underprivileged and the oppressed would have to help themselves: that they cannot expect the privileged to give up their privileges," she informed a German United Nations association. "Organisation and struggle by the underprivileged is, therefore, necessary in fighting poverty and exploitation." That was the lesson of SEWA and other grassroots groups. They were modernizers, formalizing the informal. They were feminists. Where husbands, employers, and women saw "just housewives," they viewed workers. They supported a "tradition of self help" to cushion the desperate resort to self-employment that home-based labor exemplified and ILO feminists sought to transform into a livelihood rather than a mere living.[185] They would make the woman worker into an empowered woman at home, within the community, and in the labor market.

PART III

Difference All

Centering Care, 1990s–2010s

6

Home

ON THE STREETS of Geneva and in the *Palais des Nations*, they were "something that the ILO has *never* seen before," declared South African trade unionist Myrtle Witbooi, a former domestic worker who led the International Domestic Workers Network (IDWN) in its fight for a convention.[1] On June 8, 2010, a week into the 99th session of the ILC, a giant patchwork quilt, with the handprints of 3,500 household workers, made its way through city streets, held aloft by its makers from the Asian Domestic Workers Network and activists from around the world.[2] During the entire three-week conference, through song, dance, performance, and coordinated messages, some emblazoned on T-shirts, the gathered women—joined by a few men—underscored that the time had come for decent work for domestic workers. They broke into cheers and applause, first in the middle of somber deliberations, and then, their enthusiasm redirected, at the end of sessions that resulted a year later in the Domestic Workers Convention No. 189 and Recommendation No. 201 (2011). They shouted, "Domestic workers need a convention, domestic workers need a convention, domestic workers need a convention, domestic workers in the ILO." They swayed through corridors, singing a South African refrain that became the anthem of the movement: "My mother was a kitchen girl, my father was a garden boy, that's why we are unionist, we are unionist, we are unionist." Shirley Pryce, President of the Jamaica Household Workers' Association, and once a servant to her country's Prime Minister, captured their mood: "Hear me roar in numbers too big to ignore, I have been down on the floor but no one ever going to keep me down/ . . . I am a Domestic Worker watch me grow, I can stand with you toe to toe."[3]

Stand alongside Employer, Worker, and Government delegates they did. Witbooi attended the ILC as a Worker advisor to the official South African delegation.[4] "Allowing this participation has made visible the work of millions of domestic workers," she thanked the conference. "So please forgive us if, at time, we allow ourselves to get away by the excitement of this historic moment when the

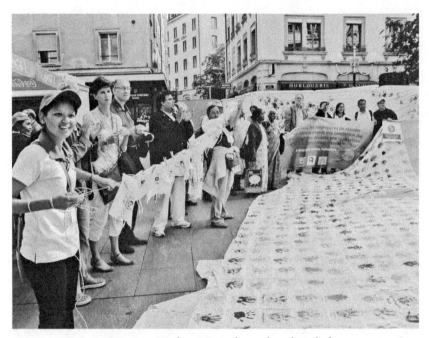

FIGURE 6.1 Asian Domestic Workers Network, patchwork quilt demonstration, June 8, 2010, Geneva. Photo by Jennifer N. Fish, on behalf of the International Domestic Workers Federation, with permission.

voices of domestic workers are heard for the first time at the international level."[5] Some Employer delegates were not so forgiving. John Kloosterman of the San Francisco anti-labor law firm Littler Mendelson disparaged the deliberations of the Committee on Domestic Workers. Before the entire ILC, he complained that decorum broke down amid hissing and booing, ovations and applause, singing and dancing, and even "demonstrations aimed at specific Employers' delegates." His refusal to engage with domestic worker organizers at home continued in Geneva, with activists seeking to gain his attention and Kloosterman threatening to obtain a restraining order against women who only wished to dialogue. The real problem, he announced, was that the ILC "is meant to be a tripartite discussion." However, the Committee on Domestic Workers generated "a four-part discussion, involving Workers, Governments, Employers and NGOs." Actually he wouldn't dignify the proceedings as "a discussion."[6]

Talking about domestic work evoked strong feelings on all sides. Everyone was an employer—or could be. During the Governing Body session later that June, Employers' Vice-Chairperson Daniel Funes De Rioja, an officer of the Argentinian Industrial Association and the International Organization of Employers, diplomatically "recognized that emotional issues could arise, as had

been the case during the discussion on domestic workers." Still, procedures were necessary to maintain "parliamentary debate" and the observer workers present had disregarded them. His association of emotion with a group of women underscored the gendered dimensions of the confrontation between cool, mostly male deliberators, and female disruptors. The Committee on Domestic Workers even saw "a person not entitled to vote" trying to cast a ballot. Workers' Vice-Chairperson Leroy Trotman, the General Secretary of the Barbados Workers' Union, considered this attempt "the result of over-enthusiastic participation, or quite simply a mistaken perception of the role," not "dishonesty." Employers had "overreacted." He explained, "Some of those present, including the speaker, had been domestic slaves." Drawing on the authenticity of experience, he admitted that he had "undertaken domestic work as a child to pay for his education. Others were in a more difficult situation." Rather than sanctions against participation at the next meeting, Trotman called for "support for those who had suffered, and were still suffering stress and deprivation." Agreeing with the Employers, he promoted realism. The delegates needed to generate "an instrument that could be ratified," though he was quick to underscore the reasonableness of domestic worker demands.[7]

In defending the observers, Trotman drew upon two prominent tropes pervading their representation: slavery and suffering. Domestic workers needed rescue and saving through the labor standards that the ILO could forge. However, the militancy and political sophistication of travelers to Geneva defied such characterization. They may have experienced exploitation, abuse, and legal exclusion, but they were workers, not servants. Still, they would take advantage of these concerns by referring to slave-like conditions, forced labor, and stunting child labor, all of which the ILO and NGOs, like Human Rights Watch, had documented throughout the world.[8] Witbooi announced upon passage of the convention, "Our dream became a reality, and we are free—slaves no more, but workers."[9]

Characterized by intimate labor, occurring within family spaces, and involving touch and personal knowledge of possessions and bodies, domestic work challenged traditional understandings of employment. Often there was no contract or agreed-upon terms, defined duties, or designated hours. Conflated with the unpaid labor of wives, mothers, and daughters, presumably undertaken out of love or obligation, commodified cleaning, cooking, and caring lacked value based on assumptions that any woman could perform such tasks. The characteristics of the workers sullied the work: only degraded people—racial others, often from a lower caste or class—performed dirty work, making such jobs unworthy of recognition and respect. The legacy of slavery, indenture, and bonded labor was real.[10]

But so was the significance of the work, which extended from the household to the global economy. Manuela Tomei, the Director of the ILO's then named Conditions of Work and Employment Programme, described it as "an essential part of life. Care work in the household was indispensable for the functioning of the economy." Trained as a social scientist in Italy, Tomei was well equipped to guide the Committee on Domestic Workers. She had served in the ILO's Regional Office for the Americas and the Caribbean before moving to Geneva in 1991, first as a specialist on rural workers' organization, and later as a senior specialist on discrimination. She understood that the labor of domestic workers not only allowed employers to undertake employment in locations away from the home, relieving the double day of earning income and caring for the household, but monies earned supplied remittances to families elsewhere. We might reframe her analysis: rather than generate profit directly, domestic work enhanced profit indirectly by taking on reproductive labor that would otherwise be performed under duress by the family. It thus freed other women for what generally was considered productive labor, jobs outside the home. However, "despite its contribution to national economies and societies," Tomei reminded delegates, "domestic work was one of the most precarious, low-paid and unprotected forms of employment."[11]

With increasing participation of married women and mothers in the labor force, domestic work continued to grow toward the end of the 20th-century and during the first decades of the 21st. As of 2010, the ILO estimated a workforce of nearly 53 million, 19 million more than fifteen years before, accounting for some 7.5% of women's labor across the globe, with larger percentages in specific regions like Latin America. As with other forms of home-based labor, no one really had an accurate enumeration; there could have been as many as 100 million domestic workers at the time of ILC consideration. As in the past, most of these were female, disproportionately from minoritized racial, ethnic, or religious groups, increasingly migrants without citizenship rights, and too often children—around 6.3 million under age fifteen as of 2012. After passage of the convention, numbers in 2013 reached 67 million, with 11.5 million migrants. Over 33% labored in the Asia and Pacific region, with migrants there composing nearly 15% of the workforce.[12]

Subject to forced labor, cheated by employment agencies, and abused behind the closed doors of households, domestic workers exposed the division between free and unfree labor as a continuum rather than a sharp break.[13] It was, as the ILO preparatory report explained in 2010, "Work like any other, work like no other."[14] Such a position justified a convention of its own to guarantee coverage under other conventions and to counter the tendency of states to remove this class of labor when permitted flexibility in meeting convention terms. Even

where national law included household workers, enforcement had proved difficult. Many hoped that a stand-alone convention would bolster compliance.

The Employers were not totally off base in their charges against the campaigners. NGO support was crucial for obtaining "Decent Work for Domestic Workers." Human Rights Watch, Migrant Forum in Asia, and various anti-trafficking and anti-slavery groups connected worker rights to human rights, amplifying the message of the IDWN, by associating it with their own foci.[15] As with the home-based workers before them, global labor federations played a central role in accessing the ILO. IUF, the International Trade Union Confederation (ITUC, formerly ICFTU), and the activist think tank and research group Women in Informal Employment: Globalizing and Organizing (WIEGO) provided the resources necessary for the IDWN. Dan Gallin, then retired but working at the Global Labour Institute, and Barbro Budin, the IUF's Equalities Officer, continued to link informal sector workers to trade unions, and both to the ILO. WIEGO was a product of the home-based labor struggle, with development expert Martha (Marty) Chen and SEWA's Renana Jhabvala the originators.[16] It formed in 1997 with the explicit goal of creating an advocacy network out of worker organizations (cooperatives, unions, and associations), academic researchers, and development professionals to provide technical assistance for informal worker organizing.[17]

These campaigners had learned that quantitative social science research could sway Government delegates and combat Employer opponents. They articulated domestic labor as one component of a rapidly expanding and heavily feminized informal economy.[18] But, unlike the push for Convention No. 177, actual workers took central stage in the domestic work struggle. Even when unable to talk during formal sessions, they issued press releases, lobbied delegates, and demonstrated before the world. They served as advisors, and a few stood as delegates. WIEGO provided crucial training in communication, assembled facts and figures, and helped orient workers to the peculiarities of the ILC. While the unions and this feminist NGO guided the campaign, they never controlled the shots. Global policymakers and unionists could act because domestic workers themselves had created their own vibrant national and regional member-based associations, sometimes fostered by local unions, over the previous decades. These organizations came together to form the IDWN. In the end, they pried open ILO tripartism, offering a model more appropriate for a world of precarious labor than the one inherited from a past of social democracy, welfare states, and collective bargaining.

As previous chapters have suggested, deliberating on global standards for domestic workers was not entirely a new issue at the ILO. In the 1930s the Office studied working conditions; it was particularly concerned that low pay and

the practice of living-in posed moral dangers, leading women to prostitution.[19] Following WWII, when sociologists and policymakers alike predicted occupational obsolescence, the ILO surveyed member nations on the plight of household workers. It understood domestic work as part of the problem of an expanded movement of women into employment, and sought solutions to what loomed as a crisis of care and household maintenance—an assessment derived from conditions in industrialized nations.[20] This initiative fizzled in the early 1950s; neither did study of the sector in subsequent decades lead to action. It would take over sixty years for the ILO to include household workers under basic labor protections.

After looking more closely at prior efforts to address domestic work, this chapter situates the making of Convention No. 189 in terms of both internal and external factors. Paving the way were ILO discussions on migrants and the informal economy. The "decent work" and "fair globalization" initiatives of Director-General Juan Somavía, a Chilean diplomat and human rights advocate who served as head of the organization from 1999 until 2012, framed the convention in the laborite terms of the ILO's essence. The very name, "Decent Work for Domestic Workers," embodied his first principle: "work was not just a cost of production but—for society and people—it was a source of personal dignity and peace in the community."[21] Nonetheless, the ILO would not have taken up the formalization of household employment without social movements on the ground, the creation of an international network, and the campaign for ILO attention. The resulting discussion at the ILO and in the streets of Geneva became "historic."[22] Not only did organized domestic workers and their NGO allies break through the barriers of ILO tripartism, but Convention No. 189 signaled the centrality of paid care work for women's labor force participation and the functioning of the global economy, which the ILO came to recognize as necessary for gender equality as well.[23]

Awareness of shifting material conditions informed these actions. An intensified crisis in social reproduction had exploded with capitalist restructuring and the worldwide slump of 2008, while transnational mothering and migration—with an accompanying "care deficit"—pushed domestic employment from national to international concern.[24] In this context, domestic work was good for the ILO, as development had been in the post-WWII years. For a new century, it made the ILO relevant again, giving the flagging organization a boost in a fight against the precarity and informality that were undermining the very idea of universal labor standards. Reproductive labor won recognition as work at a time when standardized employment had become badly frayed. Parlaying victory into better conditions would prove daunting, but the IDWN with its union and NGO allies secured more ratifications in a few years than many other conventions, notably No. 177, received in decades.

The Legacy

Post-WWII discussions of domestic work represented unfinished business from the interwar years. From time to time, delegates raised the issue of domestic servants, as they were called; some early social security conventions relating to sickness, invalidity (injury), and old-age insurance covered them. But loopholes permitted exclusion and national governments typically omitted these workers from labor laws.[25] The home location of the job made household labor subject to cultures of protection focused on the consequences of its perceived difference as intimate labor in private spaces. As we have seen, jobs supplying housing, like live-in service, were deemed inherently dangerous, exposing women to sexual assault. In 1933, as its contribution to the fight against "white slavery," the ILO adopted a convention abolishing fee-charging employment agencies, in large measure to stamp out abuse of women in domestic service who found themselves placed in environments of sexual danger. Another convention raised the minimum age for jobs deemed "dangerous to morals," which included household employment. Low wages, experts believed, made prostitution an attractive alternative to domestic work.[26]

With the onset of the Great Depression, a male Chilean Worker delegate urged the ILO to study the large number of women in this occupation who also found themselves unemployed.[27] In response, Marguerite Thibert commissioned the organization's first study on the subject. "The Social, Economic, and Legal Conditions of Domestic Servants," published in 1934 in the *International Labour Review*, concluded that the stigmatized social status of the labor trumped any "automatic balancing of supply and demand" as out-of-work women refused to enter household service. Research consultant Erna Magnus, a German socialist and worker educator, called for including domestic workers in general standards developed to improve living and laboring conditions, with the hedge "as far as possible." She further recommended legislation to extend social insurance and vocational training to household workers, permit their organizing, and encourage living out rather than living in their place of employment. The goal was to eliminate the "social difference between" servants and other workers.[28]

Discussions over holidays with pay displayed the general ambivalence attached to household workers. Delegates initially voted to discuss domestic workers along with agricultural laborers and industrial home workers as part of such a convention, agreeing with a male Swiss Worker delegate who held "that domestic servants . . . are wage-earners, and therefore entitled to protection in the same way as other wage-earners." Yet only a handful of countries—Chile, Finland, France, Latvia, Peru, Spain, and one Swiss canton—actually extended paid vacations to domestic workers.[29] In contrast, a male Swiss Employer advisor insisted that the Employers' group only represented those in industry and commerce; thus,

Employers were unconcerned with domestic work. The ILC voted to delay con-
sideration of holidays with pay for agricultural and home-based workers, both
outworkers and servants. But even within the category of the "excluded," the ILO
distinguished domestic workers from other non-factory labor. An accompanying
resolution requested that a future ILC deliberate "whether other conditions
of domestic servants' employment could form the subject of international reg-
ulation."[30] At the same time, senior officials were engaged in their own form
of opportunism. They thought that inclusion of domestic workers in holidays
with pay could curry support with women's organizations when legal equality
feminists were attacking women-specific protections. As their employers, how-
ever, feminists were not necessarily the champions of servants.[31]

Chief among the more favorable international women's organizations was the
World Young Women's Christian Association (YWCA). With the Fédération
international des amies de la jeune fille (a group pushing abolition of prostitu-
tion), the World YWCA memorialized the ILO's Governing Body to "subject"
domestic workers to regulation.[32] The YWCA had worker as well as employer
members, and its various branches encouraged household worker associations,
though more elite women dominated the Ys. From the 1920s, it agitated for
improved conditions: it offered model contracts, aided worker organization, and
urged legislation. Sometimes it was the only group in a country concerned with
regulating domestic work.[33]

In characteristic moral tones, the World YWCA committed "to make house-
hold employment a more fair, just, and satisfying occupation for women," even
while recognizing that men held such jobs outside "the west." National efforts
paralleled the strength of local women's movements, but progress was slow.
A few sections, as in Syria and Mexico, offered employees training and educa-
tion courses. Other sections pushed governments for legislation and concen-
trated on employer education.[34] With boards dominated by employers, YWCAs
generally pressed only for voluntary codes. Such standards, judged the Toronto-
based Canadian Houseworkers' Union (an offshoot), "will have no real effect in
improving our working conditions of long hours and low pay." Only minimum
wage inclusion could remedy their situation. In 1936 this Union requested treat-
ment equal to that of hotel and restaurant workers performing similar tasks.[35]

Resistance came from without and within. Generally, employer "diffidence"
interfered with gathering information, because surveys "involved 'prying into
their private affairs.'" Moreover, Orientalist assumptions about the impossibility
of action in places like India pervaded the organization's assessments. Conflicting
class interests among women watered down conference resolutions: for example,
the Australian branch would only recommend the desirability of "steps" toward
better conditions rather than endorse legislation. Nonetheless, propelled by

reformers and women experts, the World YWCA offered a broadly conceived strategy of studying domestic work as part of women's overall status.[36]

After moving its headquarters to Geneva in 1930, the organization intensified its collaboration with the League of Nations (through the Liaison Committee of Women's Organizations), as well as its involvement with the ILO.[37] Thibert relied on World YWCA studies and networks to disseminate ILO reports and conduct field investigations. In turn, she offered the association technical assistance in the construction of surveys and political advise on building public support for legislative actions and for reaching "progressive" employers, counsel consistent with ILO tripartism. Under her tutelage, the World YWCA affirmed a commitment to engage in educational outreach on labor standards.[38] Its position dovetailed nicely with the ILO's embrace of women-specific protections and its own mission to uplift and improve the lives of women wage earners. In the late 1930s, the Office began to gather additional information to guide deliberations on domestic work, but a lack of sufficient research among states delayed action.[39] A new war short-circuited these efforts, as it did with labor standards generally.

Who pushed for consideration of domestic workers tells us much about power and authority in defining the woman worker. In the early postwar years, "experts" and the Correspondence Committee on Women's Work recommended that the ILO address the question. These predominantly Western-oriented labor feminists—from government bureaus, universities, and trade unions—joined international women's associations with observer status at the UN to shape the discourse on domestic work.[40] They were not necessarily disinterested. Attuned to employer needs, they spoke of a dearth of trained workers. Most trade unionists were not accountable to domestic workers, most of whom were unorganized. Yet the Governing Body of the ILO thought experts on women's work the most appropriate group to speak on behalf of domestics. In justifying an experts meeting, it cited previous ILO calls for taking up the subject, including one by the 1946 Correspondence Committee on Women's Work, and the findings of commissions "concerned with demographic questions and the social aspects of family life."[41]

Frieda Miller led the 1951 Meeting of Experts on the Status and Conditions of Employment of Domestic Workers, with Dorothy Elliott, the prominent training school leader from the United Kingdom, heading the drafting committee. Also wording the report were Dr. Julia Elena Palacios, the former Chief of the Argentine Women's Bureau, and Joseph Zamanski, the President of the French Federation of Groups of Employers of Domestic Servants. France uniquely had "a long period of contractual relations between organizations of domestic workers and their employers," which impressed Miller.[42] Other women experts came from the Swedish Society of Arts and Handicrafts, the Mexican Bureau of Women and Children (Ministry of Labor), the Belgian Chamber of Deputies, the ILGWU,

and the British Ministry of Labour and National Service. Two additional trade unionists were men, from the French Federation of Christian Domestic Worker Unions and the Calcutta Dock Workers Union.[43]

Miller's Women's Bureau drafted the US Government statement to the Governing Body on "terms of reference." It offered definitions: "in a private home," or the broader "in the home of the employer," leaving housekeeping work in public places classified under "non-industrial occupations," the expanding service sector. The rationale for investigation, as a prelude to some instrument, derived from the poor conditions of the job—"long hours, low wages, and unsatisfactory working and living conditions," including payment in kind and through room and board. But the other factor was "the importance of domestic workers to the national economy." This reason—"services of domestic workers are essential to many women responsible for the care of young children, or invalids or aged persons" who had gone out to work—would echo decades later. The US Women's Bureau recommended that the committee discuss the status of domestic workers under social insurance, overall wage and hour standards, role of employment agencies, limited attraction of workers to the occupation, upgraded training, public education on the value of the labor, "special problems" of young and married workers, and ways to promote unionization.[44]

The Meeting of Experts on the Status and Conditions of Employment of Domestic Workers presented a complicated portrait of domestic labor; its assessments prefigured those provided by most governments, staff, and many trade unionists sixty years later. It embraced most of the US suggestions, though its definition of "domestic work" came from a French collective agreement: "a wage earner working in a household, under whatever method and period of remuneration, who may be employed by one or by several employers who receive no pecuniary gain from this work." Domestic work should gain coverage under labor standards like all other work, such as minimum age for employment and night work restrictions under age eighteen. Standards should include written and defined contracts; set hours, paid holidays, and breaks comparable to other sectors; minimum remuneration; fair social insurance coverage (counting payment in kind), specialized vocational training, and maternity and health protections. Standard setting could occur through the varieties of mechanisms typically found in ILO instruments: coverage under legal provisions, targeted provisions, model contracts, collective agreements, and/or public authorities. Such protections "would assure . . . the right to health, self-respect and human dignity . . . essential to social justice."[45]

Still, the work took on a "special character" from the sharing of household space. Health protections for the worker also safeguarded the employer and her home. Workers required adequate living areas appropriate to social standards

and had a right to privacy—factors that distinguished live-in domestic work from most occupations. To recognize "mutual obligations," the Experts called for employer-employee agreed-upon flexibility. Such a proposal underscored how difficult it was to throw off the old servile framework, including remuneration in kind through discarded items or required uniforms. The worse abuses in this vein, the Experts believed, were those associated with "underdeveloped countries" practicing "life servitude" and "quasi-adoption." The Experts made no comment on the remnants of slavery and colonialism that had shaped the occupation in the industrial West or the power relations between household occupants that threatened sexual abuse.[46]

While repeating tropes of exploitation and protection, labor feminists also deployed languages of efficacy and modernization—achievable through institutionalized venues like home help services for frail elderly and people with disabilities. They also emphasized the worth of domestic labor. Private household workers produced value; it was "by its nature one of the most socially important of all occupations."[47] According to Florence Hancock, the domestic worker advocate from Britain's Transport and General Workers' Union, such laborers were "essential to our comfort and well-being."[48] Nonetheless, this apparently residue form of production required upgrading to resemble modern conditions of employment. Despite the general belief that domestic workers, being isolated from one another, were unorganizable, Hancock promoted unionization. An ILO convention could have a boomerang effect, "encourage[ing] them in their fight for improved conditions and [it] will certainly give them added status internationally"[49]—precisely what would happen decades later.

Advocates faced major discursive and ideological hurtles. Government delegates regarded these jobs as apart from the real world of work found in industry, commerce, and agriculture.[50] Not only were there no organized employers to bargain with, Employer delegates long claimed that international regulation did not apply because domestic work just wasn't "a matter in which international competition is likely to arise."[51] In 1950 the Governing Body decided to push aside general discussion of domestic workers, but also convene the Meeting of Experts as a compromise. To justify action, one male Worker member pointed to the plight of women among wartime displaced people laboring "without a guaranteed wage and with no guaranteed conditions of employment," but more typical was the response of the Belgian Government: "It was true that the problem of domestic workers arose in an acute form in every country in the world, but owing to the dispersal of these workers the problem was so complicated that it did not seem appropriate at present to treat it in a draft Convention or even in a Recommendation." State socialist nations also downgraded domestic labor. The male Polish Government delegate argued, "In countries in which the economic

system was not a capitalist one, the question of the status of domestic workers was of no practical importance." More important for ILO leaders were issues of collective bargaining, equal pay, unemployment, and living standards.[52]

Personalism pervaded perceptions. For Western Europeans, the relationship between servant and employer allowed for individual negotiation of conditions, making labor standards unnecessary.[53] Delegates from Asia and Latin America insisted that domestic workers were "part of the family system." A male Chinese (Taiwanese) Government delegate justified the impossibility of collective bargaining: "If the employer's own conditions were unsatisfactory the servant could hardly expect to be treated any more favorably" for being "part of the family." Fernando Yllanes Ramos from the Mexican Employer's Association similarly argued, "Where domestic workers were part of the family it was difficult to see how there could be a collective agreement between a family and its domestic workers." This "one of the family" representation similarly justified the exclusion of domestic workers from labor standards throughout the Global North.[54]

The very abjection of domestic workers constituted another reason why no instrument emerged after WWII. Domestic work represented "the most exploited" and unorganized form of labor, "through no fault of their own but because of the character of their work" that led to the postponement of discussion of their conditions, a male Italian Government delegate stressed in 1950.[55] Repeatedly, delegates and advisors to the ILC referred to exploitation, specifying long hours, sub-minimum wages, and low status. But despite some recognition that such workers deserved protection, delegates went on to pass standards that either excluded domestic workers or made it easy for national governments to do so.[56]

Some of these men did not take household employment seriously because they associated the labor with the organization of domestic life—and the unpaid housewife. The contradictions in their discourse are palpable. The British Employer delegate, Sir John Forbes Watson, denied that such workers were any longer, if they were ever, exploited. If the ILO would consider standards for household labor, he claimed, "the most appropriate experts would be mothers with larger families rather than theorists with preconceived ideas as to how the intimate affairs of the family should be organized." Others sought to interject the servant question—how to obtain better workers—into what was to be a focus on the conditions of labor.[57] Male-dominated trade unions also continued to find "the subject matter . . . strange to them." US labor feminist Pauline Newman, a member of the Committee of Experts, noted, "[T]hey just don't realize its importance or relationship to the labor movement as a whole."[58] Even governments generally favorable to worker rights lumped improved conditions for the housewife with standards for the domestic worker. Sweden recommended an Employer representative to the Meeting of Experts on the basis of her being a mother of five

children.[59] A perception that domestic workers were no longer needed, thanks to modern appliances and men's greater participation in housework, confused the issue further.[60]

Support for a domestic worker convention came from the Women's and Young Workers' Section of the Office, but the very presumption of representation by labor feminists and women reformers met with opposition. Male trade unionists and employers often dismissed the women experts. A response by a male British Worker delegate, Sir Joseph Hallsworth, captured this defensive reaction: "There were, within the workers' organizations, enough people who were familiar with the conditions of employment of women to make it unnecessary to have recourse to so-called experts who might have no trade union experience and might represent nothing but their own theoretical views."[61] Ramos insulted these so-called experts as "persons who meddled in an amateur fashion with other people's interests," a display of misogyny that suggests the ingrained sexism that such professional women faced.[62]

More legible equality measures pushed domestic work off the ILO's agenda, as chapter 2 explained. This neglect persisted after requests for investigation by the Second African Regional Conference in 1964 and, a year later, the ILC. Domestic work became entangled with questions of development. The 1965 ILC "Resolution concerning the Conditions of Employment of Domestic Workers" set forth reasons for consideration: that such workers in both developing and developed countries "are either not protected at all or only insufficiently by legislation or other provisions concerning their working and living conditions"; that they were needing "a minimum standard of living, compatible with the self-respect and human dignity which are essential to social justice"; and that nations lacked "experience" in creating standards for this occupation. After acknowledging earlier resolutions and the 1951 Meeting of Experts, the resolution requested new studies, possible formulation of a model contract or code of conduct, and exploration of an international instrument. Speaking before the ILC, the Workers' Vice-Chairman of the Resolutions Committee, Kalmen Kaplansky of the Canada Labour Congress, typically portrayed domestic workers as different: those "as a rule, being exploited, . . . have no collective voices raised to speak for them, and who have not even got an Employers' group to discuss in a collective manner the conditions of their work and employment."[63]

The Office was in no hurry to produce a report. It took nearly two years to transmit a questionnaire to member States. Justifying delay, Coordinator of Women's Work Elizabeth Johnstone explained, "We want good replies, and there is no particular urgency about getting them." By adding, "the subject matter of the questionnaire is delicate, complex and difficult in any event," she gestured to the ways that ideas of privacy, questions of interdependency, and material conditions

of intimacy confronted regulators like any other employer of household labor.[64] The report finally emerged in 1970. Despite unreliable and poor data, and in spite of variations between North and South, East and West, it concluded that "domestic service in private households remains a forgotten sector," with workers "overworked, underpaid and underprotected." Informality dominated, with enforcement of contracts, when they existed, problematic, collective agreements few, and legislation scattered and uneven. Hours could be unlimited, with "genuine difficulties" of regulation "for persons living and working within a family limits." Countries had exempted domestic workers from the revised Maternity Protection Convention and failed to set minimum age or fully include them in social insurance. What could be done? The ILO reiterated its post-WWII recommendations: training, standardized conditions, model contracts, and social security coverage. It was willing to call "on the public conscience" to improve conditions, but not move toward an international instrument.[65] It could have come to the same conclusion in 1965.

In subsequent years, the ILO investigated domestic work in specific locales. In 1991 its Fact-Finding and Conciliation Commission on Freedom of Association recommended placing domestic workers under the labor law in post-apartheid South Africa.[66] The International Migration for Employment Branch generated a series of studies on the basis of increased numbers of "foreign female domestic workers" whose "work and life not infrequently becomes unbearable."[67] These reports—focused on Italy, Spain, France, the United Kingdom, Venezuela, and throughout the Middle East—emphasized exploitation and hardship, lack of protection, clandestine status, and isolation. They documented cost of migration and the unscrupulous role of recruitment agencies deployed to fill low-waged and unattractive jobs. Investigators on conditions in Spain heard from migrant women themselves, who offered a perspective from the trenches: "The bosses usually don't care, and so much the better if you have no papers. In that case they don't insure you and they know there's nothing you can do about it."[68] The Office produced further studies of the Gulf States, a major receiving region where abuse of workers received international attention.[69] It still was not ready to act.

ILO Developments

For the ILO to contemplate a convention on domestic work required willing leaders and an expansive understanding of work outside of the standard employment relation. That is, the precarious would need to come under regulatory systematization, even if casual labor remained apart from ILO instruments. That was the mission of Director-General Somavía. A law professor turned diplomat who spent years in exile, Somavía encouraged an emphasis on women's labor, the

informal economy, and transnational migration. Feminist Tomei played a pivotal role, compiling information essential to convention setting and framing her argument for coverage of domestic workers in terms of Somavía's decent work agenda. With pathbreaking research by Canadian law professor Adelle Blackett and support from ILO legal expert Martin Oelz, the Office issued *Decent Work for Domestic Workers*. This 2010 report located "care work in the home [as] part of the ILO's mandate to promote decent work for all" and offered a rights-based approach to revalue domestic labor.[70] Luc Demaret from ACTRAV (Bureau for Workers' Activities) guided the process in the Office and Tomei directed the ILC Committee.[71]

New institutional understandings of gender further encouraged action. Somavía dedicated the Office to "internalizing" gender equality in "all our technical work, operational activities and support services."[72] He established a Bureau for Gender Equality (GENDER) and an institutional gender audit evaluating women's status within the organization.[73] More than a quarter of the delegates were women in 2009, less than parity, but an advance over the meager numbers of the past. With women constituting 35% of its professional staff by then, the ILO moved closer to reflecting the gender equity that the ILC reaffirmed to be at the center of the "Decent Work" agenda.[74]

Convention No. 177 had recognized the home as a workplace, a crucial first step toward action, undermining the distinction between private and public.[75] Labor protections could extend to other forms of income generation that strayed from the full-time and continuous employment norm associated with Western male breadwinners. This opening to the informal economy contrasted with earlier efforts at codifying non-standard work. The Office first studied part-time work for women in the 1950s, but feminists in the 1960s rejected anything less than equality. In turn, Governments and Employers wanted full utilization of womanpower as they saw fit, which dampened international action. A convention finally came in 1994: the Part-Time Work Convention (No. 175) responded to erosion of full-time work, which appeared as a feminization of employment amid neoliberal promotion of free choice. But choice was hardly free when lack of adequate social supports pushed women into part-time jobs and led them to home-based labor, as previously suggested. The "Part-Time" Convention sought to address two constituencies: those who went part-time for personal reasons (whether family responsibilities or to pursue other activities) and those who found themselves without full-time options, sometimes the same persons. Part-timers were to receive treatment equal to those employed full-time in an enterprise, but the convention offered ratifiers ample means to limit its force and leave temporary workers unprotected.[76] It appeared as a gift to employers, enticing a return to the standard-setting fold.

Shifting attention to migrant labor also proved foundational for tackling domestic work. In 1970 the Office had concluded that "foreign workers" were inconsequential in most countries. Its data missed an upsurge of people moving in search of work from economic disruption and political, including armed, conflict. Five years later, the ILC responded to a UN request to counter "illicit or clandestine traffic of migrant workers" through strengthened standards. It addressed the rights of migrant workers to equal opportunity and fair treatment during the same 1975 session that marked the UN "International Women's Year."[77] With the "energy crisis" and a worldwide economic slowdown dominating discussions, attention focused on "trafficking in manpower," not sex. As with other questions, only a New Economic Order would solve the problem of migration, delegates from the Global South believed, but in the meantime, most nations were ready to update the 1949 convention on the rights of migrant workers.

"Women" and "migrants" remained two separate categories of vulnerable workers, with the woman migrant a separate but rarely evoked subcategory.[78] The 1975 plan of action on "The Promotion of Equality of Opportunity and Treatment of Women Workers" presented migrant women as victims from "discrimination and exploitation . . . [who] also run social risks." The plan would uphold "the migrant mother's need not to be separated from her children, regardless of her place of origin."[79] The Swedish Government adviser, who served as the reporter on the Committee on Migrant Workers, spoke in gender-neutral terms in referring to "a slave trade" that generated profits while keeping migrants and their families "in most deplorable conditions."[80] In contrast, the representative of the International Catholic Migration Commission, which focused on Europe and Latin America, asserted, "a migrant worker, like any other man, has an inalienable right to a normal family life." Still, he granted the presence of women by declaring, "[T]he migrant should have an effective right to fetch his wife (*or husband*) and children, parents and grandparents, or those of the spouse"[81] (italics added).

Between 1974, the first discussion on a supplementary convention, and 1975, the final one, the addition of women's NGOs to the Committee on Migration as observers reflected acknowledgement of the new feminism. Initially, only the World YWCA was among eighteen observers, but in 1975 nearly a quarter of the committee came from women's organizations. Present were the International Alliance of Women—Equal Rights—Equal Responsibilities, the latest name of the venerable suffrage group, as well as women's professional, religious, human rights, and political associations. Migrant rights groups and international trade unions composed the rest of the observers. The presence of so many NGOs both reflected their expanding role at the ILO, albeit consultative, and underscored the centrality of migration as a social and labor issue.[82]

The resulting Convention No. 143 began with a clarion call for economic and social justice. It repeated the usual pattern of citing previous declarations, including the Preamble to the ILO Constitution (1919), the Declaration of Philadelphia (1944), the Universal Declaration of Human Rights (1948), and the International Covenant on Civil and Political Rights (1968). It referred to ILO conventions on employment, discrimination, and migration. It emphasized, following the Philadelphia Declaration, that "poverty anywhere constitutes a danger to prosperity everywhere." Equality of treatment framed the discussion to combat underdevelopment and persistent, structural unemployment.[83]

The migrant woman as a problem for global governance had arrived. In 1990 the Office unit on migrant labor cast her as embodying difference, a position once occupied by the rural woman of the Global South but then projected onto those who left villages and fields for cities at home and abroad. Many lived in "precarious conditions in the informal sector, namely as domestic servants, in both developed and developing countries alike."[84] By year's end, the UN recognized the ILO's labor standards for migrants in the International Convention on the Protection of the Rights of All Migrant Workers and Members of Their Families.[85] The ILO joined other UN entities to work on the elimination of violence against women migrants, regulation of the "trade in maids," and curbing of the growth of a distinct sexual sector.[86] But new feminist organizations would question ILO provisions that excluded "artists" as a loophole through which sex-trafficked women, who appeared as "entertainers," would fall through labor protections.[87] A report on the Asian "sex sector" in 1998, edited by Senior Specialist Lin Lean Lim, similarly drew considerable ire from anti-trafficking quarters, despite recommending the elimination of underage prostitution. It refused to take sides on crimination with a disclaimer that "a position on whether prostitution should be legalized" was "outside the purview of the ILO." This study emphasized the economic basis of commercial sex: the higher wages, flexible hours, and possibilities for mobility that some women gained from prostitution. There was no doubt that sex had become a global business employing millions and could not be ignored. Lim refused to couch her report in sensationalism, which earned praise from defenders of sex worker rights.[88]

For the ILO, the migrant woman became synonymous with the domestic worker, whose invisibility in homes allowed for mistreatment of all sorts, including sexual harassment. But some Worker delegates recognized that the overall refusal to see either sex workers or domestic workers as workers led women migrants to become undocumented, forcing them to engage in sex work.[89] Discussing "a fair deal for migrant workers in the global economy," Australian Sharan Burrow in 2004 underscored human rights abuses left unreported by domestic workers, who feared losing their jobs. She was a powerful

figure as the Workers' Vice Chair of the Committee on Migrant Workers and the newly elected ICFTU President. Other delegates stressed the need for protection because such women undertook unregulated "dirty, demeaning and dangerous" work.[90] A parallel discussion on the application of the Forced Labour Convention emphasized a potential model in the ILO's technical cooperation program, "Mobilizing Action for the Protection of Domestic Workers from Forced Labour and Trafficking in South-East Asia." This effort targeted Indonesia and the Philippines as sending countries and Hong Kong, China, and Malaysia as pass-through and destination locations.[91]

Focus on the informal sector, an arena of hidden work apart from state inspection and collective agreements, further paved the way for action on domestic work, seen as a major component of this realm but one that governments failed to measure.[92] Within the informal economy, the "girl-child" appeared most at risk; her toil in homes added to the blight of exploitative child labor. The Worst Forms of Child Labour Convention, 1999 (No. 182) had linked slavery and sex work to domestic labor. Somavía insisted on the importance of "moving the world's most disadvantaged through and out of the continuum of informality"; that is, to release those "trapped" there by formalizing the informal. Yet, at the same time, he understood that "the right conclusions" depended on the "need to connect with the people living in the informal economy," the insight that ILO development feminists had recognized a quarter century before.[93]

Regulating the informal economy was to generate fair globalization and expand decent work, the tags Somavía gave to his efforts to revitalize the ILO in light of financialization, rediscovery of the sweatshop, decline of trade union power, and spread of economic "uncertainty and insecurity." By "decent work," he meant "work which is carried out in conditions of freedom, equity, security and human dignity." The ILO should promote a set of "fundamental" or core conventions embodying "rights at work." These included ones on forced labor and its abolition, freedom of association, right to organize, equal remuneration, non-discrimination, minimum employment age, and end of the "worst" forms of child labor. Such fundamentals emphasized freedom over slavery, blurring the line between equality and rights and, through omission, narrowing the meaning of social justice by promoting economic efficiency through social capital. In Somavía's vision, the ILO should work toward increased employment and income for women as well as men; extend social protection; and promote "social dialogue"—that is, deliberation between Governments, Workers, and Employers, the ILO stakeholders. Despite hope for involvement of those most impacted by globalization, he failed to specify a mechanism for their participation.[94]

ILO discussion of the informal economy in 2002 reflected contrasting perspectives on neoliberal globalization. Employers spoke of lack of market access, while Workers and Governments talked of decent work deficits. They could agree that lack of regulation had negative recuperations for business as well as workers, but trade unionists found nothing positive about the informal economy.[95] While some nations and employers emphasized the employment-generating capacity of the informal realm, especially microenterprise, others understood unfair competition as the result. "[D]efective goods and processes . . . theft and contraband and the evasion of fiscal, social and wage obligations" that impacted all, a male Mexican Employer countered. The Employers' Vice-Chair Alexandre Francis Sanzouango from the Employer Association of the Cameroons blamed corrupt governments rather than globalization, which "provided an opportunity for developing countries to reduce the gap separating them from richer countries, and to develop the economic, legal and institutional elements that would facilitate the move from informal to formal activities."[96] The World Bank equated globalization with asset ownership, human capital, microcredit, and non-contributory pensions; "empowerment," by which the Bank meant development of individual capabilities, "was essential for decent work to become a sustainable reality." Workers rejected such definitions. Workers' Vice-Chair Christine Nathan from India's Hind Mazdoor Sabha shot back, "[T]he experience of workers was that true empowerment came only from their self-organization and their collective action."[97]

Workers and Employers had different laundry lists. Workers wanted protections and rights extended within nations, better labor inspections, and implementation of not only the designated core conventions, but also ones on minimum wage fixing, home work, occupational safety, and private employment. Employers promoted better government, improved business climate, reformed tax systems, and other measures to enhance enterprises. Latin American governments understood that global forces—"protectionism, international capital flows, and cross-border migration"—generated informality beyond the control of individual states. Still, delegates agreed that nations should seek "to deliver fundamental rights and decent work to those currently working in the informal economy" by placing them under social security, ending discrimination against women, and establishing registration and related procedures.[98] They could agree only to issue a report, which encouraged research, dialogue, technical assistance, appropriate macroeconomic frameworks for decent jobs and business opportunities, worker rights, and legal frameworks to enable employers and protect workers—a hodgepodge catering to all stakeholders.[99]

Women were central to these concerns. The final resolution underscored "the feminization of poverty and discrimination by gender, age, ethnicity or disability" as well as "triple responsibilities of breadwinning, domestic chores, and elder care and childcare" that disproportionately landed women in the informal economy.[100] WIEGO aided the Office with the factual basis for action. With support from the ICFTU/ITS Women's Committee, SEWA's Jhabvala, an alternative Worker delegate from India, won election to the drafting group of the Committee on the Informal Economy. South African street vendor organizer Pat Horn, representing the IUF on the committee, noted that such "workers had been organizing themselves through trade unions, cooperatives, community organizations and other bodies." She recalled how her remarks clarified "misconceptions as to the strategic orientation of the Network" of organizations around WIEGO. They had to reassure the unions of their intent. Rather than expanding the ILO to incorporate the NGOs as a fourth partner, she explained, "Her organization was promoting representation through independent, democratic, and representative MBOs [member-based organizations] of workers in the informal economy in each country."[101]

Still, Horn was being strategic. At the ILC, the representative of the World Movement of Christian Workers underscored the necessity of democratizing the ILO to reconfigure informal work as decent work. "Structures have to be established so that informal workers are not only the object of tripartite discussion but much more active participants within that discussion. The ILO has to give them a voice," he declared.[102] Women particularly lacked "voice" since they predominated among agricultural, domestic, and other low-waged informal workers.[103] As the Office discovered with the late 1980s revision of the Indigenous and Tribal Populations Convention, 1957 (No. 107), unless the Employers would agree to flexibility toward participation of the very people impacted, the Office "will be able to do very little." Yet, exclusion "from voicing their opinions in their own names" would "risk" delegitimizing the resulting convention, no matter its provisions.[104]

In contrast to indigenous people, domestic workers could gain access to unions, some of whom, we've seen, had reached out to home-based workers and promoted organization of the informal economy. As Juana Flores of the United States' National Domestic Workers Alliance (NDWA) later commented on the Convention No. 189 process, "It was very significant to be listened to at the United Nations when decisions were being made. That was an unforgettable experience. I realized every moment that, with my voice, I was speaking for all the workers in this sector."[105] At the 2011 ILC meetings, twenty-five domestic workers would arrive with delegate status. Flores was one of them.[106]

Organizing for Survival and Transformation

By drawing upon national movements to forge a collective voice, the IDWN established a tangible presence that challenged the formal boundaries of the ILO, absent from previous considerations not only of domestic work but also sectors unrepresented by Worker delegates. The presence of national domestic worker activists clearly influenced the outcome of the nearly unanimous vote in favor of the convention. This is not to deny that the domestic worker cause benefited from the expertise of professional advocates from allied organizations outside the ILO and from within the ILO bureaucracy itself.[107] Nonetheless, activist supporters recognized that "[d]omestic/household workers want to—and have the right to—speak for themselves." A domestic worker leader from Peru explained, "We are tired of hearing others speak in our name." This insight would lead to demands for representation at the ILC as part of national delegations. It also meant that workers insisted on determining the politics of the IDWN.[108]

National domestic worker formations were essential for transnational action. They preceded global mobilization and would persist as key campaigners for ratification in states. Over the previous quarter century, these organizations had expanded, sometimes facilitated by feminist and human rights NGOs, but usually as products of worker action.[109] The year 1988 marked the formation of the thirteen-nation Latin American and Caribbean Confederation of Household Workers (CONLACTRAHO), with a branch in Europe, and the Hong Kong-based Asian Domestic Workers' Union, with members from the Philippines, Indonesia, and Thailand. These groups reached out to rural migrants in major cities, many of them undocumented and most from ethnic minority groups. They hung around parks and subways and joined community coalitions, like the Day Laborers Network in the United States. They addressed the needs of the worker as a whole person, offering "legal and psychological assistance because many of our sisters suffer from violence by their employers," as well as "workshops and capacity building," noted Peruvian organizer Leddy Mozombite.[110] By the time the ILO debated the issue in 2010, the number of nations with domestic worker organizations stood at forty-four.[111]

Having a strong domestic worker organization mattered; presence would facilitate ratification. In 2006, Uruguay, later the first signatory to Convention No. 189, had extended protective labor laws to household workers, ended barriers to social security, permitted inspection of homes, and established a Tripartite Commission on Equality of Opportunity and Treatment in Employment. Targeted for relief were Afro-Uruguayan women, who disproportionately labored in households. To constitute a wage board, the government developed

social partners necessary for its functioning: the Housewives League of Uruguay, dedicated to the revaluation of domestic labor, represented employers. The National Trade Union Confederation permitted the National Confederation of Domestic Workers, before certification as a union, to speak for workers. The Philippines, the second signatory, was known for its overseas worker program that critics viewed as more interested in facilitating remittances than protecting migrants. But united trade union support for labor rights at home, including a "Magna Carta for Household Helpers *(Batas Kasamahay)*," facilitated action.[112] In mid-2013, South Africa became the eighth country to ratify the convention; its domestic workers union, strengthened under the post-apartheid constitution, provided major leadership for the IDWN.[113]

This expanding organizational matrix propelled inquiry into worldwide conditions for domestic work. Though legal standards nearly everywhere protected domestics less than other workers, by the 2000s about 70% of them possessed some coverage, whether through general regulations, special laws, or bilateral migrant worker contracts between sending and receiving countries. Yet formal mechanisms often proved inadequate when it came to regulating hours, assuring fair wages, reducing sexual abuse, preventing forced labor, guaranteeing freedom of movement, or offering maternity leave and social security. Furthermore, enforcement was spotty. As labor educator Chris Bonner of WIEGO put it, "Governments are not going to enforce the legislation for domestic/household workers. We have to organize to do it!"[114] Fearing deportation, migrant workers were reluctant to report violations, even when entitled to redress. Fish Ip Pui-Yu, a Hong Kong domestic worker organizer, captured the tension between policy and practice before the ILC in 2011. Governments must not merely ratify the convention, she explained; they had "to put what it contains into their employment laws but also into their immigration laws and work permit systems." Despite such warnings, investigations continued to reveal inconsistent coverage: Egypt, Japan, Korea, and most of the Middle East still excluded domestic workers from labor standards in the early 21st century.[115]

The transnational forces behind migrant domestic work also facilitated transnational networks among women and the enhanced activities of global labor federations. Interaction between national and regional groups began years before the institutionalization of a global movement. Along with feminist activists, including those promoting "Wages for Housework," organizers from Latin America, South Africa, and the Philippines met at the UN's 1995 Fourth World Conference on Women in Beijing. Their attempted Network of Workers in Domestic Service was stillborn, but contact between regions started.[116] A decade later, European trade unions, along with International Restructuring Education Network Europe (IRENE) and the Platform for International Cooperation on

Undocumented Migrants (PICUM), considered what they could do to organize and "protect" domestic workers at a meeting aptly titled "Out of the Shadows." Confessed Anneke van Luijken, the tireless organizer from IRENE, "It was also hard work convincing many unions to work on this. They knew it was important, but said it was not really their 'issue' or 'priority.'" Public sector unions, however, began to get it: they were experiencing the impact of privatization on care services, with governments contracting out such work and thus hurting union membership. ITUC and IUL women's officers lobbied for union involvement.[117] The male Chairperson of the Federatie Nederlandse Vakbeweging (FNV) admitted, "It is no secret that trade unions sometimes find it difficult to support domestic workers. But the FNV Mondiaal is now making it a priority, alongside our work on child labour, migrant workers, and those working in the informal economy."[118]

As with advocacy for home workers, activists and unionists in the Netherlands proved central to linking scattered groups, convening an action conference in Amsterdam in November 2006. Women trade unionists joined the planning and fundraising with NGOs and ILO staff from the Arab States regional office and the Programme for the Elimination of Child Labour. Sponsors included migrant rights, feminist, and human rights NGOs, including the Committee for Asian Women and PICUM; the ILO would approve some of these groups to participate in the Committee on Domestic Workers during its deliberations.[119]

When sixty leaders from trade unions and support organizations arrived in Amsterdam, they listened to domestic workers and their representatives share common struggles—and particular histories.[120] Workers demanded "respect," "rights" and "protection." Spanish speakers rejected the term "domestic" for its association with "domesticated"; that is, "animals being trained to live in households." Thus, the assembly decided on the joint term "domestic/household," which further allowed speakers to differentiate the job from unwaged "love or duty."[121] Geeta Menon from the Karnataka Domestic Workers Union in India typically recast domestic work from an institution embedded in servitude to one consisting of workers eligible for legal protections. She recalled, "In our union, we felt that, unless domestic workers are given a legal identity as workers, their work and relentless toil will go unrecognized. Society must go beyond the gendered notion of housework, lift this work from patriarchal definitions, and look at its economic value, changing the attitude of looking at these women as servants or slaves and start perceiving them as workers."[122]

Out of the Amsterdam conversation emerged policy demands crafted to reach both the ILO and national governments. Requested were protection for migrant workers, coverage under national laws, elimination of child labor, and the end of abuse. According to Kamalam, the ITUC's Director of Equality, "Governments are aware of undocumented migrant workers. Without them, care services in

Europe would collapse. But they are not taking responsibility for these migrants." The issue had become "how to get these workers regularized and protected." Some unions attempted to incorporate migrants: the United Kingdom's Transport and General Workers' Union continued its long-term support of domestic work by giving migrants union ID cards, "out of solidarity because it helps to provide identity and regularization of their status." Using the ILO to enter the global stage and gain recognition, however, met some skepticism. Guillermina Castellanos of the NDWA asked, "How can a Convention be made by diplomats when we know what they do with their household workers?"[123] Nonetheless, the meeting recommended worker education about receiving countries and worker controlled pre-departure briefings, unlike those conducted by private employment agencies with government contracts.[124]

To advance the concrete goal of a global movement, advocates formed the IDWN in 2008, with a steering committee, a group of seven advisors from six global regions, and a technical support team. Populating the Interim Management Committee were unionists and feminist researchers connected to the movement: Budin, Gallin, Bonner, and Karin Pape, an economist with ties to WIEGO, the IUF, German labor unions, and the Global Labour Institute. Pape would serve as the first coordinator. The IUF housed the IDWN "as a semi-autonomous body" that consisted of trade unions and other kinds of associations. IDWN in turn promoted new unions: IUF's Africa Regional Women's Project, with funding from the Swedish government and support from the AFL-CIO-allied Solidarity Center, and it developed groups in Kenya and Ghana. Key were organizers like Tanzanian Vicky Kanyoka, IUF Africa Regional Women's Committee Chair, who became the Africa Regional Coordinator of IDWN. Such leaders enhanced the cause in their regions among existing unions, educating them to respond to the questionnaire that the ILO would send to governments about a possible domestic worker instrument. Support by the ITUC also proved essential for affiliates to accept domestic workers as workers and push for their placement onto ILC delegations. Union backing further allowed domestic workers to approach national legislatures, "where we were frightened before," explained Sayuti from Jogjakarta.[125]

Urged by the ITUC and the ILO's Workers' group, the Governing Body in 2008 scheduled "Decent Work for Domestic Workers" as an agenda item for the 2010 ILC.[126] This decision didn't just happen. Building upon the momentum from the Amsterdam conference, Luijken and IUF and ITUC leaders met with Office staff from key bureaus (ACTRAV, MIGRANT, IPEC/Child Labour, GENDER, and STANDARDS). Along with TRAVAIL, these sections prepared materials to argue the case before the Governing Body. They also educated the IDWN on the intricacies of the ILO. At the 300th Session of the Governing

Body in November 2007, the Workers argued for decent work for domestic workers as their top standard-setting item: domestic work impacted growing numbers of people, the occupation was spreading in the Russian Federation and elsewhere, and migrant workers needed legal protection. Action on domestic work, argued an Argentinian Government delegate, was necessary for fulfilling gender equality as "the heart of decent work."[127] This use of the ILO's own slogan proved effective.

By the next Governing Body meeting, in March, 2008, the Office had convinced enough governments—led by the Group of Latin American and Caribbean Countries—to vote for the Workers' choice. A German Government delegate brought the multiple factors into play when she explained, "The subject was very important both in itself and for the credibility of the ILO and the quality of its standards, with the need to reflect, in the context of globalization, on how to handle the issue of the informal sector." Even supportive delegates persisted in portraying domestic workers as vulnerable, unorganized, abused, and mostly unprotected, indeed, subject to "conditions of work . . . which in some ways often resembled a kind of slavery," declared one Venezuelan Government delegate.[128]

Making the Domestic Worker at the ILC

Appeals to the heart were among the most potent devices used to move delegates at the ILC. Workers bore witness, and their personal testimony of exploitation and suffering made the case for inclusion in national labor standards, mandated by the convention. Domestic workers had to confront two reigning discourses: that their work was inappropriate for ILO consideration, and that they were victims, not agents, in need of rescue by governments and other workers who were already protected under the law. While rejecting the first portrait, they fed into the second when it advanced their cause. As network leaders explained, "we want to reach the hearts of employers" and "leave the audience in tears." Halimah Yacob of Singapore, Workers' Vice-Chair of the Committee on Domestic Workers in 2010, had exhorted delegates to look "deep in your heart and your conscience" when voting. [129] Before that committee, the once skeptical Castellanos, as an IUF representative, asked delegates to vote "from their hearts," as IDWN messaging emphasized. She also added another common plea for rights and worth: "We have a chance to correct this injustice and to leave a legacy to our children, showing that women's work is valuable, just like any other work."[130]

During the 2010 ILC, delegates spoke in terms of hardship, suffering, and exploitation. A male Malaysian Worker delegate evoked another venerable metaphor: "Let us resoundingly reject slavery in any form."[131] The Holy See referred to a double "risk": domestic workers "come from the most disadvantaged segments

of society, with very limited resources for protection; and . . . their working environment leaves them open to exploitation."[132] Other delegates, such as a male Worker from India, referred to "extreme forms of exploitation," a "tragic plight," and "forced labour." They were "helpless and downtrodden."[133] A male Chilean Worker described the ethical imperative for action: "Domestic workers in private homes find that their hours are endless, that their days of rest are not respected and the treatment which they experience cannot be considered decent work."[134] Even those who crafted their remarks in terms of rights, justice, and fairness cast domestic workers as damaged by being enclosed in "private homes" with "endless hours," no rest days, and poor treatment.[135].

A year later, when the ILO passed the convention, Director-General Somavía saw it as "opening up a door to labour [that] could not be so easily dismissed." Speakers at the ILC continued to mix affect with rights talk. The Holy See's delegate underscored the "global care chain which is structurally built on the disruption of basic family relationships for all women involved," which required "a 'relational' approach to the economic situation of women." While he lamented the disruption of families that accompanied the trading of a mother's care for cash remittances, he embraced protections to obtain "the security that decent work desires and requires."[136] Worker delegates found in "their blood and sweat to keep afloat" reason to extend labor standards.[137] IDWN activist Ida Le Blanc of Trinidad-Tobago's National Union of Domestic Employees countered employers who viewed twenty-four-hour shifts solving acute needs by suggesting the hire of more workers for defined shifts. Confirming the expectations placed on care, she added, "I doubt that many domestic workers would turn away and do nothing [to help a needy client]. It is not just about our duties as employees but about us as human beings, with a conscience just like anyone else. Why would we need legislation for such a situation?"[138]

Calls for justice were laced with emotion. Pryce of the Jamaica Household Workers' Association announced, "Our hearts are filled that we have reached such an historic moment. We, the domestic workers of the world, have before us the text . . . that recognizes us as workers with the fundamental rights of other workers. We have been overlooked for so long and now know that what is wrong will at last be set right."[139] Similarly, observers from NGOs—including Defense for Children International, Anti-Slavery International, and Migrant Forum in Asia—shared personal experiences of abuse, which they believed gave them the authority to speak.[140] Leaders of the IDWN also deployed gendered tropes to gain legibility, while appealing for inclusion in universal rights that too often had been labeled as exclusively male. Expressing emotions ran counter to ILO procedure but electrified the proceedings. In seeking inclusion in labor standards, worker advocates ironically deployed affect that re-inscribed women,

and domestic workers in particular, as outsiders to the protocols of global governance.[141]

The Employers' group questioned the wisdom of a convention. They believed that regulation "would not directly affect the private sector companies that were its members." Employers' Vice Chairperson Kamran Rahman from Bangladesh warned that "regulation might not always be the key to mitigating poor working conditions and abuse faced by domestic workers." He stated, "Regulatory measures were not necessarily applicable in all countries, and could be counterproductive if they ignored ground-level realities," especially in countries with surplus workers. He essentially argued that rights for domestic workers would lead to unemployment. Moreover, he doubted that the actual employers of these workers had "the legal expertise to comply with rigid rules set by international labour standards," a common refrain whenever housewives were to act as employers. An unnamed Government delegate from the receiving nation of Singapore repeated the belief that domestic work "differed from other types of paid work as employers did not hire domestic workers to increase their business profits, but rather to help in the household."[142] The home remained a private sphere, but subsequent discussions determined that workers had rights there: to privacy, to leave during rest times and vacations, and even to negotiate their place of residence.[143]

For the Employers, domestic work was unlike other forms of work. Indeed, actual employers were "unique" for being "householders and families," and they too had rights, the right to privacy, as the Employers emphasized.[144] In committee, the Employers' group sought to amend the final convention with a preamble paragraph "in order to provide a balanced picture of the context in which domestic work occurred: 'Considering the unique nature of domestic work in or for households, and the unique nature of those who engage domestic workers, the majority of whom act in an individual capacity, and who are householders, parents and/or have other caring responsibilities.'" The Workers and some Governments (Australia, the United States, and Uruguay—the latter two with vigorous domestic worker organizations, and the former represented by a sympathetic feminist) shot down this proposal.[145] They countered that "domestic workers were also parents, sisters, and so on, and thus had similar concerns to those of employers of domestic workers," and that not all domestic workers were care workers. The Employers' group withdrew this particular gambit.[146]

A National Example

The case of the United States illustrates the synergy between national organizing and international convention making. This nation had disproportionate influence at the ILO, as it did on the world stage, but nevertheless rarely ratified

conventions. Usually, the power of anti-union congressional elements blocked any response. The interaction between domestic worker activists, the US Department of Labor, and the AFL-CIO during the convention-making process represented a new direction, illuminating the ways that a social movement can help make policy when policymakers are open to its inclusion—whether from ideological conviction or out of political self-interest.

Reflecting on the US government's role in developing and passing the convention, NDWA director Ai-jen Poo recounted that one of her members felt "a deep sense of pride to be from the United States, for the first time in her life."[147] During negotiations, the Obama administration usually sided with the Workers' group, even when other industrialized market economy countries and the European Union objected to specific items, such as procedures to calculate working time for payment purposes. The Unite States pushed for the rights of migrant workers, health and safety coverage, and the regulation of private employment agencies. Indeed, when its representative first spoke in support of the convention, those assembled broke into applause because, after the Bush years, it was a turnabout to have the US Government delegate defend worker rights.[148]

The AFL-CIO also advanced the process. According to Poo, "the US labor movement ... played an important progressive role in the negotiations, providing a model of the ways in which trade union federations and independent workers movements can work together to improve the lives of working people." In a joint letter with the NDWA, the AFL-CIO urged trade unions elsewhere "to take up this model of collaboration and partnership: to seat domestic worker representatives as voting delegates at the ILO and to build lasting partnerships to win ratification of the convention and labor standards for domestic workers." It gained a seat on the official US delegation for Flores, Co-Director of Mujeres Unidas y Activas in San Francisco—a significant affiliate of the NDWA.[149]

The United States expressed support for a strong convention in responses to the questionnaire that the ILO Office sent to member States. US Employer organizations never replied. In a departure from previous questionnaires on low-waged or women workers, the official US Worker response, given by the AFL-CIO, reflected the positions of the subjects of the proposed convention—the domestic workers themselves—rather than a labor bureaucracy removed from the workers under consideration. This shift occurred because the AFL-CIO jointly submitted its response with the NDWA, which had surveyed its own members and used their knowledge as the basis for AFL-CIO/NDWA comments.

A new awareness at the AFL-CIO facilitated cooperation. Since 2001 the nation's main labor federation had reversed its historic opposition to immigrant rights. It recognized that the future of the labor movement depended on organizing the growing immigrant workforce. Such an effort would require

partnerships with what had come to be called "alt-labor" (alternative labor) formations: worker centers, ethnic associations, and other organizations of "excluded" workers not legally recognized as trade unions or covered by labor standards. Whereas in the early 1970s the AFL-CIO dismissed domestic workers as unorganizable, it now partnered with the NDWA and celebrated the IDWN and its subsequent iteration, the International Domestic Workers Federation (IDWF).[150]

Despite general agreement with the US Government, US Workers presented additional, more detailed comments on specific questions. While the Government emphasized that standards for domestic workers should be the same as other workers, the Workers emphasized specific measures, such as sick leave, maternity leave, and other health and well-being provisions too often absent in the formal economy—which would remain unavailable under the "similar treatment" paradigm offered by the Government. While the Government wanted outcomes equivalent to workers in formal sectors of the economy, it felt that enforcement machinery and procedures might differ for domestic workers, given the location of this sector in private homes. The AFL-CIO/NDWA specifically called for enforcement that involved organizations of domestic workers and their union partners.[151]

Existing legislation shaped government responses to the question of care work. The US Government supported a definition of the term "domestic work" that included housekeeping, child care, and personal care. But it reiterated the exclusion of casual babysitters, a term applied to care workers. Its discussion of "home health care" was ambiguous, as the Department of Labor was at that time reviewing the 1976 classification of these workers as "elder companions" who fell outside the minimum wage and overtime provisions of the labor law. In contrast, the AFL-CIO/NDWA insisted on inclusion of "part-time, full-time, live-in and live-out workers and workers who provide care for the elderly and sick."[152]

The joint answers highlighted the perspective of the NDWA. To a question on the contents of the preamble, the AFL-CIO/NDWA offered a feminist reply: it evoked "the historical legacy of slavery, sexism, the undervaluing of work traditionally performed by women and the devaluation of reproductive labour." Moreover, it noted, "Domestic work is the work that makes all other work possible. . . . The intimate nature of the work, taking place inside someone's home, makes it easy to blur what constitutes appropriate employer-employee relations."[153] To a definitional question, it insisted, "While the term 'domestic' is still considered by some to have negative connotations, elsewhere it has been reappropriated and redefined by the workers themselves. Both terms [household worker and domestic worker] should be included . . . in order to reflect workers' perspectives, experiences and preferences." It included violence against women as

an occupational safety issue even if "the workplace is a private home."[154] Answers often specified on-the-job conditions that required rectifying, like the expectation of continuous availability of live-in workers, sudden termination of employment with immediate loss of housing, misuse of probation periods, deductions for uniforms, lack of privacy, barriers to cultural or religious expression, abusive recruitment by employment agencies, and in-kind payments.[155]

The politics of presence mattered at both the national and international levels of deliberations. As one US Government advisor and substitute delegate from the Department of Labor told ethnographer Jennifer Fish in 2011, "[W]e listened to the NDWA. We listened to Human Rights Watch [a US-based international NGO with ILO observer status allied with domestic workers], I mean obviously we have to assess their positions and how they might fit in.... They made some good suggestions, very helpful. We listened all the time to the organizations."[156] This process had begun when Ana Avendaño, a General Council at the AFL-CIO devoted to immigrant worker issues, walked staff from the NDWA through the ILO process. She facilitated access to the appropriate offices at the Department of Labor, which played a central policy role in the national response to ILO inquires. According to then NDWA staffer Jill Shenker, the Associate Deputy Undersecretary for International Affairs at Labor Carol Pier "got it." Pier formerly worked as a labor researcher at Human Rights Watch.[157] NDWA staff used the preparation for the ILO as an opportunity to present specific regulations to the Department of Labor. Proposed were employer responsibility to record hours worked; an "opt-in" system for in-kind payments or wage deductions for food; lodging with a private room with its own lock as a minimal standard and the availability of "quality/quantity" of food, including preferred kinds and facility to cook one's own; recognition of standby time as work rather than classified as sleeping; and a domestic worker bureau at the Labor agency as a way to implement draft ILO recommendations on complaint mechanisms, worker capacity building, and worker training.[158]

Further facilitating NDWA influence in Geneva was Claire Hobden, a former staffer at the multiracial New York affiliate of the NDWA that passed the first Domestic Workers' Bill of Rights (DWBOR) in June 2010 after years of concerted campaigning. Hobden had joined the ILO as a specialist in ACTRAV in 2009 and served as the notetaker during ILC committee deliberations. After passage of Convention No. 189, she put together the Research Network for Domestic Workers' Rights to support the IDWN.[159] Hobden kept Shenker informed of developments. Shenker had become the NDWA's International Organizing Director and focused on building the IDWN and then the IDWF as its North American coordinator.[160] The ties between Shenker and Hobden

were one factor generating informal access at the ILO for the IDWN. This kind of parlaying of personal relations was hardly new; connections between women in the ILO Office and women delegates and NGOs often meant that strategies and provisions crossed institutional boundaries, shaping conventions and pronouncements in the process, as the interaction of Mildred Fairchild and Frieda Miller more than a half century before showed.

Flores underscored the symbiotic process between NDWA activism and the ILO convention when she announced, "Our many years of hard work organizing among domestic workers in the United States enabled us to make a significant contribution to this process."[161] The passing in 2010 of the breakthrough New York Domestic Workers' Bill of Rights had thrilled delegates and observers at the ILO, as did the law in Uruguay. During committee deliberations in 2011, the NDWA flashed a video that promoted the New York bill as a model, along with its peer educator approach, *The Ambassador's Program*, initiated to inform nannies, elder care workers, and housekeepers of their new rights. The video announced that domestic workers were no longer forgotten; whether they were documented or not, they deserved the same rights as any other worker: a forty-hour work week, paid sick days and holidays, overtime pay, guaranteed day off, grievance procedures, and protection from discrimination—all included in New York's law.[162] Whether the difficulties of enforcement could be overcome lay in the future.

Hobden had offered the New York example to the ILO to show "fair labour policies for domestic workers is possible." In 2010 she argued that domestic worker organizations must "make industry-specific demands, but to embed them in broad messaging that has the ability to hook the support of a broad section of allies."[163] The NDWA, in turn, took the ILO example back to its state Bill of Rights campaigns. In these efforts, the convention appeared as one point in an inevitable march of victory, while organizing groups pushed for its provisions, especially those found in Recommendation No. 201. The NDWA had won legislative campaigns in eight states and the city of Seattle by spring 2019, though the strength of the resulting measures varied considerably. Allied legislators had introduced a Federal Domestic Workers' Bill of Rights, the prospects of which depended on a future Democratic President and Congress.[164]

What Was Won

McGill law professor Adelle Blackett, who served on the ILO Secretariat during the "Decent Work for Domestics" process in 2010 and 2011, has argued that "the negotiation and adoption of the new convention and recommendation reflected the ILO's effort to address and respond to a social movement . . . [that] left an indelible imprint both on the process and the substance of the new convention

and recommendation." The movement of domestic workers for human rights, to which labor standards belonged, challenged the workings of the ILO, opening up the process to NGOs in creative ways and enabling the organization to address the contours of work under 21st-century precarity and informality.[165]

The IDWN obtained most of its demands. It asked for equal treatment with other occupations for "all domestic workers, everywhere." It called for inclusion of domestic workers in the ILO's core or fundamental principles and rights at work. It demanded a written contract with all pertinent information, including tasks, terms and conditions of employment, hours of work, leaves, benefits, duration, and termination processes. ILO instruments specified wage rates never below the minimum to be paid regularly; defined working hours, with time off; social security, maternity, and medical benefits; protection of passports and identity documents; freedom of movement and residency; privacy; and occupational health and safety. Article 5 of the convention incorporated the demand "to ensure that domestic workers enjoy effective protection against all forms of abuse, harassment and violence." The convention stipulated regulation of employment agencies, worker access to courts and other mechanisms for compliance, including labor bureaus and worksite inspection.[166]

Yet there was always the caveat, "in so far as comparable with national laws and regulations," which protected employer privacy when it came to the ability to enter "household premises." This general loophole allowed for payment in kind and redefinition of work time to include night wait time "consistent" with national practices. Significantly, Article 2 permitted nations to exclude "limited categories of workers in respect of which special problems of a substantial nature arise," if agreed upon after consultation with representatives of domestic workers and their employers, or if none existed, "then most representative organizations of employers and workers." The accompanying recommendation specified responsibilities of government to update laws and enforcement, educate domestic workers on their rights, and enhance their rights and skills, including codes of conduct for diplomatic personnel. Elaborations addressed specifics of protection in each area, such as housing, working conditions, terms of employment and termination, and health care.[167]

Household workers challenged both trade unions and employer organizations. The global union federations learned to support workers not organized in traditional forms. Even the Employers' group overcame initial skepticism to accept a human rights framework, though they continued to insist that the particularities of domestic work distinguished it from other occupations and thus undercut the appropriateness of a convention. As with outwork, they wrangled over definitions, seeking to exclude those employed by "commercial" enterprises and those who worked under contractors. They questioned standardizing labor that

defied standards as well as inspection of homes and the capability of employers of domestics to keep records, which were old shibboleths, brought up whenever standards for household workers came onto national agendas. Supporters shamed the Employers into permitting the convention.

Despite the years between the home work and domestic work battles, the overlap of approaches is striking. The IUF, which remained a progressive organization of low-waged food and service sectors, became the first global union to include domestic work as part of its agenda, just as it earlier had embraced SEWA. It then helped to incubate the international movement.[168] Similarities also came from the influence of WIEGO, whose founders were central to the home work campaign.[169] The domestic workers mobilized by providing their own knowledge of the labor compiled through participatory research methods like those deployed by SEWA. They too held preparatory meetings where activists and NGOs mapped strategy and endorsed a convention. They also relied on the politics of affect, representational displays, observer status, and the knowledge and skill of interested feminists in the ILO Office.

But two aspects of the later campaign stand in contrast. The domestic workers demanded rights to be heard as well as recognition as workers and respect for their skill. As they continually noted, "they often care for the most vulnerable of society, the children, sick and elderly, increasing the well-being of all," but received "contempt and abuse" rather than respect. They asked, "How Can I Be Proud of Myself When You See Me As A Victim?"[170] To this end, unlike the outworkers, domestic workers maneuvered around ILO procedures to seize voice at the main assembly of the ILC. They did so by winning representation on official national delegations, but they also brought social movement tactics inside.[171] Of special note, while the campaign traveled from the local to the regional and then to the international level of struggle, it had strong local organizations ready to press for ratifications.[172] All of this took its own form of intense reproductive labor, to teach low-waged women of various levels of education and knowledge about their rights and how to access them, to develop consciousness through struggle. Workers in turn transformed global understanding. As South African union leader Hester Stephens reflected, "I feel proud as a domestic worker, and I also believe in our union."[173]

BY SPRING 2019, twenty-seven nations had ratified Convention No. 189, with Latin American states dominating.[174] Other countries adjusted legislation in accordance with the convention and recommendation to various degrees, with more comprehensive changes in Kenya, Spain, and Venezuela, and less in India, Zambia, and the United States. The speed of ratification developed from a concerted campaign led by the same global players, with assistance from the ILO

Office. While its aim of twelve ratifications by 2012 fell short, the convention had enough signatories to come into force in September 2013. The next month, IDWN became the International Domestic Workers Federation (IDWF) at a rousing convention in Montevideo, Uruguay. More than two hundred people attended, mostly domestic workers representing their local organizations, but also global unions, WIEGO, ILO, human rights organizations, and academic researchers and supporters.[175]

In coming to Montevideo, IDWN's leadership understood the need to forge unity and generate solidarity while respecting, indeed celebrating, regional, language, and cultural differences. The delegates heard regional reports and adopted a constitution and action plan, and they elected officers. They danced, sang, and ate together. They navigated different national political contexts. Connected to political parties, usually of the left, those from Latin America spoke more of exploitation and oppression than did representatives from the United States, some of whom hailed from Latin America, but functioned with the need for cross-class collaboration. African delegations, which included the most men, came from domestic worker organizations that were attached to general trade union confederations. The assembled delegates adopted a five-year plan in which ratification of Convention No. 189 was only one plank. Strengthening the organization's

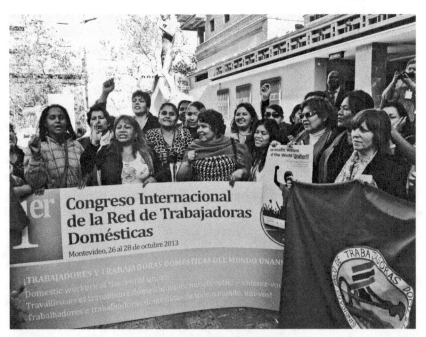

FIGURE 6.2 Founding of the International Domestic Workers Federation, Montevideo, Uruguay, October 2013. Photo by the author.

structure and educational and research capacity stood as an essential strategic goal, as was building and maintaining partnerships with affiliates, the ITUC, NGOs, the ILO, and workers in related sectors. The group committed to actions against employment agency abuses and exploitative child domestic labor and campaigns for basic labor protections, such as the right to collective bargaining, minimum wage, rest days, and occupational health and safety. Excluded workers had repeated and reiterated these demands throughout the ILO's history. The domestic workers prioritized research on the home-care industry and migrant domestic work, two significant global trends.[176] They began conducting solidarity campaigns in support of mistreated workers around the world.

Five years later, in November 2018, the IDWF assembled for a Second Congress in Cape Town at the Salt River Community House hosted by the South African Domestic Service and Allied Workers Union, with attendance from member organizations, funders, academic allies, and international unions and organizations. In small groups and plenary sessions, delegates discussed questions of organizational and environmental sustainability, gender-based violence, human rights and anti-discrimination, conditions of migrant workers amid the rise of nationalism, the impact of the online economy, and the importance of care work. They pondered how to build a self-reliant movement of low-waged workers

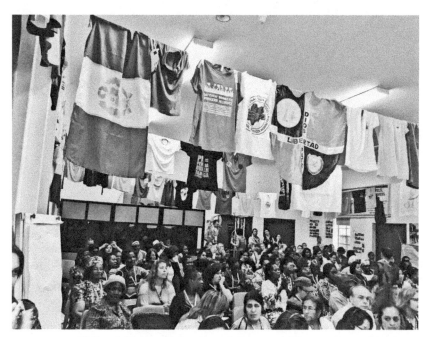

FIGURE 6.3 Hall with T-shirt display, Second Congress of the International Domestic Workers Federation, Cape Town, South Africa, November 2018. Photo by the author.

through revenues independent of targeted projects funded by foundations, other unions, and international organizations. The IDWF committed itself to organizing in places like Turkey and global campaigns like passage of an ILO convention on gender-based violence at work.[177] By spring 2019, the IDWF had grown to sixty-nine affiliates from fifty-five countries, with a membership of over 500,000 workers spanning every region of the world.[178]

Women's Place (in the Future of Work)

IN 2013 THE International Conference of Labour Statisticians, whose agenda the ILO Governing Body sets, recognized unpaid reproductive labor as "work" by recommending that official statistics include "own-use production." Its new definition encompassed work "that produces goods and services for household consumption," such as "collecting firewood and fuel, fetching water, cooking, cleaning and also providing care for children, the elderly and other dependents." Under these criteria, women toiled longer than their male counterparts everywhere, with women in "developing" countries laboring three hours more a day than men.[1] This recalibration of what constitutes work moved toward fulfilling the "long-term aim" of feminist economists some forty years earlier, as we saw, "to abolish the separation of the so-called 'productive' work from 'reproductive' work, eventually resulting in defining 'housework' as work."[2]

Accounting for reproductive labor meant expanding the concept of work to include non-monetized subsistence and family activities crucial for daily life. Such were the labors that rural women in the Global South performed and housewives took care of worldwide.[3] Care had become work. By the early 21st century, the ILO acknowledged care as "the unpaid work in the family and community that is often ignored in current thinking about the economy and society." It underscored that "much of this work is done by women and is essential to the welfare not just of the young or elderly or sick but also to those in paid work. It is also often carried out alongside paid work." The ILO further recognized that care work, like household employment, existed as an occupation and thus should have protocols and regulations as well as inclusion under social security. Such workers required "sufficient voice" through associations or unions of their own choosing. The Nursing Personnel Convention, 1977 (No. 149) and its accompanying recommendation offered a model in so far as they included the range of rights and equality of treatment found in other instruments, but for an occupation that was

mostly female-dominated and involved bodily contact.[4] Nonetheless, the care sector suffered from "discriminatory attitudes"[5]—that is, the lack of acceptance that such labor was work in the first place, because of intimate and often emotional ties between care provider and receiver, and because wives, mothers, and other relatives or friends performed similar labor. This association with home labor and domestic service had relegated paid care work to low remuneration, casualization, and invisibility.[6]

The 2011 convention on domestic work focused on commodified forms of household and care labor. As the ILO approached its Centennial in 2019, domestic work became linked with a re-emphasis on family responsibilities, packaged as care, a component of the "Women at Work Initiative." The organization had caught up to its sometimes visionary, once staffer, Guy Standing, a British economist who had become an advocate of the basic income as a defined benefit given to all. In 2001 Standing, then in charge of the Social Protection division, declared "the right to do care work should be an integral part of the ILO's 'decent work' strategy," and "there is no prospect of gender equality unless or until all forms of work are treated equally in social policy." Standing also claimed a right not to perform such labor, exposing the coercion in the obligation of women to undertake unpaid care.[7] In 2018 Director-General Guy Ryder, who came out of the British and international labor movements, had no such qualms about promoting care work. He argued, "Family-supportive policies, which enable women to remain and progress in paid employment and encourage men to take their fair share of care work, are crucial to achieving gender equality at work." A commissioned ILO-Gallup poll sampling men and women in 142 locations worldwide found that women desired employment, men "agreed," yet women faced obstacles from an inability to undertake care while earning income. Lack of "work-family balance/access to care"—what became known as the care deficit—blocked the way to equality in work.[8]

The highlighting of reproductive labor appeared as a new departure, but its components consisted of previous actions brought in from the periphery and refurbished. This move was not necessarily bad; focusing on care was long overdue. The Director-General admirably sought to cast the problem of care as not just a woman's issue; men's failure to undertake their share joined the structure of workplaces to exacerbate inequality. However, by underscoring how care deficits impacted women, the report issued in his name re-inscribed care as part of the problem of the woman worker.[9] A previous policy preference of fulfilling basic needs through infrastructure development, for example, reappeared as the road to "time sovereignty" for "millions of women . . . particularly in low-income rural settings." As argued in the 1970s and 1980s, the ILO still contended that if women had ready access to water and fuel, if housework could become less

burdensome, they could increase both productivity and leisure. Formalizing the informal economy further would end the need to take all day for "generating even a subsistence livelihood."[10] Improved infrastructure and public care services had a double advantage: they would relieve household burdens and provide employment for women.[11] What really seemed to change was the amplification of proposals through the Director-General.

In keeping with the ILO's historic focus on employment, concern with wage work lay behind this emphasis on care. The ILO considered "care for inclusive labour markets and gender equality," noting "care provision determines whether women can enter and stay in employment and the quality of jobs they perform." Care deficits interfered with women's workforce participation at a time when national needs for labor power again appeared blocked by demographic declines, requiring more women to enter the labor market. Worldwide paradoxes resulted. Despite rising education, the numbers of wage-earning women dropped in Asia and the Pacific, perhaps as a consequence of greater prosperity. In Europe and the United States, an aging society with a lack of care workers threatened to curb previous increases in women's employment, especially since austerity politics cut funding for care and welfare states were privatizing social services. Leaving jobs, women returned home to tend to family.[12]

The ILO would remake the workplace to upend care deficits by accommodating reproductive labor. This solution came through in the litany of ways that it suggested to reorganize structures of work by recalibrating working time through flexi-time and flexi-space. It would promote various ways of counting time, such as banking hours and job sharing, along with alternatives to shift and on-call work.[13] On the other hand, it would retain an earlier concern with remaking the woman worker to enter production by enabling her to combine work with maternity and housework. In 2000 the ILC had updated its Maternity Protection Convention (No. 183) to emphasize financing from general taxation rather than from employers, who had discriminated against women to avoid paying for leave—an outcome that labor feminists in 1919 and again in 1952 had warned against in promoting public financing. That 71% of working mothers worldwide lacked maternity protection reinforced the difficulty of applying job-based social benefits when self-employment/own-account, part-time, temporary, and other forms of nonstandard work by definition excluded social provision.[14]

Women continued to find in home-based labor a private solution to their need to earn income while caring for children and other family members. In a digital age, home work gained renewed saliency. The gig economy encouraged a form of telework with attenuated employer-employee relationships in which digital platforms connect those with tasks to those bidding to perform them. Though a small percentage of the workforce, telework again, as prematurely in

the late 1980s and early 1990s, seemed a harbinger of the future. A European-based study emphasized how both women and men appreciated the flexibility of working from home. Nonetheless, women "report[ed] often being sleep-deprived and feeling isolated" in contrast to men. Working from home closed off opportunity "to interact with people other than their family, to make friends, share views and compare notes." In contrast, outside employment brought social contacts that could "help [a woman] . . . quit an abusive partner." For women, the gig economy could intensify the disadvantages of home work, particularly the lack of boundaries between work and the rest of life and the extension of working-time from day into night.[15]

Reorganization of work ironically challenged restrictions on working time. Though the ILO had concluded that night work limits should apply to men as well, its most current instruments emphasized employment opportunities rather than occupational health, in keeping with the convergence between neoliberal directions of the late 20th century and feminist demands for equal treatment. Only maternity remained as a condition demanding restraints on night work. Biological reproduction retained its difference, even if most women had limited choices regarding when and where they labored, especially outside of Europe and the Anglophone industrial nations.[16]

In this context, building a new care economy emerged as the solution to winning equality—a measure that some national organizations, like Caring Across Generations in the United States, touted.[17] The ILO launched a report, *Care Work and Care Jobs for the Future of Work*, in late June 2018. It documented projected needs, predicting the growth of elders, jumping worldwide from 2.1 billion in 2015 to 2.3 billion by 2030. "Extra demand" at a time when nuclear families constituted the largest source of employed workers promised to "constrain women's labour force participation" unless policies redirected care burdens. Redistribution of care between men and women and between households and society appeared imperative to level the playing field. Drawing upon time-use surveys from sixty-seven nations, composing a majority of the world's population, the ILO calculated that women performed over 75% of unpaid care work, 3.2 times as much as men. Mothers of young children particularly suffered a care penalty. What was needed was government investment as well as different business models. Calling for a "universal carer model," the ILO supported measures that were hardly new, even if worth pushing: care as part of "comprehensive national social security systems," publicly supplied care services and worksite and community centers for children and elders, and "well-designed family leave policies." Care policies involved a mixture of direct provision of services; "care-relevant infrastructure;" labor regulations, like maternity protection and family leave; and social protection transfers and benefits, like tax rebates and cash for care.[18] Subsequent reports

amplified these observations. As Manuela Tomei, Director of the now combined Conditions of Work and Equality Department, and Shauna Olney, Chief of the Gender, Equality and Diversity & ILOAIDS Branch, concluded, "Whether women work in the fields, the boardroom or through digital planforms, whether they are own account workers or managers, the care and paid work conundrum needs to be addressed. Otherwise the future of work for women will simply replicate the past."[19] Whether nations would act on such knowledge still was up for grabs.

A related workplace issue loomed: women dominated the care sectors, whether education, health, social services, or household work; about a fifth of all employed women labored in such jobs. Displacing care obligations onto another woman, paid little for her services, only shifted the burden, while generating its own care deficits among migrant and low paid domestic/household and other service workers. Doubling investment in the care sector had the potential to generate millions of good jobs if compensated as if the work was valuable. The ILO recommended "upgrading" the conditions of paid care workers, a reiteration of Convention No. 189. A just care work also demanded fairness toward migrants; these policy realms had become intertwined.[20]

"Lack of recognition, unequal distribution and undervaluation of care work" was only one of four arenas of inequality pinpointed by the ILO's Initiative on Women's Work. Here the ILO followed the UN's 2030 Agenda for Sustainable Development. Two other arenas expressed long-standing concerns with non-discrimination and equal remuneration: "Discrimination, including stereotypes, that undermine access to decent work" and "Low pay and the absence of equal pay." Despite extensive national ratification of Conventions No. 100 and No. 111, "the persistence of gender stereotypes and sex-biased job classification systems and pay structures" still blocked "equal pay for work of equal value." Such perceptions even swept into digital crowdsourcing: despite the anonymity of the Internet, "buyers" could figure out the gender of bidders through digital footprints, paying women less.[21] That the proposed new way recommended job evaluation on the level of individual enterprises, the technique advocated by Frieda Miller coming out of WWII, rather than national solutions perhaps stood as a backward retreat from societal initiatives. It could, however, serve as a strategy to involve the Employers.

Anticipating and Responding to #MeToo

"Violence and harassment," the fourth topic, previously had entered ILO discussions in relation to refugees, though the Gender division had brought up sexual harassment as an impediment to women's workforce participation and

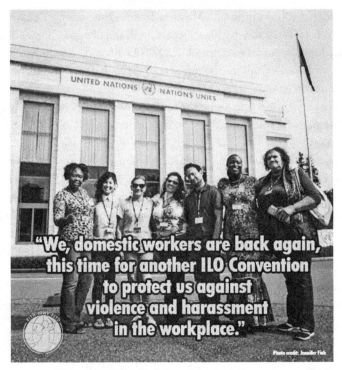

FIGURE 7.1 Domestic workers lobby for an ILO Convention on Violence and Harassment Against Men and Women in the World of Work, 2018. Photo by Jennifer N. Fish, on behalf of the International Domestic Workers Federation, reworked by Ye Ting Ma, with permission.

success in the 1980s. Six years after the ILC in 2009 considered the place of gender equality for obtaining decent work, the Governing Body approved "violence" as a topic for standard setting. A previous Meeting of Experts in 2003 formulated a set of practices for the service sector, but as a voluntary code it was more limited than a proposed convention and recommendation on gender-based violence and harassment for men and women in the world of work. At the subsequent 2016 Meeting of Experts on Violence against Women and Men in the World of Work, in which women dominated, Workers' Vice-Chairperson Catelene Passchier of the Federatie Nederlandse Vakbeweging (FNV) cited the precedent of night work bans. These limits had served as protections against violence during the journey home. Reinterpreting the past through the present, she argued, "there was an understanding that it is violence (not women) that should be banned from the workplace." The Experts would extend the meaning of violence from physical and sexual abuse to bullying and psychological intimation. They recognized that the form of violence varied by type of work and

its location. The background paper for this meeting included the home as a work site, while some speakers emphasized the particular dangers of work on the street, in agriculture, and in concealed or less exposed settings, as faced by office and hotel cleaners. Unequal power relations, along with concentration in informal and precarious jobs, impacted "LGBTI," young, migrant, indigenous, and racialized people. But the gender dimension was partially salient because "women are disproportionately affected by violence in the world of work, and that inequality, vulnerability and insecurity in employment play a role." Freedom from sexual harassment was both a human right and a violation of occupational health and safety norms. Violence, noted Tomei as the representative of the Secretary-General, was bad for productivity and "the efficient functioning of labour markets."[22]

Employers reverted to what had become a pattern of obstructionism. Insisting on the unacceptability of violence at work, their representative went on to question definitions and data. The Employers' Vice-Chairperson from the Belgium Federation of Enterprises, Kris De Meester, insisted on the need for concrete distinctions. It wasn't gender but interaction with the public that generated abuse of frontline service workers; "if men were predominant in those same situations," they too would have similar experiences, he insisted, though without any evidence. In response, Passchier argued that "while the ILO could not solve all issues at the root of violence, such as patriarchy, they needed to take these issues into account." Of particular concern was abuse by clients, including receivers of home care. In a gesture toward the Employers, the Experts resolved to find better comparative measures, but they insisted on using qualitative evidence as well as available quantitative data.[23]

The Experts cast a wide enough net to consider the fallout from domestic violence on workplace performance as well as the role of employers in mitigating intimate abuse. They agreed to consider violence and harassment "as a continuum of unacceptable behaviours and practices, and that these behaviours could result in physical, psychological or sexual harm or suffering." In speaking of "the world of work," they proposed an expansive sense of space. Standards should include the journey to work, public spaces, the home and other "intimate" workplaces, and "work-related social events." They warned about the danger of "unsocial working hours," exemplified by night work, much as previous deliberations on evening hours had. While the Employers rejected precarity as a factor, others saw insecure status heightening vulnerability.[24] As remedies, the Experts cited specific examples of collective agreements with prevention and training components as well as procedures for employers to address violations. Passchier particularly commended the effectiveness of ILO maritime conventions in responding to "extreme forms of violence," including "shipboard harassment and bullying."[25] Her

highlighting of a male-dominated occupation underscored the expansiveness of concepts of gender, in which the seafarer served as a powerful trope, as we have seen, for fusing cultures of protection with labor standards.

During the 2018 ILC, the Workers and Employers on the Standard-Setting Committee on Violence and Harassment against Women and Men in the World of Work enacted their typical disagreements even while claiming to wish for a practicable and effective result. The Employers' Vice-Chairperson, workplace relations specialist Alana Matheson from the Australian Chamber of Commerce and Industry, reiterated concerns over definitions and the breadth of any instrument. She observed that the ILO should only include the workplace where employers "had control" and not other spaces, which placed domestic violence outside of consideration. She suggested separating violence, usually subject to criminal law, from harassment, and worried that the rights of employers would be excluded, a recurring complaint no matter the topic under discussion.[26] In contrast, her Worker counterpart, Secretary-Treasurer Marie Clarke Walker of the Canadian Labour Congress, called for a convention with recommendation. Referring not only to the ILO's own human rights pronouncements but also to the #MeToo and other global social media campaigns, she underscored the ubiquity of "tolerated violence and harassment." So many women, she noted, had to "endure" such behavior "to obtain or keep a job, to be paid their salaries, to be promoted and when commuting to and from work," whether in glamorous professions, in the halls of governments, or in low-waged, often less visible, work in households, fields, offices, and factories. The Workers argued for expansive understandings of "employer," including placement agencies, and of "worker," including job seekers and interns. They highlighted the harassment that waitresses and other tipped workers faced, as well as the need to address zero-hour and other current temporary arrangements that bypassed standard employment.[27]

The adoption of a convention was not merely a concern of industrialized nations. The Africa group (of governments) offered a long historical perspective on the presence of violence and harassment in various forms of labor relations, including slavery and dependent self-employed workers. Its spokesperson from Namibia stressed the necessity "to create a standard that would be relevant worldwide," relevant for "informal and rural economies or where labour migration was prevalent."[28] The IDWF presented a platform of demands related to inclusion of its members, whose workplace was another's home and yet the "private" home was in many places still "not accepted as a 'workplace'" or subject to labor inspection or occupational health and safety regulations.[29]

The ILO went forward with a proposed convention supplemented by a recommendation. The Office questionnaire garnered much interest, with

responses from 85 Governments, 179 Workers' groups, and 29 Employers' organizations. Though not included in the Office report, comments came from civil society stakeholders like CARE and sex worker rights organizations, all of which called for worker protection.[30] The suggested instruments sought to supplement ambiguities and gaps in existing measures, including those on discrimination, home-based and informal sectors, workers living with HIV/AIDS, and occupational safety and health. As with other conventions, drafters repeated a litany of past conventions and other authorities, including the ILO Constitution and 1944 Declaration of Philadelphia, to argue for specifying "protection against injury and harmful working conditions." The UN's 2030 Sustainable Development Goals along with a range of UN human rights instruments, including CEDAW, and anti-violence initiatives further supported action.[31] The proposed convention affirmed freedom from violence and harassment in the world of work as a human right and obligated signatories to ensure laws and policies reflected that end through appropriate enforcement, monitoring, training, and individual worker supports. Member States were to require employers "to take steps"—with the ubiquitous loophole, "as far as it is reasonably practicable"—to join with workers to prevent and control such behaviors.[32] Worker rights and human rights to bodily integrity had fused a century after the ILO's founding.

The impact of violence on women's place in the workforce again wove through reports and discussions. Explained a representative of the Secretary-General, "Violence and harassment negatively affected private and public services and the erosion thereof would severely restrict women's labour market participation."[33] But specification of vulnerable workers proved contentious, not least because the Africa group and others rejected mention of LGBTQI people—to the disappointment of both Employers and Workers. A list of the particularly vulnerable went into the proposed recommendation rather than the convention. The endangered included younger and older, pregnant and breastfeeding, workers with family responsibilities, those with disabilities, people living with HIV/AIDS, migrants, indigenous and tribal peoples, ethnic and religious minorities, the "caste-affected," LGBTI, and the gender nonconforming.[34] In 2010 the ILC had recognized the vulnerability of workers with HIV/AIDS through Recommendation No. 200, which rejected discrimination and called for equality of opportunity and protection of the "sexual and reproductive rights of women and men."[35] This acknowledgement of workers as having sexual rights existed alongside the organization's persistent denial that sex work and related issues belonged to its competency. But given that stigmatized attitudes toward HIV/AIDS influenced employment decisions, the ILO intervened. It addressed sex as related to the public health of workers, as it did with seafarers and venereal diseases during the pre-WWII years.[36]

The ILO indeed marked its centennial by passing Convention No.190, "Concerning the Elimination of Violence and Harassment in the World of Work" along with Violence and Harassment Recommendation 2019 (No. 206). Framed around human rights and connected to the fulfillment of decent work and fundamental rights at work (like equality and non-discrimination), these instruments offered a universal standard. They covered both employees and "persons working irrespective of their contractual status," which included interns, trainees, and applicants, and "all sectors, whether private or public, both in the formal and informal economy, and whether in urban or rural areas." They extended to employers, supervisors, other workers, and relevant third parties. The convention applied not only to the place of work but to rest and meal areas, "work-related" social and training events, work communications, "employer-provided accommodation," and the journey to and from work. Embedded within the universal was the particular situation of women and girls, who "disproportionately" faced gender-based violence and harassment. The convention further acknowledged the impact of domestic violence on "employment, productivity and health and safety." It asked for education, remedies, and appropriate responses involving employers' and workers' groups in light of the laws and practices of each nation. Therein was the rub: signatories could interpret as they wish. Eliminating the list of vulnerable groups provided in 2018 "conclusions," which the Employers' recommended, particularly circumvented opposition to inclusion of LGBTQI people among some governments (especially Arab and African but also the US's Trump administration). What remained was coded language: protection "for workers and other persons belonging to one or more vulnerable groups or groups in situations of vulnerability that are disproportionately affected by violence and harassment in the world of work."[37]

Difference Despite Equality, Difference as the Norm

By the end of the 20th century, the ILO approached gender, work, and human rights through gender mainstreaming, the process previously noted that infuses gender equality into all aspects of an institution's strategy and programming. It created a gender audit tool for the UN system in 2001 "to review the structures, processes and polities of organizations to identify and address possible conscious and unconscious bias that may be built into their modus operandi." It set targets within its own bureaucracy, admitting that it had fallen short of its own goals in the hiring and promotion of women, while the number of delegates and advisors at the ILC never came close to reaching parity.[38] The gap between recognizing the gains accruing from the presence of women and other specified groups and

actual practice persisted. The ILO still succumbed to categorizing women as a universal group even as it specified occupational and regional foci.

Such an observation should not distract from changes over the last half century. The ILO assumed that shifting the position of men in the family and the society would improve women's status even as it sought to integrate women into the world of men. This perspective emerged after the Mexico City conference in 1975 as a response to concerns that development aid programs disadvantaged women. At the Second World Conference on Women in Nairobi in 1985, the "Forward-Looking Strategies for the Advancement of Women" had endorsed gender mainstreaming programs and projects. By the time of the Fourth World Conference on Women in Beijing a decade later, the strategy included goals relating to education, health, decision-making, leadership, and economic relations. The ILO 2010 Action Plan for Gender Equality belatedly echoed this "integrated approach"—much like broad conceptions of human rights—so as to utilize all tools available to support workers' rights (and women's rights) as human rights.

By 2018 the ILO had firmly narrated its past as a move "from an initial narrow focus on women workers' protection towards one which embraces gender equality as both a goal in itself and a means to achieve social justice." The "solution to women's problems at work lies in addressing them within the same general framework of economic and social development as those of men," it declared. It also claimed a "vanguard" position because of its embrace of equal remuneration for work of equal value from 1919 forward.[39] As the focus on care work suggested, the double position that characterized the making of the woman worker—women like men except when they aren't—was an updating of earlier foundational tenets.

"Women" was only one of seven Centennial initiatives, the others being governance, standards, green (ecological sustainability), enterprises (engagement with private business sector), poverty, and the future of work itself.[40] The latter, which also included gender as a factor, looked forward to grapple with flows of capital and shifts in the organization of production. With under 30% of workers in employment fully covered by labor regulation, with 60% of the world's laboring population in the informal economy, and with attenuated global supply chains crossing borders, the question had become whether nation-based standards can improve working conditions and protect standard of living and quality of life.[41] Can they cover migrant workers whose journeys represent a form of mobility distinct from but linked to that of corporations moving jobs across borders? The ILO offered its usual tools: migrant worker instruments; discussion among workers, employers, and governments across borders (labeled as "social dialogue"); strengthened labor administration and national governance; reconsideration of effectiveness of ILO standards and barriers to ratification; gathering of

adequate statistics; and enhancing current programs in light of UN and OECD guidelines as well as ILO frameworks.[42]

The ILO continues to promulgate best practices for working conditions and social security in the same forms as in the past, but it has added assistance with monitoring global supply chains as part of its technical cooperation portfolio. Beginning in 2007, with the International Finance Corporation (IFC), "the private sector financial arm of the World Bank," it launched the Better Work Programme for supporting business competitiveness and improved working conditions in global supply chains. Central to the effort was Business for Social Responsibility, a nonprofit association with 250 large corporate members in a range of industries. Trainings and consultations were to enhance the ability of companies and individual plants to monitor conditions on the ground, while eliminating "duplication of monitoring" in apparel, agribusiness, and other "light manufacturing." ILO instruments offered guidelines for corporate social responsibility. These included " 'the Four Freedoms of Labour': workplaces free from child labour, forced labour, discrimination . . . [but including] freedom of association and collective bargaining." These freedoms were part of the Tripartite Declaration of Principles concerning Multinational Enterprises and Social Policy.[43]

The Better Factories Cambodia project "inspired" the Better Work Programme, which initially focused on Vietnam, Jordan, and Lesotho, and then expanded to cover other nations by 2018. The ILO initially judged the Cambodia project a success for attracting jobs and bettering conditions. Subsequent reports showed that the end of the Multifiber Arrangement and a pull-back in US and European imports reversed earlier progress in labor standards—and the number of jobs declined.[44] A 2016 Tufts University study of the Better Work Programme in Vietnam, covering more than four hundred factories and 21% of the garment workforce there, lauded a turn "away from practices that cause long working hours, low pay, threats of dismissal, and abuse of contracts." More women in Vietnam gained supervisory training, while productivity increased along with higher wages.[45] It was too early to definitively judge outcomes.

Better Work fit into the voluntarist model of corporate social responsibility, given new stature through the ILO imprimatur. It represented a public-private, global-local partnership reliant on donor nations to create programs that were still dependent on international brands, including H&M, Levi Strauss, and Adidas, to finance actual factory audits. Despite frameworks for assessing compliance, dialogue for "continuous improvement," and engagement of all stakeholders— a vague concept in practice—this program and related ones faced the realities of subcontracting.[46] While global brands desired reputational benefits, the various logics of cheaper prices and squeezes along the supply chain generated a

contradictory environment. It wasn't that voluntary attempts were bad or intents were dishonest, but monitoring proved difficult. As one ILO evaluation in Indonesia discovered, worker needs for income, customary gender practices, and tenuous chains of command made it difficult to fully implement "decent work" in a supply chain even with a "desirable" corporate code of conduct. Delayed payments, irregular work orders, and subcontractor lack of resources to improve workplaces reflected a culture of passive compliance. Subsequent action goals should assess the problems of women workers, isolated in homes and without full knowledge of contracts and other aspects of their employment. To fulfill the code of conduct, evaluators suggested engagement with an expanded group of stakeholders, including local governments and NGOs.[47]

Since the 1990s, intensified campaigns against the sweatshop had mobilized consumers of apparel in Europe and the United States. With garment unions, activists sought to end abusive practices, including pregnancy testing of women employees, health and safety violations, killings of organizers, runaway shops, and low wages. NGOs of various types, such as the European Clean Clothes Campaign and US Worker Rights Consortium, engaged in independent monitoring because global brands like Nike and even those with more robust social responsibility clauses like H&M failed to police their own contractors. States often bowed out or made conditions worse from lack of real inspections of factories and repression of labor movements. The Rana Plaza fire in Dakar, Bangladesh, dramatized these horrors in 2013. The resulting independent "Accord," committing brands to a set of global labor standards on fire and safety, provided a successful, if limited, model that was only effective when the eyes of the world were watching.[48]

In this context, the ILO continued its aspirational course. Most conventions have few signatories, though they set out planks negotiated by Governments, Employers, and Workers. Consequently, enforcement is minimal. Looking at this impasse, Guy Standing has argued that ILO tripartite organization can't be fixed. Likewise, he has argued that the attempt to reinvent itself as a development agency, focused on the informal sector, floundered on lack of expertise and gumption. For Standing, basic income solutions would better enhance global living than can labor standards.[49] An organization forged under social democratic and Fordist conditions confronts readjustment to address today's global supply chains, digital and immaterial forms of labor, and crisis in social reproduction.

WE FACE A world of unmitigated corporate power. In April 2018 the World Bank floated its version of coping with the 21st-century global economy. It would allow for "lower minimum wages and greater hiring and firing powers for employers"—that is, worldwide deregulation of labor. It would also end social security contributions. "Burdensome regulations," the Bank contended, "also

make it more expensive for firms to rearrange their workforce to accommodate changing technologies." Instead, it called for greater flexibility in hiring, firing, and hours, with "a basic level of social insurance to be financed largely by . . . consumption taxes," or forcing workers to pay for a safety net through regressive means. To create an even playing field, the Bank would make the formal economy informal—a dire outcome for workers worldwide. In contrast, the ILO continued to argue for formalizing the informal.[50]

The opening up of the convention-making process with the domestic workers suggests that one component of tripartism is transforming: that of the Workers. It may well be the weakness of national and international trade unions, their feminization in many locations, that allows for inclusion of women, informal, and previously non-represented labor at the ILO. The turn to the care-work economy represents another belated move to make the institution relevant to gendered structures of work. The commodification of care is already upon us, and the issue is whether care workers will reap the rewards of their labor. Social supports for care might allow a parallel process of decommodification, allowing women and men to step outside of the labor market, even if intermittently. But this turning of care into work might also further divide those who go out to work from those who come in for work, exacerbating inequality between women and nations.

The ILO constructed the woman worker in response to needs for her labor in the home and other workplaces, but also in reaction to the demands of women themselves for recognition and rights, dignity, and daily bread. With the unraveling of labor standards and an onslaught against worker rights, the conditions once associated with women in the Global South have spread to men as well as women in the industrialized North. Those able to imagine social justice acknowledge the challenge: without a collective effort to sustain and enhance life, without justice in the home, real justice in other workplaces will remain elusive.

List of Key Conventions and Recommendations[1]

Maternity Protection Convention (No. 3), 1919
Night Work (Women) Convention (No. 4), 1919
Lead Poisoning (Women and Children) Recommendation (No. 4), 1919
Maternity Protection (Agriculture) Recommendation (No. 12), 1921
Night Work of Women (Agriculture) Recommendation (No. 13), 1921
Migration (Protection of Females at Sea) Recommendation (No. 26), 1926
Minimum Wage-Fixing Machinery Convention (No. 26), 1928
Minimum Wage-Fixing Machinery Recommendation (No. 30), 1928
Night Work (Women) Convention (Revised) (No. 41), 1934
Underground Work (Women) Convention (No. 45), 1935
Income Security (includes maternity benefit and retirement age for women)
 Recommendation (No. 67), 1944
Night Work (Women) Convention (Revised) (No. 89), 1948
Equal Remuneration Convention (No. 100), 1951
Equal Remuneration Recommendation (No. 90), 1951
Maternity Protection Convention (Revised) (No. 103), 1952
Maternity Protection Recommendation (No. 95), 1952
Plantations Convention (Part VII, Maternity) (No. 110), 1958
Discrimination (Employment and Occupation) Convention (No. 111), 1958
Discrimination (Employment and Occupation) Recommendation (No. 111), 1958
Protection of Workers against Ionising Radiations (Art. 16) Recommendation
 (No. 114), 1960
Equality of Treatment (Social Security) Convention (No. 118), 1962
Employment (Women with Family Responsibilities) Recommendation (No. 123), 1965

Nursing Personnel Convention (No. 149), 1977
Workers with Family Responsibilities Convention (No. 156), 1981
Workers with Family Responsibilities Recommendation (No. 165), 1981
Night Work Convention (No. 171), 1990
Night Work Recommendation (No. 178), 1990
Part-Time Work Convention (No. 175), 1994
Part-Time Work Recommendation (No. 182), 1994
Home Work Convention (No. 177), 1996
Home Work Recommendation (No. 184), 1996
Maternity Protection Convention (No. 183), 2000
Maternity Protection Recommendation (No. 191), 2000
Domestic Workers Convention (No. 189), 2011
Domestic Workers Recommendation (No. 201), 2011
Elimination of Violence and Harassment in the World of Work Convention (No. 190), 2019
Elimination of Violence and Harassment in the World of Work Recommendation (No. 206), 2019

Publications of the Programme on Rural Women, *1978–1988*

WEP 10/	WP. 1	*Land Reform in Asia with Particular Reference to Pakistan, the Philippines and Thailand*—Zubeida Ahmad
	WP. 2	*Reproduction, Production and the Sexual Division of Labour*—Lourdes Benería
	WP. 3	*Employment and Income Generation in New Settlement Projects*—R. Weitz
	WP. 4	*Research on Participation of the Poor in Development*—Md. Anisur Rahman
	WP. 5	*Participatory Development Efforts in Rural Bangladesh: A Case Study of the Experiences in Three Areas*—Mahabub Hossain, Raisul Awal Mahmood, and Qazi Kholiquzzaman Ahmad
	WP. 6	*Agricultural Co-operatives in North Vietnam*—Amit Bhaduri
	WP. 7	*Sind Hari Committee, 1930–1970: A Peasant Movement?*—Mahmood Hasan Khan
	WP. 8	*Land Reform and Peasant Associations in Ethiopia: A Case Study of Two Widely Differing Regions*—Alula Abate and Tesfaye Teklu
	WP. 9	*Transition to Collective Agriculture, and Peasant Participation: North Viet Nam, Tanzania and Ethiopia*—Md. Anisur Rahman

	WP. 10	*Rural Development Planning and the Sexual Division of Labour: A Case Study of a Moslem Hausa Village in Northern Nigeria*—Richard Longhurst
	WP. 11	*Peasant Struggle in a Feudal Setting: A Study of the Determinants of the Bargaining Power of Tenants and Small Farmers in Five Villages of District Attock, Pakistan, 1980*—Nigar Ahmad
	WP. 12	*Participatory Processes and Action of the Rural Poor in Anta, Peru*—Santiago Roca with the collaboration of Miguel Bachrach and Josi Servat
	WP. 13	*Women in Agriculture: Peasant Production and Proletarianisation in Three Andean Regions*—Carmen Diana Deere and Magdalena León de Leal
	WP. 14	*Rural Women in Thailand: From Peasant Girls to Bangkok Masseuses*—Pasuk Phongpaichit
	WP. 15	*Economic Role and Status of Women: A Case Study of Women in the Beedi Industry in Allahabad*—Zarina Bhatty
	WP. 16	*Housewives Produce for the World Market: The Lace Makers of Narsapur*—Maria Mies
	WP. 17	*Survival Strategies of Rural Women Traders or a Woman's Place is in the Market: Four Case Studies from Northwestern Sleman in the Special Region of Yogyakarta*—Nancy Lee Peluso
	WP. 18	*The Position of Women Workers in the Plantation Sector in Sri Lanka*—Rachel Kurian
	WP. 19	*A Preliminary Study of Women Rubber Estate Workers in Peninsular Malaysia*—Noeleen Heyzer Fan
	WP. 20	*Participation Experiences in the Countryside: A Case Study in Chile*—Sergio Gomez
	WP. 21	*Agricultural Modernisation and Third World Women: Pointers from the Literature and an Empirical Analysis*—Bina Agarwal
	WP. 22	*Grass-Roots Self-Reliance and Shramik, Sanghatana, Dhulia District, India*—P. V. Paranjape, Vijay Kanhere, Nirmala Sathe, Sudhindra Kulkarni, and Sujata Gothoskar
	WP. 23	*Fuel Availability, Nutrition and Women's Work in Highland Peru: Three Case Studies from Contrasting Andean Communities*—Sarah L. Skar

	WP. 24	*Grass-Roots Self-Reliance in Two Rural Locations in Sri Lanka: Organisations of Betel and Coir Yarn Producers*—S. Tilakaratna
	WP. 25	*Grass-Roots Self-Reliance Initiatives in Malaysia: A Case Study of Kampung Batu's Struggle for Land*—Lim Teck Ghee and Tan Phaik Leng
	WP. 26	*The Struggle toward Self-Reliance of Organised, Resettled Women in the Philippines*
	WP. 27	*Conscientising Rural Disadvantaged Peasants in Bangladesh: Intervention through Group Action: A Case Study of Proshika*—Mosharraf Hossain
	WP. 28	*Migrant Labour and Women: The Case of Ratnagiri*—Rajani X. Desai
	WP. 29	*The Theory and Practice of Participatory Action Research*—Muhammad Anisur Rahman
	WP. 30	*Young Women Workers in Export Industries: The Case of the Semiconductor Industry in Southeast Asia*—Elizabeth Eisold
	WP. 31	*Rural Households Headed by Women: A Priority Concern of Development*—Nadia H. Youssef and Carol B. Hetler
	WP. 32	*Marginalisation and the Induction of Women into Wage Labour: The Case of Indian Agriculture*—Ruchira Chatterji
	WP. 33	*Changing Patterns of Rural Women's Employment, Production and Reproduction in China*—Elisabeth Croll
	WP. 34	*Indian Women in Subsistence and Agricultural Labour*—Maria Mies
	WP. 35	*The Rural Energy Crisis, Women's Work and Family Welfare: Perspectives and Approaches to Action*—Elizabeth Cecelski
	WP. 36	*Differentiation among the Rural Poor and Its Bearing on Solidarity and Organisational Development: A Study of Five Locations in India*—A Research Collective
	WP. 37	*The Animator in Participatory Rural Development: Some Experiences from Sri Lanka*—S. Tilakaratna
	WP. 38	*Crisis de energía rural y trabajo femenino en tres areas ecológicas del Peru*—Elsa Alcántara

	WP. 39	*The Rural Energy Crisis in Ghana: Its Implication on Women's Work and Household Survival*—Elizabeth Ardayfio
	WP. 40	*The Impact of Rural Transformation on Peasant Women in Mozambique*—Stephanie Urdang
	WP. 41	*Rural Women and Social Structures in Change: A Case Study of Women's Work and Energy in West Java, Indonesia*—A Research Collective
	WP. 42	*Women in the Estate Sector of Malawi: The Tea and Tobacco Industries*—Megan Vaughan and Graham Chipande
	WP. 43	*Rural Development, International Markets and Labour Appropriation by Sex: A Case Study of l'Oulja Region, Morocco*—Lourdes Benería
	WP. 44	*Change in Domestic Fuel Consumption in Central Mexico and Its Relation to Employment and Nutrition*—Margaret I. Evans
	WP. 45	*Women Workers in Kerala's Electronic Industry*—Gita Sen and Leela Gulati

Source: "Previous Publications," in Maria de los Angeles Crummett, *Rural Women and Industrial Home Work in Latin America: Research Review and Agenda*, WEP Working Paper 46 (Geneva: ILO, June 1988), 35–37.

Notes

PROLOGUE

1. C. Dumont to EMP/RU and LEG/REL, Minute on International Workshop, March 29, 1989, WEP 10-4-04-21-1-33-02, Jacket 5, ILO Archives (ILOA), Geneva. Unless otherwise noted, archival material comes from this repository.

2. Memo from Andréa M. Singh to Gisela Schneider de Villegas, April 26, 1989, with attached copy of Working Group Reports, 14–15, WEP 10-4-04-21-1-33-02, Jacket 5.

3. Eileen Boris and Elisabeth Prügl, eds., *Homeworkers in Global Perspective: Invisible No More* (New York: Routledge, 1996).

4. Good thing I haven't relied on self-reporting through oral recollection. On the archive as a site of memory but also of knowledge construction ripe with power relations, see Anjali Arondekar, "Without a Trace: Sexuality and the Colonial Archive," *Journal of the History of Sexuality*, 14:1/2 (January/April 2005): 10–27; see also Antoinette Burton, ed., *Archive Stories: Facts, Fictions, and the Writing of History* (Durham, NC: Duke University Press, 2005); and Nupur Chaudhuri, Sherry J. Katz, and Mary Elizabeth Perry, eds., *Contesting Archives: Finding Women in the Sources* (Champaign-Urbana: University of Illinois Press, 2010). On writing contemporary history, see Eileen Boris and Jennifer Klein, "When the Present Disrupts the Past: Narrating Home Care," in *Doing Recent History: On Privacy, Copyright, Video Games, Institutional Review Boards, Activist Scholarship and History That Talks Back*, ed. Claire Bond Potter and Renee C. Romano (Athens, GA: University of Georgia Press, 2012), 249–274.

5. For example, I participated in a workshop prior to the release of a global report on home workers in July 2019 at the ILO.

INTRODUCTION

1. ILC, *Provisional Record of Proceedings, Ninety-Ninth Session* (Geneva: ILO, 2010), 8/41, 19/42, 19/39.

2. Eileen Boris and Jennifer N. Fish, "'Slaves No More': Making Global Standards for Domestic Workers," *Feminist Studies*, 40:2 (2014): 411–443.

3. Guy Standing, "Global Feminization through Flexible Labor: A Theme Revisited," *World Development*, 27:3 (1999): 583–602; David Weil, *The Fissured Workplace: Why Work Became So Bad for So Many and What Can Be Done to Improve It* (Cambridge, MA: Harvard University Press, 2014); Judy Fudge and Rosemary Owens, eds., *Precarious Work, Women, and the New Economy: The Challenge to Legal Norms* (Oxford: Hart, 2006).

4. Marcel van der Linden, "The International Labor Organization, 1919–2019: An Appraisal," *Labor: Studies in Working-Class History*, 16:2 (May 2019): 11–41; Daniel Maul, *The International Labour Organization: 100 Years of Global Social Policy* (Berlin: De Gruyter, 2019); Jasmien Van Daele, "Survey: The International Labour Organization (ILO) in Past and Present Research," *International Review of Social History*, 53:3 (December 2008): 485–511. For insider accounts, see Robert Cox, "ILO: Limited Monarchy," in *The Anatomy of Influence: Decision Making in International Organization*, ed. Robert W. Cox, Harold K. Jacobson, et al. (New Haven, CT: Yale University Press, 1973), 102–138; Robert W. Cox, "Labor and Hegemony," *International Organization*, 31:3 (Summer 1977): 385–424; Gerry Rodgers, Eddy Lee, Lee Sweptson, and Jasmien Van Daele, *The ILO and The Quest for Social Justice, 1919–2009* (Ithaca, NY: Cornell University Press, 2009); Carol Riegelman Lubin and Anne Winslow, *Social Justice for Women: The International Labor Organization and Women* (Durham, NC: Duke University Press, 1990). For earlier accounts, see Anthony Evelyn Alcock, *History of the International Labor Organization* (New York: Octagon Books, 1971).

5. James T. Shotwell, "The International Labor Organization as an Alternative to Violent Revolution," *Annals of the American Academy of Political and Social Science*, 166 (March 1933): 18–25.

6. Report of the Director-General, *The Women at Work Initiative: The Push for Equality* (Geneva: ILO, 2018), 2. See also ILO, *A Quantum Leap for Gender Equality: For a Better Future of Work for All* (Geneva: ILO, 2019).

7. The ILO remains bound to a gender binary in its collection of data and thinking, though some recent initiatives discussed in chapter 7 sought to include LGBTQ people.

8. Marieke Louis, "Women's Representation at the ILO: A Hundred Years of Marginalization," in *Women's ILO: Transnational Networks, Global Labour Standards and Gender Equity, 1919 to Present*, ed. Eileen Boris, Dorothea Hoehtker, and Susan Zimmermann (Leiden and Geneva: Brill and ILO, 2018), 207.

9. Sara R. Farris, *In the Name of Women's Rights: The Rise of Femonationalism* (Durham, NC: Duke University Press, 2017), 123.

10. Here I interpret the work of Silvia Federici and Maria Mies, cited throughout.

11. David Harvey, *A Brief History of Neoliberalism* (New York: Oxford University Press, 2007).

12. V. Spike Peterson, "Informalization, Inequalities and Global Insecurities," *International Studies Review*, 12:2 (June 2010): 244–270; V. Spike Peterson, "Global Householding amid Global Crises," *Politics & Gender*, 6 (2010): 271–304; Swatsi Mitter, "Industrial Restructuring and Manufacturing Homework: Immigrant Women in the UK Clothing Industry," *Capital and Class*, 27 (Winter 1986): 37–80; Ligaya Lindio-McGovern, *Globalization, Labor Export and Resistance: A Study of Filipino Migrant Domestic Workers in Global Cities* (New York: Routledge, 2012); Saskia Sassen, *Expulsions: Brutality and Complexity in the Global Economy* (Cambridge, MA: Harvard University Press, 2014).

13. Ellen Malos, ed., *The Politics of Housework* (London: New Clarion Press, 1995); Jocelyn Olcott, "Introduction: Researching and Rethinking the Labors of Love," *Hispanic American Historical Review*, 91 (February 2011): 1–27.

14. Leopoldina Fortunati, *Arcane of Reproduction* (New York: Autonomedia, 1989).

15. Heidi Hartmann, "The Unhappy Marriage of Marxism and Feminism," *Capital & Class*, 3 (1979): 1–33; Evelyn Nakano Glenn, "From Servitude to Service Work: Historical Continuities in the Racial Division of Paid Reproductive Labor," *Signs: Journal of Women in Culture and Society*, 18 (Autumn 1992): 1–43; Lourdes Benería and Gita Sen, "Accumulation, Reproduction, and 'Women's Role in Economic Development': Boserup Revisited," *Signs: Journal of Women in Culture and Society*, 7 (Winter 1981): 279–298; V. Spike Peterson, "Rewriting (Global) Political Economy as Reproductive, Productive, and Virtual (Foucauldian) Economies," *International Feminist Journal of Politics*, 4:1 (April 2002): 1–30; Alessandra Pescarolo, "Productive and Reproductive Work: Uses and Abuses of an Old Dichotomy," in *What Is Work: Gender at the Crossroads of Home, Family, and Business from the Early Modern Era to the Present*, ed. Raffaella Sarti, Anna Bellavitis, and Manuela Martini (New York: Berghahn Books, 2018), 114–138; Tithi Bhattacharya, ed., *Social Reproduction Theory: Remapping Class, Recentering Oppression* (London: Pluto Press, 2017).

16. Silvia Federici, *Revolution at Point Zero: Housework, Reproduction, and Feminist Struggle* (Oakland, CA: PM Press, 2012); Saskia Sassen, *The Global City*, 2nd ed. (Princeton, NJ: Princeton University Press, 2001); Barbara Ehrenreich and Arlie Russell Hochschild, eds., *Global Woman: Nannies, Maids, and Sex Workers in the New Economy* (New York: Metropolitan Books, 2004).

17. For the best overview of the literature, see Eloisa Betti, "Historicizing Precarious Work: Forty Years of Research in the Social Sciences and Humanities," *International Review of Social History*, 62 (2018): 273–319.

18. Gabriella Alberti, Ioulia Bessa, Kate Hardy, Vera Trappmann, and Charles Umney, "In, Against and Beyond Precarity: Work in Insecure Times," *Work, Employment and Society*, 32:3 (2018): 447–457, quote at 448.

19. Nick Bernards, *The Global Governance of Precarity: Primitive Accumulation and the Politics of Irregular Work* (New York: Routledge, 2018).

20. Here I cannot discuss various affects and "structures of feeling" associated with states of precarity. But see "Precarity Talk: A Virtual Roundtable with Lauren Berlant, Judith Butler, Bonjana Cvejić, Isabell Lorey, Jasbir Puar, and Ana Vujanović," *TDR: The Drama Review*, 56:4 (Winter 2012): 163–177; Isabell Lorey, *State of Insecurity: Government of the Precarious* (New York: Verso, 2015); Isabell Lorey, "The Government of the Precarious," blog post, February 23, 2015, https://www.versobooks.com/blogs/1874-precarious-futures. For a range of feminist voices, see Aylson Cole and Victoria Hattam, "Precarious Work," special issue, *WSQ*, 45:3–4 (Fall/Winter 2017).

21. The dimensions here are difficult to capture. See Annette Bernhardt, "Making Sense of the New Government Data on Contingent Work," June 10, 2018, at http://laborcenter.berkeley.edu/making-sense-new-government-data-contingent-work/, accessed June 10, 2018; Janine Berg, *Income Security in the On-Demand Economy: Findings and Policy Lessons from a Survey of Crowdworkers* (Geneva: ILO, 2016).

22. Alberti et al., "In, Against and Beyond Precarity," 352–353.

23. Leah F. Vosko, *Managing the Margins: Gender, Citizenship, and the International Regulation of Precarious Employment* (New York: Oxford University Press, 2010), 217, 223. For the best feminist critique of the standard leftist discussions of precarity that parallels my own focus on reproductive labor, see Silvia Federici, "Precarious Labor: A Feminist Viewpoint," *In the Middle of a Whirlwind*, 2008, https://inthemiddleofthewhirlwind.wordpress.com/precarious-labor-a-feminist-viewpoint/.

24. I'm indebted to the research of Susan Zimmermann, Dorothy Sue Cobble, and Françoise Thébaud, cited in chapter 1.

25. Chandra Talpade Mohanty, "Under Western Eyes: Feminist Scholarship and Colonial Discourses," in *Third World Women and the Politics of Feminism*, ed. Chandra Talpade Mohanty et al. (Bloomington: Indiana University Press, 1991), 51–80, 72.

26. Carol Miller and Shahra Razavi, "Gender Mainstreaming: A Study of Efforts by the UNDP, the World Bank and the ILO to Institutionalize Gender Issues," UNRISD Occasional Paper 4 (Geneva: United Nations Research Institute for Social Development, 1995), available at https://www.econstor.eu/handle/10419/148816.

27. Vosko, *Managing the Margins*; Judy Fudge, Shae McCrystal, and Kamala Sandaran, eds., *Challenging the Legal Boundaries of Work Regulation* (Portland, OR: Hart, 2012); for an optimistic account, see Annelise Orleck, *"We Are All Fast-Food Workers Now": The Global Uprising against Poverty Wages* (Boston: Beacon Press, 2018).

28. Lubin and Winslow, *Social Justice for Women*, passim; I have gleaned more recent iterations through interactions with ILO staff during the last decade.

29. Such was the formulation of Wages for Housework. See Silvia Federici and Arlen Austin, eds., *Wages for Housework: The New York Committee 1972–1977: History, Theory, Documents* (Brooklyn, NY: Autonomedia, 2017).

CHAPTER 1

1. League of Nations (LoN), *International Labour Conference: First Annual Meeting* (Washington, DC: GPO, 1920), 173.

2. Reiner Tosstorff, "The International Trade-Union Movement and the Founding of the International Labour Organization," *International Review of Social History*, 50 (2005): 399–433.

3. LoN, *First Annual Meeting*, 13.

4. Dorothy Sue Cobble, "The Other ILO Founders: 1919 and Its Legacies," in *Women's ILO: Transnational Networks, Global Labour Standards, and Gender Equity*, ed. Eileen Boris, Dorothy Hoehtker, and Susan Zimmermann (Leiden and Geneva: Brill and the ILO, 2018), 38.

5. I discuss Bouvier in "Sexual Divisions, Gender Constructions: The Historical Meaning of Homework in Western Europe and the United States," in *Homeworkers in Global Perspective: Invisible No More*, ed. Eileen Boris and Elisabeth Prügl (New York: Routledge, 1996), 19–37.

6. The analysis that follows comes from reading the 1919 proceedings of the ILC and the stenographic account of the International Congress of Working Women (ICWW). I am indebted to Cobble's insights in "The Other ILO Founders," 27–49; "A Higher 'Standard of Life' for the World: U.S. Labor Women's Reform Internationalism and the Legacies of 1919," *Journal of American History*, 100 (2014): 1052–1085; and "U.S. Labor Women's Internationalism in the World War I Era," *Revue Francaise d'Etudes Americaines*, 122 (2009): 44–57. See also, Lara Vapnek, "The 1919 International Congress of Working Women: Transnational Debates on the 'Woman Worker,'" *Journal of Women's History*, 26 (2014): 160–184. For Bondfield, see Ann Oakley, *Women, Peace and Welfare: A Suppressed History of Social Reform, 1880–1920* (Bristol, UK: Policy Press, 2018), 276–280.

7. Vapnek, "The 1919 International Congress of Working Women," 164.

8. Jesús Baigori-Jalón, "Conference Interpreting in the First International Labor Conference (Washington, DC, 1919)," *Meta*, L:3 (2005): 987–996.

9. Dorothy Sue Cobble introduced this term in *The Other Women's Movement: Workplace Justice and Social Rights in Modern America* (Princeton, NJ: Princeton University Press, 2004), 3–4.

10. "Stenographic Report of the ICWW, Opening Session, October 28," 2, IFWW Records, 1919–1923, Folder 3, Schlesinger Library (SL), Cambridge, MA; *Working*

Women and the World: A Review of the First International Congress of Working Women (New York: NWTULA, 1919), 3–4; Elizabeth Anne Payne, *Reform, Labor, and Feminism: Margaret Dreier Robins and the Women's Trade Union League* (Urbana: University of Illinois Press, 1988).

11. "Stenographic Report of the ICWW, Afternoon Session, November 5, 1919," 6, IFWW Records, Folder 3, SL.

12. Article 389 in International Labour Office, *The Labour Provisions of the Peace Treaties* (Geneva: ILO, 1920), 2.

13. The best account of the two 1919 conferences is Cobble, "The Other ILO Founders." For a less optimistic assessment, see Ulla Wikander, "Demands on the ILO by Internationally Organized Women in 1919," in *ILO Histories: Essays on the International Labour Organization and Its Impact on the World During the Twentieth Century*, ed. Jasmien Van Daele, Magaly Rodrígues García, Geert Van Goethem, and Marcel van der Linden (Bern: Peter Lang, 2010), 67–89. For nationalism vs. transnationalism, see Geert Van Goethem, "An International Experiment of Women Workers: The International Federation of Working Women, 1919–1924," *Revue belge de philology et d'histoire*, 84 (2006): 1025–1047; Leila J. Rupp, *Worlds of Women: The Making of an International Women's Movement* (Princeton, NJ: Princeton University Press, 1997), 208–229.

14. Paula J. Pfeffer, "'A Whisper in the Assembly of Nations': United States' Participation in the International Movement for Women's Rights from the League of Nations to the United Nations," *Women's Studies International Forum*, 8 (1985): 459–471; Carol Miller, "'Geneva—the Key to Equality:' Inter-war Feminists and the League of Nations," *Women's History Review*, 3 (1994): 218–245; Sandra Whitworth, *Feminism and International Relations* (London: Maclan Press, 1994); Nitza Berkovitch, *From Motherhood to Citizenship: Women's Rights and International Organizations* (Baltimore, MD: Johns Hopkins University Press, 1999); Paula Määttä, *The ILO Principle of Equal Pay and Its Implementation* (Tampere, Finland: University of Tampere, 2008); Nora Natchkova and Céline Schoeni, "The ILO, Feminists and Expert Networks: The Challenges of a Protective Policy, 1919–1934," in *Globalizing Social Rights: The International Labour Organization and Beyond*, ed. Sandrine Kott and Joëlle Droux (New York and Geneva: Palgrave and ILO, 2013), 49–64.

15. LoN, *First Annual Meeting*, 68.

16. Susan Pedersen, "Metaphors of the Schoolroom: Women Working the Mandates System of the League of Nations," *History Workshop Journal*, 66 (2008): 208.

17. I draw on Susan Zimmermann, "Night Work for White Women and Bonded Labour for 'Native' Women? Contentious Traditions and the Globalization of Gender-Specific Labour Protection and Legal Equality Politics, 1926 to 1939," in *New Perspectives on European Women's Legal History*, ed. Sara L. Kimble and Marion Röwekamp (New York: Routledge, 2017), 394–427, especially 418–420; "'Special Circumstances' in Geneva: The ILO and the World of Non-Metropolitan Labour

in the Interwar Years," in *ILO Histories*, 221–250; and "Globalizing Gendered Labour Policy: International Labour Standards and the Global South, 1919–1947," in *Women's ILO*, 227–254.

18. Marcel van der Linden, "The International Labor Organization, 1919–2019: An Appraisal," *Labor: Studies in Working Class History*, 16:2 (May 2019), 11–41.

19. ILO, "The International Protection of Women Workers," *Studies and Reports*, Series I, No.1 (Geneva: ILO, October 15, 1921), 1–4; Jasmien Van Daele, "Engineering Social Peace: Networks, Ideas, and the Founding of the International Labour Organization," *International Review of Social History*, 50 (2005): 435–466; Sandrine Kott, "From Transnational Reformist Network to International Organization: The International Association for Labour Legislation and the International Labour Organization, 1900–1930s," in *Shaping the Transnational Sphere: Experts, Networks and Issues from the 1840s to the 1930s*, ed. Davide Rodogno, Bernhard Struck, and Jakob Vogel (New York: Berghahn Books, 2015): 239–258.

20. Ulla Wikander, "Some 'Kept the Flag of Feminist Demands Waving': Debates at International Congresses on Protecting Workers," in *Protecting Women: Labor Legislation in Europe, the United States, and Australia, 1880–1920*, ed. Ulla Wikander, Alice Kessler-Harris, and Jane Lewis (Urbana: University of Illinois Press, 1995), 29–62.

21. Stephanie A. Limoncelli, *The Politics of Trafficking: The First International Movement to Combat the Sexual Exploitation of Women* (Stanford, CA: Stanford University Press, 1990).

22. One employer, a shipping magnate from the United States, briefly attended. Van Daele, "Engineering Social Peace," 454–455, with list of trade union principles, 442; US advisor James Shotwell from Columbia University both reconciled conflicting proposals and collected documents in *The Origins of the International Labor Organization*, 2 vols. (New York: Columbia University Press, 1934).

23. Markku Ruotsila, "'The Great Charter for the Liberty of the Workingman': Labour, Liberals and the Creation of the ILO," *Labour History Review*, 67 (2002): 29–47; Edward C. Lorenz, *Defining Global Justice: The History of U.S. International Labor Standards Policy* (Notre Dame, IN: Notre Dame University Press, 2001), 71–72; Elizabeth McKillen, "Beyond Gompers: The American Federation of Labor, the Creation of the ILO, and US Labor Dissent," in *ILO Histories*, 41–66.

24. "Introduction," Article 405, and Article 421, in *The Labour Provisions of the Peace Treaties*, n.p.–11.

25. Major disagreements were over double government representation, the binding nature of conventions, and the location of the first conference. See Van Daele, "Engineering Social Peace," 453–459.

26. Article 427 in *The Labour Provisions of the Peace Treaties*, 13–14.

27. Rupp, *Worlds of Women*, 15–34.

28. ILO, "The International Protection of Women Workers," 4–7; Arnold Whittick, *Woman into Citizen* (London: Francis and Company, Athenaeum Press, 1979),

70–71. Invited to Paris by the Union Française pour le Suffrage des Femmes, members of the IWSA from Allied nations, including Margery Corbett Ashby (who led the IWSA from 1923 to 1946), met with Gompers and the other commissioners.

29. Ruotsila, "'The Great Charter for the Liberty of the Workingman'"; Whittick, *Woman into Citizen*, 71–72.

30. During the LoN period, the Director-General went by the title Director. Gerry Rodgers, Eddy Lee, Lee Swepston, and Jasmien Van Daele, *The International Labour Organization and the Quest for Social Justice, 1919–2009* (Ithaca, NY, and Geneva: Cornell University Press and the ILO, 2009), 1–14.

31. In the 1950s, the Soviet Union would benefit from the presence of nominally separate countries like Belarus. For its relation to the ILO, see chapter 2.

32. McKillen, "Beyond Gompers."

33. These events appear throughout "Stenographic Report of the ICWW" in IFWW Records, Folder 3, SL.

34. The 1919 Congress on Working Women called for the ILO, as well as national and local labor bureaus, to establish women's departments headed by women. "Stenographic Report of the ICWW, Afternoon Meeting November 6," 34, IFWW Records, Folder 3, SL; LoN, *First Annual Meeting*, 50–51.

35. LoN, *First Annual Meeting*, 103.

36. LoN, *First Annual Meeting*, 106, 103.

37. "Stenographic Report of the ICWW, Evening Session, November 5," 12, IFWW Records, Folder 3, SL.

38. "Stenographic Report of the ICWW, October 30," 22, 32–33, IFWW Records, Folder 3, SL.

39. "Stenographic Report of the ICWW, Morning Session, October 31," 16–17, IFWW Records, Folder 3, SL.

40. "Stenographic Report of the ICWW, Morning Session, October 31," 63–65.

41. Dolores Hayden, *The Grand Domestic Revolution: A History of Feminist Designs for American Homes, Neighborhoods, and Cities* (Cambridge, MA: MIT Press, 1981).

42. "Stenographic Report of the ICWW, Morning Session, November 4," 26, 34, 42 and "Stenographic Report of the ICWW, Morning Session, November 5," 9, both in IFWW Records, Folder 3, SL; *Working Women and the World*, 3; Vapnek, "The 1919 International Congress of Working Women," 172.

43. "Press Notice: Why One Law for Men and Another for Women?" 9/12/38, National Woman's Party Records, Box IV:15, Folder 6, Manuscript Division, Library of Congress, Washington, DC.

44. Deborah Simonton, *A History of European Women's Work, 1790 to the Present* (New York: Routledge, 1998), 223.

45. "Stenographic Report of the ICWW, Afternoon Session, November 4," 35–37, IFWW Records, Folder 3, SL.

46. "Stenographic Report of the ICWW, Evening Session, November 5," 9–12.

47. "Stenographic Report of the ICWW, Evening Session, November 5," 175.

48. Cobble, "The Other ILO Founders."

49. ILO, "Conventions," http://www.ilo.org/dyn/normlex/en/f?p=1000:12000::: NO::: lists all ILO instruments. All quotations from conventions (and recommendations) come from this location.

50. ILO, "The International Protection of Women Workers," 9; Cobble, "The Other ILO Founders," provides the fullest account.

51. The ILC withdrew this Recommendation in 2004. For its text, go to https:// www.ilo.org/dyn/normlex/en/f?p=1000:12100:15130780191716::NO::P12100_ SHOW_TEXT:Y.

52. LoN, *First Annual Meeting*, 97.

53. LoN, *First Annual Meeting*, 60, 223.

54. IFWW, *Working Women in Many Countries: Report of Congress Held at Vienna, August 1923* (Amsterdam: IFTU, 1923), 10–11. The 1919 meeting generated this body, which became attached to the IFTU after 1923. See Vapnek, "The 1919 International Congress of Working Women," 174–175, Cobble, "A Higher 'Standard of Life,'" 1075–1079.

55. "Stenographic Report of the ICWW, Afternoon Session, November 5," 13, IFWW Records, Folder 3, SL; Eileen Boris, *Home to Work: Motherhood and the Politics of Industrial Homework in the United States* (New York: Cambridge University Press, 1994).

56. Minimum Wage-Fixing Machinery Convention, 1928 (No.26); Elisabeth Prügl, *The Global Construction of Gender: Home-Based Work in the Political Economy of the 20th Century* (New York: Columbia University Press), 40–48; Vivien Hart, *Bound by Our Constitution: Women, Workers, and the Minimum Wage* (Princeton, NJ: Princeton University Press, 1994).

57. LoN, *International Labour Conference*, Eleventh Session (Geneva: ILO, 1928), 98–100, 382, 384.

58. LoN, *First Annual Meeting*, 98–99.

59. See the list of 1919 Recommendations in Normlex.

60. LoN, *First Annual Meeting*, 103–104.

61. LoN, *First Annual Meeting*, 165, 167.

62. LoN, *First Annual Meeting*, 162.

63. LoN, *First Annual Meeting*, 159.

64. LoN, *First Annual Meeting*, 169.

65. LoN, *First Annual Meeting*, 93.

66. The Minimum Age (Industry) Convention (No. 5) and Night Work of Young Persons (Industry) Convention (No. 6). Compare with *Working Women and the World*, 3.

67. LoN, *First Annual Meeting*, 175. For earlier depictions, see Jennifer Morgan, "'Some Could Suckle over Their Shoulder': Male Travelers, Female Bodies, and the Gendering of Racial Ideology, 1500–1770," *William and Mary Quarterly*, 54 (1997): 167–192.

68. "Stenographic Report of the ICWW, October 28, 1919," 33–35. Denise Lynn, "The Women's Charter: American Communists and the Equal Rights Amendment Debate," *Women's History Review*, 23:5 (2014): 706–722.

69. Susan Zimmermann's papers on trade union women and their contributions are generative on this. For other accounts, see Vapnek, "The 1919 International Congress of Working Women"; Cobble, "A Higher 'Standard of Life.'"

70. Kathryn Kish Sklar, Anja Schüler, and Susan Strasser, *Social Justice Feminists in the United States and Germany: A Dialogue in Documents, 1885–1933* (Ithaca, NY: Cornell University Press, 1998).

71. LoN, ILC, *Report of the Director Presented to the Conference*, Tenth Session, 1927, Volume II (Geneva: ILO, 1927), 54.

72. Kirsten Scheiwe and Lucia Artner, "International Networking in the Interwar Years: Gertrud Hanna, Alice Salomon, and Erna Magnus," in *Women's ILO*, 75–96.

73. Wikander, "Debates at International Congresses," 34–35; Tosstorff, "The International Trade-Union Movement," 407–408; Alice Kessler-Harris, "Where Are the Organized Women Workers?" *Feminist Studies*, 3 (1975): 92–110.

74. "Stenographic Report of the ICWW, Evening Session, November 5," 3–4; Elaine Clark, "Catholics and the Campaign for Women's Suffrage in England," *Church History*, 73:3 (September 2004): 635–665.

75. Rupp, *Worlds of Women*, 140–144. See also Christine Bolt, *Sisterhood Questioned? Race, Class and Internationalism in the American and British Women's Movements* (New York: Routledge, 2004), 28–75; Johanna Alberti, *Beyond Suffrage: Feminists in War and Peace, 1914–28* (London: Macmillan, 1989), 205–210; Miller, "'Geneva—the Key to Equality'"; and Susan Zimmermann, "Equality of Women's Economic Status? A Major Bone of Contention in the International Gender Politics Emerging during the Interwar Period," *International History Review*, 41 (2017): 200–227, http://www.tandfonline.com/action/showCitFormats?doi=10.1080/07075332.2017.1395761.

76. Jane Randall, "Abbott, Wilhelmina Hay (Elizabeth)," in *The Biographical Dictionary of Scottish Women*, ed. Elizabeth Ewan, Sue Innes, and Siân Reynolds (Edinburgh: Edinburgh University Press: 2006), 3.

77. Rupp, *Worlds of Women*, 139–146; Jaci Leigh Eisenberg, "American Women and International Geneva, 1919–1939" (PhD diss., The Graduate Institute, Geneva, 2014), 116–221; Marilyn Lake, "From Self-Determination via Protection to Equality via Non-Discrimination: Defining Women's Rights at the League of Nations and the United Nations," in *Women's Rights and Human Rights: International Historical Perspectives*, ed. Patricia Grimshaw, Katie Holmes, and Marilyn Lake (New York: Palgrave, 2001), 254–271. There is no scholarly biography of Macmillan. See "Chrystal Macmillan," *First 100 Years*, https://first100years.org.uk/chrystal-macmillan/, accessed July 12, 2018; Helen Kay, "Fifteen Questions about Miss Chrystal Macmillan 1872–1937," February 2012, at http://www.sps.ed.ac.uk/__data/assets/pdf_file/0003/127866/Fifteen_questions_about_Chrystal_Macmillan_ILW.pdf, accessed July 12, 2018.

78. Harold Butler to Mary Anderson, 20 July 1927, WN 12/61/3/1.

79. The Open Door International, *Manifesto and Charter* (London: Open Door International, 1929), 4; "Policy of the Open Door Council with Respect to Pregnancy and the Other Incidents of Childbirth," WN 1000/7/0/2, Jacket 1, 03/1932.

80. Quote on World Woman's Party from Rupp, *Worlds of Women*, 141–142.

81. Katherine M. Marino, *Feminism for the Americas: The Making of an International Human Rights Movement* (Chapel Hill: University of North Carolina Press, 2019).

82. C24, C33, C35; See Normlex for provisions of these various instruments.

83. Carol Riegelman Lubin and Anne Winslow, *Social Justice for Women: The International Labor Organization and Women* (Durham, NC: Duke University Press, 1990), 32–50, 74; Françoise Thébaud, "What Is a Transnational Life? Some Thoughts about Marguerite Thibert's Career and Life (1886–1982)," in *Gender History in a Transnational Perspective: Networks, Biographies, Gender Orders*, ed. Oliver Janz and Daniel Schönpflug (New York: Berghahn Books, 2014), 162–183; Françoise Thébaud, "Réseaux réformateurs et politiques du travail feminine: L'OIT au prisme de la carrier et des engagements de Marguerite Thibert," in *L'Organisation international du travail: Origine—Développement—Avenir,* ed. Isabelle Lespinet-Moret and Vincent Viet (Rennes, France: Presses Universitaires de Rennes, 2011), 25–37; Françoise Thébaud, *Une traversée du siècle: Marguerite Thibert. Femme engagée et fonctionnaire internationale* (Paris: Belin, 2017).

84. Henri Fuss, "Unemployment and Employment among Women," *International Labour Review* 31:4 (1935): 463–497.

85. Françoise Thébaud, "Difficult Inroads, Unexpected Results: The Correspondence Committee on Women's Work in the 1930s," in *Women's ILO*, 50–74.

86. Statistic given in ILC, *Record of Proceedings*, Nineteenth Session (Geneva: ILO, 1935), 377.

87. Night Work (Women) Convention (Revised), 1934 (No. 41); Underground Work (Women) Convention, 1935 (No. 45).

88. For example, "Memorandum: The Present Position in Finland regarding Night Work," c. 1931, D601/2010/02/4/1.

89. Thébaud, "Difficult Inroads, Unexpected Results;" Eisenberg, "American Women and International Geneva"; Zimmermann, "Equality of Women's Economic Status?," underscores the maneuvers between LO and League committees that ended up separating civil and political equality from economic equality, setting the stage for the decline of women-specific protection and rise of equality standards.

90. "Open Door Council Proposed Revision of the Washington (1919) Night Work Convention, Memorandum from Open Door to Governing Body, January 1931, D601/2010/02/4/1; "Second Conference, Stockholm, August 1931: Resolutions Adopted," 8, WN 1000/7/0/2, Jacket 1, 03/1932.

91. ILO, *Minutes of the 64th Session of The Governing Body* (Geneva: ILO, October 1933), 333.

92. LoN, *International Labour Conference*, Fifteenth Session (Geneva: ILO, 1931), 325.

93. Labor feminist Hesselgren spoke in favor of exempting women managers during the 1931 ILC, while her Worker counterpart protested the change.

94. ILO, *Minutes of the 49th Session of The Governing Body* (Geneva: June 1930), 546–549, 599.

95. See various petitions and letters in D601/2010/02/4/1, including Open Door Resolutions, Rochdale and District Branch, December 1, 1930; Elizabeth Abbott, Memorandum to the Governing Body of the International Labour Organization.

96. Some ratifying governments had interpreted it that way: France, Germany, Italy, Belgium, India, and Rumania. See LoN, *Record of Proceedings*, Fifteenth Session, 344.

97. ILO, *Minutes of the 49th Session of the Governing Body*, 562.

98. "Night Work for Women," *The Vote*, December 9, 1932, 396; Reply draft to Florence Barry of the St. Joan's Alliance; Phelan to Barry, 12 November 1932; E. M. Kennedy and Caroline Haslett (The Women's Engineering Society) to H. B. Butler, 7 December 1932—all in D601/2010/02/4/1.

99. ILO, *Minutes of the 62th Session of The Governing Body* (Geneva: ILO, April 1933), 148–152.

100. LoN, *Record of Proceedings*, Fifteenth Session, 322–237, especially 324.

101. LoN, *Record of Proceedings* (ILC), Eighteenth Session (Geneva: ILO, 1934), 192–202, 318; "List of Members of Delegations," LoN, *Record of Proceedings* (ILC), Eighteenth Session, xiii–xxiii.

102. LoN, *International Labour Conference*, Fifteenth Session, 325, 328, 332, 474; "List of Members," XXIX-L.

103. Committee on the Employment of Women on Underground Work of All Kinds, "Second Sitting 7 June 1935," D619/100/1; "Draft Report," D619/10001/3 1935. See also "Appendix to the Grey Report: Information supplied by the Government of India," Appendix XI, IoN, *Record of Proceedings*, Eighteenth Session, 649.

104. Letter from Chrystal Macmillan and Winifred Le Sueur to the Governing Body, May 28, 1935, in ILO, Committee on the Employment of Women on Underground Work in Mines, 1–3, D619/1001/3 1935.

105. ILC, "The Promotion of Seamen's Welfare in Ports," Item 3 on the Agenda, First Discussion, Thirteenth Session (Geneva, 1929), 5.

106. LoN, *International Labour Conference*, Eighth Session, Vol. 1 (Geneva: ILO, 1926), 215. The best discussion of the Traffic Committee is Magaly Rodríquez García, "The League of Nations and the Moral Recruitment of Women," special issue, *International Review of Social History*, 57:S20 (2012): 97–128; see also Christina Schettini, "South American Tours: Work Relations in the Entertainment Market in South America," special issue, *International Review of Social History*, 57:S20 (2012): 129–160.

107. "Legislative Measures Adopted in Different Countries concerning Emigration in so far as they are connected with the Traffic in Women and Children," 2–3, Report of the ILO, December 1923, L/12/2/6/1 1923.

108. Eileen Boris and Heather Berg, "Protecting Virtue, Erasing Labor: Historical Responses to Trafficking," in *Human Trafficking Reconsidered: Migration and Forced Labor*, ed. Rhacel Parreñas and Kimberly Hoang (New York: IDEBATE Press, 2014), 19–29.

109. Jessica R. Pliley, "Claims to Protection: The Rise and Fall of Feminist Abolitionists in the League of Nations' Committee on the Traffic in Women and Children, 1919–1936," *Journal of Women's History*, 22 (2010): 90–113; Karen Offen, "Madame Ghénia Avril de Sainte-Croix, the Josephine Butler of France," *Women's History Review*, 17 (2008): 239–255.

110. To Mr. Tixter from GAJ, 13.5.1937, History, Minute, L10/5/1, 1939.

111. Don Pedro Sangro, in LoN, Advisory Commission for the Protection and Welfare of Children and Young People, Traffic in Women and Protection of Children Committee, Minutes of the Sixth Session, Geneva, 24 June 1927, 47, C. 338. M.113. 1927. IV, LoN Archives, Geneva.

112. Memo on International Emigration Commission, "Report on the Traffic in Women and Children," L/12/2/5 1921.

113. Representatives to the Traffic Committee can be traced in its annual reports, available at LoN Archives. Mundt went in 1932, Thibert represented the ILO after 1934.

114. Julia Laite, "Between Scylla and Charybdis: Women's Labour Migration and Sex Trafficking in the Early Twentieth Century," *International Review of Social History*, 62 (2017): 37–65.

115. ILO, *Minutes of 17th Session of the Governing Body* (Geneva: ILO, January–February 1923), 61. "Prevention of Prostitution: A Study of Preventive Measures, Especially Those Which Affect Minors," 45–70, Draft Report, LoN, Advisory Committee on Social Questions, Geneva, May 15, 1939, C.Q.S./A./19 (a), LoN Archives. On explaining the ILO's process, Mr. Ferenczi, LoN, Advisory Committee on the Traffic on Women and Protection of Children, Minutes of the Fourth Session, Geneva, July 17, 1925, 25, C. 382. M126. 1925. IV, LoN Archives.

116. Albert Thomas to The Secretary, The Association for Moral & Social Hygiene, 9 April 1921, draft of same reply, both in D 280/7, 1921.

117. "Legislative Measures Adopted in Different Countries," 2–3; The Emigration Commission of the International Labour Organization, Resolutions, 1922, L 12/5 1925; LoN, *International Labour Conference*, Fourth Session (Geneva: ILO, 1922), 236–241, 599. Luisi was a major suffragist, founder of the Uruguayan Women's National Council, and delegate to the Women's Suffrage Alliance, *International Labour Conference*, Fourth Session, xlviii. For Bondfield's speaking for women's organizations, see *International Labour Conference*, Eighth Session, 215.

118. Minutes, Committee on Simplification, 8th Session, 1926, 5th Sitting, May 31, 22–23, D 608/500/1/2.

119. Report by M. Ferenczi, 8–9; "Emigration: Report of the Sub-Committee," 24–25, both in LoN, Advisory Committee, Minutes of the Fourth Session, Geneva.

120. Minutes, Committee on Simplification, 8th Session, 1926, 5th Sitting, May 31, 20, 22, D 608/500/1/2.

121. Miss Bondfield, "Report of the Committee on Simplification of the Inspection of Emigrants on Board Ship," in LoN, *International Labour Conference*, Eighth Session, 215, 385.

122. "Immigration," Traffic Committee, Minutes of the Sixth Session, (Geneva: 1927), 28, C.338.M.113.1927.IV, LoN Archives.

123. Unemployment Indemnity (Shipwreck) Convention, 1920 (No. 8); Placing of Seamen Convention, 1920 (No. 9); Holidays with Pay (Sea) Convention, 1936 (No. 54). There were twelve additional maritime conventions in the 1940s, two in the 1950s, six in the 1970s, four in the 1980s, and two in the 1990s, many of which revised earlier ones.

124. Minimum Age (Sea) Convention, 1920 (No. 7) and its revision in 1936 (No. 58); Medical Examination of Young Persons (Sea) Convention, 1921 (No. 16).

125. Seamen's Articles of Agreement Convention, 1926 (No. 23); Repatriation of Seamen Convention, 1925 (No. 23).

126. Sickness Insurance (Sea) Convention, 1936 (No. 56).

127. The very silence in ILO discussions about same-sex acts or homosexuality may cover uneasiness among the male delegates considering the labor of seamen. It is worth further exploration.

128. "Report submitted to the Joint Maritime Commission," LoN, *International Labour Conference*, Ninth Session (Geneva: ILO, 1926), Appendix, 495; Mr. Salvesen, 358.

129. "Report submitted to the Joint Maritime Commission," 476–478.

130. "Report submitted to the Joint Maritime Commission," 479–480; ILC, *The Promotion of Seamen's Welfare in Port*, First Discussion, Item III on Agenda, Thirteenth Session (Geneva: ILO, 1929), 5–7.

131. "Report submitted to the Joint Maritime Commission," 479.

132. Judith Walkowitz, *Prostitution and Victorian Society: Women, Class, and the State* (New York: Cambridge University Press, 1980); Anne Summers, "Which Women? What Europe? Josephine Butler and the International Abolitionist Federation," *History Workshop Journal*, 62 (2006): 214–231.

133. Of 47 nations replying to a Traffic Committee questionnaire, only 19 regulated brothels. *The Promotion of Seamen's Welfare in Port*, First Discussion, 28–29; G. A. Johnson, "Report on the Meeting of the Traffic in Women and Children Committee," Geneva, April 19–26, 1929, 30.4.29, 3–4, Minutes, L 12/7/8 1929.

134. Laura Hyun Yi Kang, "Surveillance and the Work of Antitrafficking: From Compulsory Examination to International Coordination," in *Feminist*

Surveillance Studies, ed. Rachel E. Dubrofsky and Shoshana Amielle Magnet (Durham, NC: Duke University Press, 2015), 38–57.

135. Rodríquez García, "The League of Nations and the Moral Recruitment of Women," 106–109.

136. LoN, Advisory Commission for the Protection and Welfare of Women and Children, Traffic in Women and Children Committee, Minutes of the Eighth Session, August 1, 1929, 33–46, C. 294. M97. 1929. IV, LoN Archives.

137. LoN, Traffic Committee, Minutes of the Eighth Session, 50; Medical Women's Federation and other letters to the ILO in D 613/800/3 1929; *The Promotion of Seamen's Welfare in Port*, First Discussion, 30.

138. The Traffic Committee considered its intervention "timely." See LoN, Advisory Commission for the Protection and Welfare of Children and Young People, Traffic in Women and Children Committee, Minutes of the Ninth Session, July 20, 1930, 3–5, C. 246. M.121. 1930. IV.

139. Mr. Salvesen, Minutes, Committee on Seamen's Welfare in Ports, Minutes, 4th Sitting, October 16, 1929, 6, D 612/800/3 1929. See also, LoN, Traffic Committee, Minutes of the Eighth Session, 48, 51, 53; *The Promotion of Seamen's Welfare in Port*, First Discussion, 29–32; Committee on Seamen's Welfare, Draft Conclusions, D 613/800/3 1929; LoN, *International Labour Conference,* Thirteenth Session, 1929 (Geneva: ILO, 1929), 414.

140. Mr. Aftab Ali, Minutes of the Sub-Committee, Second Meeting, October 8, 1936, 3, D 621/1000/1 1936.

141. Magaly Rodríguez García, "The ILO and the Oldest Non-profession," in *The Lifework of a Labor Historian: Essays in Honor of Marcel van der Linden,* ed. Ulbe Bosma and Karin Hofmeester (Leiden: Brill, 2018), 90–114.

142. Mr. Cuthbert Laws, LoN, *International Labour Conference*, Ninth Session, 1926 (Geneva: ILO, 1926), 353.

143. Committee on the Protection of Seamen's Welfare in Ports, ILO, 21st Session, October 9, 1936, III-6-7, D621/1000/1 1936.

144. See letters to the President of the Thirteenth Session of the ILC, from Belgian Association for Women's Enfranchisement, 30 September 1929; from The Open Door International, September 20, 1929; letter to the Director, International Labour Office from International Alliance of Women, 9 October 1929—all in D613/800/13 1929.

145. See letters in D613/800/13 1929; LoN, *International Labour* Conference, Thirteenth Session, 106; ILC, *Promotion of Seamen's Welfare in Ports*, Second Discussion, Report III (Geneva: ILO, 1931), 115.

146. ODI, *Report of the Second Conference* (London and Geneva: ODI, 1931), 10.

147. Mr. Ramsay, Committee on the Protection of Seamen's Welfare in Ports, ILO, 21st Session, 6th Sitting, October 18, 1929, 4.

148. Open Door International, "Call to the Sixth Conference," 2, WN 1/017, Jacket 1, 5/1947–5/1947.

149. "Memo to Director" from Thibert, WN 1000/7/1, Jacket 1, 04/1929–11/1929.

150. Zimmerman, "Night Work for White Women;" Susan Zimmermann, "The International Labour Organization, Transnational Women's Networks, and the Question of Unpaid Work in the Interwar World," in *Women Transnational History: Connecting the Local and the Global,* ed. Clare Midgley, Alison Twells, and Julie Carlier (New York: Routledge, 2016), 33–53.

151. ILO, *Forced Labour,* Questionnaire I (Geneva: ILO, 1929), 4–6; Daniel Maul, *Human Rights, Development and Decolonization: The International Labour Organization, 1940–70* (London and Geneva; Palgrave and the ILO, 2012), 17–27.

152. LoN, *International Labour Conference,* Tenth Session, 1927 (Geneva: ILO, 1927), 160.

153. LoN, *International Labour Conference,* Tenth Session, 410.

154. LoN, *International Labour Conference,* Twelfth Session (Geneva: ILO, 1929), 5, 44, 45–46, 410.

155. ILO, *Forced Labour: Report and Draft Questionnaire,* First Discussion (Geneva: ILO, 1929), 23ff, 228–229.

156. LoN, *International Labour Conference,* Twelfth Session, 50, 72.

157. International Council of Women, the World's YWCA, the International Alliance of Women for Suffrage and Equal Citizenship, the World YWCA, the WILPF, and the World Union of Women for International Concord signed a "Memorandum," May 14, 1927, in ILO, *Forced Labour: Report and Draft Questionnaire,* 313–314.

158. "Forced Labour," *Monthly News Sheet,* XVIII:4 (March 1927): 3, WN 1000/6/10, Jacket 1, 0/2/1927–04/1927.

159. "Memorandum," 313.

160. "Memorandum," 313.

161. LoN, *International Labour Conference,* Tenth Session, 58.

162. Forced Labour Convention, 1930 (No. 29). The general terms of "Abolition of Forced Labor" Convention, 1957 (No. 105) pertained as much to Cold War politics, in which the US attacked Soviet gulags, as to unfree labor in the Global South, but would offer a tool for future campaigns against forced labor of all kinds: https://www.ilo.org/dyn/normlex/en/f?p=NORMLEXPUB:12100:0::NO:12100:P12100_INSTRUMENT_ID:312250:NO.

163. E. Unwin, "The Slavery Convention, and the Forthcoming Meeting of the I.L.O. on Forced Labour," *Monthly News Sheet,* XVIII:3 (February 1927): 3; letter from Kathleen E. Inness to Mr. Grimshaw, 8 March 1927, both in WN 1000/6/10, Jacket 1, 0/2/1927–04/1927.

164. "Memorandum on Forced Labour By a Council of British Women's Organisations," in *Forced Labour: Report and Draft Questionnaire,* 317.

165. Zimmermann, "Night Work for White Women," 413. See *The Open Door* 4 (1930): 15–16.

166. Zimmermann, "Night Work for White Women"; Eisenberg, "American Women and International Geneva," 181–209. See Equal Rights International, Minutes,

June 5, 1939, 1, The Records of the National Woman's Party, Group II, Box 67, Folder, 15, Library of Congress.

167. ILC, *Record of Proceedings*, Twenty-Fourth Session, 1938 (Geneva: ILO, 1938), 534; Alice Paul, "Safeguarding Interests of American Women," *Equal Rights*, July 1, 1938, 238; "Why Women Oppose New I.L.O. Convention, *Equal Rights*, August 1, 1938, 301 prints letter of Women's Organizations, May 13, 1938.

168. Letter from Anne Protheroe Jones, Open Door Council, to The Director, April 21, 1939, WN 1000/7/0/3, Jacket 1, 04/1939.

169. "Urge United State Disapproval of I.L.O. Proposals," *Equal Rights*, December 15, 1938, 379; "Indigenous Women," *Equal Rights*, January 1, 1939, 1; Helen Robbins Bittermann to Frances Perkins, November 19, 1938; Perkins to Bittermann, December 22, 1938, both in US Women's Bureau, International Division, General Records: ILO, 1936–1939, Box 10, Folder "1938," RG86, National Archives and Records Administration (NARA), College Park, Maryland.

170. "Widespread Support for Capper Resolution," *Equal Rights*, March 15, 1939, 45; S.RES.82, US Women's Bureau, International Division, General Records: ILO, 1936–1939, Box 11, Folder "1939," RG86, NARA; Homer Socolofsky, *Arthur Capper: Publisher, Politician, and Philanthropist* (Lawrence: University of Kansas Press, 1962). Eisenberg credits Capper and Paul for withdrawal of this proposal, "American Women and International Geneva," 193–209.

171. Frances Perkins to Arthur Capper, March 7, 1939; Note I and Note 2 sent to Frieda Miller from Alice Cheyney, n.d.; Confidential Memo from Gambs to Lubin, February 22, 1939—all in US Women's Bureau, International Division, General Records: ILO, 1936–1939, Box 11, Folder "1939," RG86, NARA.

172. "Victory Scored Against I.L.O. Treaty Proposal," *Equal Rights*, April 15, 1939, 59.

173. C064, "Contracts of Employment (Indigenous Workers) Convention, 1939, https://www.ilo.org/dyn/normlex/en/f?p=1000:12100:3032268903901::NO::P12100_SHOW_TEXT:Y. The ILC in 2018 abrogated this convention.

CHAPTER 2

1. Katherine to Bertha, 27 January 1944, BR ANRIO Qo.ADM, EVE.CNFTXT 24. Vol. 1, Fundo Federação Brasileira pelo Progresso Feminino, Arquivo Nacional, Rio de Janeiro, Brazil; Letter from Bertha to Mrs. Catt, April 10, 1944, Br.MN.BLO.DP.COR.77.3, Fundo Bertha Lutz, Museu Nacional, Rio de Janeiro, Brazil. See Katherine M. Marino, "Transnational Pan-American Feminism: The Friendship of Bertha Lutz and Mary Wilhelmine Williams, 1926–1944," *Journal of Women's History*, 26:2 (2014): 63–87.

2. Bertha to Marjorie and Katherine, May 18, 1944, BR ANRIO Qo.ADM, EVE. CNFTXT 24. Vol. 1.

3. US Department of Labor, copy of Resolution, along with form letter from Mary Anderson, August 1937, US Women's Bureau, International Division, General

Records, 1919–1938, Folder "ILO 1937," Box 10, RG86, National Archives and Records Administration (NARA), College Park, Maryland.

4. Denise Lynn, "The Women's Charter: American Communists and the Equal Rights Amendment Debate," *Women's History Review*, 23:5 (2014): 706–722; Carol Miller, "'Geneva—the Key to Equality': Inter-war Feminists and the League of Nations," *Women's History Review*, 3:2 (1994): 219–245; Sandra Whitworth, "Gender, and International Relations and the Case of the ILO," *Review of International Studies*, 20 (1994): 389–405.

5. Sandrine Kott, "Cold War Internationalism," in *Internationalisms: A Twentieth-Century History*, ed. Glenda Sluga and Patricia Clavin (New York: Cambridge University Press, 2016), 340–362.

6. Marieke Louis, "Women's Representation at the ILO: A Hundred Years of Marginalization," in *Women's ILO: Transnational Networks, Global Labour Standards, and Gender Equity, 1919–2019*, ed. Eileen Boris, Dorothy Hoehtker, and Susan Zimmermann (Leiden and Geneva: Brill and the ILO, 2018), 202–224; Ethel M. Johnson, *Women and the International Labour Organization, 1919–1945*, Report No. 148, 5 February 1946, Library of Congress, Washington, DC.

7. Frederick W. Carr, "Women See Gains from I.L.O. Conference," *Christian Science Monitor*, May19, 1944, 8.

8. See Article 41 of ILO Constitution.

9. Open Door International, *Report of the Conference*, Berlin, June 15–16, 1929 (London: Open Door International, 1929): 19–20; Dorothy Sue Cobble, *The Other Woman's Movement: Workplace Justice and Social Rights in Modern America* (Princeton, NJ: Princeton University Press, 2004).

10. Here I extend Guy Standing, whose notice of this change fails to account for its gendered meaning. See "The ILO: An Agency for Globalization?," *Development and Change*, 39:3 (2008): 355–384.

11. ILO, *The ILO and Women* (Geneva: ILO, 1969), 23.

12. Eloisa Betti, "Unexpected Alliances: Italian Women's Struggles for Equal Pay, 1940s–1960s," in *Women's ILO*, 276–299; Eileen Boris and Jill Jensen, "The Transnational Origins of Equal Pay," unpublished paper given at LAWCHA, New York City, 2013.

13. Daniel Maul, *Human Rights, Development and Decolonization: The International Labour Organization, 1940–70* (London and Geneva: Palgrave Macmillan and ILO, 2012).

14. Susan Zimmerman, "Night Work for White Women and Bonded Labour for 'Native' Women? Contentious Traditions and the Globalization of Gender-Specific Labour Protection and Legal Equality Politics, 1926 to 1939," in *New Perspectives on European Women's Legal History*, ed. Sara L. Kimble and Marion Röwekamp (New York: Routledge, 2017), 394–427.

15. "Report of ILO-Current Activities and Plans," Spring 1952, in WN 1-1-61, Jacket 1.

16. ILO, Social Security (Minimum Standards) Convention, 1952 (No. 102), http://www.ilo.org/dyn/normlex/en/f?p=NORMLEXPUB:12100:0:: NO:12100:P12100_INSTRUMENT_ID:312247:NO.

17. "Resolution concerning Women's Work," adopted 8 July 1947, in ILC, *Record of Proceedings*, Thirtieth Session, 1947 (Geneva: ILO, 1948), 591–592.

18. "ILO Declaration of Philadelphia," at http://blue.lim.ilo.org/cariblex/pdfs/ILO_ dec_philadelphia.pdf.

19. Committee on Employment, CE/PV3, 26th Session, Philadelphia 1944, May 4, IX/4, ILC 26-700-2, Jacket 1, 04/1944–0/5/1944.

20. ILC, *Record of Proceedings*, Twenty-Sixth Session, Philadelphia, 1944 (Montreal: ILO, 1944), 352.

21. Kathi Weeks, *The Problem with Work: Feminism, Marxism, Antiwork Politics, and Postwork Imaginaries* (Durham, NC: Duke University Press, 2011).

22. Draft of Office Report III, "Organization of Employment in the Transition from War to Peace," Chapter IX, 1, 3, ILC 26-100-3, Jacket 1, 2/1944–5/1944.

23. Draft of Office Report III, "Organization of Employment in the Transition from War to Peace," 5–7.

24. Lenore Cotheart, "Citizens of the World: Jessie Street and International Feminism," *Hecate* 3:1 (2005): 182–194; Francesca de Haan, "Eugénie Cotton, Pak Chong-ae, and Claudia Jones: Rethinking Transnational Feminism and International Politics," *Journal of Women's History*, 25:4 (Winter 2013): 174–189.

25. Carolyn M. Stephenson, "Women's International Nongovernmental Organizations at the United Nations," in *Women, Politics, and the United Nations*, ed. Anne Winslow (Westport, CT: Greenwood Press, 1995), 137.

26. "Committee on the ILO Conventions Concerning Women's Work Submitted by the Representative from Australia"; CSW, Second Session, "Draft Resolution," both in ESC 1004/11/2, Jacket 1.

27. Draft of Office Report III, "Organization of Employment in the Transition from War to Peace," 7–8; "Consultation on the Post-War Employment of Women," 2, WN 1001/04 01/1946–04/1948.

28. Discussion of Paragraph 5, "Report of the Committee on Employment," 355.

29. Draft of Office Report III, "Organization of Employment in the Transition from War to Peace," 3.

30. Committee on Employment, IX/3; "Report of the Committee on Employment," 366–367.

31. Committee on Employment, IX/3.

32. ILC, *Record of Proceedings*, Twenty-Sixth Session, 248.

33. Committee on Employment, IX/3–4.

34. Committee on Employment, IX/3.

35. "Mess by USA War Dept to Europe written by B. Lutz," BR ANRIO Qo.ADM, EVE.CNFTXT 24. Vol. 1.

36. ILC, *Record of Proceedings*, Twenty-Sixth Session, 485.

37. ILC, *Record of Proceedings*, Twenty-Sixth Session, 484–485. The literature on Western feminism as savior is large. For one summary, see Jawad Syed and Faiza Ali, "'The White Woman's Burden': From Colonial Civilization to Third World Development," *Third World Quarterly*, 32:2 (2011): 349–365; Megan Threlkeld, *Pan American Women: U.S. Internationalists and Revolutionary Mexico* (Philadelphia: University of Pennsylvania Press, 2014).

38. ILC, *Record of Proceedings*, Twenty-Sixth Session, 237.

39. "New Article to follow Article 22," CDT/D56, ILC 26-800-1, Jacket 1, 4/1944–5/1945; ILC, *Record of Proceedings*, Twenty-Sixth Session, 485–487.

40. ILC, *Record of Proceedings*, Twenty-Sixth Session, 485–487; Article 29 Amendment by Miss Lutz, CDT/D 79, ILC 26-800-1, Jacket 1, 4/1944–5/1945.

41. ILC, *Record of Proceedings*, Twenty-Sixth Session, 485.

42. Bertha to Marjorie and Katherine, May 18, 1944.

43. Bertha to Marjorie and Katherine, May 18, 1944; Bertha Lutz to F.A. Berry, November 7, 1944, Q0.ADM.COR.A944.13, 19, Fundo Bertha Lutz.

44. Bertha Lutz to F. A. Berry, November 7, 1944.

45. ILC, *Record of Proceedings*, Twenty-Sixth Session, 378.

46. ILC, *Record of Proceedings*, Twenty-Sixth Session, 488.

47. ILC, *Record of Proceedings*, Twenty-Seventh Session, Paris, 1945 (Geneva: ILO, 1946), 411.

48. Indonesia and Dutch colonies responses to "Questionnaire: Minimum Standards of Social Policy in Dependent Territories (Supplementary Provisions)," C.1501./55/35.C in ILC 27-415-F-V, Jacket 1, 11/1944–10/1945.

49. Great Britain, response to "Questionnaire: Minimum Standards of Social Policy in Dependent Territories."

50. Committee on Social Policy in Dependent Territories, CDT/PV20.9.5.1944, Minutes, May 3, Session XI, 3; May 2, Session X, 2.

51. French reply, English translation by Office, "Note on the Questionnaire on Minimum Standards of Social Policy in Dependent Territories (Supplementary Provisions) submitted by the International Labour Office," 1, ILC 27-415-1-E, Jacket 1, 11/1944–10/1945.

52. Dutch Guyana reply to Office Questionnaire, ILC 27-415-1-E, Jacket 1, 11/1944–10/1945.

53. Rhodesia, response to "Questionnaire: Minimum Standards of Social Policy in Dependent Territories (Supplementary Provisions)."

54. French reply, English translation by Office, 2–3.

55. Amy L. Sayward, *The United Nations in International History* (New York: Bloomsbury, 2017).

56. ILC, *Record of Proceedings*, Thirtieth Session, 445–446.

57. Committee on Social Policy in Non-Metropolitan Territories, "Proposed Convention No. I," communications, XXX/CNT/D.105, in ILC 30-503-1, Jacket 2, 6/47.

58. "Confidential: Notes Re Proposed ILO Social Policy for Non-Metropolitan Territories," Revised 5.21/47, 1; M. I. Corbett Ashby and Katherine Bompas to Chairman, Trusteeship Council, UN, 10 March 1947, both in US Women's Bureau, Office of the Director, General Correspondence, 1948–1953, Box 66, Folder, "6-2-5-1 Non-Metropolitan Territories," RG86, NARA.

59. The comparison with racialized men was not always invidious. ODI commented before the Philadelphia ILC that any discrimination on the basis of race, color, and religion, as well as sex, stymied human freedom. See Eva Hartree and Elizabeth Abbott to Chairman, ILC, 24 April 1944, ILC 26-104-1, Jacket 1, 04/1944.

60. All in Committee on Social Policy in Non-Metropolitan Territories, "Proposed Convention No. I," communications.

61. Confidential, "Proposed ILO Social Policy Convention for Non-Metropolitan Territories, Parts IV and VI, to strengthen guarantees against unfair discrimination based on sex," May 15, 1947, 3, US Women's Bureau, Office of the Director, General Correspondence, Women's Bureau, 1948–1953, Box 66, Folder "6-2-5-1 Non-Metropolitan Territories," RG86, NARA.

62. For example, Response from Union of South Africa, "Questionnaire: Minimum Standards of Social Policy in Dependent Territories (Supplementary Provisions)," in ILC 27-415-1-E, Jacket 1, 11/1944–10/1945.

63. See exchange, "Committee on Social Policy in Dependent Territories, 11th Session, 2 July 1947, XI/3-XI/4, ILC 30-503-2, Jacket 2, 06/1947. The ILC "suspended" South Africa in 1964, twenty years after its turn to apartheid. South Africa withdrew in response. It rejoined in 1994. See https://www.sahistory.org.za/dated-event/sa-withdraws-international-labour-organisation; https://www.ilo.org/dyn/normlex/en/f?p=NORMLEXPUB:11110:0::NO::P11110_COUNTRY_ID:102888, accessed August 25, 2018.

64. Confidential, "Proposed ILO Social Policy Convention for Non-Metropolitan Territories, Parts IV and VI," 3; "Confidential: Notes Re Proposed ILO Social Policy for Non-Metropolitan Territories."

65. ILC, Thirtieth Session, "Committee on Social Policy in Non-Metropolitan Territories," Tenth Sitting, 1 July 1947, X/3-X/6, ILC 30-503-2, Jacket 1, 06/47.

66. ILC, *Record of Proceedings*, Thirtieth Session, "Committee on Social Policy in Non-Metropolitan Territories," Tenth, Eleventh, and Twelfth Sessions, passim.

67. ILC, *Record of Proceedings*, Thirtieth Session, 453.

68. Restricted, "Background Paper on Changes Made by the ILO Conference of June 1947 in Proposed Convention Re Social Policy in Non-Metropolitan Territories," January 6, 1948, in US Women's Bureau, International Division: General Records 1919–1952, International Work File, 1945–1956, Box 12, Folder "CJ-2-5-1, 2nd Session," RG86, NARA.

69. ILC, *Record of Proceedings*, Thirtieth Session, 259, 445, 238–239.

70. *The Law and Women's Work: A Contribution to the Study of the Status of Women* (Geneva: ILO, 1939).

71. M. T., "Remarks on the Equal Rights Amendment," US Women's Bureau, International Division: General Records 1919–1952, Box 12, Folder "1946 ILO," RG86, NARA.

72. Frieda Miller to Marguerite Thibert, November 22, 1946, in US Women's Bureau, International Division: General Records 1919–1952, Box 12, Folder "1946 ILO," RG86, NARA.

73. The best account of Miller remains Annelise Orleck, *Common Sense and a Little Fire: Women and Working-Class Politics in the United States, 1900–1965* (Chapel Hill: University of North Carolina Press, 1995).

74. Jill Jensen, "US New Deal Social Policy Experts and the ILO, 1948–1954," in *Globalizing Social Rights: The International Labour Organization and Beyond*, ed. Sandrine Kott and Joëlle Droux (New York and Geneva: Palgrave and ILO, 2013), 172–189.

75. Landon R. Y. Storrs, *The Second Red Scare and the Unmaking of the New Deal Left* (Princeton, NJ: Princeton University Press, 2013), 1, 88, 105, 205, 229, 228, 233, 278, 279, 324. See her personnel file in ILOA.

76. Dorothy Sue Cobble, *The Other Woman's Movement: Workplace Justice and Social Rights in Modern America* (Princeton: Princeton University Press, 2004), 27–29, 52–67, 105–107.

77. "Mildred Woodbury, Teacher and Labor Economist, Dies," *New York Times*, February 12, 1975. Ruth Fairbanks gives the most complete portrait in "A Pregnancy Test: Women Workers and the Hybrid American Welfare State, 1940–1993" (PhD diss., University of Illinois Urbana-Champaign, 2015), 171–194. See also her personnel file at ILOA, and Storrs, *The Second Red Scare*, 369.

78. Daniel R. Maul, "The 'Morse Years': The ILO 1948–1970," in *ILO Histories: Essays on the International Labour Organization and Its Impact on the World During the Twentieth Century*, ed. Jasmien Van Daele, Magly Rodrígues García, Geert Van Goethem, and Marcel van der Linden (Bern: Peter Lang, 2010), 365–400.

79. Frieda to Mildred, February 4, 1949, WN 1-1-61, Jacket 1.

80. Frieda to Mildred, May 21, 1947, WN 1-1-61, Jacket 1.

81. Frieda to Mildred, May 22, 1947; Frieda to Mildred, June 4, 1947, WN 1-1-61, Jacket 1.

82. Mildred to Frieda, 29 V (May?). 1948, and additional correspondence in WN 1-1-61, Jacket 1.

83. I discuss Beyer in *Home to Work: Motherhood and the Politics of Industrial Homework in the United States* (New York: Cambridge University Press, 1994), chapters 7–9..

84. ILC, *Record of Proceedings*, Twenty-Sixth Session, 241; ILC, *Record of Proceedings*, Thirty-Second Session, 1949 (Geneva, ILO, 1951), 1949, 581.

85. See Committee Proceedings in ILC 31-501-01, especially Third Meeting, June 22, 1948, afternoon, 1–2.

86. Fourth Session, 24 June, afternoon, 1–3, ILC 31-501-01.

87. ILC, *Record of Proceedings*, Thirty-First Session, San Francisco, 1948 (Geneva: ILO, 1950), 218–219.

88. Night Work (Women) Convention (Revised), 1948 (No.89); ILC, *Record of Proceedings*, Thirty-First Session, x.

89. Dr. R. A. Métall to Mildred Fairchild, February 8, 1950 and March 10, 1950; Fairchild to Chief of the International Organisations Section, New York, February 8, 1940, on "Women's Work in the Home"; A. A. Evans To Economic Advisor, Chief of the Women's and Children's Section, Reference, "Economic Value of the Woman's Work in the Home," August 5, 1949—all in LO 1-12, Jacket 1, 03/1950–03/1964.

90. Frieda Miller to Mildred, December 29, 1949, WN 1-1-61, Jacket 1.

91. Bryce Covet, "Putting a Price Tag on Unpaid Housework," *Fortune*, May 30, 2012, http://www.forbes.com/sites/brycecovert/2012/05/30/putting-a-price-tag-on-unpaid-housework/; Marilyn Waring, *If Women Counted: A New Feminist Economics* (New York: Harper & Row, 1988).

92. R. A. Métall to Mildred Fairchild, February 8, 1950 and March 10, 1950; Fairchild to Chief of the International Organisations Section, New York, February 8, 1940, on "Women's Work in the Home," LO 1-12, Jacket 1.

93. ECOSOC, Report on the Third Session of the CSW, Beirut, Lebanon, March 21 to April 4, 1949, E/1316, E/CN.6/124, April 19, 1949, "Equal Pay for Equal Work," 17–18.

94. Elizabeth Johnstone, "Women in Economic Life: Rights and Opportunities," *The Annals*, 375 (January 1968): 103.

95. ILO, Thirty-Fifth Session, Revision of the Maternity Protection Convention, 1919 (No. 3) (Geneva: ILO Office, 1952), 4.

96. Revision of the Maternity Protection Convention, 1919, 5–11; "Maternity Protection of Employed Women," *Women's Bureau Bulletin* 240 (Washington: GPO, 1952), 43–44; Social Security Administration, Bureau of Research and Statistics, Division of Coordination Studies, "Social Security Programs in Costa Rica et al," May 5, 1947, 1, 3, 5; Karin A. Rosenblatt, *Gendered Compromises: Political Cultures and The State in Chile, 1920–1950* (Chapel Hill: University of North Carolina Press, 2000), 81–2.

97. Revision of the Maternity Protection Convention, 1919, 5–11; "Maternity Protection of Employed Women," 43–44; Susie S. Porter, *Working Women in Mexico City: Public Discourses and Material Conditions, 1879–1931* (Tucson: University of Arizona Press, 2003), 176–177, 183.

98. Memo to. Edward B. Persons from Frieda Miller, Nov. 10, 1950, Folder, 6-2-7-3 (2); US Department of Labor, "Observations of the United States Government with Respect to Revision of Convention No. 3 Concerning the Employment of Women before and After Childbirth," November 1950, Folder 6-2-9-3, both in US Women's Bureau, Office of Director, General Correspondence, 1948-63, Box 67, RG86, NARA.

99. Persons from Miller, Nov. 10, 1950, 2.

100. ILC, *Record of Proceedings*, Thirty-Fifth Session, Geneva, 1952 (Geneva: ILO, 1953), 343.

101. Memo to Edward B. Persons, from Frieda S. Miller, WB, October 30, 1952, 1, US Women's Bureau, Office of Director, General Correspondence, 1948-63, Box 67, Folder 6-2-9-3, RG86, NARA; "Observations of the United States Government with Respect to Revision of Convention No. 3," 4; International Labour Conference (ILC), "Revision of the Maternity Protection Convention, 1919 (No. 3)," *Report VII* (Geneva: International Labour Office, 1952), 14; ILC, "Committee on Maternity Protection," June 1952, 3–4, 5, 13, ILC 35-510-7 Committee on Maternity Protection Reports (Signed); Mora comment, III/2, V/6; Miller comment, VII/2; Twelfth Sitting discussion, XII/6–9, XIII/1–4, in ILO, 35th Session, Committee on Maternity, June 1952, ILC 35-510-4.

102. Persons from Miller, October 30, 1952, 4–5.

103. ILC, "Revision of the Maternity Protection Convention, 1919 (No. 3)," 34.

104. Comment of M. Budiner to Miss Fairchild, 27.9.52, Minute Sheet, 5, WN 5–62/ 5–3.

105. Jane Lewis, *Women in Britain since 1945* (Oxford: Blackwell, 1993); Robert G. Moeller, *Protecting Motherhood: Women and the Family in the Politics of Postwar West Germany* (Berkeley: University of California Press, 1993); Malgorzata Fidelis, *Women, Communism, and Industrialization in Postwar Poland* (New York: Cambridge University Press, 2010).

106. Revision of the Maternity Protection Convention, 1919, 12–40; *Maternity Protection* (Geneva: ILO, 1965), Extract from the Report of the 35th (1965) Session of the Committee of Experts.

107. "Points the U.S. Government Recommends for Consideration by the Governing Body in Connection with Revision of Convention 3 (1919), Employment of Women Before and After Childbirth," March 11, 1948, US Women's Bureau, Office of Director, General Correspondence, 1948-63, Box 67, Folder 5, 6-2-9-3(3), RG86, NARA. For opposition in 1952, see Memo to Persons from Miller, October 30, 1952, 1.

108. More than a half century later, the US still lacks a uniform system of paid leave. Megan A. Sholar, *Getting Paid While Taking Time: The Women's Movement and the Development of Paid Family Leave Policies in the United States* (Philadelphia: Temple University Press, 2016).

109. Eileen Boris and Jill Jensen, "International Labor Organization (ILO) and the Gender of Economic Rights," in *Routledge History of Human Rights*, ed. Jean H. Quataert and Lora Wildenthal (New York: Routledge, forthcoming); C110, Plantations Convention, 1958 (No. 110), at http://www.ilo.org/dyn/ normlex/en/f?p=1000:1:0::NO; C103, https://www.ilo.org/dyn/normlex/en/ f?p=1000:11300:0::NO:11300:P11300_INSTRUMENT_ID:312248. Seventeen nations renounced the maternity convention, most after its 2000 revision.

110. ILC, *Record of Proceedings*, Thirty-First Session, 348–349.

111. On this dilemma, see Vanessa May, *Unprotected Labor: Household Workers, Politics, and Middle-Class Reform in New York, 1870–1940* (Chapel Hill: University of North Carolina Press, 2011).

112. "Record of the Meeting of the Correspondence Committee on Women's Work," Appendix VII, ILC, *Minutes, 99th Session of the Governing Body* (Geneva: ILO, September 1946), 70–71.

113. ILO, *Minutes of the 77th Session of the Governing Body* (Geneva: ILO, 12-14 November 1936), 129; Elisabeth Prügl, *The Global Construction of Gender: Home-Based Work in the Political Economy of the 20th Century* (New York: Columbia University Press, 1999), 40–55.

114. "Resolution concerning Women's Work," 404–406; statement of Mr. Kelley, 236, both in ILC, Record of Proceedings, Thirtieth Session, 1947 (Geneva: ILO, 1948).

115. Lewis Coser, "Servants: The Obsolescence of an Occupation Role," *Social Forces* 52 (1973): 31–40.

116. "Meeting of the Correspondence Committee on Women's Work," 70–71.

117. ILO, "Meeting of Experts on Women's Work," Geneva, 11-15 December 1951, 8, WN 1002.

118. Fairchild to Miller, January 15, 1947.

119. K. W., "Hancock, Dame Florence (1893–1974)," in *A Historical Dictionary of British Women*, ed. Cathy Harley (London: Europa Publications, 2003), 205; Violet Markham and Florence Hancock, *Report on the Organisation of Private Domestic Employment* (London: HMSO, 1944).

120. Mildred Fairchild to Miss Elliott, January 1, 1949, in WN 8-3-25; Pamela Horn, "Experiment or Anachronism? The Role of the National Institute of Houseworkers," *Labour History Review*, 66:1 (2001): 61–78.

121. Glenda Sluga, "'Spectacular Feminism': The International History of Women, World Citizenship and Human Rights," in *Women's Activism: Global Perspectives from the 1890s to the Present*, ed. Francesca de Hann, Margaret Allen, June Purvis, and Krassimira Daskalova (London: Routledge), 44–58; Kristine Midtgaard, "Bodil Begtrup and the Universal Declaration of Human Rights: Individual Agency, Transnationalism and Intergovernmentalism in Early UN Human Rights," *Scandinavian Journal of History* 36:4 (2011): 479–499; Ellen Carol Dubois and Lauren Derby, "The Strange Case of Minerva Bernardino: Pan-American and United Nations Women's Rights Activist," *Women's Studies International Forum* 32 (2009): 43–50; Jean H. Quataert, *Advocating Dignity: Human Rights Mobilizations in Global Politics* (Philadelphia: University of Pennsylvania Press, 2009), 152–156.

122. Helen Laville, "A New Era in International Women's Rights? American Women's Associations and the Establishment of the UN Commission on the Status of Women," *Journal of Women's History*, 20 (2008): 34–56.

123. Lisa Baldez, *Defying Convention: U.S. Resistance to the U.N. Treaty on Women's Rights* (New York: Cambridge University Press, 2014): 32–56; Helen Laville, "'Woolly, Half-Baked and Impractical'? British Responses to the Commission on the Status of Women and the Convention on the Political Rights of Women 1946–67," *Twentieth Century British History*, XXIII:4 (2012): 473–495; Devaki Jain, *Women, Development, and the UN: A Sixty-Year Quest for Equality and Justice* (Bloomington: Indiana University Press, 2005), 11–42.

124. These included the World Woman's Party, the International Union of Catholic Women's League, the Women's International Democratic Federation, and the International Council of Women, as well as the International Federation of Business and Professional Women, the World Young Women's Christian Association, and the Pan-Pacific Women's Association. Karen Garner, *Shaping a Global Women's Agenda: Women's NGOs and Global Governance, 1925–85* (Manchester, UK: University of Manchester Press, 2010), 137–149; Jain, *Women, Development, and the UN*, 15–24.

125. Mildred Fairchild to Jeff Rens, January 9, 1948, ESC 1004-11-2.

126. For example, ESC 1004-11-1—for annual requests, e.g. Anna Figueroa, "Note for the Governing Body . . . Tenth Session of U.N. Commission on the Status of Women," 1, ESC 1004-11-10.

127. Mildred Fairchild to Frieda, 25 April 1953, WN 1001-07.

128. Elizabeth Rowe, "Report on the Commission on the Status of Women," March 21, 1947, ESC 1004-11-1.

129. I elaborate on this issue in "Equality's Cold War: the ILO and the UN Commission on the Status of Women," in *Women's ILO*, 97–120.

130. On Kahn, see V. Riesel, "52nd St. Woman Directs Red Labor Sabotage in US," *Milwaukee Sentential*, January 1, 1953.

131. Goldman biography in *The Work of the Commission on the Status of Women*, NY Branch AAUW, 7, Papers of Dorothy Kenyon, Box 53, Folder 1, Smith College, Northampton, MA, USA.

132. Unclassified, "Commission on the Status of Women (94th and 95th Meetings)," 10–12, Minutes Compiled by US State Department; Memo from Mildred Fairchild to Thatcher Winslow, 24 April 1951, 2, both in ESC 1004-11-5.

133. Mildred Fairchild, "U.N. Status of Women Commission: Report on the Seventh Session, 16 March–3 April 1953," 3, ESC 1004-11-7, 1953.

134. Fairchild, "U.N. Status of Women Commission," 16.

135. Letter from Fairchild to Peel, May 8, 1951, D-634-417-01; Laurel Casinader, "Equal Remuneration for Work of Equal Value (An orientation)," 1, D634-412-01.

136. Memo from Dame Caroline Haslett for the International Federation of Business and Professional Women to the ILO May 1951, 2–3, D634-412-01.

137. "Resolutions" adopted by the International Council of Women at its Triennial Meeting, Athens, March/April 1951, 5–6, D634-412-01.

138. Laurel Casinader, "Proposed Recommendation Concerning Equal Remuneration for Men and Women Workers for Work of Equal Value," May 22, 1951, D634-412-01.

139. Elizabeth Abbott and Ina Møller, "Memorandum on Equal Pay," June 1950, 7–8, D633-415-0.

140. "Equal Remuneration," V(1) 1949, 14; Harold L. Smith, "The Problem of 'Equal Pay for Equal Work' in Great Britain during World War Two," *Journal of Modern History*, 53:4 (1981): 652–672; Pat Thane, "Towards Equal Opportunities? Women in Britain since 1945," in *Britain since 1945*, ed. Terry Gourvish and Alan O'Day (London: Macmillan, 1993), 183–209; Mark J. Crowley, *Post Office Women at War, 1939–45: Gender, Conflict and Public Service Employment* (London: Bloomsbury, forthcoming 2020), chapter 6.

141. Casinader, "Equal Remuneration," 2. Breaking with its international counterpart, the Swedish Federation of Business and Professional Women agreed. See Lisa Svanberg, Memo to the Delegation of the International Social Political Co-operation, November 20, 1949, D634-412-01.

142. ILC, "Equal Remuneration for Men and Women Workers for Work of Equal Value," Report V (2), Fifth Item on the Agenda for 33rd Session (Geneva: ILO, 1950), 56.

143. "Equal Remuneration," V (2) 1950, 17–19.

144. International Federation of Christian Trade Unions, "Equal Pay for Equal Work," June 12, 1951, 1, in D634-412-01.

145. ILC, "Equal Remuneration for Men and Women Workers for Work of Equal Value," Report VII (1), 34th Session, 1951 (Geneva: ILC, 1950), 6.

146. "Equal Remuneration," VII (1), 13–14.

147. Casinader, "Equal Remuneration," 2.

148. "Equal Remuneration," V (2), 1950, 14.

149. "Equal Remuneration," V (2), 1950, 17.

150. "Equal Remuneration," V (2), 1950, 42.

151. Casinader, "Equal Remuneration," 2.

152. ILC, "Equal Remuneration," V (2), 1950, 4.

153. "Equal Remuneration," V (2), 1950, 16.

154. "Equal Remuneration," V (2), 1950, 43.

155. Casinader, "Equal Remuneration," 3–4.

156. ILC, "Committee on Equal Remuneration Seventh Sitting," June 19, 1951, and "Outline Draft, Committee Report: Equal Remuneration of Men and Women Workers," June 27, 1950, Papers of Frieda S. Miller, Box 9, Folder 185, SL, Radcliffe College, Cambridge, MA.

157. Equal Remuneration Convention, 1951 (No.100).

158. Memo to the Chief of the Women's and Young Workers' Division, Geneva, from the Chief of the International Organisations' Division, New York, July 3, 1951; Memo from the Director of the Washington Branch to the Director-General of the ILO, Att: Mr. C.W. Jenks, May 11, 1951, all in in ESC 1004-11-5.

159. Memo to the International Organization Division, Geneva, from R.A. Métall, May 9, 1952, ESC 1004-11-6.

160. ILC, "Committee on Equal Remuneration Supplement to Report VII (2)," June 1951, ILC 34-417.

161. ILC, *Record of Proceedings*, Thirty-Forth Session, 1951 (Geneva: ILO, 1952), 333–345.

162. Frieda Miller to Edward Persons, May 11, 1950; Jack Tate to Frieda Miller, May 11, 1950, both in US Women's Bureau, Office of the Director, General Correspondence of the Women's Bureau, 1948–1953, Box 68, Folder "6-2-14-1-1 Equal Pay," RG86, NARA; Government of India, Ministry of Labour and Employment, "Statement for Parliament," 2, c. 1958, ESC 77-9-1.

163. Memo signed by Elizabeth Johnstone to the Director of the I.L.O. Branch Office, Ottawa, 25 February, 1959, ESC 77-9-1.

164. Argentina typescript, nod.; Y. Sakurai to Director-General, Geneva, October 29, 1958, ESC 77-9-1.

165. Boris and Jensen, "The Transnational Origins of Equal Pay," https://www.ilo.org/dyn/normlex/en/f?p=NORMLEXPUB:11300:0::NO::P11300_INSTRUMENT_ID:312245, accessed August 26, 2018.

166. ILC, *Record of Proceedings*, Forty-Second Session, 1958 (Geneva: ILO, 1959), 33.

167. ILC, *Record of Proceedings*, Forty-Second Session, 403–405.

168. Convention #111, "Discrimination," Articles 1, 2, 5, at http://www.ilo.org/dyn/normlex/en/f?p=NORMLEXPUB:12100:0::NO:12100:P12100_INSTRUMENT_ID:312256:NO; on BFOQ, see Title VII of the 1964 Civil Rights Act, SEC. 2000e-2. [Section 703], (e), at https://www.eeoc.gov/laws/statutes/titlevii.cfm; R111, "Discrimination," http://www.ilo.org/dyn/normlex/en/f?p=NORMLEXPUB:12100:0::NO:12100:P12100_INSTRUMENT_ID:312449:NO.

169. ILC, *Record of Proceedings*, Forty-Second Session, 409.

170. Marino, *Feminism for the Americas*.

171. ILC, *Record of Proceedings*, Forty-Second Session, 709.

172. ILC, *Record of Proceedings*, Forty-Second Session, 408; ILC, *Record of Proceedings*, Forty-Second Session, 18.

173. ILC, *Record of Proceedings*, Forty-Second Session, 414.

174. "Corrigenda to C.D./RV.5, X/4, ILC, 42nd Session, Committee on Discrimination, June 18, 1958.

175. ILC, *Record of Proceedings*, Forty-Second Session, 20, 27, 41.

176. Luis Rodríguez-Piñero, *Indigenous Peoples, Postcolonialism, and International Law: The ILO Regime (1919-1989)* (New York: Oxford University Press, 2006).

177. Maria Mies, *Patriarchy and Accumulation on a World Scale* (London: Zed Books, 1986).

CHAPTER 3

1. Peterson also served as an Assistant Secretary of Labor. Dear Dave from Esther Peterson, October 18, 1961, US Women's Bureau, General Records of the Division of Legislation and Standards, 1920–1966, Box 17, Folder "Minimum Wage 1962," RG86, NARA; Dorothy Sue Cobble, *The Other Women's Movement: Workplace Justice and Social Rights in Modern America* (Princeton, NJ: Princeton University Press, 2004), 34–35. Cobble traces her domestic impact and links to US and international unions.

2. ILC, *Record of Proceedings*, Forty-Fifth Session, 1961 (Geneva: ILO, 1962), 567.

3. Dear Dave from Esther Peterson, October 18, 1961.

4. ILO, *Minutes of the 153rd Session of the Governing Body* (Geneva: ILO, November 6–9, 1962), 15, 18–19.

5. ILC, *Women Workers in a Changing World Report* VI (1) (Geneva: ILO, 1963), 7–9, 45.

6. Elizabeth Johnstone, "Women in Economic Life: Rights and Opportunities," *The Annals*, 375 (January 1968): 103.

7. ILO, *Minutes of the 152nd Session of the Governing Body* (Geneva: ILO June 1–2, 29, 1962), 46.

8. Memo from Elizabeth Johnstone to Mr. Rens, Confidential, 16.4.64, ADM 100-4, Jacket 1, 01/1964–12/1964.

9. Frieda Miller to Mildred Fairchild, February 4, 1949, WN 1-1-61, Jacket 1.

10. Gilbert Rist, *A History of Development: From Western Origins to Global Faith* (London: Zed Books, 2001); Daniel Roger Maul, "'The 'Morse Years': The ILO 1948–1970," in *ILO Histories: Essays on the International Labour Organization and Its Impact on the World During the Twentieth Century*, ed. Jasmien Van Daele, Magly Rodrígues García, Geert Van Goethem, and Marcel van der Linden (Bern: Peter Lang, 2010), 365–400.

11. Daniel Immerwahr, *Thinking Small: The United States and the Lure of Community Development* (Cambridge, MA: Harvard University Press, 2015); Amy Staples, *The Birth of Development: How the World Bank, Food and Agriculture Organization, and World Health Organization Changed the World, 1945–1965* (Kent, OH: Kent State University Press, 2006); Craig N. Murphy, *The United Nations Development Programme: A Better Way?* (New York: Cambridge University Press, 2006).

12. "Development of Opportunities for Women in Handicrafts and Cottage Industries," ILO Draft for IX Session of the Commission on the Status of Women, 28, ESC 77-8.

13. Nyket Kardam, *Bringing Women In: Women's Issues in International Development Programs* (Boulder, CO: Lynne Rienner, 1991); Anne Winslow, "Specialized Agencies and the World Bank," in *Women, Politics, and the United Nations*, ed. Anne Winslow (Westport, CT: Greenwood Press, 1995), 155–175.

14. Main Statement made on 21 June by Mr. N. N. Kaul, ILO Representative at the Seminar on the Status of Women and Family Planning, Jogjakarta, 20–30 June, 1973, UN 9-10-102-1, Jacket 1.

15. ILO, *Minutes of the 150th Session of the Governing Body* (Geneva: ILO, November 21–24, 1961), 14.

16. Bob Reinada, *Routledge History of International Organizations: From 1815 to the Present* (New York: Routledge, 2009), 339.

17. Heritage Foundation, "The History of the Bloated U.N. Budget," Table 1, at http://www.heritage.org/report/the-history-the-bloated-un-budget-how-the-us-can-rein-it, accessed 9/15/17; Ralph W. Phillips, *FAO: Its Origins, Formation and Evolution, 1945–1981* (Rome: FAO, 1981), 77–78.

18. Daniel Maul, *Human Rights, Development and Decolonization: The International Labour Organization, 1940–70* (London and Geneva: Palgrave and the ILO, 2012), 143.

19. Carol Riegelman Lubin and Anne Winslow, *Social Justice for Women: The International Labor Organization and Women* (Durham, NC: Duke University Press, 1990), 103, 200-201.

20. Mary Cannon to Mildred Fairchild, November 9, 1949; Mary Cannon, "Report on the Extraordinary Assembly of the Inter-American Commission on Women," August 1949, both in WN 100/07, Jacket 1. For Latin America, see Katherine Marino, *Feminism for the Americas: The Making of an International Human Rights Movement* (Chapel Hill: University of North Carolina Press, 2019).

21. ILO Panel of Consultants on the Problems of Women Workers, "Opening Statement of Representative of the Director-General," October 12–17, 1959, 3; ILO Panel of Consultants on the Problems of Women Workers, "Report," 12–17 October 1959, 17–19, both in WN 2-1003-1-400 (a).

22. Devaki Jain, *Women, Development, and the UN: A Sixty-Year Quest for Equality and Justice* (Bloomington: Indiana University Press, 2005), 35.

23. Lisa Baldez, *Defying Convention: U.S. Resistance to the U.N. Treaty on Women's Rights* (New York: Cambridge University Press, 2014), 54–55; Wilfred Jenks in "The ILO Approach to Human Rights," *ILO Panorama*, 32:68 (Geneva, 1968): 2–3.

24. Minute Sheet: Mary Erulkar to Miss Fairchild, 21/7/50, in FO 158-1200, 06/1950–12/150; Mildred Fairchild, "Report of ILO—Current Activities and Plans," Not for Publication, c.1952, 3, in WN 1-1-61, Jacket 1.

25. ILO, *Report to the Governments of Ceylon, India, Indonesia, Japan, Pakistan, the Philippines and Thailand on Conditions of Women's Work in Seven Asian Countries* (Geneva: ILO, 1958), 13.

26. The study of Asian women appeared as "Women's Employment in Asian Countries," *International Labor Review*, 68 (1953): 303–318, quote at 304; Minute Sheet WN 29: Mr. Rao to Miss Fairchild, 2.7.1953, Rao to Fairchild, 22/7/53, WN 2/7 11/52 to 06/63; Sixth Item on the Agenda; *Women Workers in a Changing World* Report VI (1) Forty-Eight Session 1964 (Geneva: ILO, 1964), for example, 4 (Cyprus), 15 (India).

27. "Appendix: Report of the Asian Advisory Committee," Fourth Session, Geneva, 17–18 November 1952, 5, in WN 2/7 11/52 to 06/63.

28. Memo, Fairchild to Richard M. Lyman, 18 May 1953; Fairchild to The Correspondent of the I.L.O. in Tokyo, 20 May 1953, both in WN 2/7 11/52 to 06/63; Paige Whaley Eager, *Global Population Policy: From Population Control to Reproductive Rights* (Burlington, VT: Ashgate, 2004).

29. ILO, Asian Advisory Committee, "Special Protective Legislation Affecting Women and Its Relation to Women's Employment in Asian Countries," AAC/IV/D.5, 24, in WN 2/7 11/52 to 06/63.

30. For example, Eileen Boris, "Desirable Dress: Rosies, Sky Girls, and the Politics of Appearance," *ILWCH*, 69:1 (Spring 2006), 123–142.

31. Ruth Barrett, "Big Changes Face World's Women," *Trade Union Courier*, September 1956, Papers of Frieda S. Miller, Box 15, File 289, SL. For critique, see Joan W. Scott, *The Politics of the Veil* (Princeton, NJ: Princeton University Press, 2007).

32. Meeting of Experts on Women's Work, Geneva, 11–15 December 1951, 11; Meeting of Experts on Women's Employment, Geneva, 5–10 November 1956, 3, 18, both in WN 1001, Jacket 1 01/1956–12/1958.

33. "Special Protective Legislation Affecting Women and Its Relation to Women's Employment in Asian Countries," 4–6; "Development of Opportunities for Women in Handicrafts and Cottage Industries," IX Session, 13–20.

34. Maria Mies, *The Lace Makers of Narsapur: Indian Housewives Produce for the World Market* (London: Zed Books, 1982).

35. Outline, "Development of Opportunities for Women in Handicrafts and Cottage Industries," 3, c. 1955, ESC 77-8.

36. Outline, "Development of Opportunities for Women in Handicrafts and Cottage Industries," 29.

37. "Appendix: Report of the Asian Advisory Committee," 10.

38. Memo From: The Chief of the Women's and Young Workers' Division, Geneva, To: Director of the Asia Co-operative Field Mission in Lahore, 15 June 1953, in WN 2/7 11/52 to 06/63.

39. Minute To Mr. Lamming, Mme. Figueroa from P.V. K. Ayyar, 21.10.54, ESC 77-8; "Development of Opportunities for Women in Handicrafts and Cottage Industries," 1–2.

40. ILO, Management Development Branch, Human Resources Department, "I.L.O. Activities Relating to the Development of Small-Scale and Handicraft Industries," Information Paper No.1 Prepared for Technical Co-operation Experts Serving under the I.L.O. Small Industry Programme (Geneva, September 1965), 1, New York Liaison Office 1-2-14-1, Jacket 1.

41. Speech by Mr. Luis Alvarado, 16 December, 1952, in DADG 13-6-13-1, 11/1952 to 12/1952; *ILO Co-Operative Information*, No. 2, 28th Year 1951, 9, in DADG 13-6-13-2, 1/1951 to 12/1952.

42. "Small-Scale Industries and Their Importance for Combating Underemployment in Asia," 12, 17.

43. Memo from: Richard M. Lyman, Director of the Asian Field Office, Bangalore, to The Chief of the Field Services Division, Geneva, "Information on Women's Employment in Asia," 6 May 1953, 2, in WN 2/7 11/52 to 06/63.

44. "Special Protective Legislation Affecting Women and Its Relation to Women's Employment in Asian Countries," 16–17; "Development of Opportunities for Women in Handicrafts and Cottage Industries," for IX Session, passim; "Opportunities for Women in Handicrafts and Cottage Industries Progress Report prepared by the International Labour Office," for X Session, passim, ESC 77-8.

45. "ILO Expanded Technical Assistance Programme Job Description and Details Relevant to the Appointment of Experts," in Frieda Miller, ILO Personnel File P 7353 1955–1957, Jacket 1.

46. Eileen Boris, *Home to Work: Motherhood and the Politics of Industrial Homework in the United States* (New York: Cambridge University Press, 1994), 247–252.

47. Nati Valentin, "Visiting Labor Expert to Conduct Survey," *Manila Times*, October 19, 1955, 24.

48. *Conditions of Women's Work in Seven Asian Countries*, 4; "Confidential" memo on trip, 4–5, Papers of Frieda S. Miller, Box 9, folder 192, SL.

49. *Conditions of Women's Work in Seven Asian Countries*, 36–37. For an earlier study, see "Reports and Inquiries: Conditions of Employment of Women Workers in Asia," *International Labor Review*, 70 (1954): 542–556

50. "Industrial Home Work in France," esp. 13, UN1001/06.

51. "Record of the Meeting of the Correspondence Committee on Women's Work," 72; Frieda Miller to Mildred Fairchild, May 15, 1947, UN1001/06.

52. Frieda Miller to Ingeborg Waern Bugge, December 30, 1945, WN 1001/07.

53. Frieda Miller to Eugene Staley, October 31, 1958, Papers of Frieda Miller, Box 13, Folder 257, SL.

54. Outline, "Development of Opportunities for Women in Handicrafts and Cottage Industries," 1.

55. "Opportunities for Women in Handicrafts and Cottage Industries Progress Report prepared by the International Labour Office," for X Session, 2–4.

56. "Note for the Governing Body, 135th Session: Tenth Session of the U.N. Commission on the Status of Women," 7, ESC 1004-11-10.

57. *Conditions of Women's Work in Seven Asian Countries*, 7–12.

58. "Special Protective Legislation Affecting Women and Its Relation to Women's Employment in Asian Countries," 4–6; *Conditions of Women's Work in Seven Asian Countries*, 7, 37–39, 48.

59. "Confidential" memo on trip, 2–6.

60. *Conditions of Women's Work in Seven Asian Countries*, 35; "Confidential" memo on trip, 1–2.

61. Jef Rens to Frieda Miller, 9 February 1959, Papers of Frieda S. Miller, Box 8, Folder 212, SL.

62. For example, see reports, minutes, and correspondence in RP 158-2-8-5-1, Jacket 1, 7/1963 to 12/1976, Technical Assistance, Regional Asia: human resources development, handicrafts development, regional advisor; RP 158-2-B-5-1, Jacket 2, 01/1977 to 12/1977, and subsequent Jackets.

63. Jef Rens, "The Andean Programme," *International Labour Review*, 84:6 (1961): 423–461; Maul, *Human Rights, Development and Decolonization*, 142–143.

64. To Ralph Wright from Graciela Quan V., February 2, 1961, IGO 08-1004, Jacket 1, 02/1961–09/1961.

65. Minutes: Elizabeth Johnstone to Dr. Ammar, 1.4.63; "Women in Small-Scale Industries: A Plan of Study," 1, WN 8-5, "Women in Small Industries," Study by Dr. T. K. Djang.

66. Elizabeth Johnstone, "Mission Report: 18th Session of U.N. Commission on the Status of Women," 19 March 1965, 3, ESC 1004-11-1-18; Mildred Fairchild to M.R. Bender, February 1, 1966, WN 1-1-61.

67. Minute Sheet to Mr. Cordova, 25.10.68, "Kenya Handicrafts Employment for Women: Mrs. Brambilla's Report," RP 227-2-B-5-1, Jacket 1, 02/1967–02/1970; see also, TF 159-2-C-11-1-EQ, Jacket 1, 05/79–09/83.

68. ILC, *Women Workers in a Changing World*, 1–2, 107. On UN efforts, see Arvonne S. Fraser, "Becoming Human: The Origins and Development of Women's Human Rights," *Human Rights Quarterly* 21(1999): 890–891. For another discussion of this report, see Yevette Richards, "Transnational Links and Constraints: Women's Work, the ILO and the ICFTU in Africa, 1950s–1980s," in *Women's ILO: Transnational Networks, Global Labour Standards, and Gender Equity*, ed. Eileen Boris, Dorothy Hoehtker, and Susan Zimmermann (Leiden and Geneva: Brill and ILO, 2018), 149–175.

69. Gladys Avery Tillett to Elizabeth Johnstone, December 21, 1964, Folder 869; "Statement by Mrs. Gladys A. Tillett," Press Release No. 4161, March 18, 1963, Folder 900, both in Tillett Papers, University of North Carolina, Chapel Hill, Chapel Hill, North Carolina.

70. *Women Workers in a Changing World*, 107–108.

71. *Women Workers in a Changing World*, 109–110.

72. Richards, "Transnational Links and Constraints."

73. ILC, *Record of Proceedings*, Forty-Eight Session, 1964 (Geneva: ILO, 1965), 458, 459.

74. Eva M. Rathgeber, "WID, WAD, GAD: Trends in Research and Practice," *Journal of Developing Areas*, 24:4 (July 1990): 4489–4502, lays out different schools of thought.

75. ILC, *Record of Proceedings*, Forty-Eight Session, 470, 471, 752–753.

76. ILC, *Record of Proceedings*, Forty-Eight Session, 208, 261, 459–460, 462–463.

77. ILC, *Record of Proceedings*, Forty-Eight Session, 458; http://www.ilo.org/dyn/normlex/en/f?p=NORMLEXPUB:12100:0::NO:12100:P12100_INSTRUMENT_ID:312320:NO.

78. ILC, *Record of Proceedings*, Forty-Ninth Session, 1965 (Geneva: ILO, 1965), 385.

79. Joan C. Williams, *Unbending Gender: Why Family and Work Conflict and What to Do about It* (New York: Oxford University Press, 2000).

80. ILC, *Record of Proceedings*, Forty-Eight Session, 461.

81. ILO, Employment (Women with Family Responsibilities) Recommendation, 1965 (No.123), http://www.ilo.org/dyn/normlex/en/f?p=NORMLEXPUB:12100:0::NO:12100:P12100_INSTRUMENT_ID:312461:NO.

82. Johnstone, "Women in Economic Life," 111.

83. ILC, *Record of Proceedings*, Forty-Eight Session, 462.

84. ILC, *Record of Proceedings*, Forty-Ninth Session, 374, 383–384.

85. ILC, *Record of Proceedings*, Forty-Eight Session, 469, 465, 740.

86. ILO, *Meeting of Consultants on Women Workers' Problems* (Geneva, 20–28 September 1965), 20, Appendix II, 1, WN 2-1003-2, Jacket 1.

87. ILC, *Record of Proceedings*, Forty-Ninth Session, 44.

88. ILC, *Workers with Family Responsibilities,* Report III (Part 4B), Eightieth Session (Geneva: ILO 1993), 1–5, 89–93.

89. Only nineteen ratifications occurred by 1991, with countries complaining that they lacked the laws and/or machinery to enforce this standard. Several states found implementation would violate equal treatment because women needed special treatment to compensate for family labor. http://www.ilo.org/dyn/normlex/en/f?p=NORMLEXPUB:12100:0::NO:12100:P12100_INSTRUMENT_ID:312503:NO.

90. Baldez, *Defying Convention*, 56–61; Helen Laville, "Gender and Women's Rights in the Cold War," in *The Oxford Handbook of the Cold War*, ed. R.H. Immerman and P. Goedde (Oxford: Oxford University Press, 2013), 536.

91. C. W. Jenks to John P. Humphrey, 1964, ESC 1004-11-18.

92. Baldez, *Defying Convention*, 56–61; Arvonne S. Fraser, "The Convention on the Elimination of All Forms of Discrimination Against Women (The Women's Convention)," in *Women, Politics, and the United Nations*, 78–84.

93. Minute from Abbas Ammar to E. Johnstone, 7.4.66, ESC 1004-11-19.

94. "Mission Report," Fifteenth Session, March 1961, ESC 1004-11-15.

95. Baldez, *Defying Convention*, 56–61.

96. Minute from Johnstone to IOB, ILS, JUR, 18.12.71, ESC 1004-11-24.

97. Minutes from Johnstone to N.G.O., 10.10.68, in NGO 82, Jacket 3; Francisca de Haan, "Continuing Cold War Paradigms in Western Historiography of Transnational Women's Organisations: The Case of the Women's International Democratic Federation (WIDF)," *Women's History Review*, 19:4 (2010), 547–573.

98. Minute from K. T. Sampson to Mr. Lagegen, Mrs. Johnstone, JUR, 16/12/71; Minute from Felice Morgenstern to Mrs. Johnstone, 16.12.71; Minute from Johnstone to ILS, 14.12.1971; Johnstone to Cabinet, 27.3.1972; "Inclusion in a General Convention of Matters Covered in Specific Particular Instruments: ILO Statement to 24th Session of UN CSW," 18.2.1972, all ESC 1004-11-24.

99. Fifty-second Session, Social Committee, Provisional Summary Record of the Six Hundred and Ninety-First Meeting, 23 May 1972, E/AC.7/SR.691, 25 May 1972, see especially 8, 13, and 16. See Johnstone, "Mission Report: Attendance at Twenty-Fourth Session, 1972," ESC 1004-11-24; Report on the Twenty-Fifth Session, 5, ESC 1004-11-25.

100. Johnstone, Mission Report, Twentieth Session of the CSW, 8-9, ESC 1004-11-20.

101. Report on the Twenty-Fifth Session of the CSW, 5–6.

102. Susan Zimmermann, "Gender Regime and Gender Struggle in Hungarian State Socialism," *Aspasia*, 4 (2010): 1–24.

103. ILC, *Record of Proceedings*, Sixtieth Session (Geneva: ILO, 1976), 874.

104. Johnstone, "Mission Report: Attendance at Twenty-Fourth Session, 1972," 7.

105. Minute from K. T. Sampson, 16/12/71.

106. E/AC.7/SR.691, 25 May 1972, 11; Fifty-second Session, Social Committee, Provisional Summary Record of the Six Hundred and Ninety-First Meeting, 23 May 1972, E/AC.7/SR.692, 26 May 1972, 6–7.

107. CSW, Twenty-Sixth Session, Summary of 646th Meeting, 23 September 1976, 7, ESC 1004-11-26.

108. Kate Weigand and Daniel Horowitz, "Dorothy Kenyon, Feminist Organizing 1919–1963," *Journal of Women's History*, 14: 2 (2002): 126–131.

109. CSW, Report on the Twenty-Sixth and Resumed Twenty Sixth Sessions, 13 September–1 October and 6–17 December 1976, Supplement No. 3, E/CN.6/608, 39-40, Arvonne S. Fraser Papers, Box, 23, Folder: UN Commission on the Status of Women, 26th session, Report, 1976, Minnesota Historical Society, Minneapolis, Minnesota.

110. Annex 1: Comments to UN Secretariat, ILO Activities Report to CSW, Twenty-Sixth Meeting, 1976, 2–3, in ESC-1004-11-26.

111. Minute, J. Lemoine to Morgenstern, 17.1.1977, ESC-1004-11-26.

112. Annex 1: Comments to UN Secretariat, ILO Activities Report to CSW, Twenty-Sixth Meeting, 1976, 3, ESC-1004-11-26.

113. ICSW Report to the ECOSOC on the Eighteenth Session of the Commission, 1–20 March, 1965, 60, ESC 1004-11-18; ICSW Report to the ECOSOC on the Nineteenth Session of the Commission, held at Geneva 21 February to 11 March 1966, 79, ESC 1004-11-19.

114. Lubin and Winslow, *Social Justice for Women*, 103; Sylvia Walby, "Gender Mainstreaming: Productive Tensions in Theory and Practice," *Social Politics* 12:3 (Fall 2005): 321–343.

115. Minute Sheet, A. Aboughanem to Director General, 3.6.74; Director General Cabinet Minute, 5.8.1974 in P3240.

116. Minute Sheet: Felice Morgenstern to Mr. Wolf and Mr. Lemoine, 16.12.76; Janjic to Lemoine, 20.12.76; Morgenstern to Wolf, Lemoine, and others, 21.12.76; Jajic to all, 22.12.1976; Lemoine to Morgenstern and others, 17.1.1977; letter from Margaret Bruce to Mrs. Janjic, 9.2.1977—all in ESC-1004-11-26.

117. http://www.un.org/womenwatch/daw/cedaw/text/econvention.htm, especially Article 11, 3, accessed on April 6, 2015.

118. http://www.un.org/womenwatch/daw/cedaw/text/econvention.htm#article11, accessed on April 6, 2015.

119. Baldez, *Defying Convention*, 130–151.

120. Christine Stansell, *The Feminist Promise: 1792 to the Present* (New York: Random House, 2010), 353–394; Jocelyn Olcott, *International Women's Year: The Greatest Consciousness-Raising Event in History* (New York: Oxford University Press, 2017).

121. Gladys Avery Tillett, "Classified Report of the U.S. Delegate to the 19th Session of the UNCSW," March 29, 1966, Tillett Papers, Folder 877, University of North Carolina, Chapel Hill.

122. Hilkka Pietilä and Jeanne Vickers, *Making Women Matter: The Role of the United Nations* (London: Zed Books, 1996), 73; Raluca Maria Popa, "Translating Equality between Women and Men across Cold War Divides: Women Activists from Hungry and Romania and the Creation of International Women's Year," in *Gender Politics and Everyday Life in State Socialist Eastern and Central Europe*, ed. Shana Penn and Jill Massino (New York: Palgrave, 2009), 59–74

123. Ester Boserup, *Woman's Role in Economic Development* (New York: St. Martin's Press, 1970); Elisabeth Prügl, "Home-Based Producers in Development Discourse," in *Homeworkers in Global Perspective: Invisible No More*, ed. Eileen Boris and Elisabeth Prügl (New York: Routledge, 1996), 39–59.

124. Arvonne S. Fraser and Irene Tinker, *Developing Power: How Women Transformed International Development* (New York: Feminist Press, 2004), xix.

125. Jain, *Women, Development, and the UN*, 65–67; Margaret Snyder, "The Politics of Women and Development," in *Women, Politics, and the United Nations*, 96–98. See also Kristen Ghodsee, *Second World, Second Sex: Socialist Women's Activism and Global Solidarity during the Cold War* (Durham, NC: Duke University Press, 2018), especially 137–145.

126. ILC, "Appendices: Eighth Item on the Agenda: Equality of Opportunity and Treatment for Women Workers," *Record of Proceedings*, Sixtieth Session, 1975 (Geneva: ILO, 1976), 781.

127. ILO Office for Women Workers' Questions, *Women Workers and the Development Process (Asia and the Pacific)* (Geneva: ILO, 1979), 1.

128. ILC, *Record of Proceedings*, Sixtieth Session, 774.

129. ILC, *Record of Proceedings*, Sixtieth Session, 869–870.

130. Roland Burke, "Competing for the Last Utopia? The NIEO, Human Rights, and the World Conference for the International Women's Year, Mexico City, June 1975," *Humanity*, 6:1 (Spring 2015), 47–61.

131. ILC, *Record of Proceedings*, Sixtieth Session, 873-5, 879, 880, 774, 781.

132. *United Nations, Meeting in Mexico: The Story of the World Conference of the International Women's Year, Mexico City, 19 June–July 1975* (New York: United Nations, 1975), 3; Olcott, *International Women's Year.*

133. "Report on Participation by Mrs. A. Jatarupamaya," 4, in UN 9-10-102-1, Jacket 1.
134. Zubeida Ahmad and Martha Loutfi, *Programme on Rural Women* (Geneva: ILO, 1981).
135. Jocelyn Olcott, "The Battle within the Home: Development Strategies, Second-Wave Feminism, and the Commodification of Caring Labors at the Mexico City International Women's Year Conference," in *Workers across the Americas: The Transnational Turn in Labor History*, ed. Leon Fink (New York: Oxford University Press, 2011), 194–214.
136. Devaki Jain and Shubha Chacko, "Unfolding Women's Engagement with Development and the UN: Pointers for the Future," *Forum for Development Studies*, 35:1 (2008): 1–32.
137. UN, Asian and Pacific Centre for Women and Development, *Expert Group Meeting on the Identification of the Basic Needs of Women of Asia and the Pacific and on the Formulation of a Programme of Work*, see entire report in UN, 9-10-158/168-100-1, Jacket 1; see, for example, Appendix 2, "List of Participants." For their background, see http://devakijain.com/life/cv.html; http://www.cddc.vt.edu/feminism/Jayawardena.html; http://www.sipa.columbia.edu/academics/directory/rj15-fac.html; http://asiapacific.anu.edu.au/people/personal/reide_grc.php—all accessed January 19, 2011. For Reid, see Olcott, *International Women's Year*, passim.
138. Expert Group Meeting on the Identification of the Basic Needs of Women, "Research Priorities and Considerations, Report: Part I: The Critical Needs of Women," Appendix 6, 3-4, UN 9-10-158/168-100-1, Jacket 1, 1/1977–12/1977.
139. "Report: Part I: The Critical Needs of Women," 5–7.
140. Letter to Korchounova from Mirjam Vire-Tuominen, December 3, 1979, NGO 82, Jacket 3; Celia Donert, "Women's Rights in Cold War Europe: Disentangling Feminist Histories," *Past and Present*, 218, Supplement 8 (2013): 200.

CHAPTER 4

1. Lourdes Benería to Mrs. Ahmad, Mrs. Korchounova (FEMMES), "Comments des Progrès Intervenus dans l'Application du Principe de l'Egalite de Chances et de Traitement pour les Travailleuses Inventaire des Donnees a Rassembler,'" Minute Sheet, 6.6.77, WN-1-1-02-1000.
2. Zubeida M. Ahmad and Martha F. Loutfi, *Women Workers in Rural Development: A Programme of the ILO* (Geneva: ILO, 1985); Martha Fetherolf Loutfi, *Rural Women: Unequal Partners in Development* (Geneva: ILO, 1980), 7; FEMMES, "Programme Proposals for 1986/87: Global Theme: Women Workers," 1, 30.4.84, WEP 10-4-04, Jacket 19.
3. Zubeida Ahmad, "Meeting of ILO Office Directors and CTAs of Regional Teams—Bangkok," 11, 6.1.82, WEP 10-4-04, Jacket 12.
4. A. Béguin to Ghai, "1982–1983 Programme Proposals: Rural Women," Office File, 3 November 1980, WEP 10-4-04, Jacket 9.

5. Zubeida Ahmad to Lourdes, 11.10.82, WEP 10-4-04 Jacket 14. "Ahmad, Zubeida," background sheet compiled by ILO archives.

6. Loutfi, *Rural Women,* 2, 40; Palmer quoted 50–51.

7. Zubeida Ahmad to Maria Mies, 9.11.79, WEP 10-4-04-33-1, Jacket 1.

8. "Medium Term Plan: Revisions pertaining to the Programme on Rural Women," 1981, 2, WEP 10-4-04, Jacket 11.

9. Zubeida M. Ahmad, "The ILO Programme on Rural Women: Action Oriented Research—A Pre-view of the Findings," 18.1.79, p. 6, WEP 10-4-04, Jacket 6.

10. SAREC Progress Report, 1979–1980, "Rural Women," 2; "Progress Report (Prepared for Dutch Review Meeting);" WEP 10-4-04, Jacket 9.

11. Ahmad, "The ILO Programme on Rural Women," 6.

12. Linda Tuhiwai Smith, *Decolonizing Methodologies: Research and Indigenous Peoples,* 2nd ed. (London: Zed Books, 2012); Raewyn Connell, *Southern Theory: The Global Dynamics of Knowledge in Social Science* (Cambridge, UK: Polity Press, 2001).

13. Loutfi, *Rural Women,* 53, 55.

14. M. Loutfi, "EMP/RU Project Proposal, 'Development of Self-Reliant Employment for Rural Women,'" 4.7.80, WEP 10-4-04, Jacket 9.

15. Marjorie L. DeVault, "Talking Back to Sociology: Distinctive Contributions of Feminist Methodology," *Annual Review of Sociology,* 22 (1996): 29–50.

16. Ghai to Martin, "Draft WEP Brochures," 22 September 1983, WEP 10-4-04, Jacket 16.

17. For example, Ahmad, "Meeting of ILO Office Directors and CTAs of Regional Teams—Bangkok," 3.

18. Carol Miller and Shahra Razavi, "From WID to GAD: Conceptual Shifts in the Women and Development Discourse," Occasional Paper 1, February 1995, UNRISD, UNDP (Geneva: UNRISD, 1995), 40–41.

19. Loutfi, *Rural Women,* 40.

20. Francis Blanchard, "Office for Women Workers' Questions," ILO Circular, 29.4.76, WEP 10-4-04, Jacket 6.

21. ILO, Workers with Family Responsibilities Recommendation, 1981 (No. 165), www.ilo.org/dyn/normlex/en/f?p=NORMLEXPUB:12100:0::NO::P12100_INSTRUMENT_ID:312503.

22. Ruth Cowan, *More Work for Mother: The Ironies of Household Technologies from the Open Hearth to the Microwave* (New York: Basic Books, 1983).

23. Ahmad and Loutfi, *Women Workers in Rural Development,* 5.

24. Trade union women's committees are a good place to start, as are worker education programs, but neither of these venues reached the same kind of women that the program targeted. For one example, see Yevette Richards, "Transnational Links and Constraints: Women's Work, the ILO and the ICFTU in Africa, 1950s–1980s," in *Women's ILO: Transnational Networks, Global Labour Standards and Gender Equity, 1919 to Present,* ed. Eileen Boris, Dorothea Hoehtker, and Susan Zimmermann (Leiden and Geneva: Brill and ILO, 2018), 149–175.

25. Sara Farris, *In the Name of Women's Rights: The Rise of Femonationalism* (Durham, NC: Duke University Press, 2017), 132–142.

26. Nancy Folbre, *Greed, Lust and Gender: A History of Economic Ideas* (New York: Oxford University Press, 2009)

27. For one account that shaped my own perspective, see Lourdes Benería and Gita Sen, "Class and Gender: Inequalities and Women's Role in Economic Development—Theoretical and Practical Implications," *Feminist Studies*, 8:1 (Spring 1982): especially 158–161.

28. Arvonne S. Fraser, "Preface," in *Developing Power: How Women Transformed International Development*, ed. Avronne S. Fraser and Irene Tinker (New York: Feminist Press, 2004), ix.

29. Frances Vavrus and Lisa Ann Richey, "Editorial: Women and Development: Rethinking Policy and Reconceptualizing Practice," *Women's Studies Quarterly*, 31:3–4 (Fall-Winter 2003), 6–18.

30. Irene Tinker, "Challenging Wisdom, Challenging Policies: The Women in Development Movement," in *Developing Power*, 67–70.

31. Eva M. Rathgeber, "WID, WAD, GAD: Trends in Research and Practice," *Journal of Developing Areas*, 24:4 (July 1990): 489–502; Elisabeth Prügl, "Home-Based Producers in Development Discourse," in *Homeworkers in Global Perspective: Invisible No More*, ed. Eileen Boris and Elisabeth Prügl (New York: Routledge, 1996), 39–40; Naila Kabeer, *Reversed Realities: Gender Hierarchies in Development Thought* (London: Verso, 1994).

32. Kate Young, Carol Wolkowitz, and Roslyn McCullagh, eds., *Of Marriage and the Market: Women's Subordination in International Perspective* (London: CSE Books, 1981), vii–xi, quote at viii.

33. On Mies, see, Maria Mies, *The Village and the World: My Life, Our Times* (North Melbourne: Spinifex, 2008).

34. Memo to Mr. Ghai from A. Béguin, 15 November 1977, WEP 10-4-04, Jacket 3.

35. ILO, *Programme and Budget for the Biennium*, 55th Financial Period (Geneva: ILO, 1976–1977), i.

36. For example, Minute Sheet to Mrs. Palmer, 26.1.1976; Palmer to Michael Mills, 29.1.76, both in WEP 10-4-04, Jacket 1.

37. Mr. Ghosh to Mr. Jain, 31 January 1985, WEP 10-4-04, Jacket 23. Scattered throughout the archives are proposals as well as reports of annual review meetings with donor nations, including Sweden, Finland, the Netherlands, Denmark, Germany, and Norway.

38. Mitchell A. Orenstein, "Pension Privatization: The Transnational Campaign," and Matthieu Leimgruber, "The Embattled Standard-Bearer of Social Insurance and Its Challenger: The ILO, The OECD and the 'Crisis of the Welfare State,' 1975–1985," in *Globalizing Social Rights: The International Labour Organization and Beyond*, ed. Sandrine Kott and Joëlle Droux (London and Geneva: Palgrave and ILO, 2013), 280–309.

39. "Programme of Action," in ILC, "61st Session and Tripartite World Conference on Employment, Income Distribution and Social Progress and the International Division of Labour, June 1976," *Australian Delegation Report* (Canberra: Australian Government, 1977), 90.
40. Ahmad, "The ILO Programme on Rural Women," 32.
41. Keith Griffin to Mr. Sykes, Mr. Emmerij, 12.11.1975, WEP 10-4-04, Jacket 1.
42. Keith Griffin, "A Witness of Two Revolutions," 4–7, at http://www.peri.umass.edu/fileadmin/pdf/conference_papers/Griffin-A_Witness_of_Two_Revolutions1.pdf; for his biography, http://economics.ucr.edu/people/profemer/griffin/index.html, both accessed October 19, 2017.
43. K. Griffin, Minute, 7.1.75 proposes hiring Palmer to organize research on women and work on human nutrition. See also J. Sykes to Mr. Emmerij, 5 September 1975, Minutes, both in WEP 10-4-04, Jacket 1.
44. Author biography, back cover, Ingrid Palmer, *The Impact of Agrarian Reform on Women* (West Hartford, CT: Kumarian Press, 1985); A. G. Kenwood and A. L. Lougheed, *Economics at the University of Queensland, 1912–1997* (Brisbane: University of Queensland, 1997), 12; Palmer to Barbara Harriss, 1 September 1975, WEP 10-4-04, Jacket 1.
45. I thank the ILO archives for providing information on Palmer from her closed personnel files.
46. Ingrid Palmer, "Rural Women and the Basic-Needs Approach to Development," *International Labour Review*, 115:1 (January–February 1977): 104.
47. Ingrid Palmer, ILO Activities on Women to Program (Mr. Martin), WEP 10-4-04, Jacket 1.
48. Martha Nussbaum, "The Professor of Parody: The Hip Defeatism of Judith Butler," *New Republic*, February 22, 1999, 37–45.
49. Palmer, ILO Activities on Women to Program (Mr. Martin), WEP 10-4-04, Jacket 1. A formal focus on basic needs was short-lived, however.
50. Palmer, ILO Activities on Women to Program (Mr. Martin).
51. Ingrid Palmer, "Women in Rural Development," 3–5, concept paper, WEP 10-4-04, Jacket 1.
52. Palmer, ILO Activities on Women to Program (Mr. Martin).
53. Ingrid Palmer to Mr. Aboughanen (COORD), 30.1.76, WEP 10-4-04, Jacket 1.
54. Ingrid Palmer to Sylvia Bolanos, 16 September 1975, WEP 10-4-04, Jacket 1.
55. Palmer, "Rural Women and the Basic-Needs Approach," 105.
56. Ingrid Palmer, "Letters: Women's Future Role," *New York Herald Tribune*, July 16, 1976.
57. Palmer, ILO Activities on Women to Program (Mr. Martin).
58. Ingrid Palmer to Adrienne Germain, Ford Foundation, 8 February 1976. See also Mary Racelis Hollnsteiner to Palmer, September 12, 1975; I. Z. Bhatty to Palmer, September 27, 1975; Palmer to National Council on Women and Development. Accra, 21 November 1975; Palmer to Achola Pala, 9 December 1975; Palmer to Jette Bukin, 27 January 1976—all in WEP 10-4-04, Jacket 1.

59. Kelly Coogan-Gehr, "The Politics of Race in U.S. Feminist Scholarship: An Archaeology," *Signs: Journal of Women in Culture and Society*, 37 (Autumn 2011): 83–107.

60. Louis Emmerij to Griffin, 20.2.76, WEP 10-4-04, Jacket 1. These became Tahrunnessa Abdullah and Sondra Zeidenstein, *Village Women of Bangladesh: Prospects for Change* (Oxford: Pergamon Press, 1982); Richard Longhurst, *Rural Development Planning and the Sexual Division of Labour: A Case Study of a Moslem Hausa Village in Northern Nigeria*, Working Paper (Geneva: ILO, 1982).

61. Ingrid Palmer to Martin David, n.d., late 1975, WEP 10-4-04, Jacket 1.

62. See budget proposal attached to "Women in Development" conveyed by Antoinette Béguin, 25.11.75, WEP 10-4-04, Jacket 1, but including Palmer's analysis and proposals.

63. Ingrid Palmer to Abe Weisblatt, 27 November 1975, WEP 10-4-04, Jacket 1.

64. Ingrid Palmer to Sylvia Bolanos, 16 September 1975.

65. Ingrid Palmer to Ros Morpeth, 28 October 1975, WEP 10-4-04, Jacket 1.

66. Palmer, "Rural Women and the Basic-Needs Approach," 106. Palmer was trained, as was Benería, as a classical economist, but became a feminist and an interdisciplinary researcher. She may have been divorced from Richard Palmer, whom she appeared to have married while at Queensland, because he stayed on to have a distinguished career in health economics in Australia, and she moved to Britain, but I have no documentation on this matter.

67. "Lourdes Benería," in *Engendering Economics: Conversations with Women Economists in the United States*, ed. Paulette I. Olson and Zohreh Emami (New York: Routledge, 2002), 227–248, especially 237–238, 245.

68. Lourdes Benería, *Gender, Development, and Globalization: Economics as If All People Mattered* (New York: Routledge, 2003), ix–xi.

69. Keith Griffin to Mr. A. Ali, "Replacement for Ingrid Palmer," 5.8.76 in P.20346; ILO, *Minutes of the 202nd Session of the Governing Body* (Geneva: ILO, March 1–4, 1977), VI/10, VII/3.

70. Rod Chapman, "The Slow Road to Utopia," *Guardian*, October 19, 1976, 13.

71. That was published as Keith Griffin and Azizur Rahman Khan, eds. *Poverty and Landlessness in Rural Asia* (Geneva: ILO, 1977).

72. Keith Griffin to Lourdes, 1 December 1976, WEP 10-4-04, Jacket 2; ILO, *Draft Minutes of the 201st Session of the Governing Body* (Geneva: ILO, November 16–19, 1976), II/8–9, III/10–11. Griffin went on to say, "I have been attacked in the Governing Body by, among others, a U.S. labour 'leader' (Irving Brown) who was exposed years ago by Philip Agee as having been on the payroll of the C.I.A." Actually, the Canadian Worker delegate, Vice-Chair of the Governing Body, led the charge of criticizing Griffin's comments as inappropriate because he was still on salary. Brown, however, dismissed the practicality of the conference's conclusions with an ideological attack on the concept of a new economic order that pitted the poor nations against the rich, substituting confrontation for negotiation.

73. United Nations Intellectual History Project, "Dharam Ghai," *We contributed, we contribute*, https://ismailimail.files.wordpress.com/2013/08/dharam-new.pdf.

74. Ghai to Benería, 13.2.79, in WEP 10-4-04, Jacket 6.

75. Lourdes Benería to David Gordon, 20.2.78, a copy which was copied to Mr. Martin and Mr. Sykes; Lourdes Benería, "Mission Report: Trip to New York, 26–31 December 1977, to Discuss Possible Collaboration on Studies of Rural Women in Latin America with Several Researchers," 4.1.78, both in WEP 10-4-04, Jacket 4.

76. Meeting to Discuss Research Programme on Women in Rural Development, June 15, 1977, WEP 10-4-04-0-100, Jacket 1.

77. Proposal for Advisory Informal Consultants Meeting, n.d., WEP 10-4-04-0-100, Jacket 1.

78. Indeed, the Governing Body was reviewing such panels; the one on women had what turned out to be its last meeting in 1977. A. Béguin to Mr. Ali, 28.7.77, WEP 10-4-04-0-100, Jacket 1.

79. The amount was $15,000. Dharam Ghai and Zubeida Ahmad, "Preface," in *Women in Rural Development*, v; "Briefing for the Director-General: Informal Consultants' Meeting on Women and Rural Development," Geneva, 22–24 May 1978, 1, WEP 10-4-04-100, Jacket 1.

80. Lourdes Benería and Gita Sen, "Accumulation, Reproduction, and 'Women's Role in Economic Development': Boserup Revisited," *Signs: Journal of Women in Culture and Society*, 7:2 (Winter 1981): 279–281; "Class and Gender: Inequalities and Women's Role in Economic Development," http://www.dawnnet.org/feminist-resources/about/history, accessed January 22, 2018.

81. Margalit Fox, "Fatima Mernissi, a Founder of Islamic Feminism, Dies at 75," *New York Times*, December 9, 2015.

82. Lourdes Benería, ed., *Women and Development: The Sexual Division of Labor in Rural Societies* (New York: Praeger, 1982).

83. "Curriculum Vita: Filomina C. Steady," https://www.wellesley.edu/sites/default/files/steadyf-cv-2011_7.pdf, accessed April 1, 2019.

84. "Zenebeworke Tadesse," Council for the Development of Social Science Research in Africa, http://www.codesria.org/spip.php?article1483&lang=en, accessed April 1, 2019.

85. See "Notes on Contributors," *Of Marriage and the Market*; Zahrah Nesbitt-Ahmed and Jenny Edwards, "Gender, Sexuality and Development: Revisiting and Reflecting," *IDS Bulletin*, 47:2 (2016), http://bulletin.ids.ac.uk/idsbo/article/view/2721/html, accessed October 28, 2017.

86. See urls accessed May 27, 2019: http://nekrologi.wyborcza.pl/0,11,,58873,Barbara-Tryfan-kondolencje.html; https://opendocs.ids.ac.uk/opendocs/bitstream/handle/123456789/10814/IDSB_10_3_10.1111-j.1759-5436.1979.mp10003014.x.pdf;jsessionid=B0119448B8A3B63A79585810ADC86CBF?sequence=1

87. "Elisabeth Croll," *Guardian*, October 9, 2007.

88. Lya Yaneth Fuentes Vásquez, "Magdalena León Gómez: A Life Consecrated to Building Bridges between Women, Knowledge and Action," *Nómadas*, 18 (2003): 165–179, https://dialnet.unirioja.es/descarga/articulo/3991835.pdf, accessed October 28, 2017.

89. Draft, "Women and Rural Development: A Report of an Informal Consultants' Meeting (Geneva, 22-23 May, 1978), 1–6, WEP 10-4-04-0-100, Jacket 1.

90. Draft, "Women and Rural Development: A Report of an Informal Consultants' Meeting"; *Women in Rural Development*, passim.

91. Or so was my experience in various women's liberation groups.

92. Draft, "Women and Rural Development: A Report of an Informal Consultants' Meeting."

93. Draft, "Women and Rural Development: A Report of an Informal Consultants' Meeting"; *Women in Rural Development*, passim

94. Gita Sen to Lourdes Benería, July 16, 1978, WEP 10-4-04-0-100, Jacket 1.

95. Benería, *Women and Development*.

96. Gita Sen, "Women Workers and the Green Revolution," 54–55; Kate Young, "The Creation of a Relative Surplus Population: A Case Study from Mexico," both in Benería, *Women and* Development, 149–177.

97. Richard Longhurst, "Resource Allocation and The Sexual Division of Labor: A Case Study of A Moslem Hasusa Village in Northern Nigeria," 95–117; Maria Mies, "The Dynamics of the Sexual Division of Labor and Integration of Rural Women into the World Market," both in Benería, *Women and Development*, 1–28, quote at 13, 21.

98. Noeleen Heyzer, "From Rural Subsistence to an Industrial Peripheral Work Force: An Examination of Female Malaysian Migrants and Capital Accumulation in Singapore," in Benería, *Women and Development*, 179–202.

99. Lourdes Benería to Mr. Ghai, 11.11.77; Ingrid to Dharam, February 10, 1977, WEP 10-4-04, Jacket 2.

100. Lourdes Benería, Mission Report: Seminar on "The Role of Women in The Marketing of Local Farm and Marine Produce," Accra, 12–17 December 1977, and Conference on "African Women and Development: The Decolonisation of Research," Dakar 12–17 December 1977, 22.12.77, WEP 10-4-04, Jacket 3.

101. Ahmad and Loutfi, *Women Workers in Rural Development*, 43–47.

102. Benería to Mies, 22.7.77, Lourdes to Maria, 19.10.77, both in WEP 10-4-04-33-1, Jacket 1.

103. Ahmad to Ghai, 15.11.77, WEP 10-4-04-33-1, Jacket 1.

104. Maria Mies, "Interim Report on Project, 'Impact of Market Economy on Women's Productive and Reproductive Work in the Rural Subsistence Economy of India,' " November 1978, 1, WEP 10-4-04-33-1, Jacket 1.

105. Maria Mies, *The Lace Makers of Narsapur* (North Melbourne: Spinifex Press, 2012), xii–xiii, xx–xxi. For her approach, see Maria Mies, "Towards a Methodology

for Feminist Research," in *Theories of Women's Studies*, ed. Gloria Bowles and Renate Duelli Klein (New York: Routledge & Kegan Paul, 1983), 117–139, especially 136–138.

106. Martha Roldán, "Report on Mission to Mexico, Peru, Brazil, and Colombia," 28.8.79, WEP 10-4-04, Jacket 7.

107. Mies, *The Lace Makers*, xx–xxi.

108. Mies, "Interim Report," 5.

109. Mies, *The Lace Makers*, xx; Ahmad and Loutfi, *Women Workers in Rural Development*, 14.

110. Zubeida Ahmad to Ms. Ebeid, March 11, 1983; Ebeid to Dr. Ahmad, April 2, 1983, Ebeid to Mr. Ghai, February 23, 1983, WEP 10-4-04-33-1, Jacket 1; Ahmad to Ghai, 6.4.82, WEP 10-4-04, Jacket 13.

111. Ahmad, "Report on Mission to the Hague, Nepal, Bangladesh, India, and Kuala Lumpur," 3, 5.12.83, WEP 10-4-04, Jacket 18.

112. Zubeida Ahmad, "Mission Report," Philippines, 22.3.79, 5–7, WEP 10-4-04, Jacket 6.

113. Ghai to Sen, 30 March 1978, WEP 10-4-04, Jacket 4; Mrs. Béguin to Mettral, 6.12.77; J. Kykes to Ghai, 2 December 1977—all in WEP 10-4-04 Jacket 4. The German charity, Bread for the World, covered Mies's salary because the German ministry would not. Ahmad to Ghai and Béguin, 12.6.78, WEP 10-4-04-33-1 Jacket 1.

114. Ahmad to Ghai suggests publication of lace maker section separately as part of their working papers series, 26.10.79; Ahmad to Ghai, 8.1.80; Ghai to Béguin, 2.4.80, W. L. Jones to Chair, 11 June 1980. It was published in May 1980 as a working paper. All in WEP 10-4-04-33-1, Jacket 1.

115. Joan Ebeid, Review, *South: the Third World Magazine*, April 1983, sent to Ahmad, April 2, 1983, WEP 10-4-04-33-1, Jacket 1.

116. Lourdes Benería to Maria Mies, 18 December 1978, WEP 10-4-04, Jacket 4.

117. To Maria from Lourdes, 29/7/79, WEP 10-4-04, Jacket 4.

118. Mies to Benería, September 13, 1979; Maria to Zubi, 20.8.79—all in WEP 10-4-04-33-1, Jacket 1.

119. Dharam Ghai to Mr. Martin, 15 January 1985; Martin to Mr. Jain, 13.6.85, WEP 10-4-04-33-1, Jacket 1. On Blanchard, see https://www.ilo.org/global/about-the-ilo/how-the-ilo-works/ilo-director-general/former-directors-general/WCMS_192714/lang--en/index.htm, accessed March 26, 2019.

120. Jahan to Mies, 14 March 1986; Mies to Jahan, 19.3.86; Mies to Jahan, 23.12.85; WEP 10-4-04-33-1, Jacket 1.

121. Rounaq Jahan to Ms. Karavasil, 10.1.86; Jospehine Karavasil to Jahan, 10.3.86; Philippe Egger to Ms. Karavasil, 3.4.86; Jahan to Mr. Ghai, 27.5.87—all in WEP 10-4-04-33-1, Jacket 1.

122. Minute Sheets, R. S. Kirkman to Mr. Payró, 6.3.1981, WEP-4-04-24-1-158-9, Jacket 1. See also, Magaly Rodríguez García, "The ILO and the Oldest Non-Profession,"

in *The Life Work of a Labor Historian: Essays in Honor of Marcel van der Linden*, ed. Ulbe Bosma and Karin Hofmeester (Leiden: Brill, 2018), 90–114.

123. Pasuk Phongpaichit, "Rural Women of Thailand: From Peasant Girls to Bangkok Masseuses," International Labour Organisation, World Employment Programme Research—Working Paper, November 1980, iii, 1, 141–142.

124. Minute Sheets, R.S. Kirkman to Mr. Payró, 6.3.1981; To CABINET (Mr. Ahmad) from A. Taqi, 21.8.81, referring to Minutes 20.8.81, both in WEP-4-04-24-1-158-9, Jacket 1.

125. Ghai to Payro, 26.3.81; Minute Sheet Zubeida Ahmad to Ghai, 3.10.80; Martha F. Loutfi to Mrs. Ahmad and Mr. Ghai, 3.10.80—all in WEP-4-04-24-1-158-9, Jacket 1.

126. Minute Sheets, J. P. Martin to Director-General from J. P Martin, 15.1.81; Martin to Mr. Payró, 15.1.8; Martin to Director-General, 21.12.81—all in WEP-4-04-24-1-158-9, Jacket 1.

127. Minute Sheets, Mr. Trémeaud from Kyril Tidmarsh, PRESSE, 20 October 1981; Martha Winnacker to M. Loutfi, October 25, 1981; Loufti to Rachel Grossman, 20 October 1981; Grossman to Loutfi, 16 November 1981; For later publicity, see Ed Harriman, "Used and Abused in Bangkok," *Guardian*, 2 May 1984; The World Confederation of Labour, *Monthly Review*, October 1982, 14—all in WEP-4-04-24-1-158-9, Jacket 1.

128. Compare Phongpaichit, "Rural Women of Thailand," 4–30, 134–145, with Pasuk Phongpaichit, *From Peasant Girls to Bangkok Masseuses* (Geneva: ILO, 1982), 1–6, 71–76, quote at 76.

129. FEMMES, "Programme Proposals for 1986/1987."

130. "Report of the International Labour Organization on Its Activities of Special Interest to Women," CSW 28th Session, Vienna 1980, 11 October 1979, ESC 1004-11-28, Jacket 28.

131. E. Korchounova to M. de Givry, Mr. Jain, 24.5.1979; Ahmad to Mr. Thompson, 29.5.79; WEP 10-4-04, Jacket 6; J.P. Martin to Mr. Givry, 5.6.79—all in WEP 10-4-04, Jacket 7.

132. "Report of the International Labour Organization on Its Activities of Special Interest to Women."

133. Zubeida Ahmad to Mr. Martin, "EMP/RU Programme on Rural Women and Relations with FEMMES," May 1984, WEP 10-4-04, Jacket 19.

134. J. P. Martin to P. Adossama (PROLEGAL), 17.12.84, hand delivered and given to Mr. Jain, CABINET, WEP 10-4-04, Jacket 22. It is not clear if there was an agreement that Russian women would obtain the FEMMES post.

135. Béguin to All Focal Points, Ahmad and Loutfi, 15 January 1982, with penciled comments; Table of Contents, *Women at Work* No.1/1982; Loutfi to M. Hopkins, 19 January 1982, "World Labour Report—Analytical Framework for Employment Chapter," Ahmad incorporating Loutfi to Mrs. Patel, 22.2.82—all in WEP 10-4-04, Jacket 12.

136. Expert Meeting on Employment, 1983, 10, WEP 10-4-04, Jacket 18.

137. Diane Werneke, "The Impact of the Recent Economic Slowdown on the Employment Opportunities of Women," in *World Employment Programme Research Working Papers* (Geneva: ILO, May 1977), I–V, "Preface," n.p.

138. "Future Action (1984–85), WEP 10-4-04, Jacket 18.

139. ILC, *Employment and Conditions of Work and Life of Nursing Personnel*, Report VI (1) (Geneva: ILO, 1976); ILC, *Workers with Family Responsibilities*, Report III (Part 4B), 80th Session (Geneva: ILO, 1993) summarizes the earlier shift.

140. ILC, *Record of Proceedings*, Seventy-First Session, 1985 (Geneva: ILO, 1986), LXXV–LXXXIV, especially, LXXX, LXXXIV.

141. ILC, *Record of Proceedings*, Seventy-First Session, 40/3–5.

142. ILC, *Record of Proceedings*, Seventy-First Session, 9/9.

143. Loutfi to Jasleen Dhamija, 22.5.84, WEP 10-4-04, Jacket 19; On Loutfi, see Juan Somavía to Ms. Loutfi, July 27, 2000, and other materials in her "Official Status File," S.P.21325/1. Contents of personnel files were shared with me without full access to these records.

144. Carol Riegelman Lubin and Anne Winslow, *Social Justice for Women: The International Labor Organization and Women* (Durham, NC: Duke University Press, 1990), 141–142, is nearly useless in its sketchy portraits and lack of citations.

145. Jahan to Radwan, 5.5.88, WEP 10-4-04, Jacket 35.

146. Ghai to Megevand, 28.1.81, in WEP 10-4-04, Jacket 10.

147. "Report on Mission to Algeria, Morocco, and Egypt," September 6–23, 1982, 2–3, WEP 10-4-04, Jacket 13.

148. ILO, *Programme and Budget for the Biennium 1992–93* (Geneva: ILO, 1991), 60–10–11.

149. Ahmad to Lourdes, 11.10.82.

150. Ahmad, "Mission to New Delhi and Bangalore August 18 to 29 1984," WEP 10-4-04, Jacket 21.

151. Peggy Antrobus, "Development," draft paper for discussion, August 1984, 10, WEP 10-4-04, Jacket 21.

CHAPTER 5

1. Renana Jhabvala and Bina Sharma to Rounaq Jahan, 16 May 1988; Jhabvala to Elimane Kane, 10 May 1988, both in WEP 10-4-04, Jacket 35. For an overview, see Annie Delaney, Rosaria Burchielli, Shelley Marshall, and Jane Tate, *Homeworking Women: A Gender Justice Perspective* (New York: Routledge, 2018).

2. Peter Rütters and Rüdiger Zimmermann, eds., *On the History and Policy of the IUF*, translated by Rhodes Barrett (Bonn: Friedrich-Elbert-Stifiung, 2003), 30, 73–74.

3. Kalima Rose, *Where Women Are Leaders: The SEWA Movement in India* (London: Zed Books, 1992), 97. Phone conversation between Renana Jhabvala and author, February 13, 2018.

4. Ela R. Bhatt at 20th IUF Congress, 2, WEP 10-4-04-21-1-33-02, Jacket 6.

5. "Resolution Passed by 14th World Congress of ICFTU," 18 /3/88, attached to Jhabvala and Sharma to Jahan.

6. Elisabeth Prügl and Eileen Boris, "Introduction," in *Homeworkers in Global Perspective: Invisible No More*, ed. Eileen Boris and Elisabeth Prügl (New York: Routledge, 1996), 3–17.

7. Zubeida M. Ahmad and Martha F. Loutfi, *ILO Programme on Rural Women* (Geneva: ILO, December 1980), 8.

8. Richard P. Appelbaum and Nelson Lichtenstein, "A New World of Retail Supremacy: Supply Chains and Workers' Chains in the Age of Wal-Mart," *International Labor and Working-Class History*, 70 (2006): 106–125; Ursula Huws, *The Making of a Cybertariat: Virtual Work in a Real World* (New York: Monthly review Press, 2003).

9. Renana Jhabvala, "SEWA's Programmes for the Organization of Home-Based Workers—India," in *Action Programmes for the Protection of Homeworkers: Ten Case Studies from Around the World*, ed. Ursula Huws (Geneva: ILO, 1995), 15–16.

10. "The Home-Based Are Workers Too," typescript draft, p. 4, in WEP 10-4-04-158, Jacket 2.

11. Fourth Session of the Textile Committee, Stenographic Record of the Seventh Sitting, Friday 13 Feb 1953, Morning, VII/62, IC 5-4-202, Jacket 1, 2/1953.

12. "Points Suggested for Inclusion in the Director-General's Speech to the Textile Committee, 4th Session," Feb 53, DADG 13-6-16-10, Jacket 1.

13. ILO, Tripartite Technical Meeting for the Clothing Industry, *General Examination of the Labour and Social Problems in the Clothing Industry*, Report I (Geneva: ILO, 1964), 26. Problem with the 90% figure for industrialized nations in 1964 comes from excluding most of Eastern Europe, North Korea, China, and North Vietnam from such calculations. Textiles began their dispersion earlier and workers expressed concern from the late 1940s.

14. ILO, Textiles Committee, Seventh Session, *General Report*, Report I (Geneva: ILO, 1963), 72.

15. Eileen Boris, *Home to Work: Motherhood and the History of Industrial Homework in the United States* (New York: Cambridge University Press, 1994); Shelia Allen and Carol Wolkowitz, *Homeworking: Myths and Realities* (London: Macmillan, 1987); Shelley Pennington and Belinda Westover, *A Hidden Workforce: Homeworkers in England, 1850–1985* (London: Macmillan, 1989); Laura Johnson and Robert Johnson, *The Seam Allowance: Industrial Home Sewing in Canada* (Toronto: Woman's Press, 1982).

16. Karl Marx, *Capital*, vol. I (New York: International Publishers, 1967), 461.

17. Maria de los Angeles Crummett, *Rural Women and Industrial Home Work in Latin America: Research Review and Agenda*, WEP Working Paper 46 (Geneva: ILO, June 1988), 29.

18. To Mrs. Ahmad, Mr. Chai, Mr. Martin from Martha F. Loutfi, Memo, "Items for First Discussion at 72nd (1986) I.L.C.," 19.12.83, WEP 10-4-04-018, Jacket 1; Gisela

Schneider de Villegas, "Home Work: A Case for Social Protection," *International Labour Review*, 129:4 (1990): 423–425.

19. "Speech Given by SMT. Ela R. Bhatt at the 14th World Congress, 14–18 March 1989, Melbourne," WEP 10-4-04-21-1-33-02, Jacket 6.

20. ILO, Documents of the Meeting of Experts on the Social Protection of Homeworkers, "Social Protection of Homeworkers," Geneva, 1990, MEHW/1990/7, 7–9, and passim; for one example, see Carla Freeman, *High Tech and High Heels in the Global Economy: Women, Work, and Pink-Collar Identities in the Caribbean* (Durham, NC: Duke University Press, 2000).

21. Wendy Chapkis and Cynthia Enloe, eds., *Of Common Cloth: Women in the Global Textile Industry* (Amsterdam: Transnational Institute, 1983).

22. ITGLWF, *Report on Fourth World Congress*, 22–26 October 1984 (Brussels: ITGLWF, 1984), 53. On changes in the world economy, see Elisabeth Prügl, *The Global Construction of Gender: Home-Based Work in the Political Economy of the 20th Century* (New York: Columbia University Press, 1999), 100–103.

23. Transcript of Recorded Debate of the Sixth Sitting, 1 October 1980, Afternoon, VI/72, IC 17-2-202; Ellen Israel Rosen, *Making Sweatshops: The Globalization of the U.S.A. Apparel Industry* (Berkeley: University of California Press, 2002); Robert J. S. Ross, *Slaves to Fashion: Poverty and Abuse in the New Sweatshops* (Ann Arbor: University of Michigan Press, 2004).

24. ILO, Second Tripartite Technical Meeting for the Clothing Industry, *Contract Labour in the Clothing Industry*, Report II (Geneva: ILO, 1980), 27.

25. Preliminary Report for the First Meeting of the Textiles Committee, November 1946, 42, IC/T/1/1; ILO, Fourth Session of the Textile Committee, Stenographic Record of the Second Sitting, Tuesday, 3 February 1953, Afternoon, II/44-45, IC 5-4-202, Jacket 1, 2/1953; A. Abate, "Comment on UNCTAD on 'Note on the Proceedings of the Second Tripartite Technical Meeting for the Clothing Industry," IC 17-2-200-1.

26. ILO, Third Technical Tripartite Meeting for the Clothing Industry, 1987, *Note on Proceedings* (Geneva: ILO, 1988), 8.

27. 1964 Tripartite Technical Meeting for the Clothing Industry, *General*, 45, 53–59; ILO, Textiles Committee, Seventh Session, *General Report*, Report I (Geneva: ILO, 1963), 79–80; Schneider de Villegas, "Home Work," 425–427.

28. 1964 Tripartite Technical Meeting for the Clothing Industry, *General*, 3; Second Tripartite Technical Meeting, *Contract Labour in the Clothing Industry*, 1.

29. 1964 Tripartite Technical Meeting for the Clothing Industry, *General*, i–iii.

30. 1964 Tripartite Technical Meeting for the Clothing Industry, *General*, 34–35, 45, 64–65; Second Tripartite Technical Meeting, *Contract Labour in the Clothing Industry*, 9, 19, 21–22; Third Tripartite Technical Meeting for the Leather and Footwear Industry, *General Report*, Report I (Geneva: ILO, 1985), 26–52 passim.

31. Prügl, *Global Construction of Gender*, 102.

32. ITGLWF, *Report on Homework* (Brussels: ITGLWF, 1 June 1978), quote at 10; ITGLWF, *Employment of Women in the Textile, Garment and Leather Industries* (Brussels: ITGLWF, 1980), 19–20.

33. Transcript of the Third Sitting, 26 September 1980, Afternoon, III/102, IC 17-2-202.

34. ITGLWF, *Second World Congress*, 22-26 March 1976 (Brussels: ITGLWF, 1976), 188.

35. 1964 Tripartite Technical Meeting for the Clothing Industry, *General*, 35.

36. "Reports and Enquiries: Industrial Home Work," *International Labour Review*, 58:6 (December 1948): 750. That there is nearly a twenty-year gap in ILO research suggests the low priority of the topic. See Maria Tamboukou, "Jeanne Bouvier: A Feminist Seamstress and Writer in Paris," in *Gendering the Memory of Work: Women Workers' Narratives* (New York: Routledge, 2016), 46–97.

37. Second Tripartite Technical Meeting, *Contract Labour in the Clothing Industry*, 1.

38. "ITGLWF Second World Congress, Dublin, March 1976 Resolution on Industrial Homework," Annex 1, in *Report on Homework*, 38–39; see also, *Report on Homework*, 1–6.

39. ITGLWF, *Second World Congress*, 187–188; Boris, *Home to Work* traces US union objections from the late 19th century to the 1980s.

40. ITGLWF, *Second World Congress*, 187–188.

41. ITGLWF, *Second World Congress*, 187–188; ITGLWF, *Report of the First World Congress* (Brussels: ITGLWF, 1972), 10.

42. Charles Ford to All Clothing Affiliates, 14 November 1979, Box 6, Folder 5, ILGWU International Relations Department Records, Collection Number 5780/062, Kheel Center, Cornell University, Ithaca, New York.

43. Second Tripartite Technical Meeting, *Contract Labour in the Clothing Industry*, 74.

44. ILO, Second Tripartite Technical Meeting for the Clothing Industry, *Note on the Proceedings* (Geneva: ILO, 1981), 71; "Report of the ILO on Its Activities of Special Interest to Women," 11 October 1979, 7, ESC 1004-11-28; "Résolution (No. 13) concernant le travail industriel à domicile," Deuxième Réunion technique Tripartite Pour L'Industrie Du Cuir et De La Chaussure, *Note Sur Les Travaux* (Genève: BIT, 1979), 68.

45. For example, Transcript of Fourth Sitting, IV/42.

46. Joint Congress of the International Shoe and Leather Workers' Federation and the International Textile and Garment Workers' Federation, Fokkestone (London: n.p., 1970), 8.

47. Second Tripartite Technical Meeting, *Contract Labour in the Clothing Industry*, 45.

48. Second Tripartite Technical Meeting, *Contract Labour in the Clothing Industry*, 62–66. See also, Third Tripartite Technical Meeting for the Clothing Industry, *General Report: Effect Given to the Conclusions of the Previous Meetings*, Report I, Parts 1 and 2 (Geneva: ILO, 1987), 20–30; Luz Vega Ruiz, "Home Work: Towards a New Regulatory Framework?" *International Labour Review*, 131:2 (1992): 197–216.

49. Hong Kong, IC 17-2-171-1, Jacket 2. See also, Malta, 5, IC 17-2-171-1, Jacket 3.

50. Transcript of Recorded Debate of the Fifth Sitting, 30 September, Morning, V/74, VI/22, IC 17-2-202. See also IV/80 and IV/103, Transcript of Fourth Sitting, 29 September 1980, Afternoon, IC 17-2-202.

51. Transcript of Fifth Sitting, V/53.

52. Transcript of Sixth Sitting, VI/22.

53. Third Technical Tripartite Meeting, *Note on Proceedings*, 15.

54. "October 4–5, 1979—ICFTU/ITS Consultative Committee on Women Workers' Questions," in ITGLWF, *Report on Activities, Third World Congress* (Brussels: ITGLWF, 1980), 48.

55. Transcript of the Eight Sitting, 2 October 1980, Afternoon, VIII/4, IC 17-2-202.

56. Paragraph 43, Second Tripartite Technical Meeting, *Note on the Proceedings*, 24.

57. Third Technical Tripartite Meeting, *Note on Proceedings*, 48.

58. ITGLWF, *Report on Fourth World Congress*, 105, 163–165; Boris, *Home to Work*, 337–361.

59. Jane Tate, "Introduction to Part III," in *Women in Trade Unions: Organizing the Unorganized*, ed. Margaret Hosmer Martens and Swasti Mitter (Geneva: ILO, 1994), 63–64.

60. ILO, Fourth Tripartite Technical Meeting for the Clothing Industry, *Recent Developments in the Clothing Industry*, Report I (Geneva: ILO, 1995), 40, 73–76; Eric Tang, *Unsettled: Cambodian Refugees in the New York City Hyperghetto* (Philadelphia: Temple University Press, 2015), 114–134.

61. Third Technical Tripartite Meeting, *Note on Proceedings*, 12, 14–17. See also, ILO, Third Tripartite Technical Meeting for the Clothing Industry, *General Report: Effect Given to the Conclusions of the Previous Meetings*, Report I Parts 1 and 2 (Geneva: ILO, 1987), 4–30.

62. Sonia Laverty, "National Outwork Campaign—Australia," in *Action Programmes for The Protection of Homeworkers: Ten Case-Studies from Around the World*, ed. Ursula Huws (Geneva: ILO, 1995), 27–40; Jane Tate, "Australia," in *Women in Trade Unions*, 67–73.

63. Ruiz, "Home Work," 212–213; Schneider de Villegas, "Home Work," 429–431; Alexandra Dagg, "Organizing Homeworkers into Unions: The Homeworkers' Association of Toronto, Canada," in *Homeworkers in Global Perspective*, 239–258; Jane Tate, "Canada," in *Women in Trade Unions*, 77–79; Documents of the Meeting of Experts on the Social Protection of Homeworkers, *Social Protection of Homeworkers*, 1990 (Geneva: ILO, 1991), 27.

64. Third Technical Tripartite Meeting, *Note on Proceedings*, 92.

65. Third Technical Tripartite Meeting, *Note on Proceedings*, 18–19; Fourth Tripartite Technical Meeting, *General Report*, 94.

66. ILC, *Record of Proceedings*, Seventy-Fifth Session, 1988 (Geneva: ILO, 1989), 16/44.

67. Bernadette Segol to Korchounova, 7 February 1980, Folder "1980-83," Box "ILO General Correspondence 1978-80," Archive of the ITGLWF /ITBLAV, Archives of Social Democracy, Friedrich-Ebert-Stiftung, Bonn.

68. Zed published Mies' study in 1982, the year that Ghai spoke. Ghai to Petitpierre, Minute Sheet, 24.3.82; Ahmad to Ghai, Minute Sheet, 8.1.80; Ghai to Béguin,

2.4.89—all in WEP 10-4-04-33-1, Jacket 1; Maria Mies, *Housewives Produce for the World Market: The Lace Makers of Narsapur*, World Employment Programme Research Working Paper, December 1980 (Geneva: ILO, 1980).

69. Zarina Bhatty, *Economic Role and Status of Women: A Case Study of Women in the Beedi Industry in Allahabad*, World Employment Programme Research Working Paper, December 1980 (Geneva: ILO, 1980). It appeared in 1981 as *The Economic Role and Status of Women in the Beedi Industry in Allahabad, India*, Vol. 63, Social Science Studies on International Problems (Fort Lauderdale, FL: Verlag Breitenbach, 1981). On Bhatty, see her *Purdah to Piccadilly: A Muslim Woman's Struggle for Identity* (London: SAGE, 2016).

70. Dharam Ghai, "Preface," in Bhatty, *The Economic Role and Status of Women*, ii.

71. Dharam Ghai, "Preface," in Maria Mies, *The Lace Makers of Narsapur: Indian Housewives Produce for the World Market* (London: Zed Press, 1982), x.

72. For example, Zubeida Ahmad, "Employment Opportunities for Poor Women in Rural Areas in Developing Countries," Talk 1980, WEP 10-4-04, Jacket 9; Ahmad, "Mission to Bangkok," 8-24-1982, 4, WEP 10-4-04, Jacket 12; Loutfi, "Mission, The Netherlands," 31 August 1982, WEP 10-4-04, Jacket 13; Loutfi, "Mission, Belgrade," 14-17 November 1982, 2, WEP 10-4-04, Jacket 14. See also, Eggar to Ms. Belinda Leach, 31 July 1985, which cites Mies, WEP 10-4-04, Jacket 25. For influence of the studies elsewhere, Margaret Owen to Martha Loutfi, 8 November 1982, WEP 10-4-04-018, Jacket 1.

73. Bhatty, *The Economic Role and Status of Women*, 9–10.

74. Bhatty, *The Economic Role and Status of Women*, 6–7, 37–38, 44, 48.

75. Mies, *The Lace Makers*, 9, 51, 81. All quotes from the 2012 Spinifex edition.

76. Mies, *The Lace Makers*, 201–202.

77. Crummett, *Rural Women and Industrial Home Work in Latin America*, 29.

78. Ahmad and Loutfi, *ILO Programme on Rural Women*, December 1980, 14.

79. Ahmad and Loutfi, *ILO Programme on Rural Women*, December 1980, 14.

80. Loutfi to Margaret Owens, 14 July 1982; Anne-Marie Causanillas to Loutfi, Ahmad, Ghai et al., "External Collaboration: Ms. Margaret Owen," 1 September 1983—all in WEP 10-4-018, Jacket 1. The Minute sheets in this folder show Loutfi seeking the approval of NORMS and other divisions for this project.

81. As convention making was under way, Kelles-Viitanen dropped the term "legal" from a SEWA proposal "not to scare employers and governments," since social protection includes that. "ILO Multi-Bilateral Programme of Technical Cooperation, Summary Project Outline;" Telegram from Anita Kelles-Viitanen to Azita Berar-Awad, 22 January 1992, both in WEP 10-4-04-028-158, Jacket 3; "The Home-Based Are Workers Too," 11.

82. Ahmad to Mr. Sidibé, Ghai and others, 7.8.81; Th. Sidibé to Ahmad, 29.9.81, both WEP 10-4-04, Jacket 11.

83. Loutfi to Mr. M. Hopkins, 19 January 1982, WEP 10-4-04, Jacket 12; Loutfi to Mr. Richards.

84. ILO, *Programme and Budget for the Biennium*, 1980–1981 Fifty-Seventh Financial Period (Geneva: ILO, 1979), 90/10.

85. Loutfi to Ahmad, Ghai, Martin, "Items for First Discussion at 72nd (1986) I.L.C.," 19.12.83, with attached "Proposal for development of an instrument (Convention/ Recommendation) concerning homeworkers (domestic outworkers)," WEP 10-4-04-018, Jacket 1.

86. Notice, An informal workshop, "Laws and Policies affecting Home-based Workers under a Putting-Out System," 2 December [1983], WEP 10-4-04-018, Jacket 1.

87. Loutfi to Ahmad, Ghai, Martin, "Agenda for 72nd (1986) Session of the Conference," 1 February 1984, WEP 10-4-04, Jacket 18.

88. Ela Bhatt to B.G. Deshmukh, 3 December 1984; Bhatt to S.K. Jain, 4 December 1984, both in RL 33-3-100, Jacket 1.

89. Loutfi, Note for the file, "Social Protection of Home-Based Workers, '86–87,'" 23.7.84, WEP 10-4-04-018, Jacket 1; Loutfi to Ahmad, Ghai, and Martin, 3.12.84, WEP 10-4-04, Jacket 22.

90. "1984–85 Regular Budget Work Programme: Employment of Rural Women," WEP 10-4-04, Jacket 18; "Progress Report on SAREC-Financed Research," 1984, WEP 10-4-04, Jacket 21.

91. Loutfi to Rahman, Ghai, Martin, Sidibé and others, "Social Protection of Home-based Producers," 27.2.85, in WEP 10-4-04-018, Jacket 2. Andréa Menefee Singh and Anita Kelles-Viitanen of New Delhi would edit these papers as *Invisible Hands: Women in Home-based Production* (New Delhi: Sage Publications, 1987). This collection prefigured Shelia Rowbotham and Swasti Mitter, eds., *Dignity and Daily Bread: New Forms of Economic Organizing among Poor Women in the Third World and the First* (London: Routledge, 1994), and Boris and Prügl, eds., *Homeworkers in Global Perspective*.

92. K.T. Samson to EMP/RU, 16.5.84 (really 85); Loutfi to Samson, 10.5.85; Hilary Kellerson to EMP/RU, 8.5.85; Arturo Bronstein to Yemin, EMP/RU (Loutfi), 15.5.85; A. Taqi to Ghai, 24.5.85; Rounaq Jahan to Ghai, 12.6.85, WEP 10-4-04-018, Jacket 2.

93. Gunseli Berik, *Women Carpet Weavers in Rural Turkey: Patterns of Employment Earnings and Status* (Geneva: ILO, 1987); Gita Sen and Leela Gulati, *Women Workers in Kerala's Electronic Industry*, WEP Working Paper No. 45 (Geneva: ILO, March 1987); Crummett, *Rural Women and Industrial Home Work in Latin America*.

94. ILO, *Programme and Budget for the Biennium 1986–87*, Sixtieth Financial Period (Geneva: ILO, 1985), 80/7; 90/17–18. These monographs traced the situation in specific nations, industrialized and industrializing. Ruiz, "Home Work," 215–216; Prügl, *The Global Construction of Gender*, 110, fn.31 191–192; on legal, see H. Boukris, "Conclusion," 2, WEP 10-4-04-018, Jacket 2.

95. ILC, *Record of Proceedings*, Seventieth Session, 1984 (Geneva: ILO, 1984), 37/ 6; ILC, *Record of Proceedings*, Seventy-First Session, 1985 (Geneva: ILO, 1986),

40/3; ; ILC, *Record of Proceedings*, Seventy-Fifth Session, XCVI; see also, *Social Protection of Homeworkers*, 1.

96. Rounaq Jahan to Mr. Taqi, 13/6/[85], WEP 10-4-04-018, Jacket 2; Azita Berar-Awad, Mission to Philippines, 12.7.91 for "Rural Women Workers in the New Putting Out System," ACD 53-0-04.

97. "Research on Rural Women, 1984," 3–4, WEP 10-4-01, Jacket 19. For a comparison of WWF and SEWA, see Margaret Hosmer Martens, "Experience in Organizing Women in the Informal Sector in India," 127–129, and, on WWF, Claire L. Bangasser, "The Working Women's Forum: A Case Study of Leadership Development in India," 131–143, both in *Women in Trade Unions*; Bhatt to Loutfi, 4 June 1984, WEP 10-4-04-018, Jacket 1.

98. Huws, *Action Programmes for The Protection of Homeworkers*, v; see within Jane Tate, "The National Group on Homeworking—United Kingdom," 81–98; "Maria van Veen, "The Vrouwenbond FNV's Home Work Projects—Netherlands," 99–110.

99. Rose, *When Women Are Leaders*, 55–56; "The Ramon Magsaysay Award," http://www.rmaf.org.ph/newrmaf/main/the_foundation/about, accessed January 27, 2016.

100. Md. Anisur Rahman to Ahmad and Ghai, "RBTC: Policy Oriented Participatory Study—SEWA, India," 30.4.1981, WEP 10-4-04, Jacket 10; Minute from Janjic to Jain, 7 April 1982, WEP 10-4-04, Jacket 14; Egger to Ghai, 22 August 1983; DRAFT WEP brochure attached to Ghai to Martin, 22 September 1983, both in WEP 10-4-04, Jacket 16.

101. Francis Blanchard to Irving S. Friedman, July 1983; Blanchard to Azim Husain, 19.1.83, both in WEP 10-4-04, Jacket 16. Justification for nominating SEWA for the Third World Prize in 1986 emphasized it as a different kind of trade union that had "made visible nationally and internationally the cause of the poor self-employed casual (woman) workers." Jahan to Ghai and Martin, 3.9.86, WEP 10-4-04, Jacket 29.

102. For example, Ela R. Bhatt to "My dear Martha," 4 June 1984, WEP 10-4-04-018, Jacket 1, and Bhatt to Zubeida and Martha, 9-11-84, in WEP 10-4-04, Jacket 22, compared to Ela R. Bhatt to Ahmad, 4 December 1980, and Ahmad to Bhatt, 24 December 1980, both in WEP 10-4-04, Jacket 9.

103. To Mrs. Ahmad, Mr. Chai, Mr. Martin from Martha F. Loutfi, Memo, "Items for First Discussion."

104. Quoted in Edward Webster, "Organizing in the Informal Economy: Ela Bhatt and the Self-Employment Women's Association of India," *Labour, Capital and Society* 44:1 (2011): 105. For the political economy of the region, see Jan Breman, *The Making and Unmaking of an Industrial Working Class: Sliding Down the Labour Hierarchy in Ahmedabad, India* (New Delhi: Oxford University Press, 2004).

105. M.V. Shobhana Warrier, "Gender, Class and Community in the Mobilization of Labour: Cotton Mills in the Madras Regions, 1914–1951," unpublished paper presented at the First Conference of the European Labour History Network, Turin, Italy, December 16, 2015, in author's possession; Rose, *When Women Are Leaders*, 36–38; Ela R. Bhatt, *We Are Poor but So Many: The Story of Self-Employed Women in India* (New York: Oxford University Press, 2006), 15.

106. Bhatt, *We Are Poor but So Many*, 9.

107. S. Selliah, *The Self-Employed Women's Association, Ahmedabad, India* (Geneva: ILO, 1989), 3.

108. Ela R. Bhatt, "Towards the Second Freedom," in *First Independence towards Freedom: Indian Women since 1947*, ed. Bharati Ray and Aparna Basu (New Delhi: Oxford University Press, 1999), 36; Sharit K. Bhowmik, "Understanding Labour Dynamics in India," *South African Review of Sociology*, 40:1 (2009): 47–61.

109. Quoted in Webster, "Organizing in the Informal Economy," 106.

110. ITGLWF, *Report from Affiliate Organizations*, Third World Congress (Brussels: ITGLWF, 1980), 111.

111. "Renana Jhabvala," http://www.wiego.org/sites/default/files/resources/files/Renana-Jhabvala-CV.pdf, accessed June 23, 2018.

112. Bhatt, *We Are Poor but So Many*, 13, 16, 63, 126; Rose, *Where Women Are Leaders*, 29; Anita Kelles-Viitanen, "Mission to Ahmedabad, 7–9 September 1989," WEP-10-4-04-21-1-33-02, Jacket 6.

113. Rose, *Where Women Are Leaders*, 45; Webster, "Organizing in the Informal Economy," 107; for scope, see Bhatt, *We Are Poor but So Many*.

114. "Project Description: Follow up Activities Toward an ILO Discussion on Homework," EMP 63-4-1, Jacket 1; http://www.sewa.org/About_Us_Structure.asp, accessed August 17, 2014; Bhatt, *We Are Poor but So Many*, 17.

115. The figures come from Renana Jhabvala.

116. Bhatt to Shelia Arnopoules, 16.5.1974, ILGWU Collection, Box 6, Folder 3, Kheel Center, Cornell University.

117. Jhabvala, "SEWA's Programmes for the Organization of Home-based Workers—India," 20–22, 25–26.

118. "National Institute of Design Remarks," n.d., c. 1983, Folder "1972–1980, January 1981 to July 1983," ITGLWF/ITBLAV, Box "India: Self-Employed Women's Association," Archive of Social Democracy (ASD), Fredrich-Ebert Stifung Foundation.

119. E. Horii to Buch, 7 May 1979, Folder 1978–1980, ITGLWF /ITBLAV, Box, "Correspondence India," ASD, Fredrich-Ebert Stifung Foundation.

120. ITGLWF, Report from Affiliate Organizations, 112.

121. ITGLWF, *Employment of Women*, 30–41, quote at 31.

122. ITGLWF, Report on Activities, 54–55.

123. Amal Mukherjee to Ghai, 22.7.83, RL 33-3-100, Jacket 1.

124. Bhatt to Charles Ford, 23 June 1981, copy sent to Deputy Director-General S.K. Jain, 3 July 1981, RL 33-3-100, Jacket 1.

125. Buch tried to curry favor with Charles Ford of the ITGLWF in a series of letters. See Buch to Ford, 10/8/81; 6 November 1981; see also Bush to Brother Kurian, 22 August 1983—all in Folder "TLA 1978-81, 1982," ITGLWF/ITBLAV, Box, "Correspondence: India," ASD, Fredrich-Ebert Stifung Foundation.

126. Jennifer Sebstad, *Struggle and Development among Self-Employed Women: A Report on the Self Employment Women's Association Ahmedabad, India* (Washington, DC: AID, March 1982), 219–229, quote at 340; Rose, *Where Women Are Leaders*, 78–79; Renana Jhabvala, "SEWA's Programmes for the Organization of Home-based Workers—India," in *Action Programmes for the Protection of Homeworkers*, 17–18, http://www.sewa.org/About_Us_History.asp, accessed August 17, 2014.

127. Bhatt, *We Are Poor but So Many*, 9.

128. Memo, S. Selliah to C. F. Poloni, "SEWA Rural Study," 21.04.1988, 38, WED 31-0-33-3, Jacket 1.

129. Circular Letter from Ela Bhatt, attached to Memo to RELTRAV from ILO Office, New Delhi, 25 September 1981, RL 33-3-100, Jacket 1.

130. S.R. Mohan Das, "The Labour Scene: Unions—Membership or Mass Organisations?," *Financial Express*, September 8, 1981, 28.

131. Memo, S. Selliah to C. F. Poloni, "SEWA Rural Study," 35–38; Sebstad, *Struggle and Development among Self-Employed Women*, 258–262.

132. Margaret Owens to Loutfi, 14 June 1984, reporting on National Homeworking Conference in Britain, WEP 10-4-04-018, Jacket 1; Ahmad, "Meeting of ILO Office Directors and CTAs of Regional Teams," Bangkok, 6.1.82, 5, WEP 10-4-04, Jacket 12.

133. Loutfi to Singh, 4.8.83, WEP 10-4-04, Jacket 16; Amal Mukherjee to Ghai, 22.7.83; J.P. Martin to Mr. Jain, 19 August 1983, RL 33-3-100, Jacket 1.

134. Not that it was always easy. Loutfi reported that she was having a hard time finding a donor for home-based production in Southeast Asia. Loutfi, "Mission to Washington" 3.11.83; Loutfi to Singh, 4.8.83, both in WEP 10-4-04, Jacket 16.

135. Bhatt to Zubeida and Martha, 9.11.84.

136. Jhabvala, "SEWA's Programmes for the Organization of Home-based Workers—India," 18.

137. Selliah, *The Self-Employed Women's Association*, 16; Rose, *Where Women Are Leaders*, 89. The combined group became International Union of Food, Agricultural, Hotel, Restaurant, Catering, Tobacco and Allied Workers' Associations (IUF). See, https://uia.org/s/or/en/1100036509, accessed February 20, 2018.

138. Interview with Jhabvala; Dan Gallin to author, e-mail correspondence, January 9, 2018 and February 2, 2018.

139. http://www.sewa.org/About_Us_History.asp; "ILO Study Tour: Evaluation Seminar Report 19 June to 10 July 1989," 3, 7, WEP 31-0-33-3, Jacket 1.

140. Memo, Anita Kelles-Viitanen to Philippe Egger, 17 October 1986, "Legal Camp for Women Beedi Workers in Indore," WEP-10-4-04-21-1-33-02, Jacket 2.

141. "Generating Awareness in Workers," SEWA document, n.d., WEP 10-4-04-21-1-33-02, Jacket 6.

142. "Generating Awareness in Workers."

143. Memo, Anita Kelles-Viitanen to Rounaq Jahan, 25 August 1986, "Participatory Action Research Project on the Development of Effective Monitoring Systems and Application of Legislation on Home-Based Piece-Rate Producers," and enclosed copy, "First Camp for Women Garment Workers under the ILO Project at Ahmadabad, 16-5-1986 to 21-5-1986;" "The Five Day Training Camp of Women Beedi Labourers held at Municipality Community Hall, Indore"—all in WEP-10-4-04-21-1-33-02, Jacket 1.

144. "Report of Mission to Indore, Madya Pradesh, 2–7 September 1986," 5, WEP-10-4-04-21-1-33-02, Jacket 1.

145. "First Camp for Women Garment Workers under the ILO Project at Ahmadabad," 6.

146. Kelles-Viitanen, "Report of Mission to Indore, Madya Pradesh," 5.

147. "Report of Mission to Indore, Madya Pradesh," 5–7.

148. "First Camp for Women Garment Workers under the ILO Project at Ahmadabad."

149. "Report of Mission to Indore, Madya Pradesh," 11–12.

150. Anita Kelles-Viitanen, "Minutes of a Meeting held on 22 July 1986," WEP-10-4-04-21-1-33-02, Jacket 1.

151. Bhatt, *We Are Poor but So Many*, 88–89; Letter to Ms. Crow from Andréa Singh, 13 April 1993, CWL 7-1-11-3, Jacket 1; e-mail from Renana Jhabvala to author, January 25, 2015.

152. Rosalinda Pineda Ofreno, "PATAMBA's Action Programme for Homeworkers' Empowerment—Philippines," *Action Programmes for the Protection of Homeworkers*, 65–67, 71; "Project Document: Employment Promotion and Social Protection of Home-Based Workers in Asia."

153. Annie Delaney, "Organising Homeworkers: Women's Collective Strategies to Improve Participation and Social Change," PhD dissertation, School of Management, La Trobe University, June 2009, 78–97; Jane Tate, "Making Links: The Growth of Homeworker Networks," in *Homeworkers in Global Perspective*, 273–289; Renana Jhabvala and Jane Tate, "Out of the Shadows: Homebased Workers Organize for International Recognition," *SEEDS*, 18 (1996), 1–17.

154. E-mail from Jane Tate, to author, March 25, 2018; for example, "Resolution from meeting of IUF Asia Pacific Regional Conference, 1989, WEP 10-4-04-21-1-33-02, Jacket 6.

155. E-mail from J. Tate to author, March 25, 2018; conversation with Marty Chen, May 23, 2018, Stockholm.

156. Francis Blanchard to John Vanderveken, 18 March 1987, RL 33-3-100, Jacket 1.

157. ILO, *Official Bulletin*, LXXIII, Series A, No. 1 (1990), 15.

158. Barbro Budin to Ela, 19 December 1989, Box, "Correspondence Organizations Affiliates, 1989," Folder, "India: SEWA"; Bhatt to Gallin, October 9, 1990; Barbro to Bina, n.d., Box, "Correspondence Organizations Affiliates, 1990," Folder, "India: SEWA," both in IUF Papers, ASD, Friedrich-Ebert-Stiftung.

159. "Annex," *Social Protection of Homeworkers*, 1–4.

160. "Report Adopted by the Meeting of Experts," *Social Protection of Homeworkers*, 74, 89–93.

161. ILC, *Record of Proceedings*, Seventy-Seventh Session, 1990 (Geneva: ILO, 1991), 7–15, 32/7, 19/38–19/39.

162. Prügl, *The Global Construction of Gender*, 79–80; ILO, *Employment, Incomes and Equity: A Strategy for Increasing Productive Employment in Kenya* (Geneva: ILO, 1972).

163. ILC, *Record of Proceedings*, Seventy-Eighth Session, 1991 (Geneva: ILO, 1992), 5/2, 1/7–1/8, 1/12–14.

164. ILC, *Record of Proceedings*, Eighty-Second Session (Geneva: ILO, 1996), 27/51.

165. *Social Protection of Homeworkers*, 76–77.

166. *Social Protection of Homeworkers*, 3.

167. *Social Protection of Homeworkers*, 26; 75–77; C177, Home Work Convention, 1996," http://www.ilo.org/dyn/normlex/en/f?p=NORMLEXPUB:12100:0::NO:12100:P12100_INSTRUMENT_ID:312322:NO.

168. Bhatt to Singh, 21 January 1991, WEP 10-4-04-028-158, Jacket 3.

169. *Social Protection of Homeworkers*, 80.

170. ILC, *Record of Proceedings*, 82nd Session, 27/24; ILO, *Meeting of the Governing Body*, 248th Session (Geneva: ILO, November 1990), III/1–2.

171. *Social Protection of Homeworkers*, 88–89.

172. Bhatt to Gallin, October 9, 1990.

173. ILC, *Record of Proceedings*, Eight-Second Session, 27/32, 44, 37; *Social Protection of Homeworkers*, 80.

174. E-mail Jane Tate to author, March 25, 2018.

175. ILC, *Record of Proceedings*, Eight-Second Session, 27/38; ILC, *Record of Proceedings*, Eighty-Third Session, 1996 (Geneva: ILO, 1996), 219.

176. *Social Protection of Homeworkers*, 75–81, 83.

177. ILC, *Record of Proceedings*, Eighty-Second Session, 252, 27/19ff; ILC, *Record of Proceedings*, Eighty-Third Session, 7–10.

178. ILC, *Record of Proceedings*, Eight-Second Session, 27/21; *Social Protection of Homeworkers*, 80.

179. ILC, *Record of Proceedings*, Eight-Second Session, 27/32, 34.

180. ILC, *Record of Proceedings*, Eighty-Third Session, 213–214; e-mail E. Prügl to author, August 21, 2014; e-mail J. Tate to author, February 16, 2018.

181. Suzanne Franzway and Mary Margaret Fonow, *Making Feminist Politics: Transnational Alliances between Women and Labor* (Urbana: University of Illinois Press, 2011); Margaret Keck and Kathryn Sikkink, *Activists Beyond Borders: Advocacy Networks in International Politics* (Ithaca, NY: Cornell University Press, 1998).
182. Blanchard to Friedman, July 1983; Blanchard to Husain, 19.1.83.
183. "Report of the International Community Leadership Project, March 6 to 22, 1983," WEP 10-4-04, Jacket 16.
184. Some branches of the Office actually promoted microenterprise and advised countries on privatization for employment and poverty alleviation. For an example, M. Allal to Mr. Prokopenko, 1992/93 Activities Report, MEIS Section Contribution to the DG's Report, 14.9.1993, SM 0-1, Jacket 1.
185. Jahan to Ghai, 10.7.86, WEP 10-4-04, Jacket 28.

CHAPTER 6

1. Quoted in Jennifer N. Fish, *Domestic Workers of the World Unite! A Global Movement for Dignity and Human Rights* (New York: NYU Press, 2017), 10. This chapter draws upon our co-authored writings. I am indebted to Fish for sharing her ethnographic field notes and insights and for bringing me into the circle around the IDWN/IDWF. I have benefited from an advanced reading of Adelle Blackett, *Everyday Transgressions: Domestic Workers' Transnational Challenge to International Labor Law* (Ithaca, NY: ILR Press, 2019).
2. "Giant Apron Reaches Geneva," blog post, *IDWN ILO Blog*, June 8, 2010, https://idwnilo.wordpress.com/2010/06/08/giant-apron-reaches-geneva, accessed March 26, 2018.
3. Jennifer N. Fish, *C189: Conventional Wisdom*, Sisi Sojourner Productions, 2012, *at* http://jennifernataliefish.com/film/; Shirley Pryce, "I am a Domestic Worker," June 7, 2001, at https://idwnilo.wordpress.com/2011/06/07/domestic-workers-speak-out-with-through-song-and-poetry/, both accessed March 26, 2018.
4. The United States had Juana Flores, a migrant from Colombia and then Co-Director of Mujeres Unidas y Activas in San Francisco and a leader in the National Domestic Worker Alliance, as an advisor, and Jamaica had Pryce as advisor and substitute delegate in 2010 Worker delegations. See lists of delegates in ILC, *Provisional Record*, Ninety-Ninth Session (Geneva: ILO, 2010).
5. ILC, *Provisional Record*, Ninety-Ninth Session, 19/38–39.
6. ILC, *Provisional Record*, Ninety-Ninth Session, 19/36. On confrontation with US domestic workers in San Francisco, see Interview Notes by author with Jill Shenker and Claire Hobden, September 17, 2015, in author's possession. See also Eileen Boris and Megan Undén, "The Intimate Knows No Boundaries: Global Circuits of Domestic Worker Organizing," in *Gender, Migration, and the Work of Care*, ed. Sonya Michel and Ito Peng (New York: Palgrave, 2017), 258–259.

7. ILO, *Minutes of the Governing Body for the 308th Session* (Geneva: ILO, June 2010), 8–10.

8. Human Rights Watch, *Swept under the Rug: Abuses against Domestic Workers around the World* (New York: Human Rights Watch, 2006).

9. "A Message from Myrtle Witbooi, IDWN Chair," *IDWN News*, October 2011, 1.

10. Eileen Boris and Rhacel Parreñas, "Introduction," in *Intimate Labors: Cultures, Technologies, and the Politics of Care*, ed. Eileen Boris and Rhacel Parreñas (Stanford, CA: Stanford University Press, 2010), 1–12.

11. ILC, *Record of Proceedings*, Ninety-Ninth Session, 12/3, "Ms. Manuela Tomei," at http://www.ilo.org/public/english//protection/condtrav/contacts/mt.htm, accessed April 2, 2018.

12. ILO, *Domestic Workers across the World: Global and Regional Statistics and the Extent of Legal Protection* (Geneva: ILO, 2013), 2; Labour Migration Branch, *ILO Global Estimates on Migrant Workers* (Geneva: ILO, 2015), 6, 33; Ito Peng, *Transnational Migration of Domestic and Care Workers in Asia Pacific* (Geneva: ILO, 2017), 1.

13. ILO, *Profits and Poverty: the Economics of Forced Labor* (Geneva: ILO, 2014).

14. ILC, *Decent Work for Domestic Workers*, Report IV (1) (Geneva: ILO, 2009), 12. ILO reports have no attributed author, but Canadian law professor Adelle Blackett served as the academic expert. See, Blackett, "Introduction: Regulating Decent Work for Domestic Workers," *Canadian Journal of Women and the Law*, 23:1 (2011): acknowledgements, 1; n.32, 9.

15. Fish, *Domestic Workers of the World*, 195, makes a similar point. See also, Jo Becker, *Campaigning for Justice: Human Rights Advocacy in Practice* (Stanford, CA: Stanford University Press, 2013), 32–55.

16. Chris Bonner, Pat Horn, and Renana Jhabvala, "Informal Women Workers Open ILO Doors through Transnational Organizing, 1980s–1910s," in *Women's ILO: Transnational Networks, Global Labour Standards, and Gender Equity*, ed. Eileen Boris, Dorothy Hoehtker, and Susan Zimmermann (Leiden and Geneva: Brill and ILO), 176–201.

17. WIEGO, "Who We Are," February 1, 2013, http://wiego.org/wiego/who-we-are, accessed March 24, 2018.

18. Martha Alter Chen, "Recognizing Domestic Workers, Regulating Domestic Work: Conceptual, Measurement, and Regulatory Challenges." *Canadian Journal of Women and the Law*, 23:1 (2012): 167–184.

19. "Prevention of Prostitution: A study of preventive measures, especially those which affect minors," 45–70, Draft Report, League of Nations, Advisory Committee on Social Questions, Geneva, 15 May 1939, C.Q.S./A./19 (a), League of Nations Archive, Geneva.

20. Lewis Coser, "Servants: The Obsolescence of an Occupation Role," *Social Forces*, 52 (1973): 31–40; ILC, *Record of Proceedings, Thirtieth Session, 1947* (Geneva: ILO, 1948), 592.

21. ILC, *Record of Proceedings*, Ninety-Ninth Session, 12/12.

22. For "historic" reference, for example, ILC, *Record of Proceedings*, Ninety-Ninth Session, 6/5, 8/22, 12/2, 12/5, 12/6, 12/12, 12/13, 12/99, 12/121, 12/123, 19/38, 19/39.

23. Recent reports acknowledge the significance of care, both paid and unpaid. See ILO, *A Quantum Leap for Gender Equality: For a Better Future of Work for All* (Geneva: ILO, 2019); ILO, *Work for a Brighter Future: Global Commission on the Future of Work* (Geneva: ILO, 2019); Amelita King-Dejardin, *The Social Construction of Migrant Care Work* (Geneva: ILO, 2019).

24. Sonya Michel, "Mothers Working Abroad: Migrant Women Caregivers and the ILO, 1980s–2010," in *Women's ILO*, 318–339; Judy Fudge, "Feminist Reflections on the Scope of Labour Law: Domestic Work, Social Reproduction, and Jurisdiction," *Feminist Legal Studies*, 22:1 (2014): 1–23.

25. Martin Oelz, "The ILO's Domestic Workers Convention and Recommendation: A Window of Opportunity for Social Justice," *International Labour Review*, 153:1 (2014): 146–146. For example, "Note on Tokyo Office Report," 12/1930/05 in WIN 104/1/35, Jacket 1.

26. ILO, "The Moral Protection of Young Women Workers," in Advisory Committee on Social Questions, Prevention of Prostitution, "Draft Report submitted by the Rapporteur," 45–77, quote at 60.

27. LoN, *Record of Proceedings*, Fiftieth Session, 1931 (Geneva: ILO, 1931), 216.

28. Erna Magnus, "The Social, Economic, and Legal Conditions of Domestic Servants: I," *International Labour Review*, 30:2 (1934): 190, 195; Magnus, "The Social, Economic, and Legal Conditions of Domestic Servants: II," *International Labour Review*, 30:3 (1934): 363–364. On Magnus, see Kirsten Scheiwe and Lucia Artner, "International Networking in the Interwar Years: Gertrud Hanna, Alice Salomon and Erna Magnus," in *Women's ILO*, 75–96.

29. ILO, *Minutes of the Seventy-Seventh Session of the Governing Body* (Geneva: ILO, 12–14 November 1936), 129.

30. ILO, *Record of Proceedings*, Twentieth Session, 1936 (Geneva: ILO, 1936), 440, 465, 630–631, especially, 636, 740.

31. ILC, *Minutes of the Seventy-Seventh Session of the Governing Body*, 129.

32. ILC, *Record of Proceedings*, Twentieth Session, 1936 (Geneva: ILO, 1936), 630; "Resolution of the World's Y.W.C.A. Executive Committee concerning Domestic Servants," in ILO, *Minutes of the Eighty-First Session of the Governing Body* (Prague: ILO, 6–9 October 1937), 144; "Communications intended for the Governing Body," in ILO, *Minutes of the Eighty-Fifth Session of the Governing Body* (London: ILO, 25–27 October 1938), 164.

33. Anna Rice, *A History of the World's Young Women's Christian Association* (New York, 1947).

34. "The Growth of an Idea No. 9," August 1936, WN104/1/01, Jacket 1.

35. President, Secretary to Houseworkers' Union of Toronto, 10 March 1936, WN104/1/01, Jacket 1.

36. "Extract from a letter to Mrs. Fox from Miss Hutchison," April 29, 1936; Mrs. C. Beresford Fox to Miss P.M. Hage, November 17, 1939; World YWCA Council, "Meeting of Sub-Committee on Household Employment in the East," September 12, 1938, 2–6; "Programme of Conference on Household Employment as an Occupation for Women," August 11, 13, 1936, 2—all in WN104/1/01, Jacket 1. For an overview, see Social and Industrial Section, World's YWCA Executive Committee, *Household Employment*, Occasional Paper No. 9, February 1936. Here the Y notes the efforts of Thibert, 7.
37. Rice, *A History*, 209–214.
38. Mrs. C. Beresford Fox to M. Thibert, 14 December 1936; Social and Industrial Section, World's YWCA, "Household Employment," Occasional Paper No. 9, February 1936, 3, 7; M. Thibert to Mademoiselle Rossi, 13 March 1937; Fox to Dear Friends, "Household Employment in the East," 20 October 1938—all in WN104/1/01, Jacket 1.
39. ILC, *Record of Proceedings*, Twentieth Session, 630; ILO, *Minutes of Seventy-Seventh Session of the Governing Body*, 82, 129; "Resolution of the World's Y.W.C.A. Executive Committee concerning Domestic Servants," ILO, *Minutes of the Eighty-First Session of the Governing Body*, 144; ILC, "Communications intended for the Governing Body," in *Minutes of the Eighty-Fifth Session of the Governing Body*, 164.
40. In July 1945 the group consisted of members from women's bureaus, WYWCA, Catholic groups, trade unions and trade union support groups (such as the National Women's Trade Union League in the United States), and academic experts (like Mary van Kleeck of the Russell Sage Foundation).
41. ILO, *Minutes of the 117th Session of the Governing Body* (Geneva: ILO, 20–23 November 1951), 31; reprint of "Seventh Item on the Agenda: Status and Conditions of Employment of Domestic Workers," G.B.111/7/10, March 1950, 1–2, in US Women's Bureau, Office of the Director, General Correspondence of the Women's Bureau, 1948–1953, Box 68, Folder "Domestic Workers," RG86, National Archives and Records Administration (NARA), College Park, MD.
42. Frieda Miller to Joseph Harmen, November 30, 1951, US Women's Bureau, Office of the Director, General Correspondence, 1948–1953, Box 68, Folder "Domestic Workers," RG86, NARA.
43. ILO, *Minutes of the 113th Session of the Governing Body* (Brussels: ILO, 21–25 November 1950), 165; ILO, *Minutes of the 115th Session of the Governing Board* (Geneva: ILO, 1, 2, 22–23 June 1951), 38, 49.
44. Alice Angus to Mr. Persons, February 23, 1950; "Proposed Statement of U.S. Position on Terms of Reference for ILO Committee on Domestic Service," February 23, 1950, both in US Women's Bureau, Office of the Director, General Correspondence of the Women's Bureau, 1948–1953, Box 68, Folder "Domestic Work," RG 86, NARA.
45. ILO, *Minutes of the 117th Session of the Governing Body*, 93–94.
46. ILO, *Minutes of the 117th Session of the Governing Body*, 93–94.

47. ILO, *Minutes of the 99th Session of the Governing Body* (Montreal: ILO, 16, 17, and 27 September 1946), 70.

48. ILC, *Record of Proceedings*, Thirty-Sixth Session, 281.

49. ILC, *Record of Proceedings*, Thirty-Seventh Session, 1954 (Geneva: ILO, 1955), 297.

50. ILC, *Record of Proceedings*, Twenty-Ninth Session, 1946 (Montreal: ILO, 1948), 180; ILO, *Minutes of the 110th Session for the Governing Body* (Mysore, January 3–7, 1950), 29.

51. ILO, *Record of Proceedings*, Twentieth Session, 1936, 465.

52. ILO, *Minutes of the 110th Session of the Governing Body*, 29–30.

53. ILC, *Record of Proceedings,* Thirty-Seventh Session, 564–565.

54. ILO, *Minutes of the 117th Session of the Governing Body*, 32.

55. ILO, *Minutes of the 110th Session of the Governing Body*, 35.

56. For example, the revision of the maternity convention allowed for "temporary" exclusion of domestic workers and other non-standard occupations, see ILC, *Record of Proceedings*, Thirty-Fifth Session, 1952 (Geneva: ILO, 1953), 338. In responding to implementation of equal remuneration before the ILO Application of Conventions and Recommendations Committee, the Italian Constitutional Court in 1960s ruled that domestic workers and caretakers were outside of their collective labor law. ILC, *Record of Proceedings*, Forty-Ninth Session, 1965 (Geneva: ILO, 1965), 592–593. See also, ILC, *Record of Proceedings*, Twenty-Ninth Session, 179, 181, 458; ILC, *Record of Proceedings*, Thirty-Second Session, 1949 (Geneva: ILO, 1953), 501, 515; ILC, *Record of Proceedings*, Thirty-Sixth Session, 1953 (Geneva: ILO, 1954), 170, 405; ILO, *Minutes of the 110th Session of the Governing Body*, 38.

57. ILO, *Minutes of the 112th Session of the Governing Body* (Geneva: ILO, June 1950), 80–83.

58. Pauline Newman to Mildred Fairchild, August 7, 1951, in WN 8-3-61.

59. Memo from S. Thorsson to Chief of Women's and Young Workers' Section, 22 February 1950, in WN 8-3-1001.

60. Malvina Lindsay, "Global Kitchen Revolution: Who Will Do the Work?," *Washington Post*, January 23, 1952.

61. ILO, *Minutes of the 99th Session of the Governing Body*, 31.

62. ILO, *Minutes of the 117th Session of the Governing Body*, 32.

63. ILC, *Record of Proceedings*, Forty-Ninth Session, 511–512, 433.

64. Minutes, Elizabeth Johnstone to Dr. Amar; Amar to Johnstone, February 2, 1965; see also July 1, 1965—all in WN 8-3, Jacket 2, 8/1964–3/1976; Johnstone minute, to H.R.D., C.W.L. S.I.D., January 31, 1966, and following correspondence, especially October 10, 1966, February 14, 1967, April 26, 1967—all in WN 8-3-1003-01, Jacket 1.

65. "The Employment and Conditions of Domestic Workers in Private Households: An ILO Survey," *International Labour Review*, 102 (October 1970): 391–392, 395, 399, 401.

66. Adelle Blackett, *Making Domestic Work Visible: The Case for Specific Regulation*, Labour Law and Labour Relations Programme (Geneva: ILO, 1998), 8.

67. Patricia Weinert, "Foreign Female Domestic Workers: HELP WANTED!" Working Paper, MIG WP.50 (Geneva: ILO, March 1991), quote at ii; see also, Colectivo Ioé, "Foreign Women in Domestic Service in Madrid, Spain," Working Paper, MIG WP.51.E (Geneva: ILO, April 1991); Lega Italo-Filippina Filippini Emigrati, "Filipino Migrant Women in Domestic Work in Italy," Working Paper, MIG WP.5e3 (Geneva: ILO, July 1991). Significantly, the latter two reports came from collectives able to survey workers.

68. Quoted in Colectivo Ioé, "Foreign Women in Domestic Service in Madrid, Spain," 46.

69. Noeleen Heyzer and Vivienne Wee, "Domestic Workers in Transient Overseas Employment: Who Benefits, Who Profits?" in *The Trade in Domestic Workers: Causes, Mechanisms and Consequences of International Migration*, ed. Noeleen Heyzer, Geerje Lycklama à Nijeholt, and Nedra Weerakoon (London: Zed Books, 1994), 31–101.

70. ILC, *Decent Work for Domestic Workers*, Report IV(1), 11–14.

71. Fish, *Domestic Workers of the World*, 89–92.

72. Director General's Announcement, "Gender Equality and Mainstreaming in the International Labour Office' (Circular no. 564) of December 1999, in author's possession.

73. ILO, *Women's Empowerment: 90 Years of ILO Action* (Geneva: ILO, 1999): 8–10.

74. ILO, *Women's Empowerment*, 9–10; Shauna Olney, "The ILO, Gender Equality, and Trade Unions," in *Making Globalization Work for Women: The Role of Social Rights and Trade Union Leadership*, ed. Valentine M. Moghadam, Suzanne Franzway, and Mary Margaret Fonow (Albany: SUNY Press, 2011), 159–167.

75. ILC, *Decent Work for Domestic Workers*, Report IV(1), 15.

76. Manuela Tomei, "Decent Work for Domestic Workers: Reflections on Recent Approaches to Tackle Informality," *Canadian Journal of Women and the Law*, 23:1 (2011), 187. For part-time work, Leah F. Vosko, *Managing the Margins: Gender, Citizenship, and the International Regulation of Precarious Employment* (New York: Oxford University Press, 2010), 95–103.

77. "Statement of the Representative of the Secretary-General," Annex, I-3, ILC 59-507-2, Jacket 1.

78. For example, remarks of Mr. Ople from Philippines, ILC, *Record of Proceedings*, Sixtieth Session, 1975 (ILO: Geneva, 1976), 58.

79. "Women's Participation in the Workforce," Clause f, ILC, *Record of Proceedings*, Sixtieth Session, 776.

80. ILC, *Record of Proceedings*, Fifty-Ninth session, 1974 (ILO: Geneva, 1975), 715.

81. ILC, *Record of Proceedings*, Sixtieth Session, 794.

82. These included: International Catholic Girls' Society, International Council of Social Democratic Women, International Council of Women, International

Federation of University Women, and the Special Committee of International NGOs on Human Rights: Subcommittee on the Status of Women. Compare, Committee on Migrant Workers, ILC, *Record of Proceedings*, Fifty-Ninth Session, 46, with Committee on Migrant Workers, ILC, *Record of Proceedings*, Sixtieth Session, 66.

83. For the full text, see http://www.ilo.org/dyn/normlex/en/f?p=NORMLEXPUB :12100:0::NO:12100:P12100_INSTRUMENT_ID:312288:NO.

84. Patricia Weinert, comment, Minute Sheet: Inter-Departmental Project Proposal— Equality for Women Workers, 8 May 1990, MIG 31, Jacket 1.

85. "International Convention on the Protection of the Rights of All Migrant Workers and Members of Their Families," General Assembly Resolution 45/158, 18 December 1990, see https://treaties.un.org/Pages/ViewDetails. aspx?chapter=4&lang=en&mtdsg_no=IV-13&src=IND, accessed May 28, 2019.

86. Noeleen Heyzer, et al., *The Trade in Domestic Workers*, contained papers from a conference of the Asian and Pacific Development Centre; Lin Lean Lim, ed., *The Sex Sector: The Economic and Social Bases of Prostitution in Southeast Asia* (ILO: Geneva, 1998).

87. Notes on the Meeting with Ms. Hoffman and Ms. Wijers (Thursday, 20 September 1990), handwritten, MIG 31, Jacket 1.

88. Lim, ed., *The Sex Sector*, v-vi; Janice Raymond, *Legitimating Prostitution as Sex Work: UN Labor Organization (ILO) Calls for Recognition of the Sex Industry: A Critical Report* (Coalition Against Trafficking in Women, December 1998), in author's possession. Communications with various ILO officials on this study.

89. ILC, *Record of Proceedings*, Ninety-Second Session, 2004 (Geneva: ILO, 2004), 26/35.

90. ILC, *Record of Proceedings*, Ninety-Second Session, 22/4, 9, 18, 45.

91. ILC, *Record of Proceedings*, Ninety-Second Session, 7/5, 24 Part 2/9; for an overview, see Judy Fudge, "Precarious Migrant Status and Precarious Employment: The Paradox of International Rights for Migrant Workers," *Comparative Labour Law and Policy Journal*, 34:1 (2012): 101–137.

92. ILC, *Decent Work and the Informal Economy*, Report VI (Geneva: ILO, 2002), 2, 10–11.

93. ILC, *Record of Proceedings*, Ninetieth Session, 2002 (Geneva: ILO, 2002), 18/5.

94. http://www.ilo.org/dyn/normlex/en/f?p=NORMLEXPUB:12000:0::NO::::; Juan Somavía, "Decent Work for All in a Global Economy: An ILO Perspective," Third WTO Ministerial Conference in Seattle, 30th November to 3rd December, 1999, at http://www.ilo.org/public/english/bureau/dgo/speeches/somavia/1999/ seattle.htm.

95. ILC, *Record of Proceedings*, Ninetieth Session, 25/14–17.

96. ILC, *Record of Proceedings*, Ninetieth Session, 9/18, 12/10, 12/45, 25/3.

97. ILC, *Record of Proceedings*, Ninetieth Session, 25/13–14.

98. ILC, *Record of Proceedings*, Ninetieth Session, 25/22–32.

99. ILC, *Record of Proceedings*, Ninetieth Session, 25/53–61.

100. ILC, *Record of Proceedings*, Ninetieth Session, 25/56.

101. ILC, *Record of Proceedings*, Ninetieth Session, 25/12; Bonner et al., "Informal Women Workers Open ILO Doors," 188.

102. ILC, *Record of Proceedings*, Ninetieth Session, 17/43.

103. *Decent Work and the Informal Economy*, 71, 75, 82.

104. T. Sidibe to Cabinet, "Revision of the Indigenous and Tribal Populations Convention," 2/10/1987, ILC 75-4-416, Jacket 1.

105. Celia Mather, *"Yes, We Did It!" How the World's Domestic Workers Won Their International Rights and Recognition* (Manchester, UK: WIEGO Limited, 2013), iii.

106. Fish, *Domestic Workers of the World*, 207.

107. Helen Schwenken and Elisabeth Prügl, "An ILO Convention for Domestic Workers: Contextualizing the Debate," *International Feminist Journal of Politics*, 13:3 (2011), 438–443. See also Becker, *Campaigning for Justice*; Fish, *Domestic Workers of the World*. This section draws upon Eileen Boris and Jennifer N. Fish, "'Slaves No More': Making Global Labor Standards for Domestic Workers," *Feminist Studies*, 40:3 (Summer 2014): 411–443.

108. IRENE, *Respect and Rights: Protection for Domestic/Household Workers!* (Tilburg and Geneva: IRENE and IUF, 2008), "Preface," 14, 29.

109. For an overview from the movement, see Mather, *"Yes, We Did It!"* See also Mary Goldsmith, "Los Epacios Internacionales De La Participación Politica De Las Trabajadoras Remuneradas Del Hogar," *International Spaces for the Political Participation of Paid Female Household Workers*, 45 (2013): 233–246; Merike Blofield, *Care Work and Class: Domestic Workers' Struggle for Equal Rights in Latin America* (University Park: Pennsylvania State University Press, 2012).

110. Quoted in Schwenken and Prügl, "An ILO Convention for Domestic Workers," 444–445.

111. Becker, *Campaigning for Justice*, 52.

112. ILC, *Decent Work for Domestic Workers*, Report IV(1), 27–28, 41, 61, 74, 78; ILC, *Decent Work for Domestic Workers*, Report IV(2) (Geneva: ILO, 2010), 1; Robyn Rodriquez, *Migrants for Export: How the Philippine State Brokers Labor to the World* (Minneapolis: University of Minnesota Press, 2010); "Landmark treaty for domestic workers to come into force," 5 September 2012, at http://www.ilo.org/global/about-the-ilo/newsroom/news/WCMS_189191/lang--en/index.htm, accessed May 28, 2019.

113. Jennifer N. Fish, *Domestic Democracy: At Home in South Africa* (New York: Routledge, 2006).

114. IRENE, *Respect and Rights*, 16.

115. *Domestic Workers Across the World*, v, 43–47, 50–52; ILC, *Decent Work for Domestic Workers*, Report IV(2), 1; ILO, "Snapshot ILO in Action: Domestic Workers," 31 May 2013, http://www.ilo.org/travail/Whatsnew/WCMS_214499/lang--en/index.htm, accessed May 28, 2019.

116. Mather, *"Yes, We Did It!,"* 3.

117. Mather, *"Yes, We Did It!,"* 8, 12. On European care workers, see Francesca Degiuli, *Caring for a Living: Migrant Women, Aging Citizens, and Italian Families* (New York: Oxford University Press, 2015).

118. Mather, *"Yes, We Did It!,"* 8, 12.

119. They were: IRENE; FNV Mondiaal, a Netherlands trade union; Committee for Asian Women; Asian Domestic Workers' Network; Asia Monitor Resource Centre; WIEGO; BLINN, Bonded Labour in the Netherlands Humanitas/Oxfam; GLI, Global Labour Institute; PICUM, and IUF.

120. Other organizers were the Asian Domestic Workers' Network, Asia Monitor Resource Centre, Bonded Labour in the Netherlands Humanitas/Oxfam, and Global Labour Institute run by Dan Gallin, with support from CONLACTRAHO as well as the international labor federations. See IRENE, *Respect and Rights*, n.p., 10, 15; Bonner et. al., "Informal Workers Open ILO Doors," 191.

121. IRENE, *Respect and Rights*, n.p.

122. IRENE, *Respect and Rights*, 59.

123. Mather, *"Yes, We Did It!,"* 31.

124. IRENE, *Respect and Rights*, 19, passim.

125. I am indebted to Mather, *"Yes, We Did It!,"* 15–20, 40, for the most comprehensive account of these networks and their activities. See also Bonner et al., "Informal Women Workers Open ILO Doors," 190–192.

126. Becker, *Campaigning for Justice*, 52–53.

127. Mather, *"Yes, We Did It!,"* 26–27; ILO, *Minutes of the 300th Session of the Governing Body* (Geneva: ILO, 13–15 November 2007), 6–9, 29.

128. ILO, *Minutes of the 301th Session of the Governing Body* (Geneva: ILO, 18–20 March 2008), 4–10.

129. Jennifer N. Fish, ILC, field notes 2010, from Boris and Fish, " 'Slaves No More,' " 436.

130. Fish, *Domestic Workers of the World*, 88.

131. ILC, *Record of Proceedings*, Ninety-Ninth Session, 8/22.

132. ILC, *Record of Proceedings*, Ninety-Ninth Session, 8/20.

133. ILC, *Record of Proceedings*, Ninety-Ninth Session, 8/15.

134. ILC, *Record of Proceedings*, Ninety-Ninth Session, 8/10.

135. ILC, *Record of Proceedings*, Ninety-Ninth Session, 8/10. See also opening remarks of Director-General, 6/5.

136. ILC, *Record of Proceedings*, One-Hundredth Session (Geneva: ILO, 2011), 9/9.

137. ILC, *Record of Proceedings*, One-Hundredth Session, 9/34.

138. ILC, *Record of Proceedings*, One-Hundredth Session, 9/36.

139. ILC, *Record of Proceedings*, One-Hundredth Session, 10/42.

140. "Report of the Committee on Domestic Workers," in ILC, *Record of Proceedings*, One-Hundredth Session, 15/12–13.

141. Fish, ILC, field notes 2010, from Boris and Fish, "'Slaves No More,'" 437–441.

142. ILC, *Record of Proceedings*, Ninety-Ninth Session, 12/4–6.

143. ILC, *Record of Proceedings*, One-Hundredth Session, 15/30–15/50.

144. ILC, *Record of Proceedings*, One-Hundredth Session, 15/4.

145. On government and domestic worker activism during the proceedings, see Boris and Undén, "The Intimate Knows No Boundaries."

146. "Report of the Committee on Domestic Workers," in *Proceedings,* One-Hundredth Session, 15/18.

147. Jennifer N. Fish, Field Notes, 2011, in author's possession.

148. Eileen Boris, Field Notes from conversations with ILO staff, 2010, in author's possession.

149. Fish, Field Notes, 2011. See list of delegations for 2010 and 2011 in respective ILC, *Record of Proceedings*.

150. Eileen Boris and Jennifer Klein, *Caring for America: Home Health Workers in the Shadow of the Welfare State* (New York: Oxford University Press, 2012), 135.

151. ILC, *Decent Work for Domestic Workers*, Report IV(2), passim, 208.

152. ILC, *Decent Work for Domestic Workers*, Report IV(2), 38, 41. Boris and Klein, *Caring for America*, 213–214, 226–228.

153. ILC, *Decent Work for Domestic Workers*, Report IV(2), 34.

154. ILC, *Decent Work for Domestic Workers*, Report IV(2), 45, 171.

155. ILC, *Decent Work for Domestic Workers*, Report IV(2), passim.

156. Fish, Field Notes, 2011.

157. Megan Undén and Eileen Boris, Interview Notes with Jill Shenker and Claire Hobden, September 15, 2015, in author's possession.

158. Memo to Pier, March 13, 2010, in authors' possession.

159. Hobden biography at https://keywiki.org/Claire_Hobden, accessed May 9, 2018. She then became in charge of domestic worker issues in the Bureau for Workers' Activities.

160. Shenker biography, personal communication; she left the NDWA in late 2017.

161. The law in Uruguay provides for tripartite wage boards. On the US efforts to pass Bills of Rights, see Boris and Undén, "the Intimate Knows No Boundaries," 257–263; Flores quoted in Hina Shah and Marci Seville, "Domestic Worker Organizing: Building a Contemporary Movement for Dignity and Power," *75 Albany Law Review* 445 (2012). The original press release issued by the NDWA and the California Domestic Workers Coalition no longer is on their websites.

162. https://www.youtube.com/watch?v=loLvvMPK8yA&feature=youtu.be, accessed September 14, 2015.

163. Claire Hobden, *Winning Fair Labour Standards for Domestic Workers: Lessons Learned from the Campaign for a Domestic Worker Bill of Rights in New York State* (Geneva: ILO, 2010), 31.

164. Boris and Undén, "The Intimate Knows No Boundaries." For the latest victories, and bills, go to https://www.domesticworkers.org/, accessed, March 26, 2019.

165. Adelle Blackett, "Current Development: The Decent Work for Domestic Workers Convention and Recommendation, 2011," *American Journal of International Law*, 106 (October 2012), 791.

166. IDWN, *Platform of Demands*, ILC, Ninety-Ninth Session (Geneva: IUF, 2010), 3, 7–11; C189, Domestic Workers Convention, 2011 (No. 189), at http://www.ilo.org/dyn/normlex/en/f?p=NORMLEXPUB:12100:0::NO:12100:P12100_INSTRUMENT_ID:2551460:NO; R201, Domestic Workers Recommendation, 2011 (No. 201), at http://www.ilo.org/dyn/normlex/en/f?p=NORMLEXPUB:12100:0::NO:12100: P12100_INSTRUMENT_ID:2551502:NO

167. C189, Domestic Workers Convention, 2011 (No. 189); R201, Domestic Workers Recommendation, 2011 (No. 2011).

168. ILC, *Decent Work for Domestic Workers*, Report IV(1), 78–83.

169. Delaney, "Organizing Homeworkers," 97–98; http://wiego.org/, accessed August 20, 2014; Boris, Field Notes, Montevideo, October 24–30, 2013.

170. IRENE, *Respect and Rights*, 14, 13, 18.

171. Fish, *Domestic Workers of the World*.

172. Boris and Fish, "'Slaves No More;" Blofield, *Care Work and Class*; Helen Schwenken, "From Maid to Worker," *Queries*, 7:1 (2012): 14–21; Schwenken and Prügl, "An ILO Convention for Domestic Workers," 437–461; Becker, *Campaigning for Justice*, 32–55.

173. Quoted in Schwenken and Prügl, "An ILO Convention for Domestic Workers," 445–446.

174. Ratifications of C189 at http://www.ilo.org/dyn/normlex/en/f?p=1000: 11300:0::NO:11300:P11300_INSTRUMENT_ID:2551460, accessed March 26, 2019.

175. IDWF, *Domestic Workers of the World Unite: The Founding Congress of the IDWF* (IDWF, May 2014).

176. IDWN, Founding Congress, "Item 6: IDWN 5 Years Action Plan," 1–3, in author's possession.

177. Among funders present were representatives from WIEGO, ILO, Solidarity Center, ITUC, Open Society Foundation, The Olof Palme International Center, Friedrich Ebert Stiftung Singapore, IUF, and Migrant Forum in Asia. Boris, field notes, November 15–19, 2018.

178. http://idwfed.org/en/affiliates, accessed, March 25, 2019.

CHAPTER 7

1. ILO, *Women at Work: Trends 2016* (Geneva: ILO, 2016), 19–20.

2. Programme on Rural Women, "Medium Term Plan," 2, WEP 10-4-04-01, Jacket 11.

3. Eileen Boris, "Subsistence and Household Labour," in *The Global History of Work Handbook*, ed. Karin Hofmeester and Marcel van der Linden (Boston: De Gruyter, 2018), 329–344.

4. ILC, *Employment and Conditions of Work and Life of Nursing Personnel*, Report VI (1) (ILO: Geneva, 1976).

5. Mary E. Daly, ed., *Care Work: The Quest for Security* (Geneva: ILO, 2001), v; ILO, *ABCs of Women Workers' Rights and Gender Equality*, 2nd ed. (Geneva: ILO, 2007), 28–29.

6. Eileen Boris and Jennifer Klein, *Caring for America: Home Health Workers in the Shadow of the Welfare State* (New York: Oxford University Press, 2012) 53–54.

7. Guy Standing, "Care Work: Overcoming Insecurity and Neglect," in Daly, *Care Work*, 19, 32; http://www.guystanding.com/career, accessed, June 16, 2018.

8. http://www.ilo.org/global/about-the-ilo/history/centenary/WCMS_480301/lang--en/index.htm, accessed June 16, 2018.

9. Report of the Director-General, *The Women at Work Initiative: The Push for Equality* (Geneva: ILO, 2018), 2–3.

10. *The Women at Work Initiative*, 19.

11. ILO, *A Quantum Leap for Gender Equality: For a Better Future of Work For All* (Geneva: ILO, 2019), 77–84.

12. *The Women at Work Initiative*, 5–7; Global Commission on The Future of Work, "Addressing Care for Inclusive Labour Markets and Gender Equality," Issue Brief 3 (Geneva: ILO, 2018), 1.

13. ILO, *Ensuring Decent Working Time for the Future*, Report III(B), (Geneva: ILO, 2018).

14. *The Women at Work Initiative*, 12–13.

15. *The Women at Work Initiative*, 6–7; *Ensuring Decent Working Time*, 269, 274.

16. *Ensuring Decent Working Time*, 149–154.

17. https://caringacross.org/, accessed June 25, 2018.

18. ILO, *Care Work and Care Jobs for the Future of Work* (Geneva: ILO, 2018); *The Women at Work Initiative*, 18; Issue Brief 3, 2.

19. Manuela Tomei and Shauna Olney, "Preface," in ILO, *A Quantum Leap for Gender Equality*, 5.

20. *Care Work and Care Jobs; The Women at Work Initiative*, 17–18; Issue Brief 3, 3; Amelita King-Dejardin, *The Social Construction of Migrant Care Work: At the Intersection of Care, Migration and Gender* (Geneva: ILO, 2019)

21. *The Women at Work Initiative*, 7.

22. ILO, *Meeting of Experts on Violence against Women and Men in the World of Work*, Final Report (Geneva: ILO, 2016), 3, 5–7; Bernice Yeung, *In A Day's Work: The Fight to End Sexual Violence against America's Most Vulnerable Workers* (New York: New Press, 2018). Yeung shows the need for a multi-prolonged organizing, education, and legal approach in which unions play a key role.

23. *Meeting of Experts on Violence against Women and Men*, 12, 14, 33.

24. *Meeting of Experts on Violence against Women and Men*, 32, 34–36.

25. *Meeting of Experts on Violence against Women and Men*, 24.

26. ILC, "Reports of the Standard-Setting Committee on Violence and Harassment against Women and Men in the World of Work: Summary of Proceedings," *Provisional Record*, 107th Session (Geneva: ILO, May–June 2018), 8B (Rev.1), 4.

27. "Reports of the Standard-Setting Committee on Violence and Harassment," 5, 15–17, 43–44.

28. "Reports of the Standard-Setting Committee on Violence and Harassment," 9.

29. IDWF, *Platform of Demands: Violence and Harassment against Women and Men in the World of Work*, 4, at http://www.idwfed.org/en/resources/platform-of-demands-violence-and-harassment-against-women-and-men-in-the-world-of-work, accessed June 20, 2018.

30. ILC, *Ending Violence and Harassment against Women and Men in the World of Work*, Report V(2) (Geneva: ILO, 2018), 1.

31. ILC, *Ending Violence and Harassment against Women and Men in the World of Work*, Report V(1) (Geneva: ILO, 2018), 38–41.

32. ILC, "Reports of the Standard-Setting Committee: Resolution and Proposed Conclusions," *Provisional Record*, 107th Session, 8A (Geneva: ILO, 2018), 4–7, quote at 5.

33. "Reports of the Standard-Setting Committee on Violence and Harassment," 63.

34. "Reports of the Standard-Setting Committee on Violence and Harassment," 82–85, 120–123; "Proposed Conclusions with a View to a Recommendation," paragraph 26, in "Reports of the Standard-Setting Committee," 9.

35. R200, "HIV and AIDS Recommendation, 2010," at http://www.ilo.org/dyn/normlex/en/f?p=NORMLEXPUB:12100:0::NO::P12100_ILO_CODE:R200.

36. Magaly Rodríquez García, "The ILO and the Oldest Non-profession," in *The Life Work of a Labor Historian: Essays in Honor of Marcel van der Linden*, ed. Ulbe Bosma and Karin Hofmeester (Leiden: Brill, 2018), 90–114.

37. Informal conversations with officials and delegates with author illuminated the politics of passage. "Fifth item on the agenda: Violence and harassment against women and men in the world of work: Reports of the Standard-Setting Committee: Summary of proceedings," *Provisional Record*, 8B (Rev.1), 10 October 2018; further compare "Fifth item on the agenda: Violence and harassment against women and men in the world of work: Reports of the Standard-Setting Committee: Resolution and proposed Conclusions," *Provisional Record*, 8A, 107th Session, Friday 8 June 2018, with ILC, Convention 190; Recommendation 206, both downloadable from https://www.ilo.org/global/about-the-ilo/newsroom/news/WCMS_711891/lang--en/index.htm, accessed July 3, 2019.

38. *The Women at Work Initiative*, 14, 20.

39. *The Women at Work Initiative*, 11.

40. ILO Centenary Initiatives, at https://www.ilo.org/global/about-the-ilo/history/centenary/lang--en/index.htm, accessed June 21, 2018.

41. ILO, *The Future of Work We Want: A Global Dialogue* (Geneva: ILO, 2017), 18, 14; Eurofound, *Non-standard Forms of Employment: Recent Trends and Future Prospects* (Dublin: Eurofound, 2018); "More than 60 Per Cent of the World's Employed Population are in the Informal Economy," ILO Press Release, April 30, 2018, http://www.ilo.org/global/about-the-ilo/newsroom/news/WCMS_627189/lang--en/index.htm, accessed June 21, 2018.

42. ILC, *Decent Work in Global Supply Chains*, Report VI (Geneva: ILO, 2016), 65–68.

43. "ILO, IFC Join to Promote 'Better Work' in Global Supply Chains: An Interview with Ros Harvey," September 17, 2007, http://www.ilo.org/global/about-the-ilo/newsroom/features/WCMS_084048/lang--en/index.htm, accessed June 21, 2018.

44. Nelson Lichtenstein, "The Demise of Tripartite Governance and the Rise of the Corporate Social Responsibility Regime," in *Achieving Workers' Rights in the Global Economy*, ed. Richard P. Appelbaum and Nelson Lichtenstein (Ithaca, NY: Cornell University Press, 2016), 104–108.

45. *Ensuring Decent Working Time*, 313; "ILO-IFC Programme in the Garment Industry Makes Workers' Lives Better and Stronger," September 27, 2016, http://www.ilo.org/hanoi/Informationresources/Publicinformation/Pressreleases/WCMS_528714/lang--en/index.htm, accessed June 21, 2018.

46. "Better Work," January 16, 2018, at http://www.ilo.org/washington/areas/better-work/lang--en/index.htm, accessed June 21, 2018; for overall critiques of corporate responsibility projects, see Appelbaum and Lichtenstein, *Achieving Workers' Rights*.

47. Lin Lean Lim, *Employment Relationships and Working Conditions in an IKEA Rattan Supply Chain* (Geneva: ILO, 2015).

48. Eileen Boris, "'Social Responsibility on a Global Level': The National Consumers' League, Fair Labor, and Worker Rights at Century's End," in *A Coat of Many Colors: Immigration, Globalism and Reform in the New York City Garment Industry*, ed. Daniel Soyer (New York: Fordham University Press, 2004), 211–233; Appelbaum and Lichtenstein, *Achieving Workers' Rights*; Gay W. Seidman, *Beyond the Boycott: Labor Rights, Human Rights, and Transnational Activism* (New York: Russell Sage, 2007); Louis Hyman and Joseph Tohill, eds., *Shopping for Change: Consumer Activism and the Possibilities of Purchasing Power* (Ithaca, NY: ILR Press, 2017).

49. Guy Standing, "The ILO: An Agency for Globalization?," *Development and Change*, 39:3 (2008), 355–384; Guy Standing, *Work after Globalization: Building Occupational Citizenship* (Northampton, UK: Edward Elgar, 2009).

50. Larry Elliott, "World Bank Recommends Fewer Regulations Protecting Workers," *Guardian*, April 20, 2018, https://www.theguardian.com/money/2018/apr/20/world-bank-fewer-regulations-protecting-workers?CMP=share_btn_link, accessed April 20, 2018.

APPENDIX I

1. "List of Conventions and Recommendations," in *The ILO and Women, 1919–1969* (Geneva: ILO, 1969), 42. See also Maryse Gaudier, *The Development of the Women's Question at the ILO, 1919–1994: 75 Years of Progress towards Equality* (Geneva: ILO, 1996); ILO, "Lists of Instruments by Subject and Status," (Geneva: ILO, 2009), http://www.ilo.org/dyn/normlex/en/f?p=1000:12030:::NO:::.

Index

Page numbers in italic indicate an illustration.

Abbott, Elizabeth (Great Britain), 33, 36
Abbott, Grace (United States), 53–54
Action Plan for Gender Equality, 239
AFL-CIO, 216–222
African American Women at The Conference of Working Women, 27
African development, 104
"African Women and Development: The Decolonisation of Research" workshop, 143
agricultural workers, maternity standards for, 30
Ahmad, Zubeida M. (Pakistan): on basic needs approach, 130; on Mies, 143; on participatory research, 144–145; on the Programme for Rural Women, 123; on putting-out system, 171–172; on reproductive labor, 123; retirement of, 152; SEWA and, 157; on sexual division of labour, 153; on *Women at Work*, 150
Alegría, Garza, Paula (Mexico), 60
Alliance and the Liaison Committee, 71
alternative labor formations, 221
Ambassador's Program, The, 223

Anthrax Prevention Recommendation (No. 3), 29
Archdale, Helen (Great Britain), 33
archives as a site of memory, xx
Asian Advisory Committee, 96
Asian and Pacific Centre for Women and Development, 119
Asian Domestic Workers Network, *194*
Asian "sex sector" report, 209
Asian Technical Conference on Cooperation, 99
Asian women, 95–98
Assalé, Charles (France), 66
Atanatskovitch, Milena (Yugoslavia), *37*
attire in the workplace, 97
Australian Clothing and Allied Trade Union, 168
Avendaño, Ana, 222

Barrett, June, *xviii*
basic needs, 119–120, 124, 127, 130–134, 137, 149, 230
Bautista, Marcelina, 1
Beauvoir, Simone de, 2
beedi workers, 125, 169–171, 179–181, 188
Béguin, Antoinette, 138, 152, 172

Benería, Lourdes (United States): career of, 136–138; at Dakar Decolonisation project, 142–143; on *Lace Makers of Narsapur*, 146; on rural women, 122; on wage labor, 140; *Women and Development*, 138, 140–142. *See also* Programme on Rural Women

Bernardino, Minerva (Dominican Republic), 80

Better Factories Cambodia, 240

Better Work Programme, 240

Beyer, Clara (United States), 71

Beyond the Veil (Mernissi), 138

Bhatt, Ela R.: Blanchard on, 175, 183; on home work, 155, 185–186; Magsaysay Award, 175, 178; on putting-out system, 172; relations with TLA, 175–176, 178–179; significance of, 172–176; on victimization, 177. *See also* Self Employed Women's Association (SEWA)

Bhatty, Zarina (India), 169–170

Blackett, Adelle, 207, 223, 307n14

Blanchard, Francis (France), 146, 149, 175, 183, 188

Blanco, Gilda, *xviii*

Bompas, Katherine (Great Britain), 53

bona fide occupational qualification, 84

Bondfield, Margaret (Great Britain), 19, 20, 27–28, 30, 40, 42

Bonner, Chris, 214

Boris, Eileen, *xviii*, xx

Bornstein, Melanie (Poland), *18*

Boserup, Ester (Denmark), 117, 122

Bouillet, Georgette (France), *18*

Bouvier, Jeanne (France), *18*, 19, 26, 28

breadwinner models, male, 6–7, 59, 126

British Commonwealth League, 64

British Medical Women's Federation, 45

Brown, Irving, 289n72

Brunn, 95–96

Buch, Arvind (India), 164–165, 167, 176, 178

Bureau for Gender Equality (GENDER), 207

Burrow, Sharan (Australia), 209

Business for Social Responsibility, 240

Butler, Harold (Great Britain), 33–34

Butler, Judith, 8, 132

Cappe, Victoire (Belgium), *18*

Capper, Arthur, 50–51

care work, economic aspects, 242

care work, future of, 229–233

care work, recognizing, 13–14

Care Work and Care Jobs for the Future of Work (ILO), 232

Casselman, Cora (Canada), 60

Castellanos, Guillermina, 216–217

CEDAW (Convention on the Elimination of All Forms of Discrimination Against Women), 4, 91, 94, 110–116, 121

Centennial initiatives, 239

Chatterjee, Mirai, 176

child protections in tavern employment, 46

class and gender approaches to women's work, 31–34

clothing and textile industry. *See* textile and clothing industry

Cold War, impact of, 65–66, 79–80

colonial powers, 21–22, 61–64, 82

Committee of Experts on the Social Protection of Homeworkers, 183–187

Committee on Dependent Territories, 62

Committee on Domestic Workers, 194–196, 215, 217

Committee on Employment, 57–58

Committee on Equal Remuneration, 82–83

Committee on Migrant Workers, 208–210

Committee on Post-War Employment, 59

Committee on Seamen's Welfare, 43–44

Committee on the Informal Economy, 212

Committee on the Night Work of Women, *37*

Committee on the Status of Women (CSW), 78–79, 83, 110–116

commodity production, 159

community development through cooperatives, 92

comparable worth, 58

Conditions of Women's Work in Seven Asian Countries (Miller), 101

CONLACTRAHO (Latin American and Caribbean Confederation of Household Workers), 213

Contracts of Employment (Indigenous Workers) Convention, 1939 (No. 64), 48, 51–52

Convention on the Elimination of All Forms of Discrimination Against Women (CEDAW), 4, 91, 94, 110–116, 121

Convention on the Political Rights of Women, 94

Convention on Violence and Harassment Against Men and Women in the World of Work, *234*

conventions, enforcement and implementation, 282n89

Co-operation and Handicrafts Division of the Office, 98

Correspondence Committee on Women's Work, 35

cottage industries, 98–99, 103

Croll, Elizabeth (New Zealand), 139, *140*

Crowdy, Dame Rachel (Great Britain), 44

CSW (Committee on the Status of Women), 78–79, 83, 110–116

DAWN (Development Alternatives with Women for a New Era), 138, 153, 154, 175

Decade for Women, 119, 122, 126–127, 149, 175, 180

Decades of Development, United Nations, 91

"Decent Work" agenda, 198, 207, 210–212, 216

"Decent Work for Domestics" (Convention No. 189), 1, 223

Declaration of Philadelphia (1944), 55, 57–58, 209

Declaration on Equality of Opportunity and Treatment for Women Workers, 94, 115, 117–118

Declaration on the Elimination of Discrimination Against Women, 94

Deere, Carmen Diana, 139

de Lalieux, Berthe (Belgium), *18*

Demaret, Luc, 207

De Meester, Kris (Belgium), 235

Development Alternatives with Women for a New Era (DAWN), 138, 153, 154, 175

development and developing countries: Asian and Pacific Centre for Women and Development, 119; in a changing world, 89, 104–105; concept of, 92–93; discourse on, 89; "The Economic and Social Advancement of Women in Developing Countries," 105; handicraft production and, 97–103; ILO development feminists, 124–126, 175, 210; labor force participation in, 90; WID theory, 94, 106–107, 128–129; *Woman's Role in Economic Development*, 117. *See also* home work and workers; Programme on Rural Women

Diallo-Touré, Tamaro (Senegal), 118

Discrimination (Employment and Occupation) Convention, 1958 (No. 111), 84–86

Dobrzanska, Sophie (Poland), *18*

domestic work and workers: advocates, 201–203; campaigners, 197; Committee on Domestic Workers, 194–196; contracting of, 50; in equality deliberations, 58; Expert Committee on Domestic Work, 78; growth of, 196; at the ILC, 217–219; migrant workers in relation to, 208–210; NDWA, *xviii*, 212, 216, 220–223; night work and, 26–27; opponents, 194, 203–204; part-time work in relation to, 207; policy demands, 215–216; reports on, 206; "Resolution concerning the Conditions of Employment of Domestic Workers," 205; sex work and slavery linked to, 209, 210; significance of, 195–196; studies on, 199

Domestic Workers Bill of Rights (DWBOR), 222–223

Domestic Workers Convention (No. 189) and Recommendation No. 201 (2011): deliberations, 193–194, 217–219, 222; historical aspects, 199–206; ratification of, 213–214, 225–226

significance of, 1, 196, 223–227; U.S. role, 219–223

dress in the workplace, 97

DWBOR (Domestic Workers Bill of Rights), 222–223

Ebeling, Lena (United States), 81–82

Economic and Social Council (ECOSOC), 79–80

Economic Role and Status of Women (Bhatty), 169–170

Ekendahl, Sigrid (Sweden), 109

Elliott, Dorothy (Great Britain), 78, 201

emigrant women and sex, 39–40

Emmerij, Louis (Netherlands), 130

Employer delegates, 5

Employment (Women with Family Responsibilities) Recommendation, 1965 (No. 123), 108–110, 115

Employment and Development Branch (EMPLOI), 124, 132, 137–138, 149, 153, 179, 183

Employment of Women in the Textile, Garment, and Leather Industries, The (ITGLWF), 178

Employment/Rural (EMP/RU), 124, 147, 149, 172

equality, legal: barriers to, 107; defining, 66–67, 70; deliberations, 59–62; discourses of, 56; Equal Rights Amendment, 31, 33, 54; equal treatment, 13; female difference vs., 57–58, 84–86; obtaining and measuring, 3; special protections vs., 32–36; "Third World" difference and, 63–64

equal remuneration, 9, 76–83, 126

Equal Remuneration Convention, 1951 (No. 100), 55–56

Expert Meeting on Employment, 150

Experts Committee of Domestic Work, 78

External Relations Branch (RELTRAV), 179

Fairchild, Mildred (United States), 56, 68–71, 78, 80, 96

family responsibilities, 13, 56, 72–74, 108–110, 115

FAO (Food and Agricultural Organization), 92, 130, 142

Farris, Sara, 6

Federatie Nederlandse Vakbeweging (FNV), 156, 183, 215, 234

female difference, 95, 96, 105

FEMMES (Office of Women Workers' Questions), 115, 117, 121, 126, 133, 137, 149–150, 169

Figueroa, Anna (Chile), 93

First-Dilic, Ruza (Croatia), 139

Fish, Jennifer, 222, 306n1

Flores, Juana (United States), 212, 220, 223, 306n4

Food and Agricultural Organization (FAO), 92, 130, 142

forced or compulsory labor, 47–52

Ford, Charles, 165, 169, 178, 179–180, 184

Fortunati, Leopoldina, 7

Four Freedoms of Labour, 240

Fourth Conference of American States Members, 103

Funes De Rioja, Daniel, 194–195

Gallin, Dan, 155, 180, 183, 186, 197, 216

Gandhi, Mahatma, 175

garment industry. *See* textile and clothing industry

GENDER (Bureau for Gender Equality), 207

gender and development field, 128

gender and the organization of labor, 5

gender integration, 91, 107, 120, 139–140

gender mainstreaming, 5, 11, 115, 126, 238

geography and the organization of labor, 5

Ghai, Dharam (Uganda), 137, 142, 145, 147–148, 152, 169

gig economy, the, 231

Global South. *See* development and developing countries

Gompers, Samuel (United States), 22–23, 32

Green, Edith, 84

Griffin, Keith (United States), 130–131, 134, 136–137, 289n72

Group of 77, the, 118

Hancock, Florence (Great Britain), 78, 203

handicraft production, 97–104

Hanna, Gertrude (Germany), 32, 36

Hansenne, Michael (ILO), 184

Hesselgren, Kerstin (Sweden), 18, *37*

Hinder, Eleanor, *54*

HIV/AIDS, workers with, 237

Hobden, Claire, 222, 223

home work and workers: domestic work compared to, 225; employers on, 166–167; equal Remuneration and, 76–78; in the garment industry, 159, 162, 168; gendered aspects, 166, 231–232; grassroots organizations, 171–175; growth of, 160, 168; ILO strategists, 171–173; in India, 158; industrial, 28, 92, 100–101; International Workshop on Homebased Workers, xix; putting-out system and, 169–171; rates of, 162; sectorial committees, 161–165; textile and clothing unions, 161–165, 167–168; TLA, SEWA and, 177–179

Home Work Convention, 1996 (No. 177), 10, 154, 157, 188

Homeworkers in Global Perspective (Boris), xx

Horn, Pat (South Africa), 212

household workers, 193, 197–199, 203, 213, 214, 216, 224–225

Housewives Produce for the World Market (WEP), 169

ICFTU (International Confederation of Free Trade Unions), 155–156, 162, 166, 177–178, 183, 186, 197, 210, 212. *See also* Home Work Convention, 1996 (No. 177)

Identification of the Basic Needs of
Women, 119–120
IDWF (International Domestic Workers
Federation), 2, 221–222,
226–228, 236
IDWN. *See* International Domestic
Workers Network (IDWN)
IFC (International Finance
Corporation), 240
ILC (International Labour Conference).
See International Labour
Conference (ILC)
ILGWU (International Ladies' Garment
Workers' Union), 164, 167, 168, 183
*Indian Women in Subsistence and
Agricultural Labour* (Mies), 147
Indigenous and Tribal Populations
Convention, 1957 (No. 107), 212
industrial home work, 28, 92, 100–101
informal sector, formalizing the, 8, 11,
210–212, 229
Inness, Kathleen (Great Britain), 49
International Catholic Migration
Commission, 208
International Confederation of Free
Trade Unions (ICFTU), 155–156,
162, 166, 177–178, 183, 186, 197,
210, 212. *See also* Home Work
Convention, 1996 (No. 177)
International Conference of Labor
Statisticians, 229
International Congress of Working
Women, 9, *18*, 19–20, *25*, 29
International Convention on the
Protection of the Rights of All
Migrant Workers and Members of
Their Families, 209
International Domestic Workers Federation
(IDWF), 2, 221, 222, 226, 227, 226–228
International Domestic Workers
Network (IDWN): delegates, 2;
demands of, 224; formation of, 197;

impact of, 198; relation to IDWF,
226
role of, 216
Shenker and, 222
significance of, 212–213
strategies of, 193, 217–218; Witbooi at,
193–195
International Federation of Trade Unions
(IFTU), 17–19, 31–34
International Federation of Working
Women, 31
international feminist federations, 81
International Finance Corporation
(IFC), 240
International Garment Workers'
Federation, 161–162
International Labour Conference
(ILC): 1964 agenda, 104;
Committee on the Night Work
of Women, *37*; domestic workers
at, 217–219; on domestic workers
resolution, 204; First, 9, 25–31; on
home work, 157–158; Philadelphia,
54, 57–62; relations with the
International Congress of Working
Women, 18–19; role of, 12; on rural
women, 151; women in, 5
International Labour Organization
(ILO): constitution, 47–48;
expansion of, 93; financial
aspects, 129; nomenclature of, xvii;
origin and purpose of, 2, 22–24;
role and purpose of, xix; *Rural
Development and Women in
Africa*, *123*; "Social, Economic and
Legal Conditions of Domestic
Servants, The," 199; staffing, 127;
standards, xx, 1; structure of, 3, 12–
13; twin principles of, 91
International Ladies' Garment
Workers' Union (ILGWU), 164,
167, 168, 183

International Restructuring Education
Network Europe (IRENE),
173, 182, 214–215

International Textile, Garment and
Leather Workers' Federation
(ITGLWF), 163–165, 167, 169, 184

International Trade Union Confederation
(ITUC), 197, 215–216, 227

International Union of Food,
Agricultural, Hotel, Restaurant,
Catering, Tobacco and Allied
Workers' Association (IUF),
155–157, 173, 179–180, 183, 197, 212,
216–217, 225

International Woman Suffrage Alliance
(IWSA), 23–24

International Women's Year (IWY), 115,
117, 118

International Workshop on Homebased
Workers, xix

IRENE (International Restructuring
Education Network Europe),
173, 182, 214–215

ITGLWF (International Textile,
Garment and Leather Workers'
Federation), 163–165, 167, 169, 184

IUF (International Union of Food,
Agricultural, Hotel, Restaurant,
Catering, Tobacco and Allied
Workers' Association), 155–157, 173,
179–180, 183, 197, 212, 216–217, 225

IWY (International Women's Year), 115,
117, 118

Jahan, Rounaq, 146–147, 153, 189

Jain, Devaki (India), 93–94

Janjic, Marion (Switzerland), 115, 149,
175

Jayawardena, Kumari (Sri Lanka), 120

Jenks, C. W., 83

Jhabvala, Renana, 155–156, 176, 180, 197, 212

Johnson, George A., 44

Johnstone, Elizabeth, 90, 91, 104, 108,
111–112, 115, 121, 205

Jouhaux, Léon (France), 22–23, 28

Kahn, Elinor (United States), 79

Kanyoka, Vicky, 1

Kelles-Viitanen, Anita, 171, 299n81

Kenyon, Dorothy (United States), 113

Kjelsberg, Betzy (Norway), 18, 29

Kloosterman, John, 194

Korchounova, Ekaterina (Soviet Union),
121, 149

Kuusinen, Hertta (Finland), 117

Labor feminists, impact of, 31

labor force participation statistics, 90

Lace Makers of Narsapur (Mies), 145–
147, 169

lacemaking workers, 143–144, 170

Lafrance, Robert, *54*

Lalita and Kumari, Krishna, 143–144

Landova-Stychova, Luisa
(Czechoslovakia), *18*

Latin American and Caribbean
Confederation of Household
Workers (CONLACTRAHO), 213

Latin American feminists, 85

Laverty, Sonia (Australia), 168

Law and Women's Work
(Thibert), 66–67

Lead Poisoning (Women and Children)
Recommendation (No. 4), 29

League of Nations, historical aspects, 3–4

Le Blanc, Ida (Trinidad-Tobago), 218

Legal Regulations (LEG/REL), 173

Legien, Carl (Germany), 32

Léon de Leal, Magdalena, 139

LGBTQI people, 67, 235, 238

Lim, Lin Lean, 209

location politics, 30

Longhurst, Richard (Great Britain), 142

Lorey, Isabell, 8

Loutfi, Martha F. (United States), 124–125, 150, 152, 157, 169, 171–175

Lukasiuk, Yadwiga (Poland), *18*

Lutz, Bertha, 53–54, 60–62

Macarthur, Mary (Great Britain), 17, 18

Macmillan, Chrystal (Great Britain), 33, 35

Magnus, Erna (German), 199

Majerová, Marie (Czechoslovakia), *18*, 26

male breadwinner model, 6–7, 59, 126

maritime commission, committees, and conventions, 42–47, 235–236

"Market Economy on Women's Productive and Reproductive Work in the Rural Subsistence Sector in India" (Mies), 143–144

Marxism, 159

maternity benefits, 27

Maternity Protection Convention, 1919 (No. 3), 28, 30, 73–76

Maternity Protection Convention, 2000 (No. 183), 231

Matheson, Alana (Australia), 236

Meeting of Experts on the Status and Conditions of Employment of Domestic Workers, 201–205

Mehta, Hansa (India), 80

Menon, Geeta (India), 215

Mernissi, Fatima (Morocco), 138

Métall, R. A. (ILO), 73

microenterprises, 5, 179, 211, 306n184

Mies, Maria (Germany): on capitalism, 139; on home work, 166, 169–170; *Indian Women in Subsistence and Agricultural Labour*, 147; *Lace Makers of Narsapur*, 145–147; "Market Economy on Women's Productive and Reproductive Work in the Rural Subsistence Sector in India" 143–144; significance of, 129;

in *Women and Development*, 139, 142

migrant labor in relation to domestic workers, 208–210

migrant workers, 39–42, 215–216

Migrant Workers (Supplementary Provisions) Convention, 1975 (No. 143), 209

Miller, Frieda (United States): in Asia, 99–100; *Conditions of Women's Work in Seven Asian Countries*, 101; on development issues, 97; and domestic workers, 201–202; on equal Remuneration, 54–55; Fairchild and, 69–73; on maternity convention, 74–76; role and impact of, 56; significance of, 67; on Third World women, 95; on training, 91; U.S. activities, 84

mines, 38–39

Minimum Age (Non-Industrial) Employment Convention, 1932 (No. 33), 41

Minimum Wage-Fixing Machinery Convention, 1928 (No. 26), 28–29

"Mobilizing Action for the Protection of Domestic Workers from Forced Labour and Trafficking in South-East Asia," 210

modernization theory, 127

Mohanty, Chandra, 10

Momzombite, Leddy (Peru), 213

Montevideo, Uruguay, 2, 103, 226

moral protections, 41–42

Morgenstern, Felice (ILO), 116

Morse, David (ILO), 69, 89, 92–93, 158–159

Mukherjee, Shanta (India), 66

multinational enterprises, 160

Mundt, Martha (Germany), 35

Myrddin-Evans, Guildhaume, Sir (Great Britain), 65–66

Nathan, Christine (India), 211

National Domestic Workers Alliance (NDWA), *xviii*, 212, 216, 220–223

National Group on Homeworking, 174

National Woman's Party (NWP), 31, 33–34

native and indigenous workers, 21–22, 47–52, 60–64, 103, 212

Nelson-Cole, Norma (Nigeria), 108

neoliberalism, origin and nature of, 6

New Dealers, 69–70

New International Economic Order, 94, 116, 118–119

Newman, Pauline (United States), 67, 204

night work, 26–27, 29–30

Night Work Convention, 1990 (No. 171), 36–37, 71–72, 114

night work deliberations, 29–30

Nikolaeva, Tatiana (Soviet Union), 113

Nilsson, Karin, 38

Nursing Personnel Convention, 1977 (No. 149), 229–230

ODI (Open Door International), 33–34, 64, 81, 269n59

OECD (Organisation for Economic Co-operation and Development), 129

Office for Women Workers' Questions (FEMMES), 115, 117, 121, 126, 133, 137, 149–150, 169

offshoring, 157–160, 165

Olney, Shauna, 233

Olszewska, Konstancja (Poland), *18*

Open Door International (ODI), 33–34, 64, 81, 269n59

Organisation for Economic Co-operation and Development (OECD), 129

outwork. *See* home work and workers

own-use production, 229

Palmer, Ingrid (Australia), 124, 131–135, 148, 289n66

participatory research, 125, 144–145

part-time labor, 98–104, 107–108

Part-Time Work Convention (No. 175), 207

Passchier, Catelene (Netherlands), 234

PATAMABA (Philippine National Network of Homeworkers), 182

Paul, Alice (United States), 33, 34, 50, 51

Percy Amendment, 117

Perkins, France (United States), 50–51, 54

Peterson, Esther, 89, 107–109

Philadelphia conference, 54, 57–62

Philadelphia Declaration (1944), 209

Philippine home-based work, 101

Philippine National Network of Homeworkers (PATAMABA), 182

Phongpaichit, Pasuk, 147–148

PIACT (Working Conditions on Employment), 173

Pier, Carol, 222

Plantations Convention, 1958 (No. 110), 76

Poo, Ai-jen, 220

Popova, Elizavieta Aleskseevna (Russia), 79–80

Preparatory Subcommittee on Handicraftsmen, 98

Programme on Rural Women: case studies, 141–143; as class-based, 94; consultants' workshop, 137–142; FEMMES relations with, 149–150; on home work, 171; home work and, 157–158; nature and purpose of, 122, 124–127; Palmer and, 131–135; relations with SEWA, 174–175; significance of, 10, 153–154; technical cooperation shift, 152

prostitution, 40–41, 45–46

protective standards vs. cultures of protection, 9, 20–21, 24, 26, 34–39

Prügl, Elisabeth, 188

Pryce, Shirley (Jamaica), 193, 306n4

putting-out system, 169–173

race discrimination, 84–86
radical feminism, 132
Raharison, Dorothée, 106
Rahman, Kamran (Bangladesh), 219
Rao, Raghunath (ILO), 95–96
RELTRAV (External Relations Branch), 179
Rens, Jef (Belgium), 60, 77–78, 102
Report on Homework (ITGLWF), 164
reproductive labor: attitudes toward, 119; commodity production linked to, 159; definition of, 123–124; discussions, 38; forced labor linked to, 48–49; income from, 130; Palmer on, 131–135; productive labor in relation to, 7. *See also* Programme on Rural Women
"Resolution concerning the Conditions of Employment of Domestic Workers," 205
retail and light manufacturing, 150
Rhondda, Margaret (Great Britain), 33
Roberts, Alfred (Great Britain), 78
Robins, Margaret Dreier, *18*, 19, 31
Roldán, Martha (Mexico), 144
Roosevelt, Eleanor, 78
rural workers: handicraft production and, 97–104; *Rural Development and Women in Africa*, *123*; Rural Employment Policies Branch, 149, 172; rural women in development, 122–124; *Rural Women of Thailand*, 147–148; Rural Workers' Organisations Convention, 1975 (No. 141), 125; scholarship on, 127–129; *Women and Rural Development in China*, *140*. *See also* development and developing countries; Programme on Rural Women
Ryder, Guy (ILO), 230

Salvesen, T. (Norway), 43
Sarabhai, Anasuya, 175
Savané, Marie-Angélique, 138
Scheepers, Anna (South Africa), 164
Scottish Federation of the National Union of Women Workers, 33
seafarers and sex, 39–40
seafarers' protections, 42–47, 235–236
sectorial committees, 161–167, 171
Self Employed Women's Association (SEWA): Ahmad and, 157; history and purpose of, 175–177; on home-based workers, 155, 156; impact of, xix; organizing strategies, 180–182; putting-out system and, 171; relations with ITGLWF, 177–178; relations with the Programme on Rural Women, 174–175; relations with unionists, 178–179; significance of, 154, 158, 188–189
sex workers, 39–42, 44–46, 209
Shenker, Jill, 222
Slavery Convention, 47–52
small-scale industries, 98–99, 102
Smirnova, Raïssa (Soviet Union), 109, 118
"Social, Economic and Legal Conditions of Domestic Servants, The" (ILO), 199
Social Policy (Non-Metropolitan Territories) Convention, 1947 (No. 82), 63–64
social reproduction, 7–8, 63
Social Security (Minimum Standards) Convention, 1952 (No. 102), 56
Somavía, Juan (ILO), 198, 206–207, 218
South African relations with ILC, 65, 269n63
Soviet Union relations with ILO, 65
Standing, Guy, 230, 241
Street, Jessie (Australia), 58
structural analysis, 141

Subordination of Women Workshop
 (SOW), 128–129
Sutherland, Mary (Great Britain), 80
sweatshops, 159, 241

Taka, Tanka (Japan), 29
Tate, Jane (Great Britain), 182, 188
technical cooperation, 93
technology and reproductive labor, 133
telework, 160
Tenison, Mary (United Nations), 83
textile and clothing industry: geographic
 aspects, 295n13; historical aspects,
 158–161; home work rates, 162;
 sectorial committees, 163–166; SEWA
 and, 181–182; TLA, 175–176, 178–179;
 unions, 168–169; women in, 161
Textile Labor Association (TLA), 175–176,
 178–179
"The Economic and Social Advancement
 of Women in Developing
 Countries" resolution, 106–107
Thibert, Marguerite (France), 35–36, *37*,
 54, 61–62
"Third World" difference, 62–64,
 108–110, 151
Third World women, 10, 95–96
Thomas, Albert (France), 32, 44
Tillett, Gladys Avery (United States),
 104–105
Tinker, Irene, 128
TLA (Textile Labor Association), 175–176,
 178–179
Tomei, Manuela (ILO), 196, 207, 233, 235
Tomlinson, George (Great Britain), 59
trade unions: catholic, 32; on domestic
 workers, 213–215; home-based
 industries and, 155–157; on home
 work, 167–169; ICFTU, 155–156, 162,
 166, 177–178, 183, 186, 197, 210, 212;
 IDWF, *2*, 221, 222, 226–228; ITUC,

197, 215–216, 227; IUF, 155–157, 173,
 179–180, 183, 197, 212, 216–217, 225
Latin American and Caribbean
 Confederation of Household
 (CONLACTRAHO), 213; textile
 and clothing, 156, 158–159, 161–163.
 See also Self Employed Women's
 Association (SEWA)
Traffic Committee, 41, 42, 45
training in developing countries, 91, 100,
 103, 104
transportation industry, 71
Trotman, Leroy (Barbados), 195
Tryfan, Barbara (Poland), 139

Ulfbeck, Fanny (Denmark), 41
United Nations (UN): 1975 Conference
 on Women, 117; Asian and
 Pacific Centre for Women and
 Development, 119; CSW, 78–79;
 Decades of Development, 91;
 FAO, 130; historical aspects, 3; ILO
 relations with, 63–64; impact of, 76;
 International Convention on the
 Elimination of All Forms of Racial
 Discrimination, 110–111; Research
 Institute for Social Development, 131;
 UNRISD, 131; WID theory, 128–
 129; "Women Workers in a Changing
 World," 104–105; World Conference
 on Women, 10
United States relations with ILO, 65,
 67–71, 129
United States role in Domestic Workers
 Convention (No. 189), 219–223
United States Woman's Bureau, 74–76
universal carer model, 232
unpaid labor. *See* family responsibilities
Uttar Pradesh, 169

Vandervelde, Emile (Belgian), 32

van Kleeck, Mary, 31
van Luijken, Anneke, 215–216
Varley, Julia (Great Britain), *37*
violence and harassment, 221, 233–238, 318n37
Vrouwenbond (Women's Union), 174

Walker, Marie Clarke (Canada), 236
Washington Conventions, 19, 25–31
Wasniewska, Eugenia, 38
Watson, John Forbes, Sir (Great Britain), 59, 204
Welfare Committee, 45
welfare states, 6
WEP (World Employment Programme), 127, 130–135, 150, 152, 169
White Lead (Painting) Convention (No. 13), 34
WID (women in development) theory, 94, 106–107, 128–129
WIDF (Women's International Democratic Federation), 58, 112, 117
WIEGO (Women in Informal Employment: Globalizing and Organizing), 197, 212, 225–226
Williams, Faith (United States), 65, 66
Winslow, Thatcher, 83
Witbooi, Myrtle (South Africa), 193, 195
Women and Development (Lourdes Benería), 138
Women With Family Responsibilities Recommendation, 108–110, 115
Women and Rural Development in China (Croll), *140*

Women at Work (FEMMES), 169
Women at Work magazine, 149–150
women in development (WID) theory, 94, 107, 128–129
Women in Informal Employment: Globalizing and Organizing (WIEGO), 197, 212, 225–226
Women's International Democratic Federation (WIDF), 58, 112, 117
women's liberation framework, 120
women-specific protections, 17–19, 29, 32–36
Woman's Role in Economic Development (Boserup), 117
Women Workers in a Changing World (United Nations), 104–105
Workers with Family Responsibilities Convention, 1981 (No. 156), 56, 110
Working Conditions and Environment (PIACT), 173
Working Women's Forum, 173
World Bank, 92, 129, 211, 240
World Conference of the International Women's Year, 117, 119
World Employment Programme (WEP), 127, 130–135, 150, 152, 169
World Woman's Party (WWP), 34, 50, 64

Yacob, Halimah (Singapore), 217
Yllanes Ramos, Fernando (Mexico), 204–205
Young, Kate, 138, 141
YWCA (Young Women's Christian Association), 49, 200–201